Impressionism in America

Ulrich W. Hiesinger

Impressionism in America

The Ten American Painters

Prestel

This book was published in conjunction with the exhibition of the same name
held at the Jordan-Volpe Gallery, 958 Madison Avenue,
New York, from May 18 to June 28, 1991.

Front cover: Edmund C. Tarbell, *Girl with Sailboat*, 1899 (plate 73)
Back cover: Childe Hassam, *End of the Trolley Line, Oak Park, Illinois*, 1893 (plate 47)
Spine: Childe Hassam, *Paris Nocturne*, c. 1889 (detail; plate 12)

Prestel-Verlag
Mandlstrasse 26
D-8000 Munich 40
Federal Republic of Germany
Tel.: (89) 3 81 70 90; Fax: (89) 38 17 09 35

Distributed in continental Europe by Prestel-Verlag,
Verlegerdienst München GmbH & Co KG,
Gutenbergstrasse 1, D-8031 Gilching
Federal Republic of Germany
Tel.: (81 05) 21 10; Fax: (81 05) 55 20

Distributed in the USA and Canada by te Neues
Publishing Company, 15 East 76th Street, New York, NY 10021, USA
Tel.: (2 12) 2 88 02 65; Fax: (2 12) 5 70 23 73

Distributed in Japan by YOHAN-Western
Publications Distribution Agency, 14-9 Okubo 3-chome, Shinjuku-ku,
J-Tokyo 169
Tel.: (3) 2 08 01 81; Fax: (3) 2 09 02 88

Distributed in the United Kingdom, Ireland and all other remaining countries
by Thames & Hudson Limited,
30-40 Bloomsbury Street, London WC1B 3QP, England
Tel.: (71) 6 36 54 88; Fax: (71) 6 36 47 99

Designed by Dietmar Rautner, Munich
Typesetting by Setzerei Max Vornehm, Munich
Offset lithography by Gewa-Repro, Gerlinger + Wagner, Munich
Printed and bound by Passavia Druckerei GmbH, Passau

Printed in the Federal Republic of Germany

ISBN 3-7913-1142-5

Contents

Acknowledgments

The realization of this book is owed to the good will and assistance of many people. Among those who generously made their paintings available for study and reproduction we would particularly like to thank Ruth Sharp Altshuler, Sid and Diana Avery, Sewell C. Biggs, William and Zelma Bowser, Phyllis and Irwin Chase, Mr. and Mrs. Raymond J. Horowitz, Meg Newhouse Kirkpatrick, Dr. Jovin Lombardo, Mr. and Mrs. C. Thomas May, Jr., Mr. and Mrs. Samuel P. Peabody, Richard Pfeil, Mr. and Mrs. Thomas A. Rosse, the late Harry Rubin, Doris Rubin, Mr. Richard Rubin, Mr. Robert Rubin, and Mr. and Mrs. Hardwick Simmons. Sincere thanks also go to the many individuals who preferred not to be named, but who contributed equally by allowing their paintings to be included here and by sharing their time and knowledge. Separate and special thanks go to Richard Manoogian and Edward Shein not only for the loan of paintings, but also for offering their enthusiastic support and expertise.

Particular thanks are also owed to Robert Lorenzson for expert help in photography; to Ellen Lanahan for patiently surmounting countless duties of organization and administration; and to David Dufour for ably serving as liason to many collectors and other individuals.

Among the many people who helped in providing information, securing photographs, or locating works of art we are indebted to Joan Barnes, Faith Bedford, Richard Berglund, Doreen Bolger, Marissa Boyescu, Terry Carbone, Mr. and Mrs. William Carlin, Conna Clark of the Philadelphia Museum of Art, Marjorie Crodelle, Deborah Force, Karen Gabrielsen, Elizabeth E. Gunter, Fred Hill, Katurah Hutchinson, Joanne Klein, Alan Kollar, Edward Lipowicz of the Canajoharie Library and Art Gallery, New York, Alicia Longwell of the the The Parrish Art Museum, Southampton, Long Island, Lisa Lorch, Mary Lublin, Liz MacPherson, Janis McFarling, Grete Meilman, Joan Michelman, Dara Mitchell, Ursula Pfeffer, Colleen Schafroth of the Maryhill Museum of Art, Goldendale, Washington, the late Edward B. Simmons, Julian Simmons, Paul Swisher, Edmund Tarbell II, Richard Thune, Robert C. Vose, Jr., Abbott W. Vose, Robert C. Vose III, Richard York, and Mary Zlot.

Those who facilitated research in many useful ways are Anita Gilden, Gina Erdreich, Lilah Mittelstaedt, and Catherine Fox of the Philadelphia Museum of Art Library; Bernard Pasqualini, Arnold Jordan, John Pfeffer, Diane Jude McDowell, Janet Dixon, Blanca Pfeffer, Victoria Mikus, Barbara J. Bates, Jill McConkey, and Zandra Moberg in the various departments of the Philadelphia Free Library; Mme. Caroline Durand-Ruel Godfroy, Durand-Ruel & Cie., Paris; Eugenia Fountain, Essex Institute, Salem, Massachusetts; Cheryl Leibold, Pennsylvania Academy of the Fine Arts Archives; Lisa Luedtke, Corcoran Gallery of Art, Washington, D.C.; and Allan Van Oy, Cincinnati Art Museum Library. For assistance in gathering research materials thanks also to Robert Woltersdorf, Helen Neithammer, and especially Patricia Ronan, who did substantial work in the late stages of the book.

Deepest thanks are also owed to George Marcus for the benefit of much good advice, to Kathryn Hiesinger for patient concern and valuable comments, and to William Matthias Benjamin and Margaret Amalia for much the same.

Finally, we are indebted to the staff of Prestel-Verlag, who somehow manage to safeguard the demanding publishing process as a humane, professional, and totally sympathetic occupation.

The Ten and Concepts of Impressionism

The story of the Ten American Painters represents a pivotal chapter in one of the most energetic and tumultuous eras in American painting. Although organized as a formal group only in the winter of 1897/98, the members of the Ten had been among the leaders of the sweeping reform movements that transformed the American art world from about the time of America's Centennial Exhibition in 1876. Their legacy stems from a generation that challenged all the old assumptions with fresh artistic visions and new techniques and, in the process, fundamentally altered the relationship of the artist to his audience.

The secession of the Ten from the Society of American Artists in late 1897 began as a modest and essentially private affair. There was no manifesto, no proclamations of any far-reaching aims. Three weeks of official silence followed the receipt of the artists' resignations by the Society and, if everything had gone according to plan, we undoubtedly would know very little about the smoldering controversy that led to their defection. Yet the implications of this event and the depth of feeling on both sides made publicity inevitable, and what might have remained a quiet feud among professionals became, instead, a loud public quarrel about the dismal state of American art.

Although the immediate circumstances of their withdrawal from the Society offer a fascinating picture of contemporary art politics in America—a rare instance of artistic tempers bared in public and one reported in the press with a gossipy intimacy never found in the polite art journals—the deeper significance of the Ten's rebellion, and the key to its ultimate contribution to American art, lie in the history of conflict that marked the preceding two decades.

Later fame helped to obscure the background and controversial origins of these artists. Members of the Ten were partly responsible for this, for, typically, they were never much interested in examining the past, and brief accounts written many years after the fact by Childe Hassam and Edward Simmons[1] were sketchy and, in some ways, genuinely misleading. By the time they disbanded, much diminished in various respects after twenty years of joint exhibitions, the Ten had come full circle, possessed of a reputation for conservatism in a world shaken by the more radical modernist experiments. In concentrating on this late phase, recent critics too often have been diverted from the original importance of the movement,[2] tending to perpetuate the reputation of the Ten as a distinguished but essentially peripheral feature of the American art world at the turn of the century, and, because of its members' varied styles, even disputing their claim to be called Impressionists.

Nonetheless, from the very beginning of their group career until its end the Ten were recognized—and regularly condemned—as radicals under the "Impressionist" banner. According to present-day criteria, several of the group were hardly Impressionists, and did not appear as such even to some nineteenth-century critics, but, perhaps because they were among the lesser contributors to the Ten exhibitions, contemporaries swept them together in their assessments. Under the looser nineteenth-century usage of the term, few contemporaries hesitated to identify the Ten with the Impressionist cause. As late as 1914 a critic said of them: "The flag of the impressionist floats over the whole, as it has for seventeen years, and the tenets of that cult are worthily represented."[3]

The various interpretations given to the word "Impressionism" by nineteenth-century American critics and commentators exist along a sliding scale of value. At the trivial

extreme it was used as a catchall phrase to describe anything considered "novel and unusual."[4] At the other end of the scale, as used by the best writers, the term was understood much as it is today, as identifying a specific school of painting with a specific outlook and specific methods.

The earliest mention of the movement came from a correspondent abroad, who made some deprecating comments about the first Impressionist exhibition held in Paris in 1874.[5] By the late 1870s the term "impressions" had come to be used fairly often in association with the loosely painted techniques of the French Barbizon painters. Two main qualities were associated with the word: its rejection of conventional detail and its supposed insistence on highly personal or subjective interpretations of nature. George Inness, for example, used the term in this sense to describe his own efforts to convey the inner spiritual qualities of his subjects[6] and as an indirect endorsement of the Barbizon painters. The painter-critic Earl Shinn, in a 1879 review of the National Academy exhibition, quite clearly contrasted the "Hudson River School and the impression [sic] school" as representing old and new tendencies in American painting, connecting the latter with the styles of Jean Baptiste Camille Corot and Théodore Rousseau.[7] Similarly, L. Lejeune, in his review for *Lippincott's Magazine* of the fourth Impressionist exhibition held in Paris in 1879, thought Impressionism applicable to the loose technique of the Barbizon painters, although he also included Mariano Fortuny on account of his dashing brushwork. According to Lejeune, the art of Fortuny, Corot, and Jean François Millet represented "true Impressionism," for they succeeded in uniting their broad techniques with an inspirational mood or feeling.[8]

These attitudes became so firmly entrenched that, when the French art dealer Paul Durand-Ruel brought a spectacular exhibition of nearly three hundred French Impressionist paintings to New York in 1886, a large number of observers, ignorant of the origins of the Impressionists included, were inclined to believe that either a mistake or a swindle was taking place. One critic, for instance, who had his own definition of Impressionism as something to do with beauty "impressing" itself on the artist's soul, regarded the work of Edouard Manet, Claude Monet, Auguste Renoir, Edgar Degas, Alfred Sisley, and their companions, and solemnly declared them not to be Impressionists at all![9] Another pointedly separated the "Paris Impressionists" from the "American Impressionists," indicating the difference by including in the latter category only such Barbizon-influenced Americans as Alexander Wyant, Dwight Tryon, and Charles Warren Eaton.[10] The clearest statement along these lines came from a critic at the *Commercial Advertiser* who, writing under the sub-heading "Some Impressions that Are Not Impressions," said that the new crowd of artists introduced by Durand-Ruel were imposters, and that: "The genuine impressionist is only a development of the school which started at Barbizon. He aims at simplicity, at breadth, at clear and transparent coloring; he appreciates good draughtsmanship . . . he would repudiate with the rest of the sensible world such miserable stuff as is here paraded under a fair and honorable name."[11]

Often in conjunction with its application to Barbizon-style painting, "Impressionism" also acquired an even more universal meaning, as S. G. W. Benjamin demonstrated in 1880 when he applied the term to all great painters who appeal to the imaginative sense, including Turner, Corot, Velázquez, and the Japanese.[12] Elizabeth Pennell made similar use of the term when she asserted in 1900 that Impressionism "simply means the work of men of strong individuality, and therefore, great men," concluding that Monet himself *might* someday qualify.[13]

Those who concentrated more on its relevance to technique made Impressionism a byword for anything painted so broadly as to seem bizarre. This is one reason why James McNeill Whistler was labeled an Impressionist,[14] and why the Munich-based painter Frank Currier, despite a pitch-black palette, could be identified as belonging to the "most advanced class of the 'impressionist' school."[15] More than once, in fact, the loose brushwork of Munich-trained American artists led critics to connect the two, as a reviewer of John Twachtman's paintings did when he attributed the beginnings of the Impressionist movement to Munich.[16]

Impressionist technique was often regarded as something inherently dishonest, a cheap substitute for hard work or genuine ability. Lucy Hooper, in describing the "maniacs of impressionism" from Paris in 1880, said they found it was "easier to dash off an unnatural daub, defying all the rules of perspective and coloring, than it is to paint an accurate and carefully finished picture."[17] In America it was said that a diligent genre painter such as Thomas Hovendon would never "shirk" the difficulty of finishing a work just to pass off an "impression" as art.[18] Charles De Kay dismissed such talk of Impressionism as "the false understanding of the word, as it is defined by those who are ignorant," and declared the Impressionist to be someone who, like Whistler, had acquired the ability to work rapidly and expertly out of long experience and sheer control of his technique and materials.[19] Charles Dempsey explained in his 1882 essay on the aesthetic movement in England that Whistler's concept of "art for art's sake" involved an intimate technical knowledge of painting that made it *by definition* inaccessible to the

general public. Whistler's art, he stated, intentionally moved "from a world-wide appreciation to one private and technical Once for all, art, *qua* art, is only to be appreciated by artists."[20] (Whistler, said Dempsey, was thus "caviare" to common taste, a phrase that, significantly, was repeated on several occasions to describe the Ten.)

Whistler was linked to Impressionism not only by his technique but equally by his insistence on the primacy of subjective individual temperament. His disdain for the public's understanding of art, and his belief that the artistic process was the isolated province of individual genius, were ideas made famous in America after the Ruskin trial of 1878 and after the publication here in 1888 of his "Ten O'Clock Lecture," delivered in London in 1885. These ideas became associated not only with Whistler personally, but with the Impressionist viewpoint in general, merging with the quality of subjectiveness held also to be part of the Barbizon painters' philosophy.

Whistler was a legendary figure who, even from abroad, represented in many ways the artistic conscience of progressive American artists. (It was said that, at the Society of American Artists, it was always a cause for congratulation if one of his pictures could be obtained for exhibition. His *The White Girl* [National Gallery of Art, Washington, D. C.] and *Portrait of the Painter's Mother* [Louvre, Paris], exhibited in 1881 and 1882, were among the best remembered in New York.) Among members of the Ten, William Merritt Chase knew him best from a brief but intense encounter in London and Holland in 1885, but most other members of the group also knew him personally. J. Alden Weir had met him as early as 1877, though at the time was unimpressed, and later Thomas Dewing, Robert Reid, Simmons, and Twachtman had varying degrees of acquaintance with him. Hassam, though he did not know him personally, wrote to Weir after re-reading the "Ten O'Clock Lecture": "How true it is! and it is reassuring too!"[21]

With the question of "Americanism" ever-present, modern writers have often stressed the differences that supposedly kept these and other native artists from experiencing "true Impressionism." On the one hand, it is said, the innate practicality and realism of the American temperament barred their way. Others point to early academic training as having inhibited the development of a free and full form of the Impressionist style. These and other well-meaning attempts to characterize the distinctive qualities of American Impressionism overlook several crucial points, not the least of which is the absence of any easy definition of what constitutes Impressionism anywhere. There simply is no touchstone by which to measure deviation or orthodoxy

within the Impressionist style. The French artists who represent our ultimate standard not only pose the difficulty of being a self-defining group, but also themselves demonstrate a variety of temperaments and painting techniques. Far from being uniform, Impressionism in France was itself a diverse and constantly evolving style.

American historians, like their nineteenth-century American predecessors, have tended to use Monet as the principal, if not the sole, standard by which to judge the American Impressionists, focusing above all on the role played by light and atmosphere in dissolving form. Yet Monet's unique emphasis on this process was but one, albeit important, aspect of Impressionist technique, while for such artists as Degas, Mary Cassatt, or Renoir the principles of spatial perspective, drawing, and modeling remained important concerns—without, one need hardly add, jeopardizing their status as "Impressionists." When evaluating the American achievement, therefore, one should allow equal latitude, and recognize in it not a single definitive component, but several factors—including the rendering of bright outdoor light and color, the optical breakdown of detail, the concern for contemporary life, and the cultivation of a direct and spontaneous approach to subjects—that could occur separately or in combination.

Finally, the effort to understand the American involvement with Impressionism must take into account the fact that, when the style first took root in America, the Impressionist revolution in Europe was already an accomplished fact, and the Paris Impressionists, discernible by any intelligent professional as a school with its own separate history and identity, could *only* be viewed with a certain amount of detachment. There was never a question of actually "joining" the European Impressionists, as some writers seem to imply.[22] This realization, indeed, underlay the entire critical discourse regarding Impressionism in America, and is precisely what determined the course followed by most of the Ten and by other artists involved with the style in America. Moreover, at the very moment in the mid-1880s when Impressionism took hold in America, in France it was being challenged from within. The year 1886 marked both the first great exhibition of Impressionist work in America and the last of the Impressionist group shows in Paris. The subsequent work of Vincent van Gogh and Paul Gauguin, of Georges Seurat, Paul Signac, and Camille Pissarro, represented a host of new departures based on what had already been accomplished over a generation. French Post-Impressionism and American Impressionism, occurring simultaneously, might be said to have headed in opposite directions, the former toward greater subjectivity or science, the latter

toward an ultimate reconciliation of Impressionist innovations with traditional painting values. Although their starting points, as well as their results, were vastly different, the Ten American artists did share with their contemporary European counterparts the desire to absorb, expand, and individualize the lessons of Impressionism which they had inherited.

While the Ten did not comprise a school in any strict sense, a shared interest in the outlook and techniques of Impressionism was undeniably at the heart of their union. The Ten, moreover, never became an organization in any official or public sense. There were no officers or formal meetings, no records kept except for the exhibition catalogues, and, after the beginning, no thought of expansion beyond the original membership. The Ten was simply a collective banner held out by the group on the occasion of their annual exhibitions, though membership in the group also served as a useful advertisement in their private careers. The members exhibited their work separately as they pleased, in local group shows, in the large national annuals held in New York, Washington, D.C., Pittsburgh, Philadelphia, St. Louis, Cincinnati, and elsewhere, and in frequent solo exhibitions. This practice was established at the outset, when Reid held a brief one-man exhibition at the Durand-Ruel gallery in New York immediately following the first Ten exhibition there in 1898. Occasionally, it was remarked how shows by the various individual members diminished the impact and commercial success of the group exhibitions, but interest in their work remained strong enough to overcome this fact.

The conflict over what was regarded as popular versus artistic success was one that polarized the Ten and the American art world from the last quarter of the nineteenth century. Most of the picture-viewing public, encouraged by the most widely read art journals, continued to see painters and sculptors as members of an elevated artisan class whose function was defined as serving established taste—or, as one critic expressed it, "art is for the people, not for a special jury of professional experts."[23] According to established standards, good art should tell a story, be finished in careful detail, and confine itself to a rather obvious range of inspirational themes and character types.

The Ten, among other American artists of the new generation, saw themselves in a different role, one in which it was both the artist's prerogative to dictate the terms of his own work and his obligation to lead. As Chase said, in dismissing the importance of subject *per se*: "The value of a work of art is in its quality of making you a sharer in the thoughts and sensations of rarely gifted men."[24] In the hands of such painters, the work of art left the public arena to become a medium of private dialogue. The phrase "painter's painter" was widely applied to the Ten as artists whose work initially appealed to fellow prefessionals rather than to the public, and who rejected the role of illustrator, humorist, storyteller, or historian. They comprised the body of what critics called "extremists," and were characterized as followers of the so-called doctrine of "art for art's sake," who flaunted technique, ignored the public, and set themselves apart in precious isolation. Thus, the painter's own image of himself as an interpreter coincided with the earliest definition of Impressionism in America as a highly personal or subjective mode and, because "Impressionist" came to mean someone who was fundamentally a translator of experience in this loose sense, we can better understand why it was possible to see both Whistler and Monet as Impressionists, and even the Ten themselves in the variety and diversity of their styles.

Notes

1 Childe Hassam, "Reminiscences of Weir," in *Julian Alden Weir: An Appreciation of His Life and Works*, The Phillips Publications, No. 1, New York, 1922, pp. 67–68; Edward Simmons, *From Seven to Seventy: Memories of a Painter and a Yankee*, New York and London, 1922, p. 221 ff.
2 For instance, D. Hoopes, in *The Ten*, exhibition catalogue, Art Museum of South Texas, Corpus Christi, 1977, p. 5, went out of his way to disassociate the group from Impressionism, saying that Edmund C. Tarbell, Frank W. Benson, and Joseph R. De Camp reverted to a genteel tradition "that seems almost antithetical to the spirit of impressionism," and that "there was not the slightest hint of rebellion among them." Similarly, W. Gerdts, in *Ten American Painters*, exhibition catalogue, Spanierman Gallery, New York, 1990, p. 75, said of the Ten that their very conservatism was their "most enduring claim to fame."
3 *Sun*, Mar. 22, 1914, p. 12.
4 See "The Observer," *Art Interchange* 31, no. 4 (Oct. 1893), p. 96, which states: "when anything strikes the average individual as novel and unusual it is set down as belonging to the impressionist school, even though he is unable to tell just what that school consists of or where its boundaries end—if it has any such."

5 *Appleton's Journal*, June 20, 1874, as cited in John Rewald, *The History of Impressionism*, 4th rev. ed., New York, 1973, p. 326, n. 30.
6 George Inness, "An Artist on Art," *Harper's Magazine* 56 (1878), p. 458. In his repeated use of the term "Impression" there is no hint that Inness either knew or understood the contemporary French Impressionists, and indeed, he later referred to their movement as a "sham." See *Art Interchange* 33, no. 3 (Sept. 1894), p. 75; also his remarks in "Mr. Inness on Art Matters," *Art Journal* (New York) 5 (1879), pp. 374–77, and George Inness, Jr., *Life, Art, and Letters of George Inness*, New York, 1917 (reprinted 1969), p. 168 ff.
7 Edward Strahan (pseud. Earl Shinn), "The National Academy of Design," *Art Amateur* 1 (June 1879), p. 4.
8 L. Lejeune, "The Impressionist School of Painting," *Lippincott's Magazine* 24 (Dec. 1879), p. 726.
9 Edward Rudolf Garczynski, "Jugglery in Art," *Forum* 1 (Aug. 1886), pp. 592–602.
10 *Churchman*, June 12, 1886, pp. 672–73.
11 "Impressionists," *Commercial Advertiser*, Apr. 10, 1886, p. 6. In further demonstrating the potential confusion over the nature and terminology of the move-

ment, at least one critic in New York later became aware of the term "Neo-Impressionism," coined by Félix Fénéon in 1886 to distinguish the new style of Seurat, Signac, and Pissarro, but misapplied it, making the original company of Monet, Renoir, et al. into "Neo-Impressionists" in order to separate *them* from what he considered the original "Barbizon" Impressionists. See "The Neo-Impressionists," *New York Times*, June 19, 1982, p. 19.

12 S. G. W. Benjamin, *Art in America: A Critical and Historical Sketch*, New York, 1880, p. 192. According to Benjamin, the Impressionist aimed at capturing intangible qualities, which he likened to those of music, while optical objectivity, the antithesis of "Impressionism," was the province of detailed "finished paintings."

13 Elizabeth Robins Pennell, "Some Interesting Things About American Art at the Paris Exposition," Boston, 1900 (reprint from *Nation*). According to the author W. H. W., in "What is Impressionism?" *Art Amateur* 27 (Nov. 1892), p. 140, who conceded the dual usage of the term, this was the broad "intrinsic" meaning of the word "Impressionism": "In a general sense, Impressionism is as old as art, and merely points at the artist's independent way of looking at nature, and receiving fresh impressions from her as wax receives impressions from a seal."

14 Henry James, "The Grosvenor Gallery and the Royal Academy," *Nation* 24 (May 31, 1877), p. 320.

15 F. W., "Notes on a Young 'Impressionist,'" *Critic* 1, no. 15 (July 30, 1881), pp. 208 f.

16 See "The National Academy Exhibition," *Art Amateur* 26 (May 1892), p. 141.

17 "Art Notes from Paris," *Art Journal* (New York) 6 (1880), pp. 188–90.

18 For this characterization of Hovendon's *The Puzzled Voter*, see *Art Interchange* 6, no. 4 (Feb. 17, 1881), p. 34, and 6, no. 5 (Mar. 3, 1881), p. 53; and for related remarks on Henry Mosler, *Art Amateur* 13 (Nov. 1885), pp. 113–15. Theodore Child, "Joseph De Nittis," *Art Amateur* 11 (Nov. 1884), pp. 122–23, refused for this reason to accept the Impressionist label for the Paris-based Italian Giuseppe De Nittis—who had actually exhibited in the first Impressionist exhibition—precisely because he viewed him as "too conscientious and too complete an artist to disdain perfection of drawing, truth of coloring, and order of composition as the ordinary super-disdainful impressionist is inclined to do."

19 Charles De Kay, "Whistler: The Head of the Impressionists," *Art Review* 1 (Nov. 1886), pp. 1–3.

20 Charles W. Dempsey, "Advanced Art," *Magazine of Art* 5 (1882), p. 359.

21 Hassam to Weir, Aug. 12, 1903, Archives of American Art, Roll # NAA 2.

22 Jerrold Lanes, in *Burlington Magazine* 110 (Jan. 1968), p. 57, is one of few to recognize the "externality" for Americans of such European artists as Manet and Degas.

23 "Lay Art Criticism," *Art Amateur* 5 (Aug. 1881), p. 46.

24 Walter Pach, "The Import of Art (An Interview with William M. Chase)," *Outlook* 95 (June 1910), p. 444.

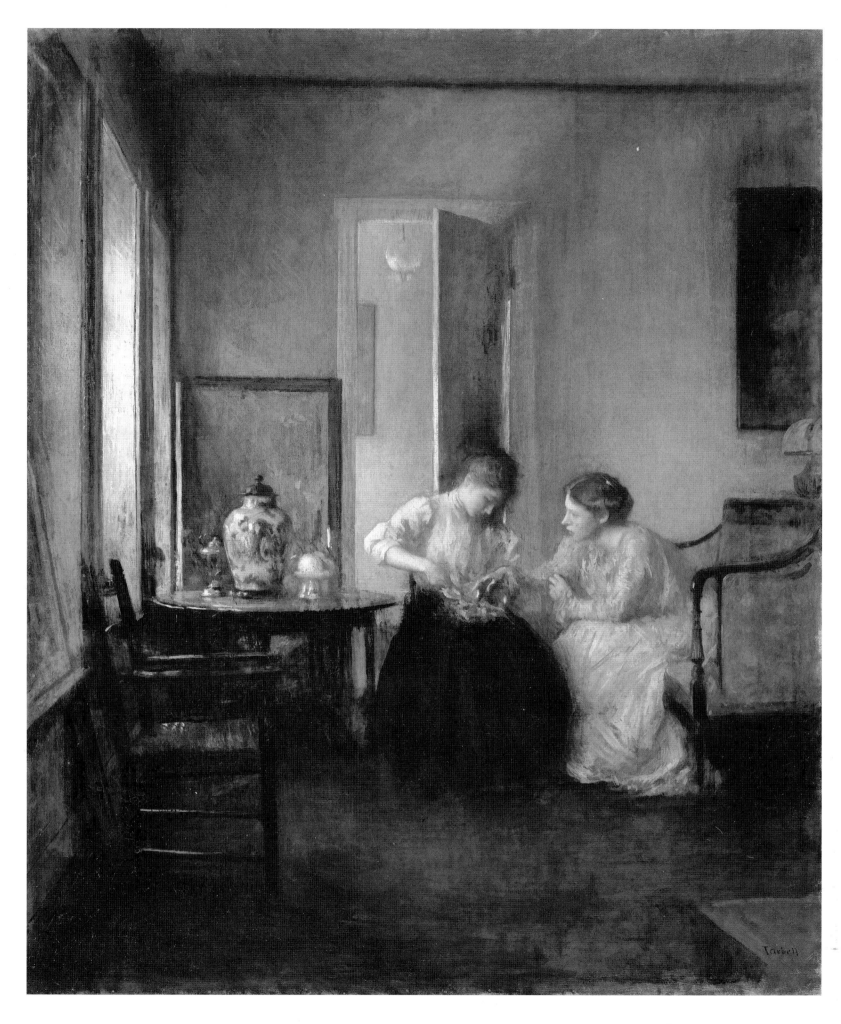

The Founding of the Ten American Painters

"A tempest in a teapot...a sideshow....It has been absurdly claimed that the secession of these artists from the Society has deep significance, and means a new and important movement in the American art world, and the incident has thus more absurdly been magnified into proportions that it does not deserve."[1] So wrote the critic of the *New York Times* on January 15, 1898, a week after it had been first announced that ten prominent members—generally regarded as the "Impressionist" group—were resigning in protest from the Society of American Artists. The group consisted of Childe Hassam, J. Alden Weir, John Twachtman, Robert Reid, Willard Metcalf, Frank W. Benson, Edmund C. Tarbell, Thomas W. Dewing, Joseph R. De Camp, and Edward Simmons. William Merritt Chase was added to the group several years later, while two other painters, Abbott H. Thayer and Winslow Homer, were originally asked to join but declined.[2] One report, though unconfirmed, named still two others, Alfred Q. Collins and George De Forest Brush, as among those also asked to join but who refused.[3]

The name of the group first became known on the occasion of their initial exhibition, in March 1898, and the form it took—"Ten American Painters"—suggested as much a description as a title in the programmatic sense. Nevertheless, "Ten American Painters" remained their formal title, and it was not long before this was abbreviated in the press (and informally amongst the members) as "The Ten."[4]

What lent particular irony to the situation, and made debate especially vehement, was the fact that the Society of American Artists had itself grown out of a similar revolt twenty years earlier. Then it had been the National Academy of Design, bastion of the Hudson River School, that stood against a generation of adventurous young artists back from Europe. In breaking away, the Society of American Artists had assumed the role of enlightened rival, and for years its exhibitions served as the leading forum for progressive art in America, numbering, along with those who would become the Ten, such figures as John Singer Sargent, James McNeill Whistler, Thomas Eakins, Mary Cassatt, and Winslow Homer. Now it was the Society's turn to be accused of backwardness. The secession was being seceded from, and for those who remained in the Society the humiliation was intense.

All of the Ten had already left behind the first youthful stage of their careers. The senior members—Weir, Twachtman, Simmons, and Dewing—were in their mid-forties and, except for Simmons, long-standing veterans of the Society. The others were in their mid- to late thirties, and had joined the Society either in the late 1880s or, in the case of Hassam and Reid, were among the last of the "progressives" to be admitted, in 1890 and 1891 respectively. All had achieved a certain level of distinction, some being quite famous, others having earned at least some measure of respectful notice in the press and among many of their colleagues. About half of the painters had won major prizes in the exhibitions of the Society and the National Academy of Design, several quite recently.

Tarbell, Benson, and De Camp lived in Boston; the others were centered around New York. Yet most of these—Hassam, Dewing, Metcalf, Simmons, and Reid—also had early ties to Boston (and to each other), having been born and educated in that city. Reid, for example, had known Tarbell

Fig. 1 Edmund C. Tarbell, *New England Interior*, c. 1906.
30⅛ x 25⅛ in. (76.5 x 63.8 cm).
Museum of Fine Arts, Boston. Gift of Mrs. Eugene C. Eppinger

and Benson as fellow students at the Boston Museum school, where they both now held forth as the principal teachers. Twachtman and De Camp were Cincinnatians and had known each other as students in Munich and in Venice. Weir, the only native New Yorker, was the youngest son of Robert F. Weir, a distinguished painter of the Hudson River School generation, and thus moved comfortably within the older as well as the new artistic establishments. Most of the men were family heads, while both Reid and Metcalf led a freewheeling bachelor's life in Manhattan, as did Simmons, who had left his wife and children more or less permanently in Europe. Hassam, Reid, De Camp, and Twachtman were all noted for their outspoken, pugnacious natures. Weir, distinguished looking and popular, was the diplomat of the group.

When the Ten assembled in New York a week before Chistmas, 1897, to organize their group, they drew up a "founding charter" which still survives among Hassam's papers. It has more the character of a contract than of a mani-festo, consisting of two sheets signed by each member, one simply containing a pledge to "resign from the Society of American Artists," the other an undertaking to "cooperate and consolidate for the purpose of holding an annual exhibi-tion of work." This agreement was drawn up on December 17, just three days after the Society had elected the jury for its upcoming annual spring exhibition, a jury in which, we learn, conservative members had gained control yet again. The *Sun* gave this account:

The ten members [who have resigned] have been known among their col-leagues as being of the impressionistic school, and the final breaking off seems to have come as the last of a chain of disagreements in which the dif-ferent styles of painting figured largely Three years ago, according to one of the members of the society who did not resign, the impressionistic group got control of the jury of the society and ran things pretty much to their own liking. Since then, however, the more conservative element has regained and kept control of the society, and in every exhibition since then the jury has been in the hands of the conservative members. [5]

Fig. 2 Childe Hassam, *La Bouquetière et la Laitière*, c. 1888. Watercolor on paper, 17 x 26 in. (43.2 x 66 cm). Private collection

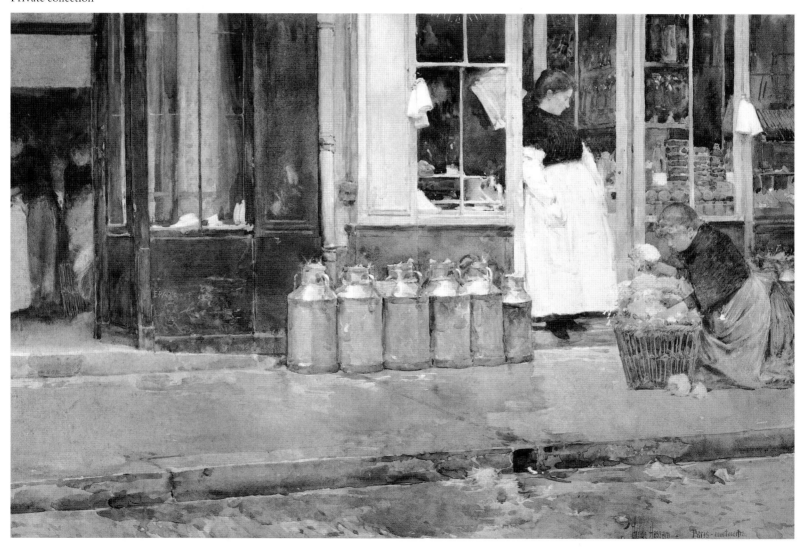

Fig. 3 Childe Hassam,
*The Manhattan Club
(The Stewart Mansion)*, c. 1891.
18¼ x 22⅛ in. (46.4 x 56.2 cm).
Collection of the Santa Barbara
Museum of Art,
Gift of Sterling Morton
for the Preston Morton Collection

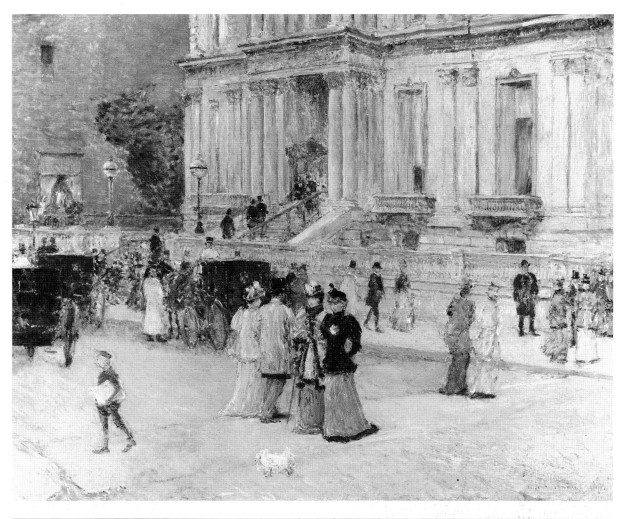

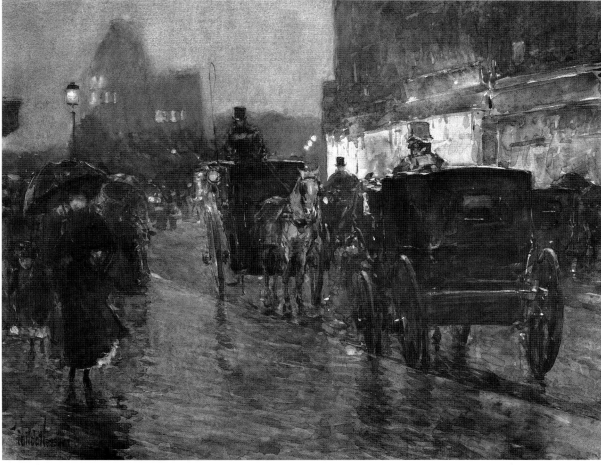

Fig. 4 Childe Hassam,
Horsedrawn Cabs at Evening, c. 1890.
Watercolor and gouache on paper,
13½ x 17¼ in. (34.2 x 43.8 cm).
Private collection

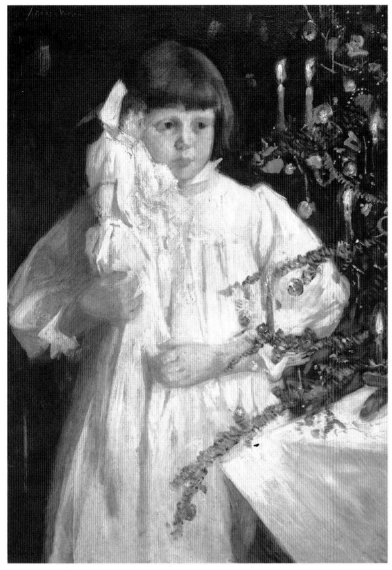

Fig. 5 J. Alden Weir, *The Christmas Tree*, 1890.
36¾ × 25½ in. (93.4 × 64.8 cm). Private collection

Tarbell denounced the factionalism and decline in standards at the Society, claiming that artists of mediocre ability who had been added to the membership over time had now voted themselves into control, and that he did not think it right for a committee of unaccomplished men to be passing judgment on artists of recognized merit.[7]

The most damning accusation the Ten made against those controlling the Society concerned their "commercialism" in pursuing sales over artistic objectives: "The men composing this clique are interested more in making a paying business venture of the exhibitions than in following the true bent of art and educating the public. They want to bring the exhibition down to the level of the picture buying public, and they have no sympathy with true art. I do not say that it is reprehensible to paint pictures that will sell, but I do say that the public taste—usually very bad—should not dominate the exhibitions. I believe in exhibiting good pictures, and those are not the sort usually that the public are anxious to buy at present."[8]

The charge of commercialism—"too much business and too little art"—was repeated in the statements by most other members of the Ten, and the consensus expressed that the Society had simply, as De Camp said, "outlived its usefulness." "There was a time," he stated, "when it was deemed an honor for an artist to be enrolled among the membership of the society, as he then had an opportunity to display his work before critical audiences, but that time has passed. The composition, with a few exceptions, of the society, has reached such a state that so-called artists, who could never be admitted to the original society, are admitted openly."[9] Those within the Society responded by accusing the Ten of intrigue and selfishness. "The point of the whole thing," said one, "seems to be an effort to hurt the society...," adding: "You will notice that every man in the list, with the exception of Mr. Dewing and Mr. Simmons, belongs to the impressionistic school."[10]

George Barse, Jr., the secretary of the Society, observed that the dissidents had once controlled the exhibition jury themselves but were now no longer in the majority. The Society, he said, refused to be dominated by such "fads" of style as that represented by the Ten, and he personally was unsympathetic to what he characterized as the "advanced" ideas of the seceders. "These men have left the society," he said, "because they did not have the sympathy they wished, or because, in other words, they could not do as they pleased....I don't think that this movement is at all serious, and I expect to see all ten back in the society sooner or later." With a final swipe, he added: "Five of them, by the way, are in arrears for dues."[11]

Between the time the resignations arrived at the Society, around December 20, and the first public notice of the break about two and a half weeks later, much discussion must have taken place, since the first public statements on either side were unusually and uncharacteristically heated. Among the charges made by the Ten against the Society was that it had become politicized and overrun by inept members. "A clique is endeavoring to control it," said a member of the Ten who wished to remain anonymous, and another, in comparing their movement to the secessions in France and Germany, complained that within the Society, "with its large leaven of business and society painters, art in the best sense is getting to be a more and more vanishing quantity, and the shop element is coming more and more into the foreground. As the organization has been managed for the last two years it might (as was said by one of the men who stayed) be called the Society of Mediocrity."[6]

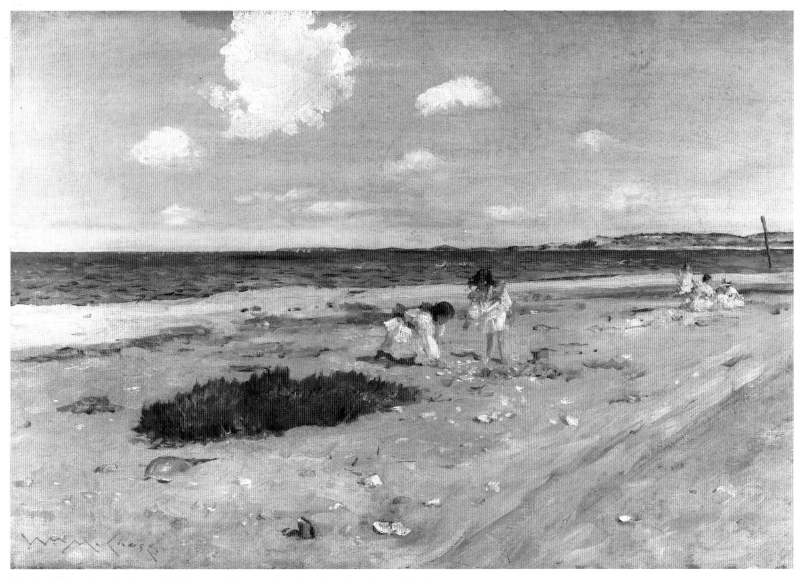

Fig. 6 William Merritt Chase, *Shell Beach at Shinnecock*, c. 1892. 18 x 26 in. (45.7 x 66 cm).
The Thomas Gilcrease Institute of American History and Art, Tulsa, Oklahoma

After the opening salvos, both sides tried to adopt a more diplomatic posture, but in an atmosphere increasingly filled with charges and countercharges the effort was only partly successful. Some in the Society hinted that the whole affair might be undone, pointing out that the resignations had not been formally accepted. The president, John La Farge, was conciliatory, saying how much the seceding members were admired as artists and even suggesting that, should they secede, their pictures would still be received and well placed in Society exhibitions.[12] J. Carroll Beckwith, who had been among the leading progressives in the early years of the Society and one of its most active administrators, stated officially that he regretted the departures, but that the Society had always been liberal to the dissenters and had always operated in "harmony." Several months later in private, however, he expressed himself quite differently. "I am much disgusted with the Society," he wrote. "It is an organization vacillating from one fad to another and each young crowd rules it. The 10 who have seceded did quite right."[13]

One journalist tried to play down the whole affair, and deny that major philosophical or artistic differences had played a part, even to the point of claiming that the painters had not resigned as a body. They had no personal animosity toward members of the Society, he said, and were not trying to injure the organization. They regretted that the matter had been made public at all. The purpose, it was explained, was simply to get away from the large miscellaneous exhibitions, following the example of other painters who had arranged to exhibit alone.[14]

The controversy did not abate, however, and others in the Society continued to rail at the selfishness and disloyalty of the departing members. They were accused of abandoning the Society after having used it to make their reputations; they were complainers who looked for the prizes but did

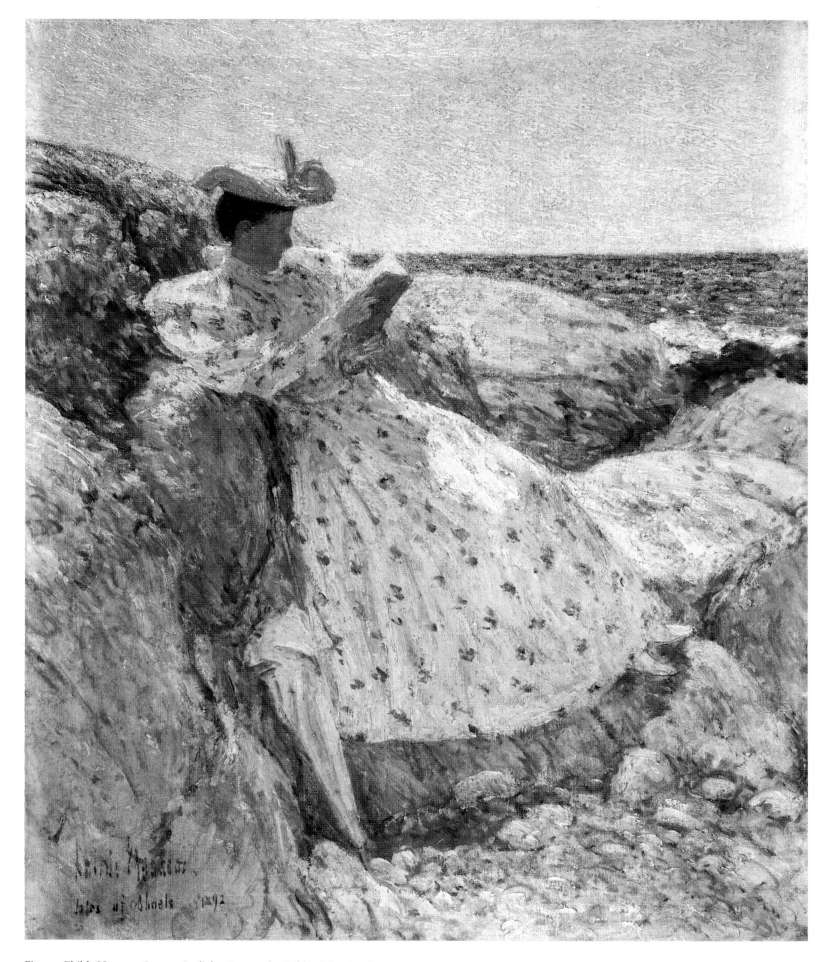

Fig. 7 Childe Hassam, *Summer Sunlight*, 1892. 22¾ x 18⅞ in. (58 x 48 cm).
Israel Museum, Jerusalem

none of the work: "They don't even attend regularly, and don't exhibit except when it pays, and yet they complain when they don't have the whole control. It is true that the seceders are among the best artists in the Society, and that it would be a blow to us for them to resign.... But, like many careless artists, they are for themselves and do not care to foster a general spirit of kindly art."[15]

Members of the Ten termed "absurd" the notion that they were leaving the Society because no further selfish advantage could be gained from it. They also dismissed the thought of reconsidering their resignations. Moved to restraint, nonetheless, they conferred and issued a statement through Weir regretting that publicity had kept them from leaving "in a quiet and dignified manner" and that it had produced "somewhat exaggerated and inaccurate statements on both sides."[16]

On Tuesday evening, January 11, a special meeting of the Society's Board of Control was held, having been delayed a day, probably to allow time for negotiations. The Board, comprised of La Farge, Barse, Kenyon Cox, Samuel Isham, William B. Faxon, Samuel H. Adams, and George Maynard, formally accepted the resignations of the seceding members

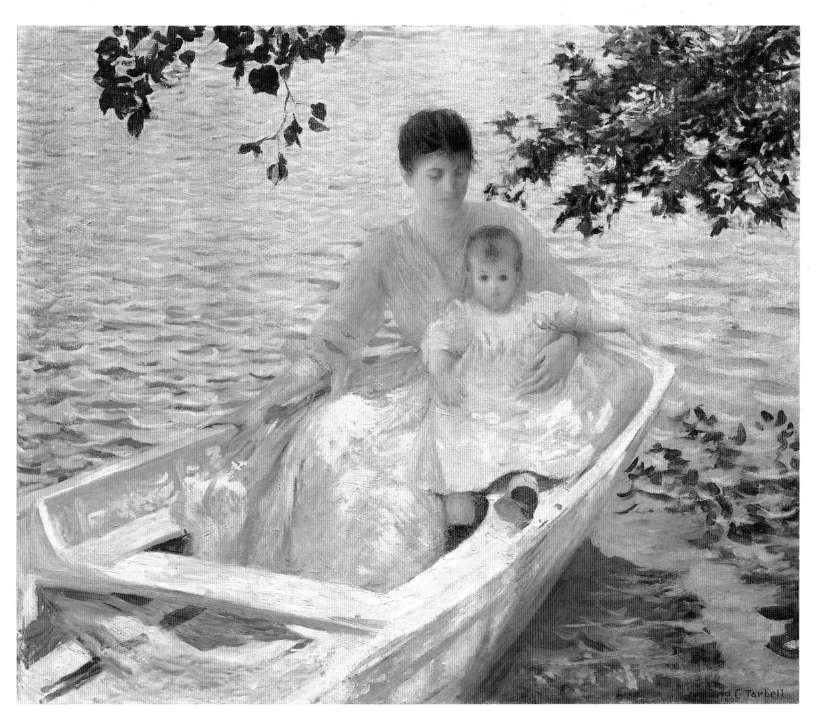

Fig. 8 Edmund C. Tarbell, *Mother and Child in a Boat*, 1892. 30 x 35 in. (76.2 x 88.9 cm).
Museum of Fine Arts, Boston. Bequest of David P. Kimball in memory of his wife, Clara Bertram Kimball

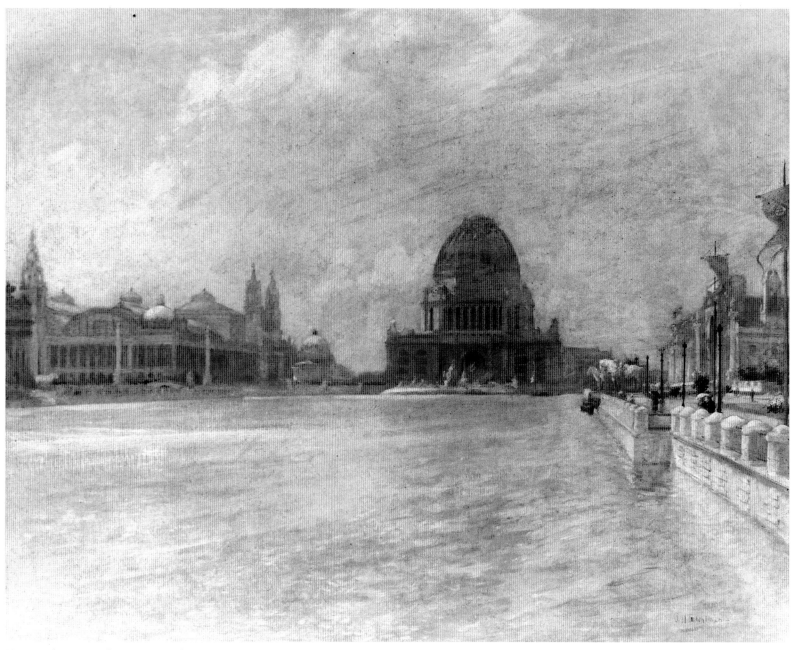

Fig. 9 John H. Twachtman, *Court of Honor, World's Columbian Exposition, Chicago, 1893,* 1893.
25 x 30 in. (63.5 x 76.2 cm). Columbus Museum of Art, Columbus, Ohio. Bequest of Frederick W. Schumacher

and declined comment, except to say that they were accepted "with regret."[17] On Wednesday night a full meeting of the Society, forty members being present, was held to fill the vacancies on the Jury and Hanging Committees left by the resignees. It began with the reading of an official public statement prepared by the Ten:

In withdrawing from the Society of American Artists we had hoped to do so without undue publicity, or causing any ill-feeling, but not succeeding in this, some statement seems to be called for from us as a body. A high standard in art is apparently impossible to maintain in an institution like this Society, as at present organized, from its imperative need of attracting the public in order to meet its large expenses. Recognizing this, and feeling the uselessness of longer continuing a protest against abandoning the

earlier ideals of the Society—which were perhaps only possible when it was smaller—a protest in which we are forced to believe that we are in a minority, it has seemed wiser to resign, and it is for these reasons that we have done so.[18]

The statement having been "received and read without comment," the membership proceeded to elect H. Siddons Mowbray to replace Simmons on the Hanging Committee, and it was reported that five artists—Abbott H. Thayer, Alfred Q. Collins, Robert Blum, George De Forest Brush, and Frederick Vinton—were elected to take the places of Reid, Benson, Weir, and Dewing on the jury. It was not overlooked that Thayer had originally been invited to join the seceders. With the election accomplished, it was

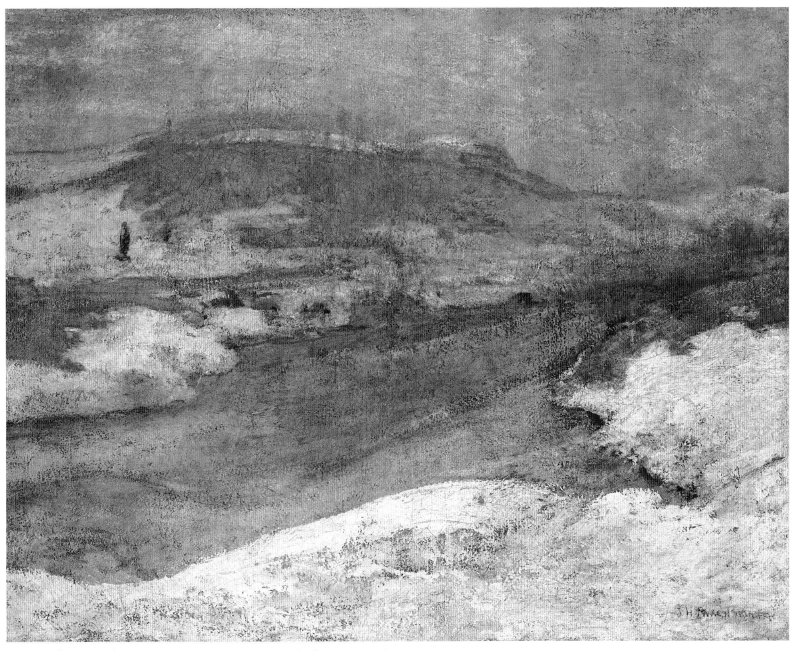

Fig. 10 John H. Twachtman, *River in Winter*, c. 1895. 36 × 48 in. (91.4 × 121.9 cm).
The Carnegie Museum of Art, Pittsburgh; Purchase, 1907

remarked: "The incident seems to be closed as far as the Society is concerned."[19]

Events show that the group clearly had not expected the public notoriety that engulfed them. Simmons confirmed this later, saying: "We were accused of starting as an advertisement, and, indeed, it proved a big one, but there was no such idea in the mind of any one of us."[20] Their first designation as the "Group of American Painters" was merely an impromptu title given to the press, and the fact is that, beyond the idea for a joint exhibition somewhere and at some time in the future, they had done little real planning.

Speaking to reporters on January 13, Reid announced that a meeting of the Ten was scheduled for the next Saturday evening at his studio to work out plans for the future. Reid seemed almost embarrassed by all the attention. There had been quite enough publicity already, he observed: "We are not nearly so dangerous as the public is trying to make out. We haven't any wonderful ideas of elevating art or founding a school or educating the public. We are simply a dozen [sic] men who want and intend to give an exhibition.... We do not care to make announcements, as it is a serious matter and needs no advertising. No officers are to be elected, as no society is to be organized."[21]

In the studio meeting that followed, a spring date was proposed for the group's first exhibition. There was also some discussion about allowing other artists to join the group through election, but this idea was quickly abandoned. Very little, in fact, seems to have been decided except

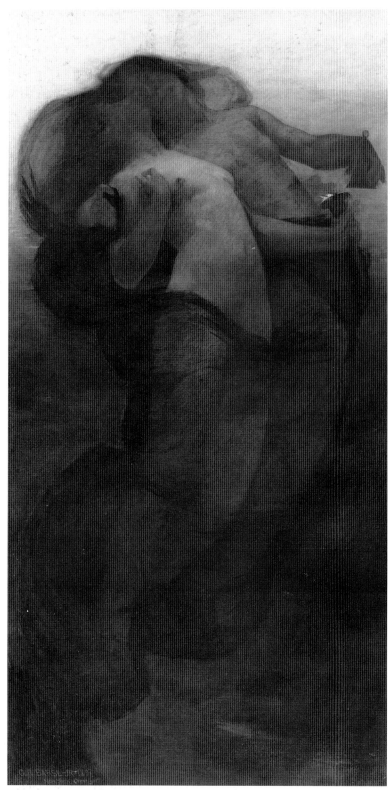

Fig. 11 George R. Barse, Jr., *Night and Waning Day*, 1897.
80×40 in. (203.2×101.6 cm). Tazio Nuvolari.
The painting received the Society of American Artist's Shaw prize in 1898

that another meeting would probably be held the following week.[22] Afterwards there was little public comment about the Ten until their first show was held two months later, in March 1898.[23]

Throughout the secession controversy little discussion had come from the Ten about their styles of painting vis-à-vis the Society or about Impressionism in particular, possibly because it was not an issue to win much sympathy. The press, however, firmly identified the group as members of the "impressionistic school," and their opponents used the label to imply a kind of incorrigibility that might explain away everything. One Society member termed the majority of the seceders "men of highly impressionistic tendencies," though he also noted without apparent self-contradiction that at least three of them were "in harmony" with the rest of the Society. He argued that these Impressionists had always been treated well at the Society, had won prizes, and had their canvases hung in the best places, the latter, he confessed, being a concession that required "great magnanimity." Although certainly dubious of the eventual outcome of their effort, he did recognize that the "curious and unusual impressionistic conceptions of nature" would now for the first time be "concentrated in one harmonious 'Group'" rather than scattered throughout the exhibitions.[24]

Impressionism as an aesthetic theory or artistic style was still embroiled in controversy in the United States in 1898, having been introduced on a significant scale just over a decade earlier in exhibitions of French Impressionist works organized in New York by Paul Durand-Ruel. By the time of the 1893 Chicago World's Columbian Exposition, a number of American artists, including many of the Ten, were painting in "impressionistic" styles that were received with some favor by critics. While the Columbian Exposition has thus been seen as a favorable turning point for Impressionism in America, like the exhibition architecture itself, the Exposition was dominated by a strong resurgence of classical taste and it was just this renewal of conservatism that helped set the revolt of the Ten in motion five years later.

Many of the Exposition artists were quick to abandon their Impressionist experiments, and those that did not remained very much in the minority. It was thus understandably common in the post-Exposition era to speak of Impressionism as a passing fad, and the Society's Vice President, Kenyon Cox, even attributed the secession of the Ten in part to the style's waning influence. "Most of them are impressionist painters," he said of the group, "and while impressionism continued to be looked upon as the beginning and end of art, they, naturally, received rather more

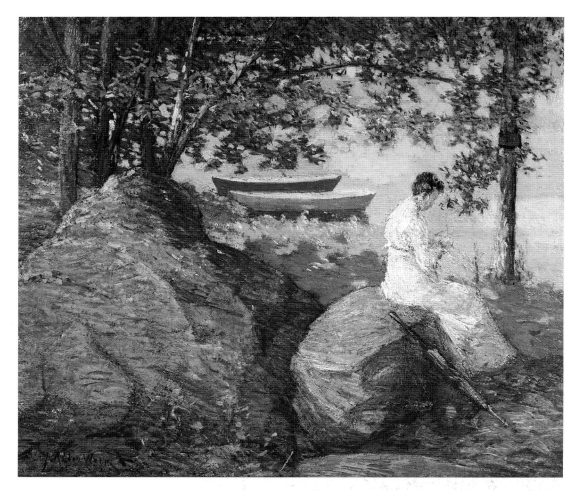

Fig. 12 J. Alden Weir, *On the Shore*, c. 1900/5.
25 x 30 in. (63.5 x 76.2 cm).
IBM Collection

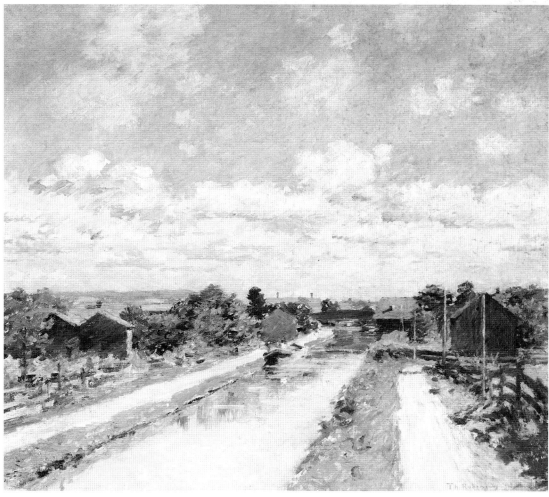

Fig. 13 Theodore Robinson, *Port Ben,
Delaware and Hudson Canal*, 1893.
28¼ x 32 in. (71.8 x 81.3 cm).
The Pennsylvania Academy of the Fine Arts,
Philadelphia. Gift of the Society of American
Artists as a memorial to Theodore Robinson

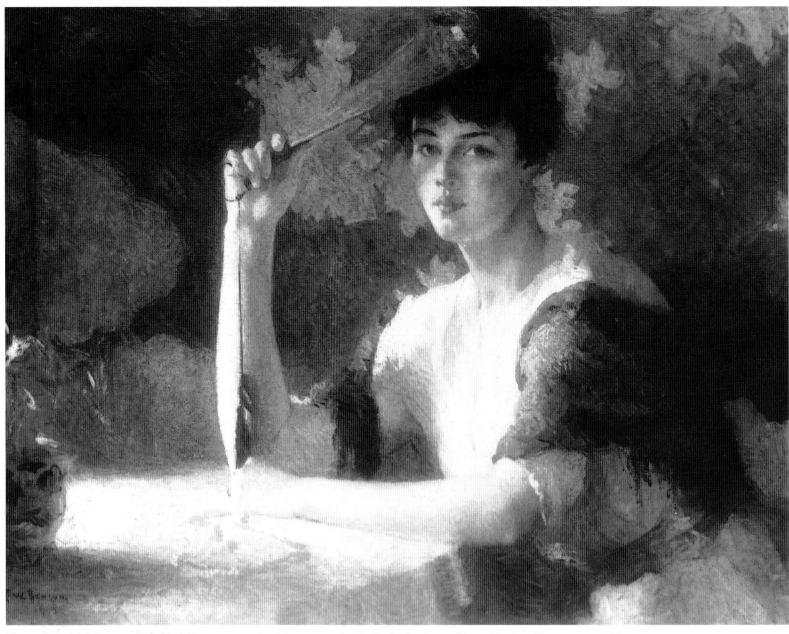

Fig. 14 Frank W. Benson, *Red and Gold*, 1915. 31 x 39 in. (78.7 x 99.1 cm). The Butler Institute of American Art, Youngstown, Ohio

consideration than now when people are beginning to see that there are other things."[25]

Conservative members of the Society argued that the secession of the Ten was reckless and spiteful, and a momentary product of the faddish Impressionist style, but the artists themselves declared that the battle lines had been drawn long before. "This movement is no sudden impulse," stated Weir, "for it has been growing these four or five years past,"[26] and, separately, De Camp also said that the secession was "planned about three years ago, but for various reasons it was delayed until a better opportunity presented itself."[27]

In fact, many struggles over the issue of Impressionism had occurred in previous years, not only at the Society but throughout the New York art world. In 1893 conservatives in the National Academy of Design scored a triumph by reelecting Thomas Waterman Wood as president, and by rejecting for membership Tarbell and Benson, both Academy prize winners, who had been put up for election that year.[28] Two years later, at the Metropolitan Museum of Art, a group of "radicals" headed by the youngest trustee, Robert W. de Forest, led a bitter but unsuccessful attempt to oust the museum's director, General Cesnola. "If they succeed," the conservative president, Henry G. Marquand, had warned, "the conservative force will go and the Museum will be run by the impressionists."[29]

In 1890 J. Carroll Beckwith had already recorded the friction within the Society's exhibition jury due to "a crowd of new radicals . . . the Monet gang back from Europe [who] want anything pale lilac and yellow."[30] Eventually, the So-

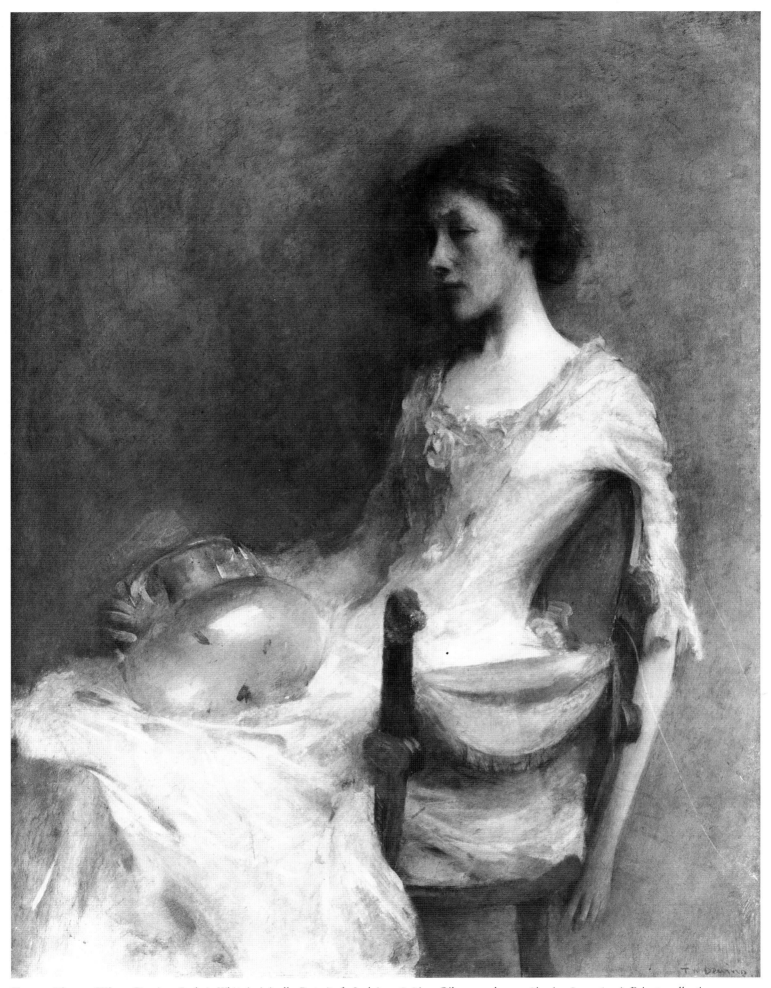

Fig. 15 Thomas Wilmer Dewing, *Lady in White* (originally *Portrait of a Lady*), c. 1898/99. Oil on panel, 20 x 16 in. (50.8 x 40.6 cm). Private collection

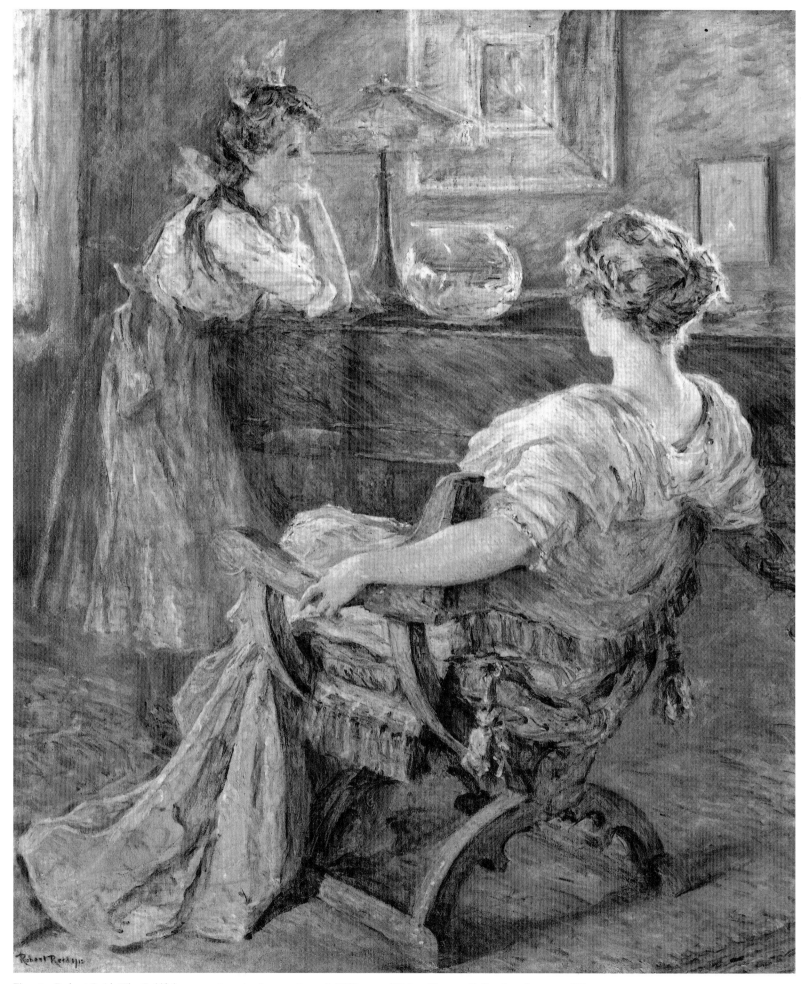

Fig. 16 Robert Reid, *The Goldfish*, 1912. 36 x 30 in. (91.4 x 76.2 cm). William and Zelma Bowser Collection, Sonoma, CA.
Photo courtesy Jordan-Volpe Gallery, New York

ciety operations seem to have become entirely politicized. In 1894 "petty jealousies" were said to rule the Society elections, and we learn that, in the previous spring, only three out of eighteen nominees had been elected to membership, and narrowly at that.[31] As a member of the exhibition jury that year, the Impressionist painter Theodore Robinson described his efforts to "protect" the entries of his friends, and thought that the placing of Metcalf's portrait in the category of doubtful pictures was a clear result of personal animosity. Said Robinson of the jury: "A gang, led by [Kenyon] Cox and rather loud-mouthed was rather ill-disposed to impressionistic pictures." Later that year he described how Twachtman successfully schemed with himself, Weir, Hassam, and other friends to pack the following year's exhibition jury with their own candidates.[32] Nonetheless, when the time came to elect new members in the spring of 1895, they found themselves defeated when, in Robinson's words, a majority led by a "solid phalanx of mossbacks . . . voted down every impressionistic aspirant," including his friends Theodore Butler and John Leslie Breck.[33]

Dramatic evidence of victory for the conservative forces also came in 1895 with the resignation of Chase who, as president, had remained a force for tolerance and moderation within the Society for a decade and a firm supporter of Impressionism. When conservative members forced new policies regarding teaching methods at the affiliated Art Students League, Chase also quit his post there, which he had held since 1878. A few months later the Impressionists lost one of their strongest representatives when Robinson died on April 2, 1896, and, as if to underscore Impressionism's official disrepute, only two months after the Ten seceded New York's Metropolitan Museum of Art refused to accept for its collections a major canvas by the late artist, *Port Ben, Delaware and Hudson Canal* (fig. 13), which had been offered through the Society as a memorial gift from his friends. It was afterwards reported that the museum's Art Committee had rejected the gift without apology, being quoted to the effect that Robinson's painting "was an example of a school it did not think it wise to encourage."[34]

When the Society held its annual exhibition in 1897 press reports confirmed that the jury had been drastically changed and that the Impressionists were the losers,[35] a fact also reflected in their small showing that year. Recalling the event nearly forty years later, Benson described how Twachtman had first raised the possibility of secession with him immediately after their disappointment at this exhibition.[36]

The one firm purpose of the group, besides leaving the Society, was to hold exhibitions among themselves and to

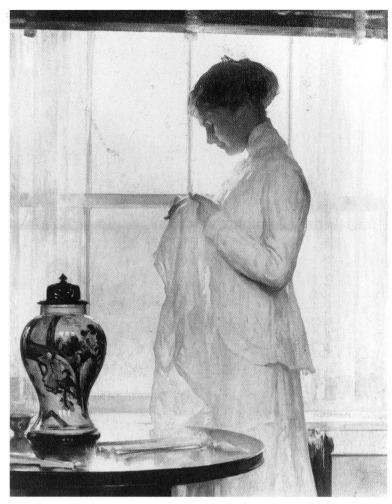

Fig. 17 Joseph R. De Camp, *The Window*, c. 1910. Location unknown

establish a new system of smaller, concentrated exhibitions consistent in theme and direction. In explaining this purpose, Weir said that "one object of his friends and himself, following the Japanese view, is to get rid of the barbaric idea of large exhibitions of paintings."[37] Another of the Ten described the general arrangements under which there would be no juried selection and each man would be responsible for hanging his own works: "the walls will be divided into ten equal spaces, which will be numbered and the members will then draw lots for them. There will be no place of honor, no jury and no distinction not equally enjoyed by all. Each member will place his own pictures in the space that falls to him by lot."[38]

The Ten wanted principally to move from the antiquated, circus-like atmosphere of the large annual salons into a setting that allowed concentration on individual work. This had become a growing issue in previous years and, at both the 1889 Paris Exposition Universelle and the 1893 World's Columbian Exposition, plans were made to alleviate the chaos by hanging the American pictures in groups so that an artist's work could be appreciated collectively. In Chicago

the plan was abandoned for lack of time and space, but the idea survived. Café gossip among artists, reported in 1894, indicated a consensus on the futility of showing in the large miscellaneous exhibitions, since good paintings were invariably swallowed up in the crowd. Many artists, it was said, were withholding their works for better conditions in one-man or small group exhibitions.[39] In February 1894 a small group calling itself "The Society of Independents" rented space at 819 Broadway and held an exhibition in which each painter received a share of the wall space to hang as they wished. Most of the named participants have been forgotten, but among them was the painter Arthur B. Davies who, twenty years later, was to manage the famous Armory show.[40] Even more significant was another "alternative" exhibition, held that spring and summer at the Fine Arts Society's Galleries, in which many of the Ten participated, namely Hassam, Twachtman, Reid, Simmons, Weir, and Chase, who by himself occupied the whole of one end wall. Each artist shared the gallery rental by paying for wall space, which was partitioned off and assigned by lot. Afterwards they were free to hang it as they liked, forming small ensembles ranging from about two to twenty paintings. In retrospect, this "Group Exhibition," as it was called, seemed almost like a dress rehearsal for the early Ten exhibitions.[41]

While critics focused on the group's Impressionist leanings, it is well to remember that, for the Ten themselves, larger principles were at stake than loyalty to any single style. More than Impressionism, it was the whole trend of modern principles that the Society now seemed to repudiate. The 1898 Society exhibition, comprising 346 paintings, took place as usual, with one critic noting the absence of "extremists" which seemed to make the whole "more sane and inspiring."[42] Notwithstanding competition from such exhibitors as Chase, Sargent, and Whistler, the Webb prize for landscape that year was awarded to George Bogert's *Evening, Honfleur*, and the Shaw prize for figural work went to *Night and Waning Day* by George R. Barse, Jr. (fig. 11), the Society's secretary who had bitterly opposed the Ten. One has to suspect that the award to Barse, who once described his artistic credo as "symbolism beautified,"[43] was something of a pointed gesture. In any event, nothing could better demonstrate the standards that had taken over the once proud Society and that the Ten now turned their backs on.

By abandoning the Society of American Artists, the Ten provided a noisy climax to years of struggle that had pitted the forces of change against prevailing attitudes. The Society itself lingered on for a while, but the Ten's departure effectively signalled the end of an institution whose vitality, never certain in any case, had been steadily declining over the years. In 1906 the Society formally merged with the National Academy of Design and ceased to exist as a separate entity. Its name erased, it was not long before its memory, too, faded into history.

Notes

1 *New York Times*, Jan. 15, 1898, p. 46.

2 A correction of the number "12" to "10" in the group's founding document shows that twelve members were originally expected. Simmons stated that Thayer at first accepted enthusiastically, but later declined, saying that the Society needed him. Lobbying by Society members may have swayed his decision while efforts were being made to dissuade the Ten from carrying out their plans. A footnote to Thayer's involvement came in a letter he sent many years later to Dewing. Judging by his last remarks and its date at the end of September 1916, Thayer may have been responding to an idea that he eventually take the place of Chase, who was in failing health and shortly to die. Thayer wrote: "As for that other gaucherie my not coming into 'The Ten Painters' when you all gave me the chance, had I dreamed of its looking like conceit I think I must have gone with you at once. As far as I remember I solely looked at my funny unfitness to play up to my part of any kind of cooperation, and merely felt weary of arranging in any way my position in societies, content to go on in the old SAA or anywhere else where there was wall space. Now ... I am in a new mood and should be greatly inspired by being one of the 'Ten', and should sometimes have something ready. I am really painting with strange unmistakable high quality." Abbott Thayer to Dewing, Sept. 21, 1916, Archives of American Art, Roll # D200.

Homer's dispirited reply to the invitation was sent to Weir on January 20, 1898, long after the break had become public. He said he was too old to work and had already decided "to retire from business." His letter states: "On receiving your letter I am reminded of the time lost in my life in not having an opportunity like this that you offer—The chance that each member will have of showing their work in a group—the larger the better, and under their own direction will be a great spur in tempting them to great effort and enterprise. I know on my own part that I have been kept from Academy exhibitions by the fear of the corridor and the impropriety of my trying to make terms as to placing my work. You do not realize it, but I am too old for this work and I have already decided to retire from business at the end of the season. So you see that I cannot join you at even this most cordial invitation—and admiring as I do all of you. — You see it would oblige me to work—at this late day—when I wish to make the most of the few years I have left." Archives of American Art, Roll # 125; quoted in Dorothy Weir Young, *The Life and Letters of J. Alden Weir*, New Haven, 1960, p. 198.

3 *New York Herald*, Jan. 9, 1898, p. 7.

4 The Roman numeral ten, appearing as an emblem on their first catalogue, makes one wonder whether the name was not indirectly inspired by the group known as the XX (*Les Vingt*), an exhibition society founded in Brussels in 1884 for promoting new and unconventional art.

5 *Sun*, Jan. 9, 1898, p. 2. Society exhibition records confirm the weakening of the progressives' position. In the early 1890s the future members of the Ten were fairly well represented on the Selection Jury, though not on the Hanging Committee. The prestigious Webb or Shaw prizes went to Twachtman in 1888, to a compatriot of the Ten, Theodore Robinson, in 1890 and 1892, and to Tarbell in 1893. In 1895 the future Ten had a show of strength, with all but Dewing on the Jury, while Tarbell and Robinson were on the three-man Hanging Committee. The Society's two major awards went that year to Hassam, for *Plaza Centrale, Havana*, and to Chase, for *A Friendly Call* (plate 50). In 1896 the group was still strong, with Reid and Dewing on the Hanging Committee and all but Chase, Twachtman, and De Camp on the Jury. Metcalf (*Gloucester Harbor*; plate 6) and Benson (*Summer*; fig. 25) won the major prizes. In 1897 the pendulum swung back, with only Benson, Chase, Dewing, and Simmons on the Jury and none of the group on the Hanging Committee. They would have fared little better in 1898.

6 *Commercial Advertiser*, Jan. 8, 1898, p. 1.

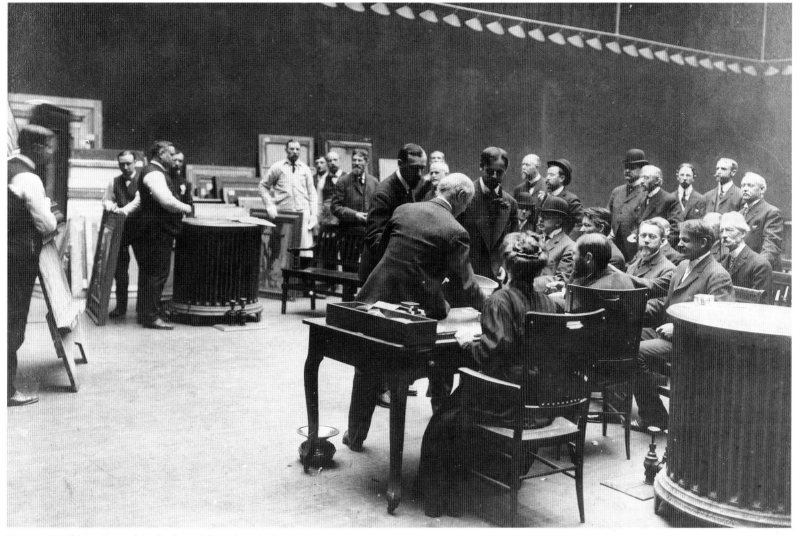

Fig. 18 Exhibition Jury of the Society of American Artists, 1906

7 *New York Herald*, Jan. 11, 1898, p. 7. Citing parallel reasons, Thomas Eakins re-signed from the Society in 1892 after finding that his paintings, including *The Agnew Clinic* (University of Pennsylvania, Philadelphia), were rejected from the exhibitions for several years in a row. For Eakins's letter of resignation, see Lloyd Goodrich, *Thomas Eakins*, Cambridge, Mass., and London, vol. 2, p. 50 ff.

8 *New York Herald*, Jan. 9, 1898, p. 7, quoting Ten member anonymously.

9 *Ibid.*, quoting De Camp.

10 *Sun*, Jan. 9, 1898, p. 2, quoting anonymously. In reporting the secession, the *Art Amateur* 38 (Feb. 1898), p. 56, said several of the artists were among the most notable of painters who had adopted Impressionism "to a greater or lesser extent," conclud-ing: "But the seceding group cannot be said to be one composed of impressionists, for Mr. Dewing and Mr. Simmons, at least, do not follow the new formulas in their work."

11 *New York Herald*, Jan. 9, 1898, p. 7.

12 *New York Daily Tribune*, Jan. 10, 1898, p. 7.

13 J. Carroll Beckwith, quoted in *New York Daily Tribune*, Jan. 10, 1898, p. 7, and National Academy of Design, Beckwith diaries, Apr. 2, 1898. Ronald G. Pisano, in *A Leading Spirit in American Art: William Merrit Chase 1849–1916*, exhibition catalogue, Henry Art Gallery, University of Washington, Seattle, 1983, p. 164, cites this with a slightly different reading.

14 *Evening Mail and Express*, Jan. 10, 1898, p. 3.

15 *Commercial Advertiser*, Jan. 10, 1898, p. 1, quoting anonymously.

16 *New York Daily Tribune*, Jan. 10, 1898, p. 7, quoting Weir.

17 *New York Herald*, Jan. 12, 1898, p. 9.

18 *Evening Post*, Jan. 13, 1898, p. 7; *Commercial Advertiser*, Jan. 13, 1898, p. 4; *New York Daily Tribune*, Jan. 13, 1898, p. 7. This did not constitute their joint resignation. Indi-vidual letters of resignation were sent weeks before and, together with other Society papers, have disappeared.

19 *New York Daily Tribune*, Jan. 13, 1898, p. 7; *Commercial Advertiser*, Jan. 13, 1898, p. 4.

20 Edward Simmons, *From Seven to Seventy: Memories of a Painter and a Yankee*, New York and London, 1922, p. 222.

21 *Commercial Advertiser*, Jan. 14, 1898, p. 1.

22 *Commercial Advertiser*, Jan. 14, 1898, p. 1; also *New York Times*, Jan. 16, 1898, p. 4.

23 A short notice in *Art Interchange* 40, no. 4 (Apr. 1898), p. 89, said that the ten se-ceders, who are "now irreverently designated in the studios as 'the A-P-apes,'" would hold their first exhibition at the Durand-Ruel gallery at the end of March.

24 "H.," Letter to the Editor, *Commercial Advertiser*, Jan. 11, 1898, p. 4.

25 *Commercial Advertiser*, Jan. 10, 1898, p. 1, quoting Cox; later repeated in *Art Inter-change* 40, no. 2 (Feb. 1898), p. 40.

26 *New York Daily Tribune*, Jan. 10, 1898, p. 7, quoting Weir.

27 De Camp, quoted in *New York Herald*, Jan. 11, 1898, p. 7. These statements are revealing, for in Hassam's later description of the event—on which many have relied—Hassam claimed credit for the group all to himself—"'The Ten' was my idea entirely"—and, in telling with some exactness how he proposed the idea to Weir one night after thinking it over on his walk downtown, he at least implied that the secession was a spontaneous event rather than one that had been long building. See Childe Has-sam, "Reminiscences of Weir," in *Julian Alden Weir: An Appreciation of His Life and Works*, The Phillips Publications, No. 1, New York, 1922, pp. 67–68. Hassam later repeated this claim in "Twenty-Five Years of American Painting," *Art News* 26 (Apr. 14, 1928), p. 22: "Among the latter was the exhibition of the Ten American Painters (my idea) started by J. Alden Weir and myself, with Twachtman first, then Dewing...came in with Reid, Simmons, Metcalf and the three Boston men, Tarbell,

De Camp and Benson.... The exhibitions were not too large to be seen easily. It was not an effort, as larger collections of pictures usually are. These small shows were decidedly a success."

Though not ultimately a crucial question, we do know enough of the facts not to take Hassam's account at face value. While there is no proof, there are repeated intimations that Twachtman's son may not have been entirely wrong when he said it was his father who deserved most of the credit for initiating the movement and organizing the first exhibitions. See John Douglas Hale, "The Life and Creative Development of John H. Twachtman," 2 vols., unpublished Ph. D. dissertation, Ohio State University, 1957 (University Microfilms), p. 93, n. 1, and p. 96.

For Simmons's account, see Simmons, 1922, p. 221 ff. See also n. 36.

28 *Art Interchange* 31, no. 1 (July 1893), p. 7.

29 See Calvin Tomkins, *Merchants and Masterpieces: The Story of the Metropolitan Museum of Art*, New York, 1970, p. 80 ff., and the brief report in *Art Interchange* 34, no. 4 (Apr. 1895), p. 114.

30 National Academy of Design, Beckwith diaries, Apr. 20, 1890.

31 *Art Amateur* 31 (Nov. 1894), p. 114.

32 Frick Art Reference Library, Robinson diaries, Mar. 1, 1894, and Nov. 20, 1894: "P. M a meeting of the SAA at which Platt, Tarbell and I are on hanging committee, and a jury rather more progressive than usual.... After the meeting a group adjourned and talked matters over—Twachtman, Weir, Reinhart, Hassam, Franzen, Taylor and I. Twachtman in great good humor over the success of his scheme—a lot of us only voting for 16 or 17 men instead of 27 thus getting *our* men in and leaving out a few of our enemies." The 1895 selection jury included Benson, De Camp, Metcalf, Reid, Simmons, Twachtman, and Chase.

33 *Ibid.*, May 5, 1895. Robinson also previously mentioned that his candidates for membership were refused in 1893 (May 6, 1893). Weir also indicated his distaste for the Society proceedings in 1895, saying in a letter to his wife: "We have talked the Jury over of the S. A. A. and I have decided not to go [to the meeting], as I think there will be no good." Weir from Philadelphia Nov. 18, 1895, Archives of American Art, Roll # 125.

34 According to a letter from the painter Will H. Low (Feb. 19, 1898, Pennsylvania Academy of the Fine Arts archives), a Robinson gift fund was established soon after the artist's death, although appeals for contributions did not begin until the estate sale was actually arranged in the early part of 1898. Before the sale of Robinson's studio in March 1898 a committee headed by La Farge selected the painting, and it was subsequently listed in the sale catalogue as having been "presented" by the Society to the museum. Weir, a member of the purchase committee, said that he learned that spring that the painting would not be welcomed, as it was thought not "enough of a picture." Only at its next annual meeting, in December 1898, did the Society press the museum for a response, which it again received informally. Said the *New York Times*: "To say that the artists who made the offer were surprised and disgusted would be putting the case mildly." The ensuing battle sounded familiar in the wake of the Ten controversy, and there were some who saw it as a dispute between the older and newer generations like the one that had caused the Society's break from the Academy twenty years earlier (*Art Interchange* 42, no. 2 [Feb. 1899], p. 37 ff.). The analogy was not entirely far-fetched in view of the fact that the Society's old nemesis, Daniel Huntington, now eighty-three years old, happened to be on the museum's three-man committee which rejected the gift.

Robinson's supporters pressed their appeal on the grounds that the gift was endorsed by many artists of "varying schools." George A. Hearn and William P. Evans, two of America's foremost collectors, each offered to substitute for the disputed painting other works by Robinson from their own collections, but these were also judged by the museum to be "not important enough." Robinson's friends tried to rouse public support in an effort to embarrass the museum into accepting, even though it was conceded that Robinson's picture "was not of the class which might be called popular." Weir spoke out angrily against the museum's willingness to accept any third- or fourth-rate European painting while neglecting American artists. Yet Weir failed to persuade the committee, just as he and Chase several years earlier had failed when they urged the museum to buy Whistler's *The White Girl* while it was on loan there. Only in 1900 was the Robinson issue finally laid to rest when, at the prompting of Harrison Morris, the Society decided to donate Robinson's painting to the Pennsylvania Academy. For these events, see *New York Times*, Dec. 30, 1898, p. 1, and Dec. 31, p. 12; *Art Collector* 9, no. 5 (Jan. 1, 1899), p. 67; 9, no. 6 (Jan. 15, 1899), p. 85; and 9, no. 8 (Feb. 15, 1899), p. 117 ff.; *New York Times*, Jan. 4, 1899, p. 7, and Jan. 8, 1899, Supp. p. 3; May 31, 1899, p. 7; Nov. 23, 1900, p. 7.

Committee members Henry G. Marquand, and Daniel Huntington may have been the ones to effect the veto against Robinson's painting. Samuel P. Avery, the third committee member, reportedly witnessed the selection and had already agreed to it, but some accounts leave his role less clear.

The only Impressionist pictures then on view at the Metropolitan Museum of Art were two Manets acquired under unusual circumstances from the collector Erwin Davis and, quoting the recently published *Cyclopedia of Painting and Painters* by John Champlin and Charles Perkins (New York, 1885), they were labeled by the museum as the work of a Salon reject and an "eccentric realist of disputed merit."

35 *New York Daily Tribune*, Mar. 28, 1897, p. 7.

36 Benson to Dorothy Weir Young, July 8, 1938: "it is hard to remember with certainty. But the formation of the Ten was a big matter in our lives and I can tell you my recollection of it. Usually such things come to life in a formal meeting. This one bloomed out suddenly at a jury meeting of the S. A. A. You know we had large juries—twenty five or thirty—and when the show was hung, before the public opening, we, who liked each other's works, were looking over the results of the jury's work. We were pretty discouraged with the tone of the show. I was with Twachtman and he was stating his feelings freely, and then and there the proposition was made that a small group of us should split off and make our own show the following year. We knew each other so well that there was no question of who should come into the group, and I am sure it justified itself in its results.... I should have guessed that the proposition was put forth by Twachtman, but that may be merely because I was with him at the time it happened." Archives of American Art, Roll # 125.

37 *New York Times*, Jan. 9, 1898, p. 12, quoting Weir.

38 *New York Daily Tribune*, Jan. 9, 1898, p. 9, quoting unidentified Ten member.

39 "The Observer," *Art Interchange* 32, no. 1 (Jan. 1894), p. 23.

40 See *Art Interchange* 32, no. 3 (Mar. 1894), p. 91, and *Art Amateur* 30 (Mar. 1894), p. 101.

41 See "The Group Exhibition," *Art Amateur* 31 (June 1894), pp. 3–4, and 31 (July 1894), p. 28; also "American Paintings Grouped," *New York Times*, May 11, 1894, p. 4, and "Group Exhibits of Paintings," *New York Times*, July 7, 1894, p. 5.

42 *Art Interchange* 40, no. 5 (May 1898), p. 116. Another remarked on the freedom from "impressionistic error" and observed "a gratifying lack of sensational pictures, no fads ... and the broad impression conveyed is one of mingled energy and sobriety." "Art Exhibitions: The Society of American Artists," *New York Daily Tribune*, Mar. 19, 1898, pp. 6–7.

43 *New York Times*, Apr. 6, 1906, section IV, p. 8.

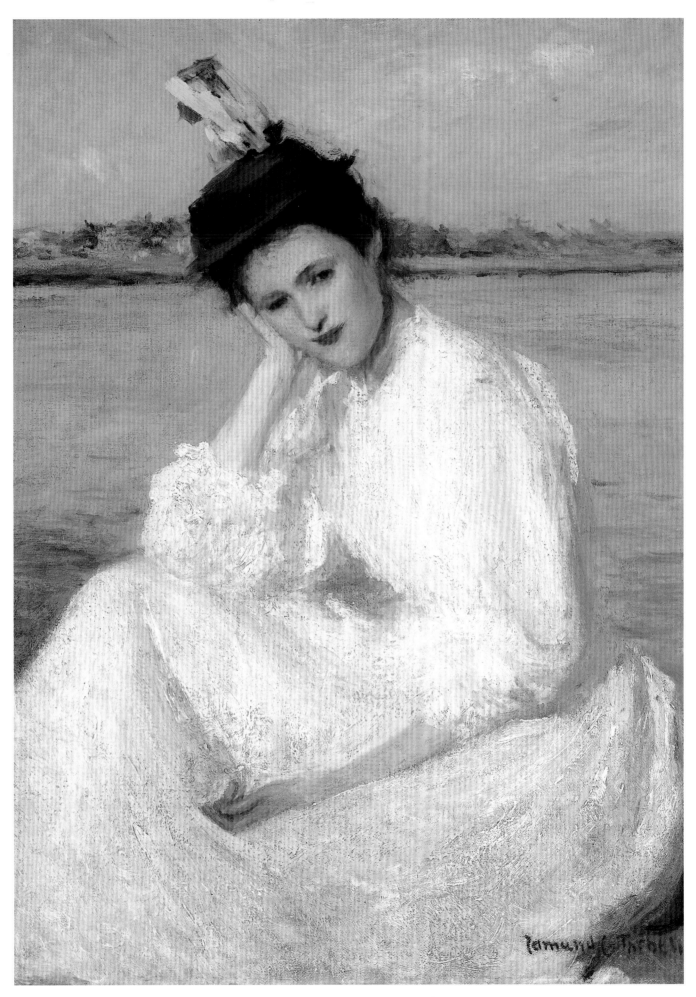

1 Edmund C. Tarbell, *Portrait of a Lady*, c. 1891. 20 x 14 in. (50.8 x 35.6 cm). Sid and Diana Avery Trust

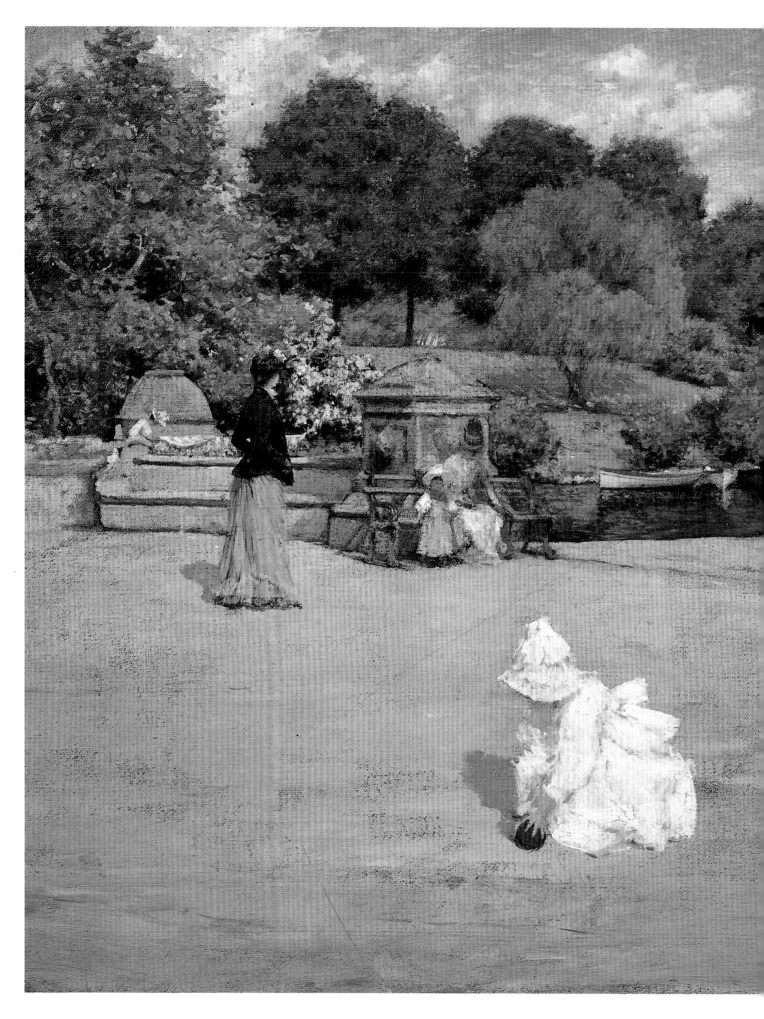

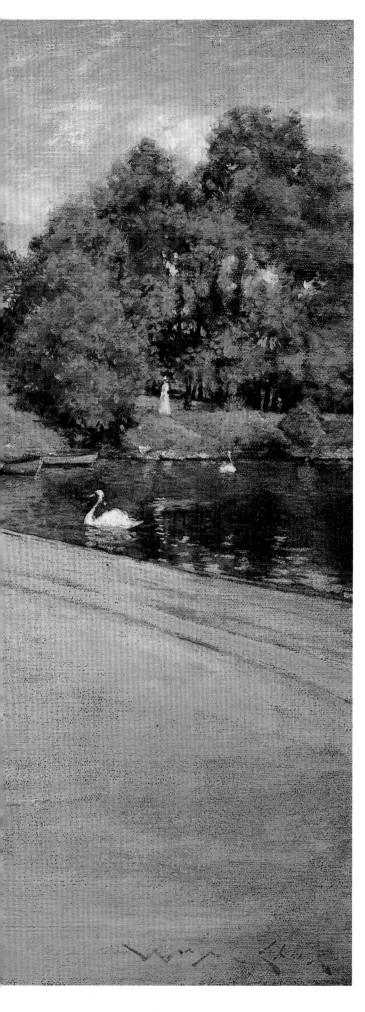

2 William Merritt Chase, *A Bit of the Terrace*, c. 1890.
20¾ x 24½ in. (52.7 x 62.2 cm). Private collection

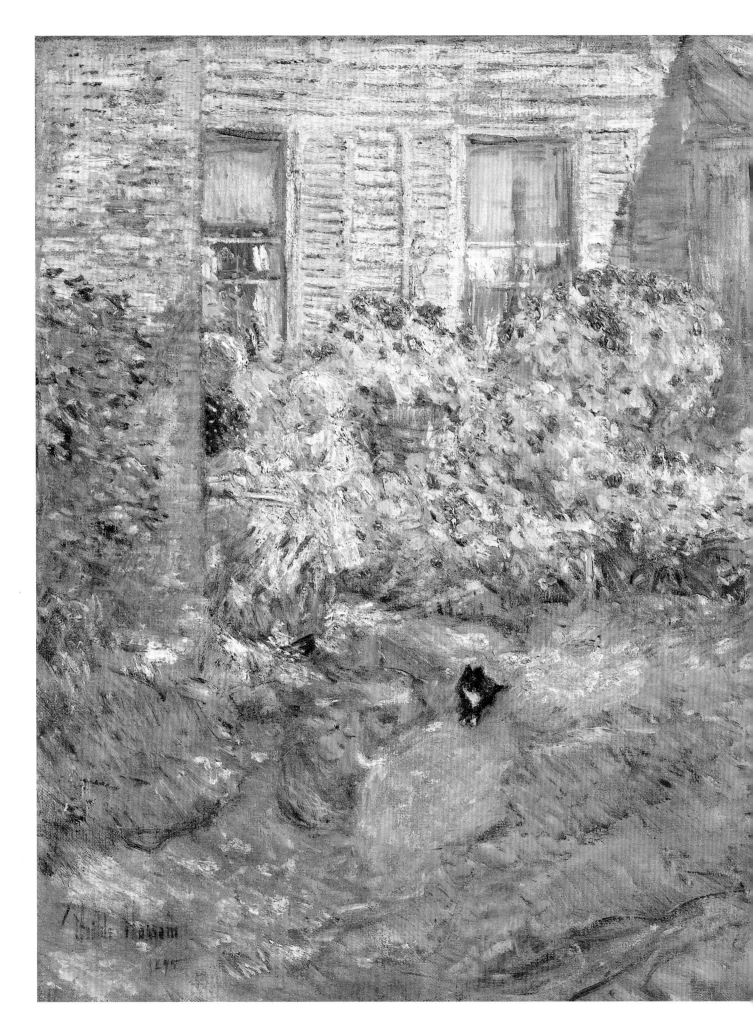

3 Childe Hassam, *A Fisherman's Cottage, Gloucester*, 1895.
20 x 24 in. (50.8 x 61 cm). Collection of Richard Rubin

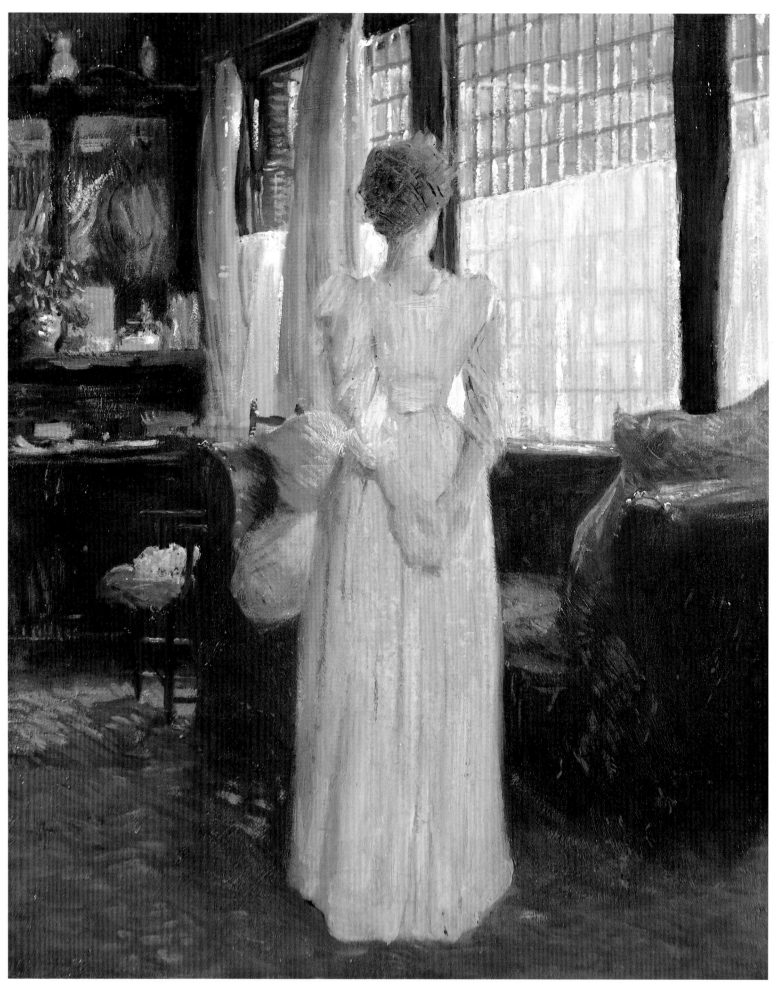

4 J. Alden Weir, *In The Livingroom*, c. 1890. 25 x 20 in. (63.5 x 50.8 cm). Private collection

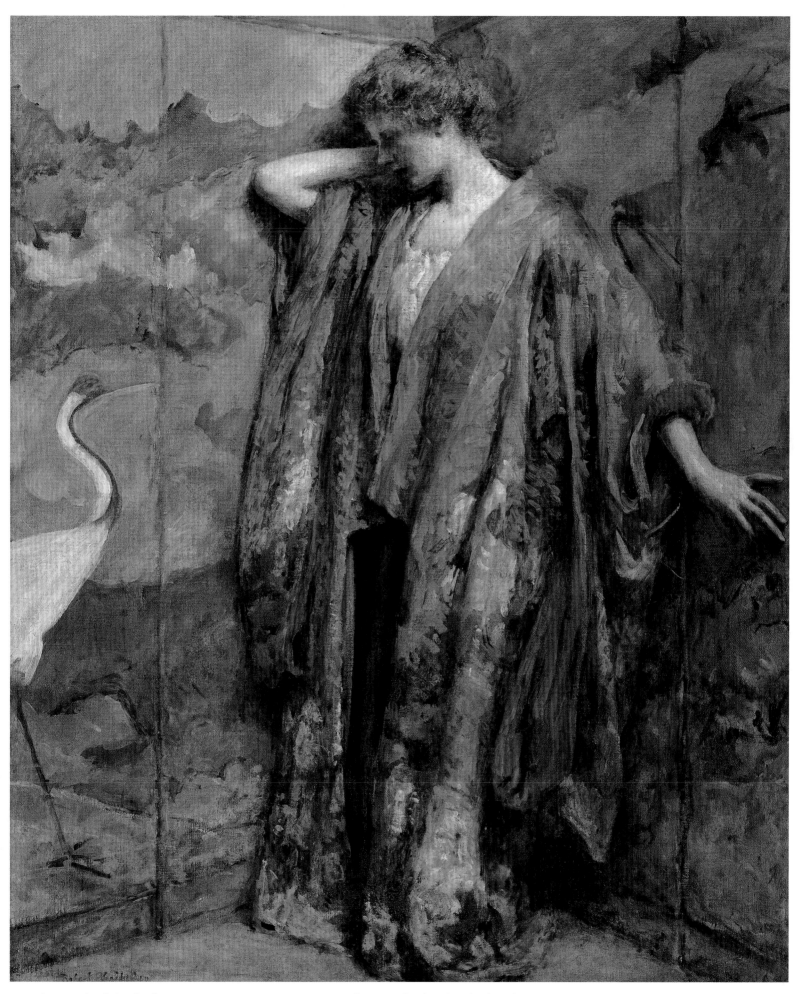

5 Robert Reid, *Blue and Yellow*, 1910. 36 x 32 in. (91.4 x 81.3 cm). Collection of Deborah and Edward Shein

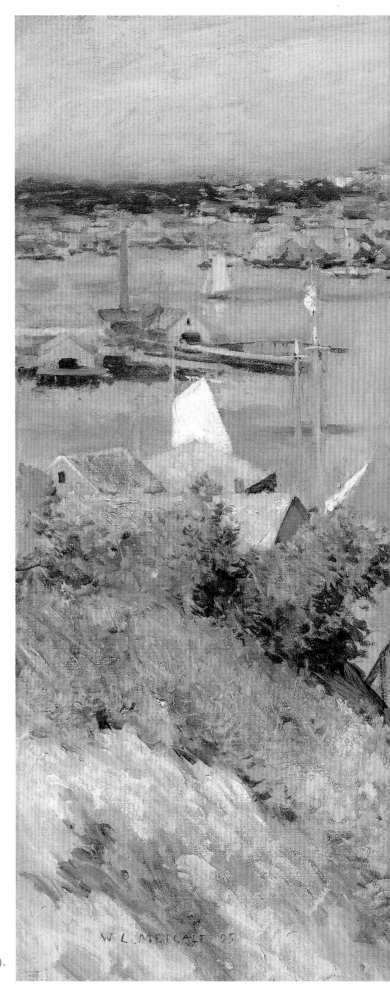

6 Willard Metcalf, *Gloucester Harbor*, 1895. 26 x 28 in. (66 x 73 cm).
Amherst College, Mead Art Museum. Gift of George D. Pratt

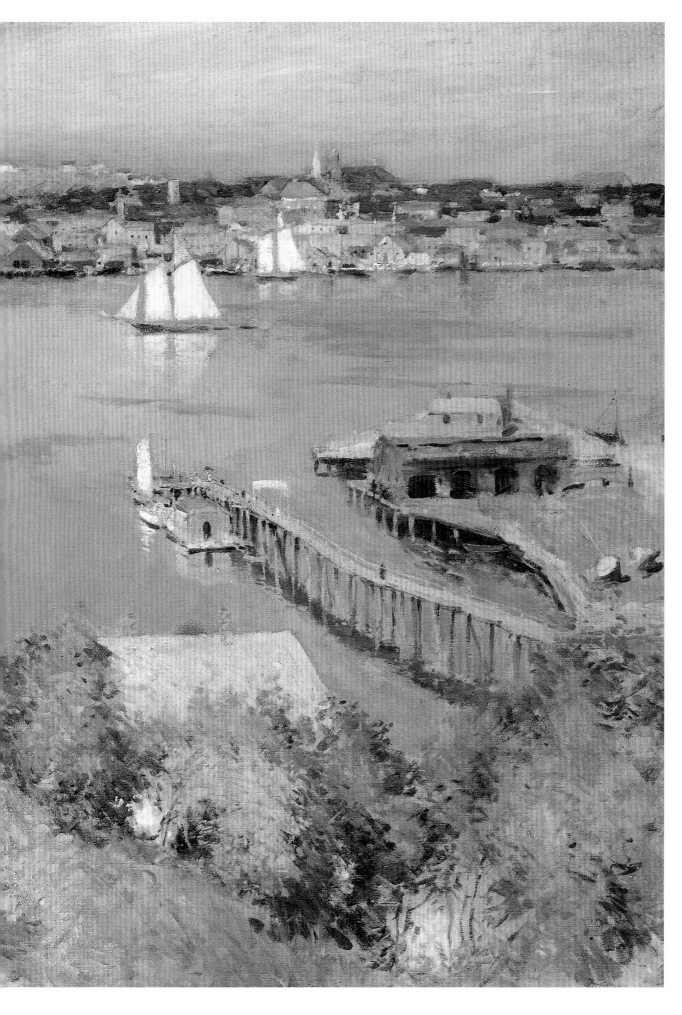

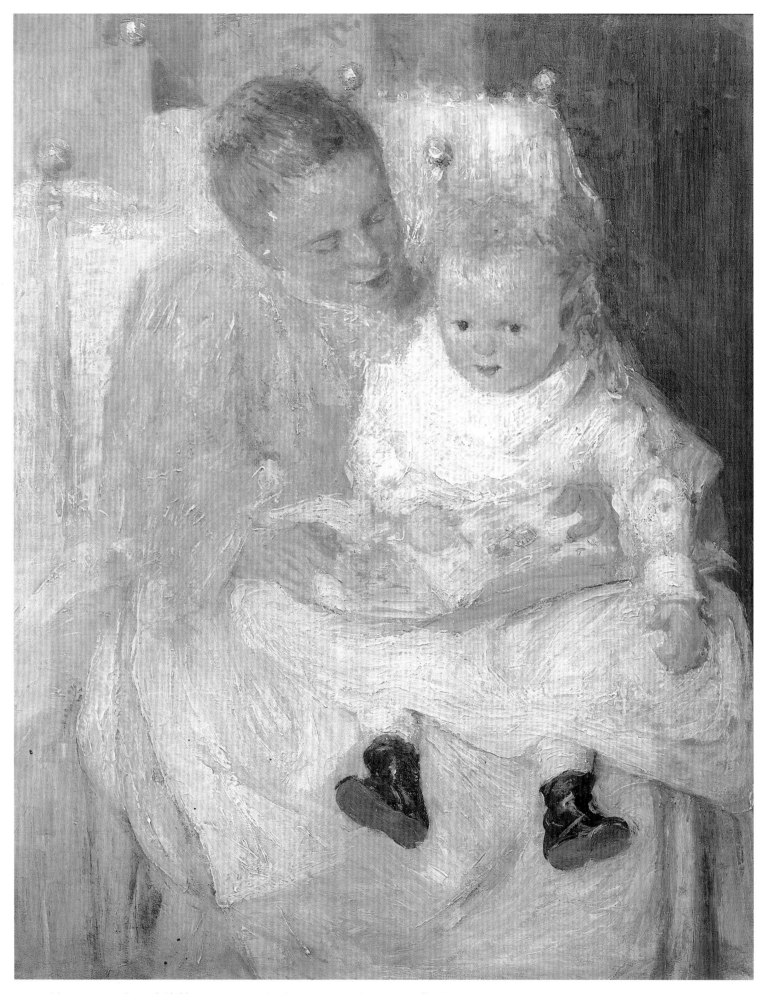

7 J. Alden Weir, *Mother and Child*, c. 1891. 48 x 30 in. (121.9 x 76.2 cm). Private collection

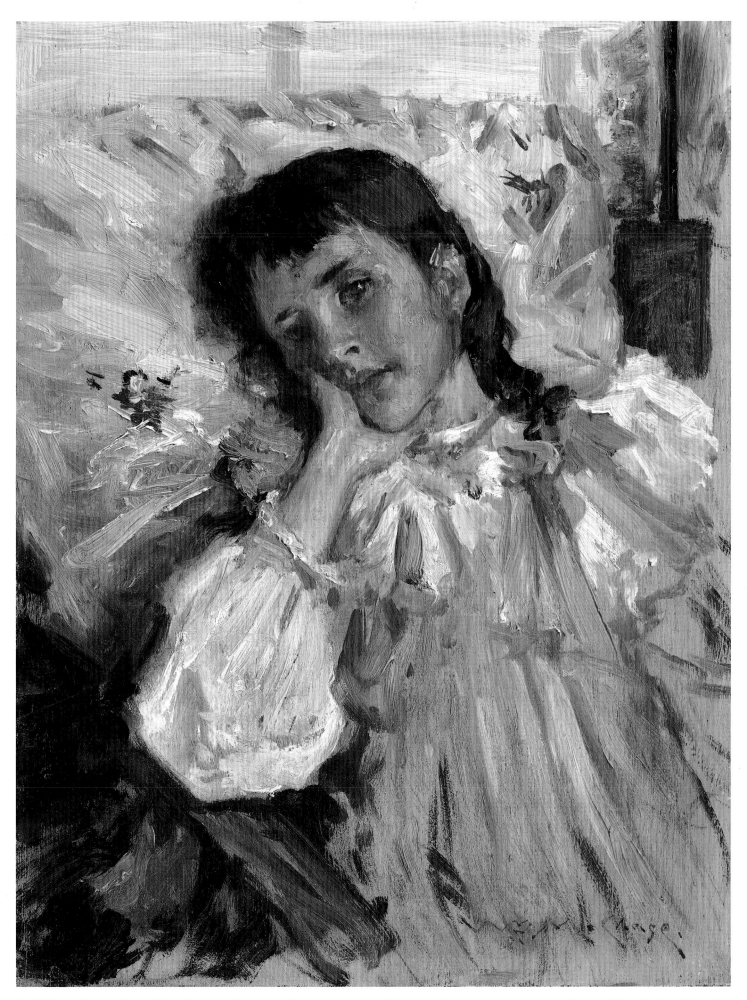

8 William Merritt Chase, *Tired (Portrait of the Artist's Daughter)*, c. 1894. Oil on panel, 13 x 9½ in. (33 x 24 cm). Jordan-Volpe Gallery, New York

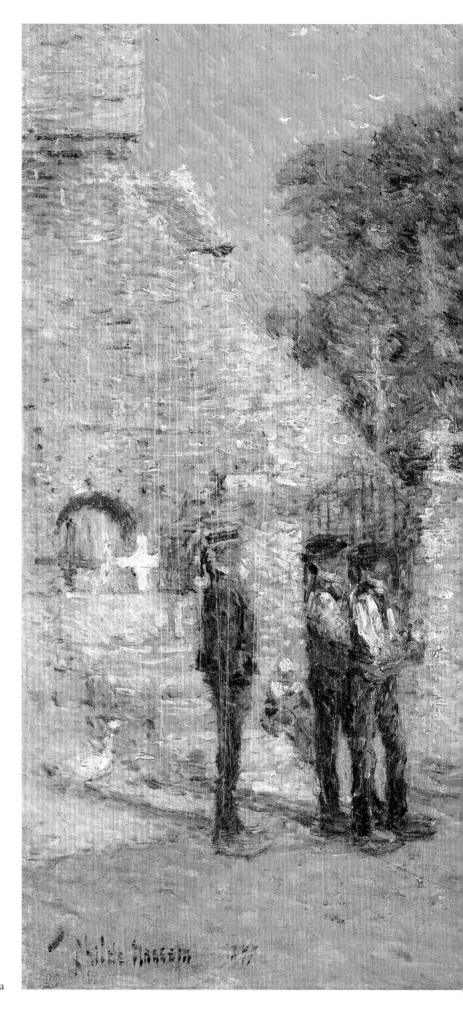

9 Childe Hassam, *Afternoon in Pont Aven, Brittany*, 1897.
20 x 24 in. (50.8 x 61 cm). Cummer Gallery of Art, Jacksonville, Florida

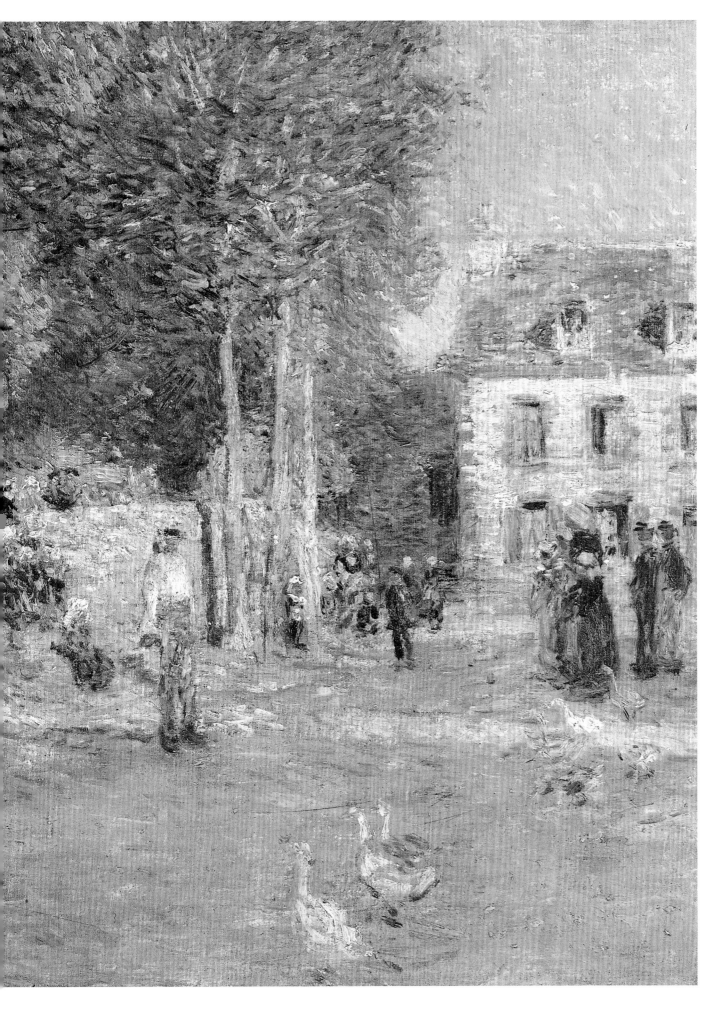

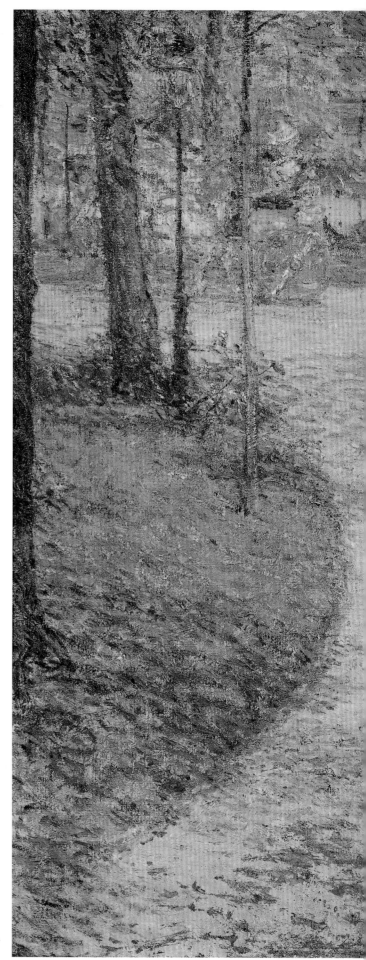

10 Childe Hassam,
Spring in Central Park
(originally *Springtime*), 1898.
29½ x 37½ in. (74.9 x 95.3 cm).
Collection of Robert Rubin

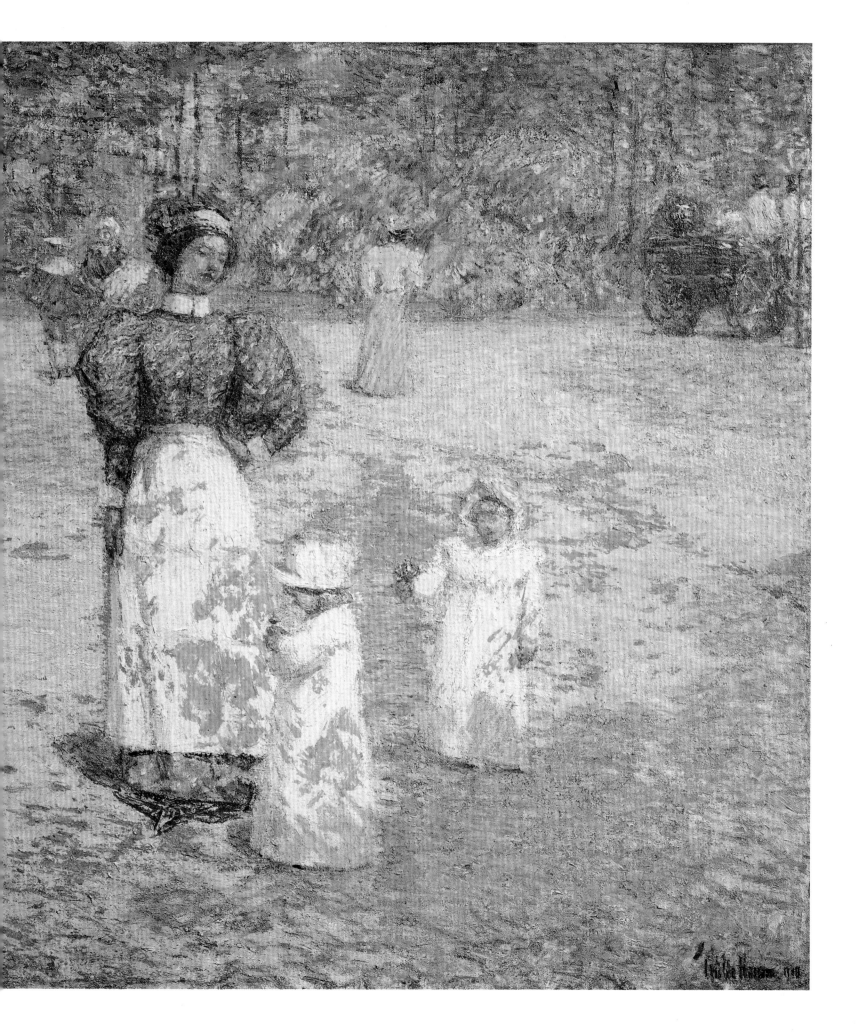

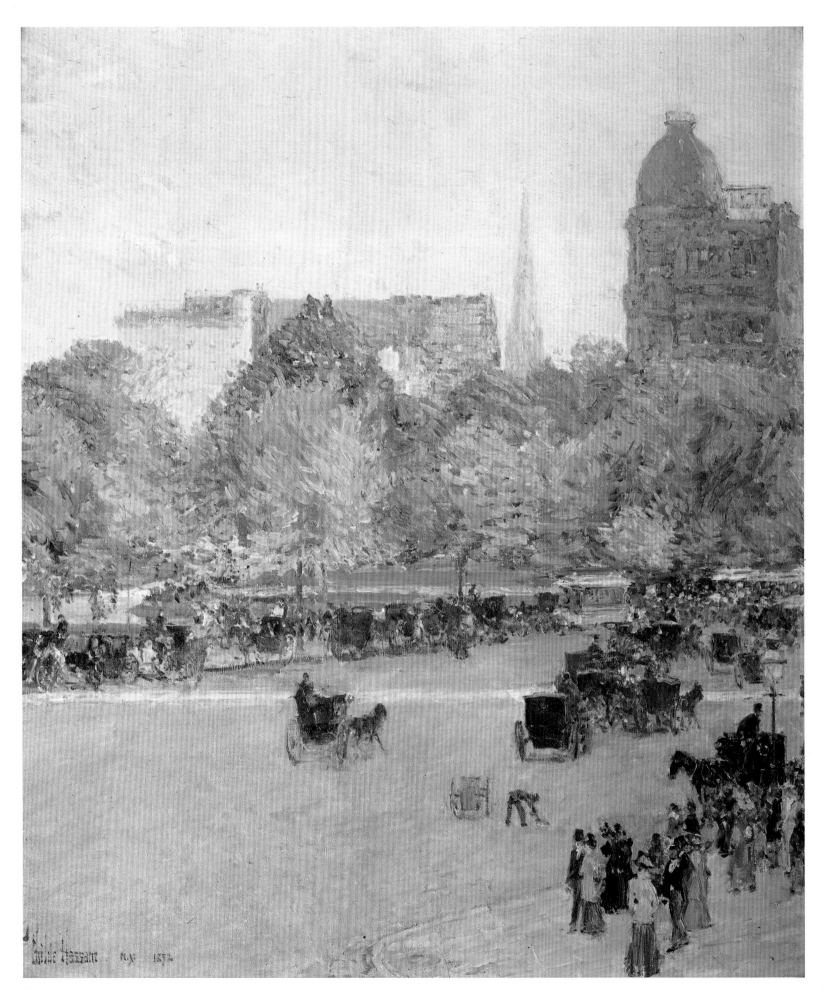

11 Childe Hassam, *Union Square*, 1892. 18 x 15 in. (45.8 x 38.1 cm). The Artis Group, Ltd.

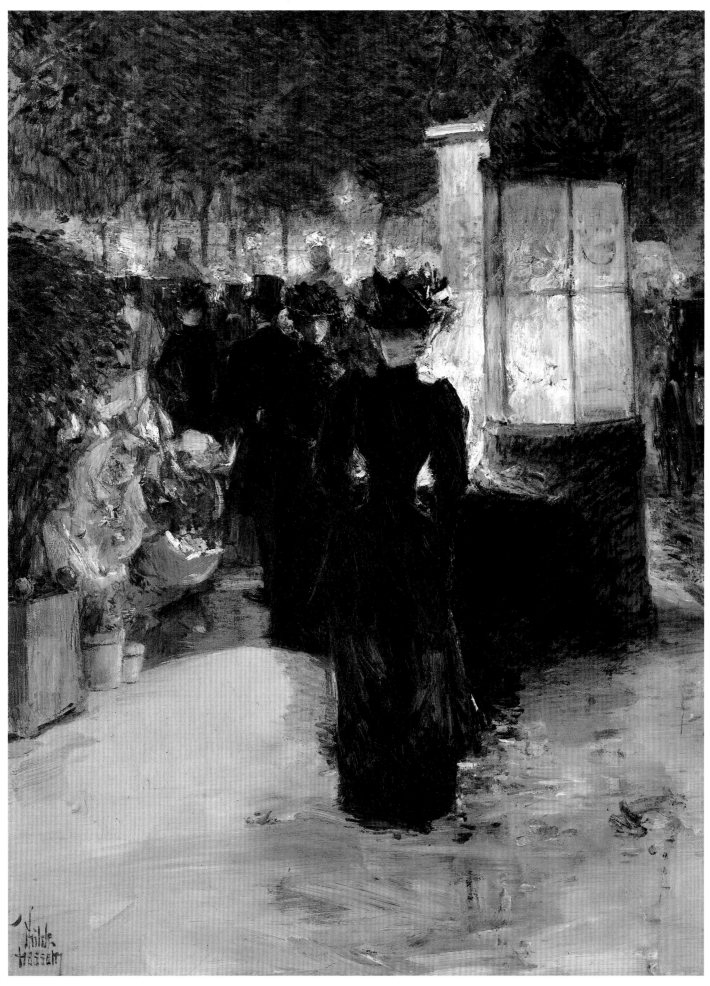

12 Childe Hassam, *Paris Nocturne*, c. 1889. 27¼ x 20¼ in. (69.2 x 51.4 cm). Private collection

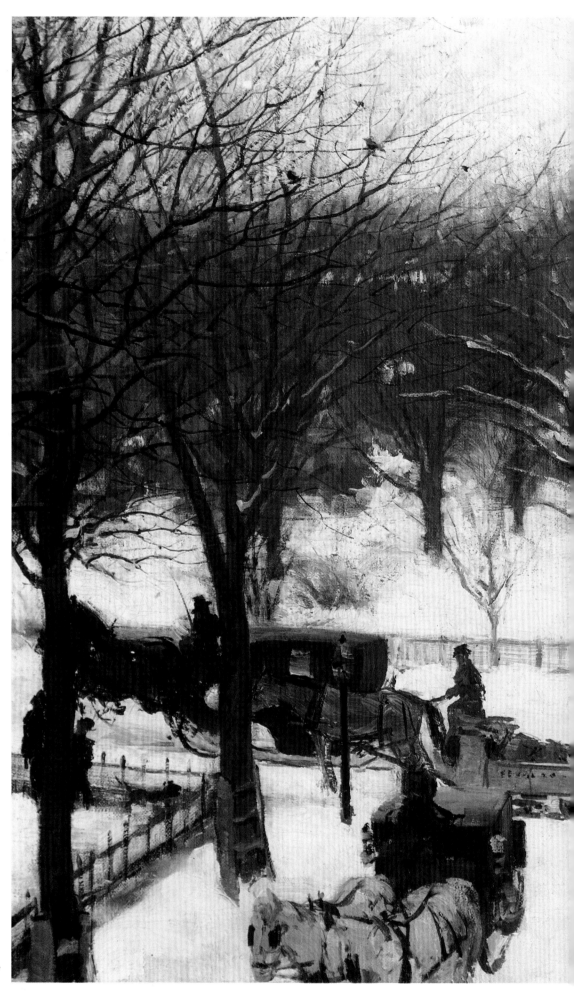

13 Edward E. Simmons,
Boston Public Gardens, 1893.
18¼ x 26 in. (46.4 x 66 cm).
Daniel J. Terra Collection,
Terra Museum of American Art,
Chicago (34.1984)

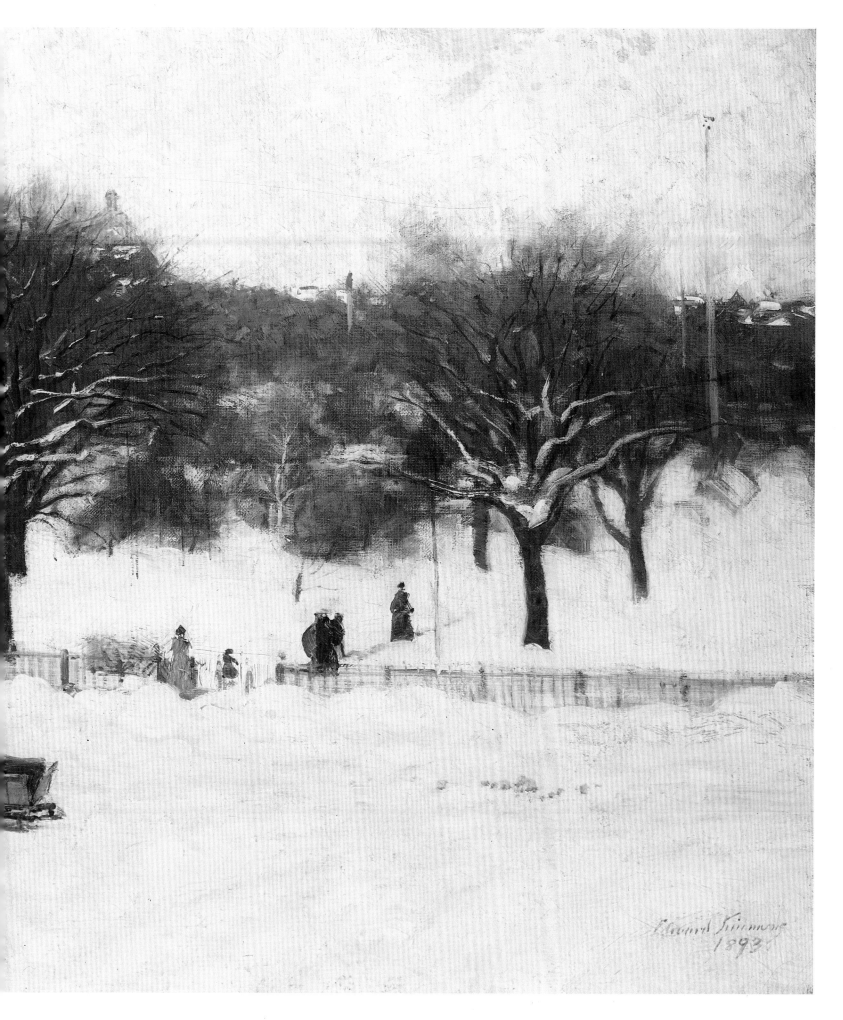

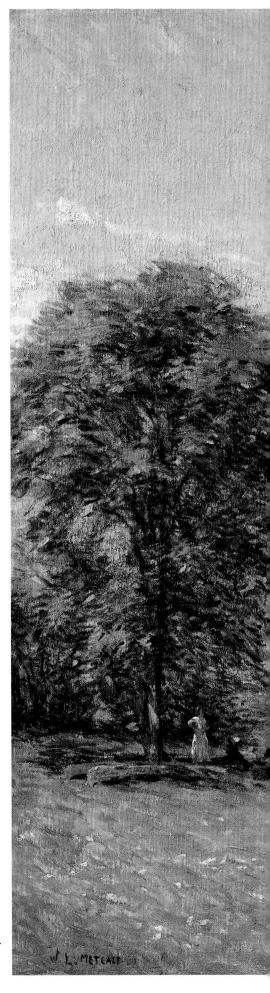

14 Willard Metcalf, *The Boat Landing*, c. 1902.
26 x 29 in. (66.1 x 73.7 cm).
Jordan-Volpe Gallery, New York

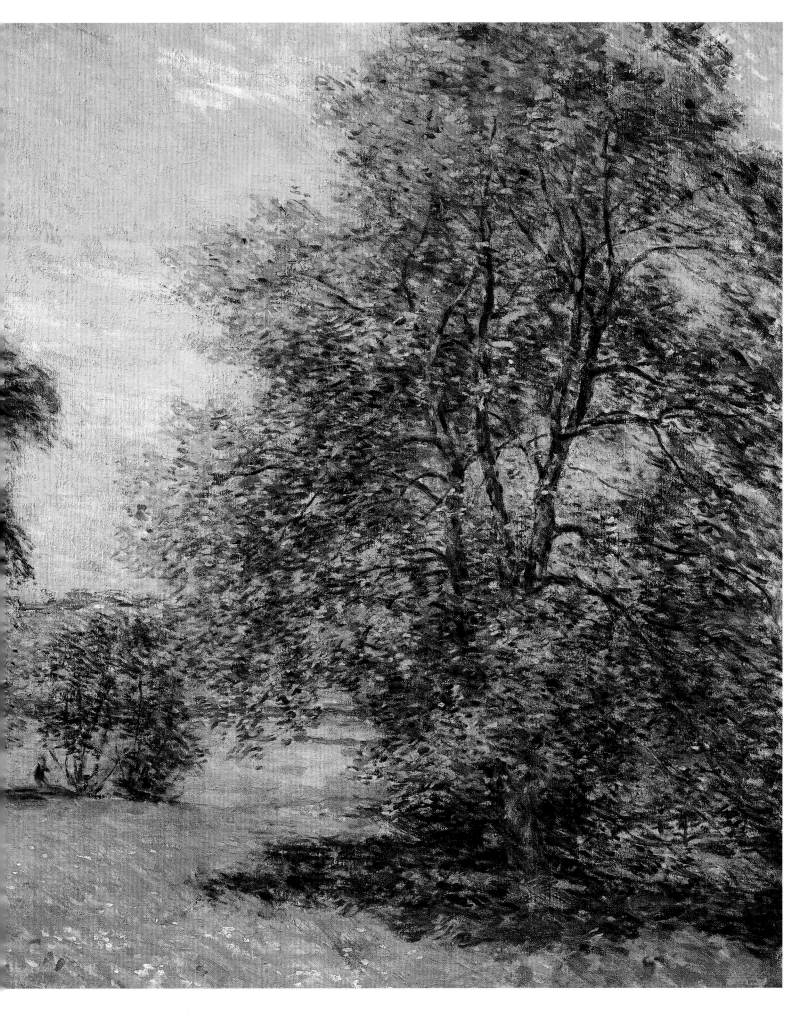

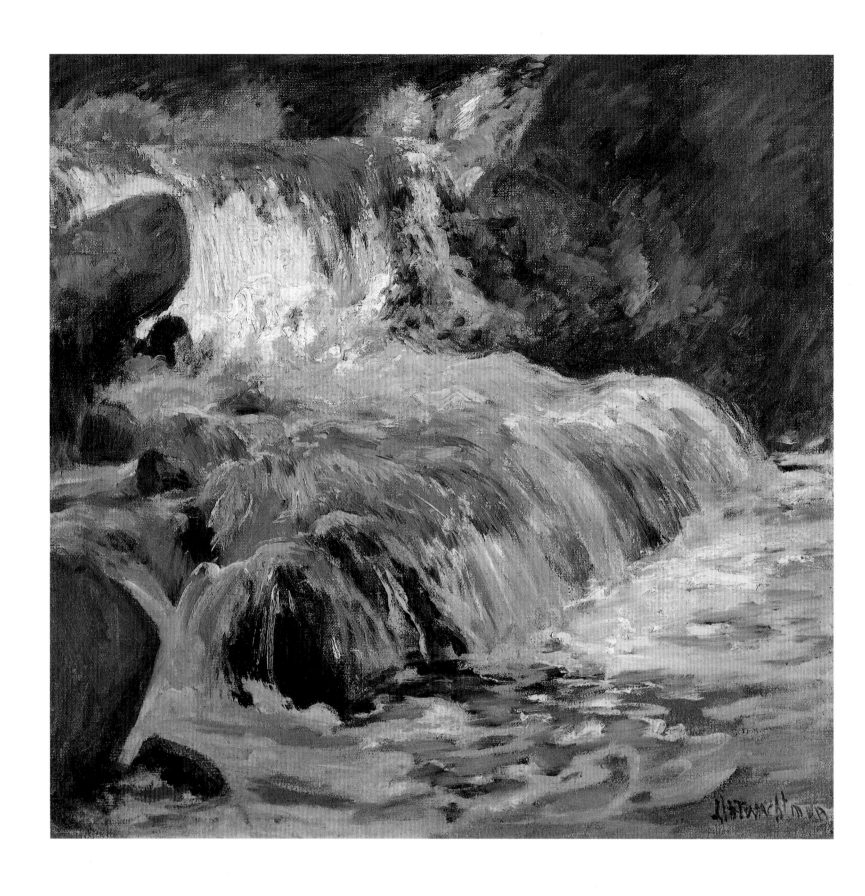

15 John H. Twachtman, *The Waterfall*, c. 1890/1900.
30 x 30¼ in. (76.2 x 76.8 cm).
Worcester Art Museum, Worcester, Massachusetts

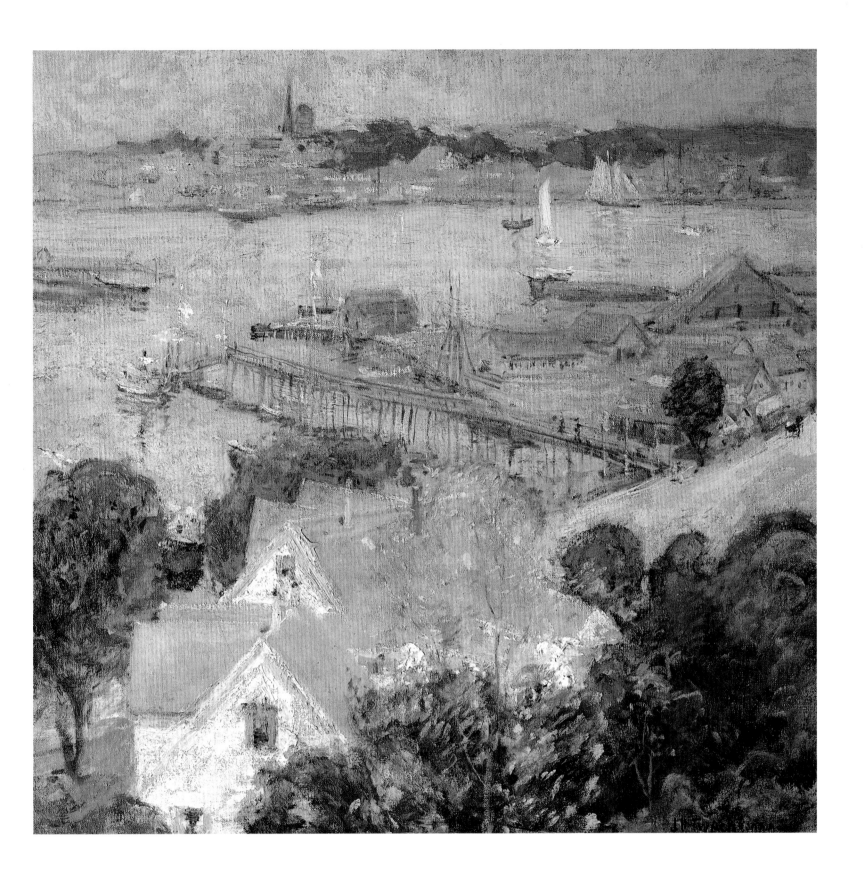

16 John H. Twachtman, *Gloucester Harbor*, c. 1900.
25 x 25 in. (63.5 x 63.5 cm).
Canajoharie Library and Art Gallery, Canajoharie, New York

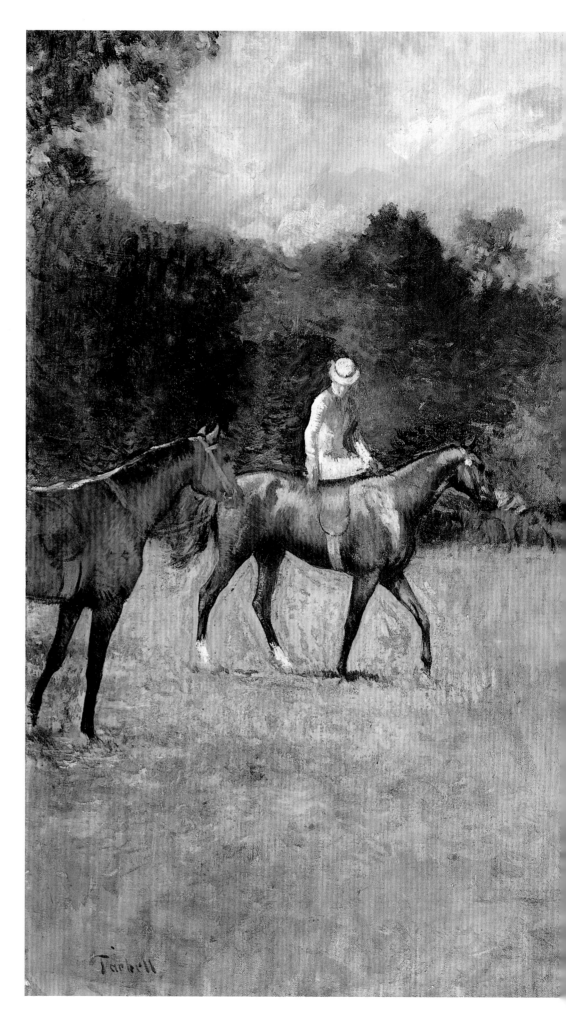

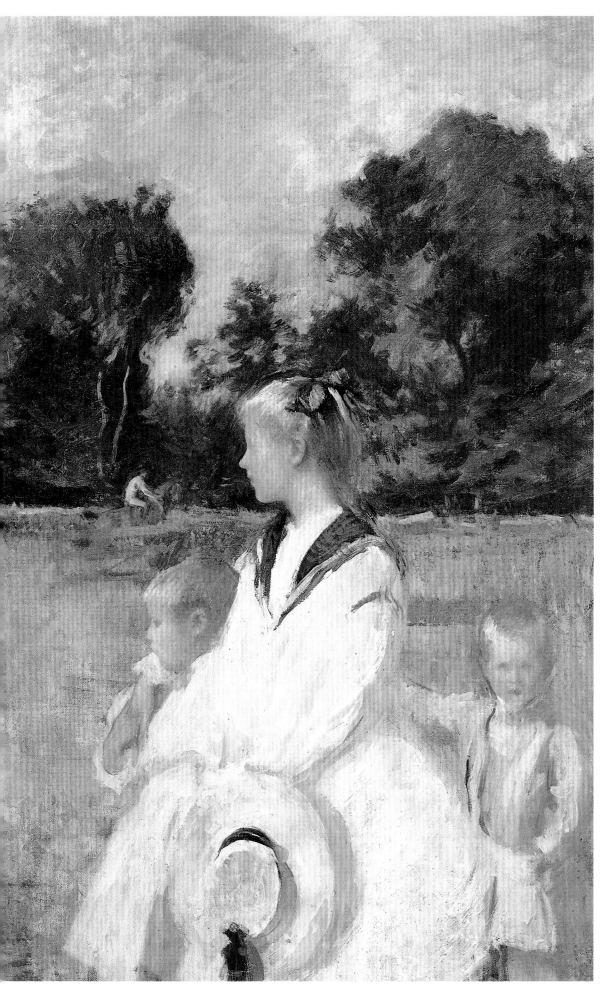

17　Edmund C. Tarbell,
Schooling the Horses, 1902.
24 x 29½ in. (61 x 74.9 cm).
The Currier Gallery of Art,
Manchester,
New Hampshire: 1975.25

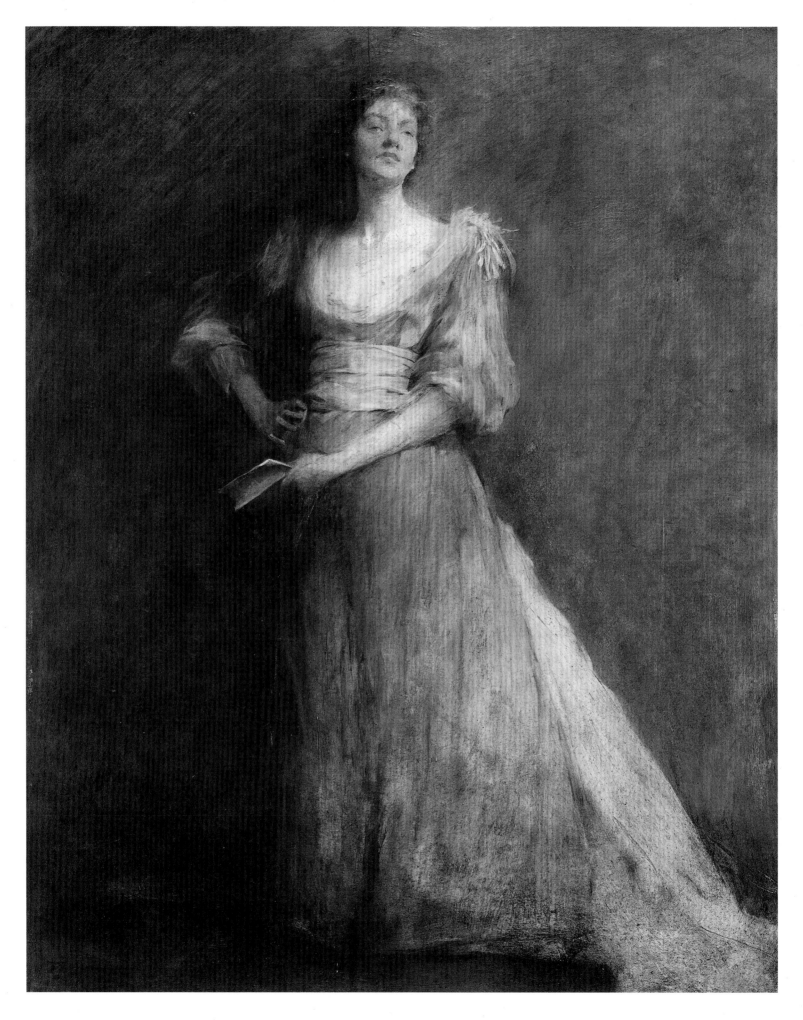

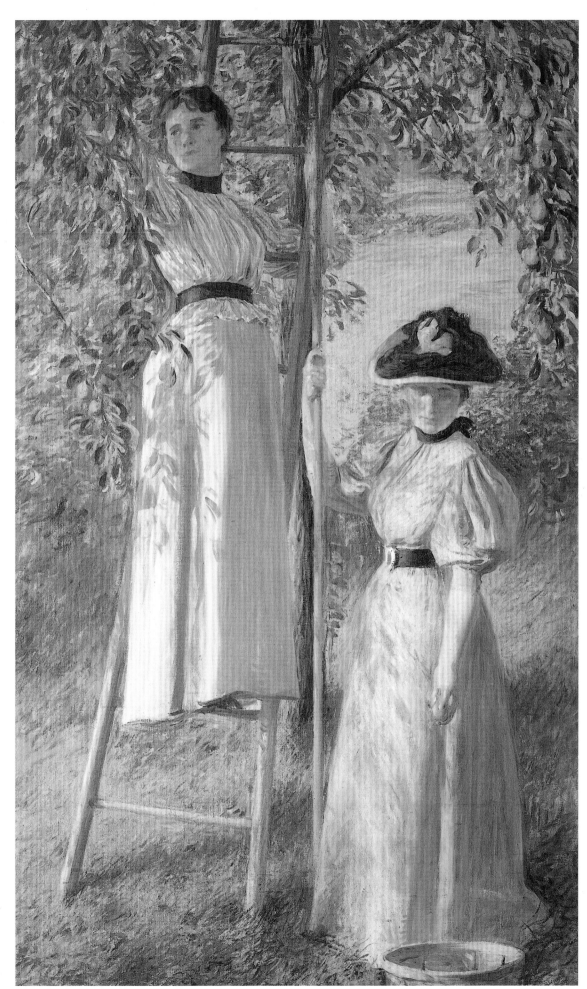

18 Thomas Wilmer Dewing,
Comedia, c. 1894/95.
19⅞ x 14¾ in. (50.5 x 37.5 cm).
Philadelphia Museum of Art:
Given by Mrs. Alex Simpson and
A. Carson Simpson, Jr. Collection

19 Joseph R. De Camp,
The Pear Orchard, c. 1895.
60 x 35½ in. (152.4 x 90.2 cm).
Private collection.

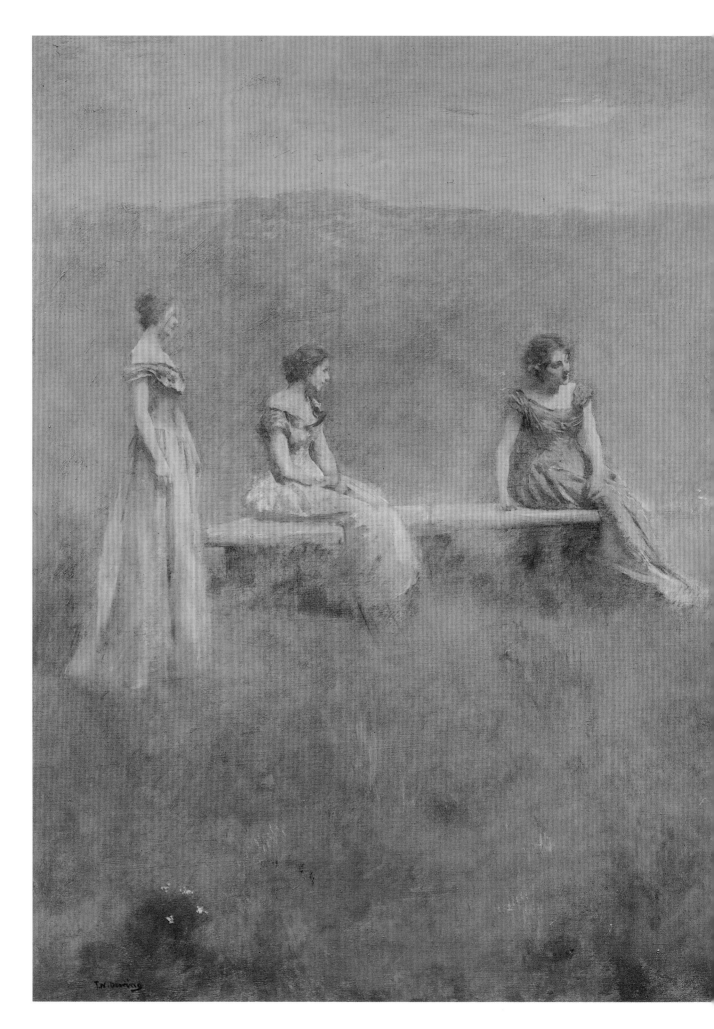

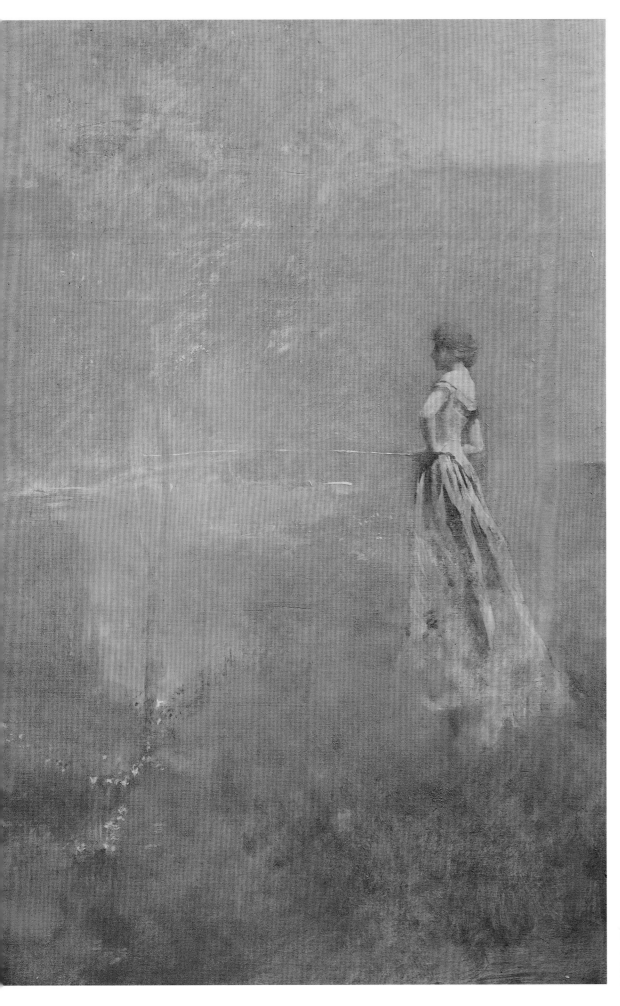

20 Thomas Wilmer Dewing,
La Peche, c. 1904.
35 x 48 in. (88.9 x 121.9 cm).
Private collection

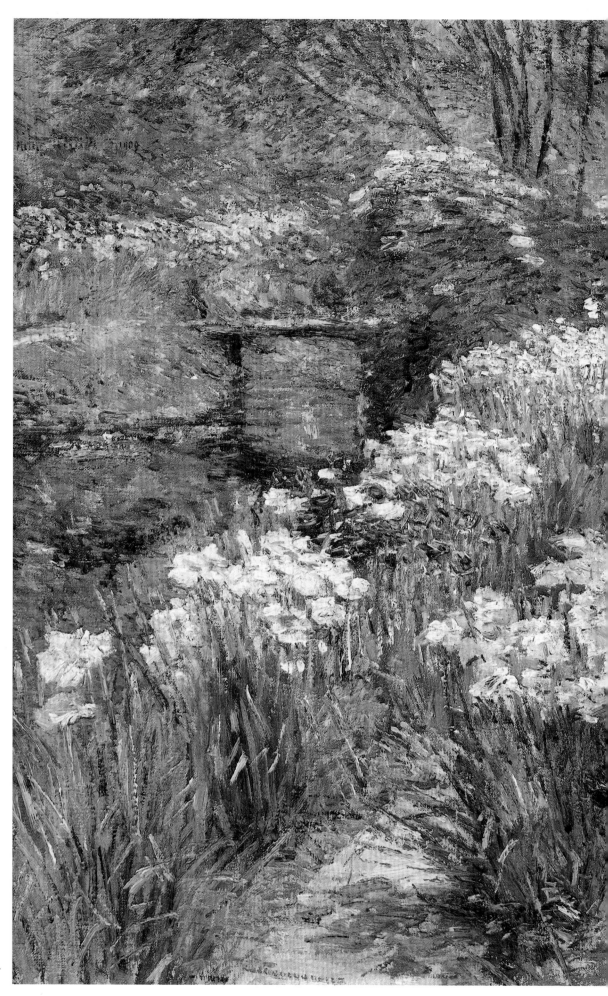

21 Childe Hassam,
The Water Garden, 1909.
24 x 36 in. (61 x 91.4 cm).
Private collection

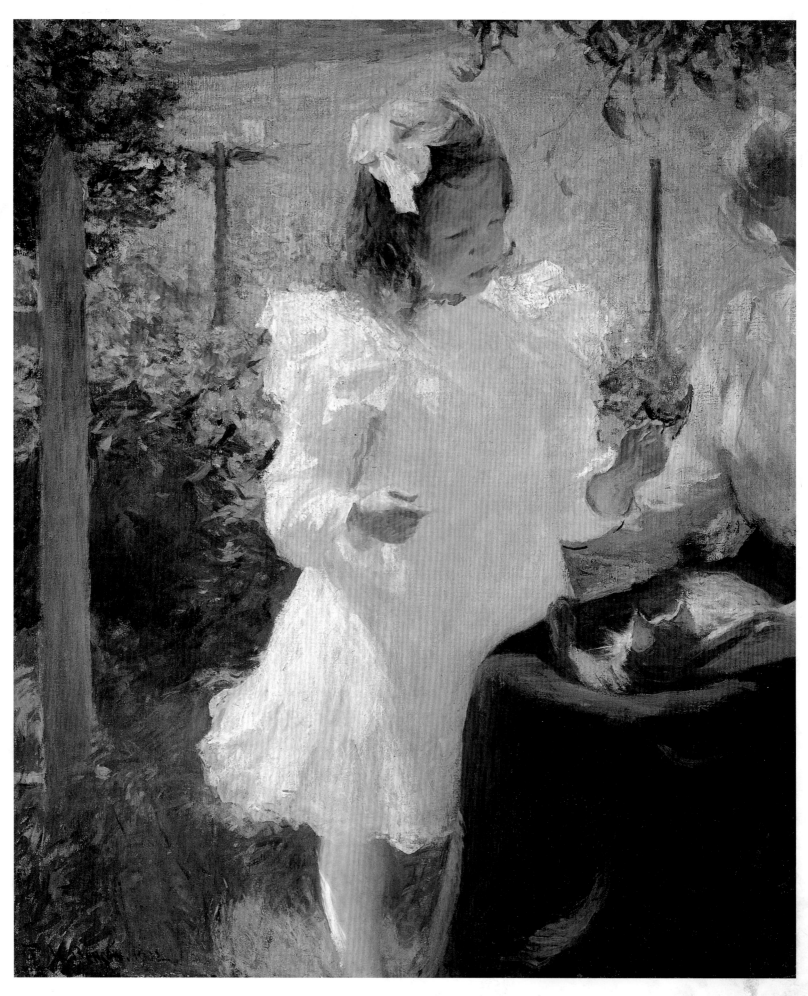

22 Frank W. Benson, *Sunlight*, 1902. 44 x 36 in. (111.8 x 91.4 cm). Courtesy of the Pfeil Collection

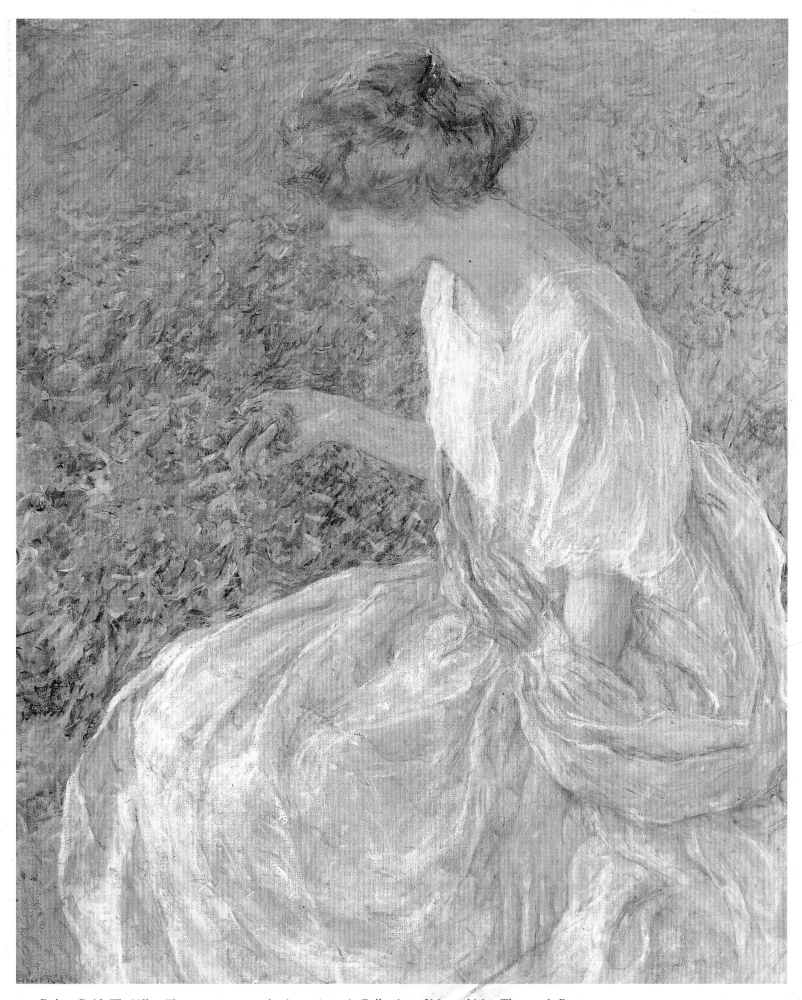

23 Robert Reid, *The Yellow Flower*, 1908. 37 x 30 in. (94 x 76.2 cm). Collection of Mr. and Mrs. Thomas A. Rosse

24 J. Alden Weir, *Summer*
(originally *Friends*), 1898.
24 x 20 in. (61 x 50.8 cm).
Private collection. Photo
courtesy Jordan-Volpe Gallery,
New York

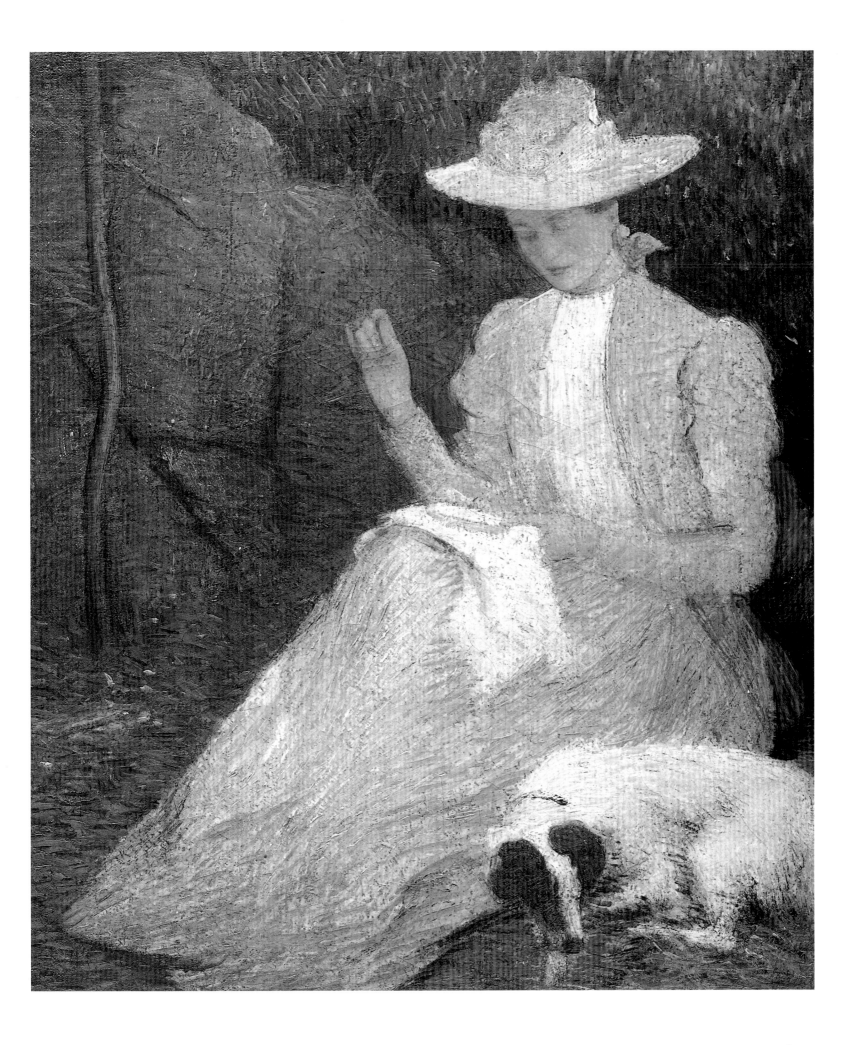

25 Willard Metcalf, *The Winter's Festival*, 1913.
26 x 29 in. (66.1 x 73.7 cm).
The Fine Arts Museums of San Francisco,
Gift of Mrs. Herbert Fleishhacker

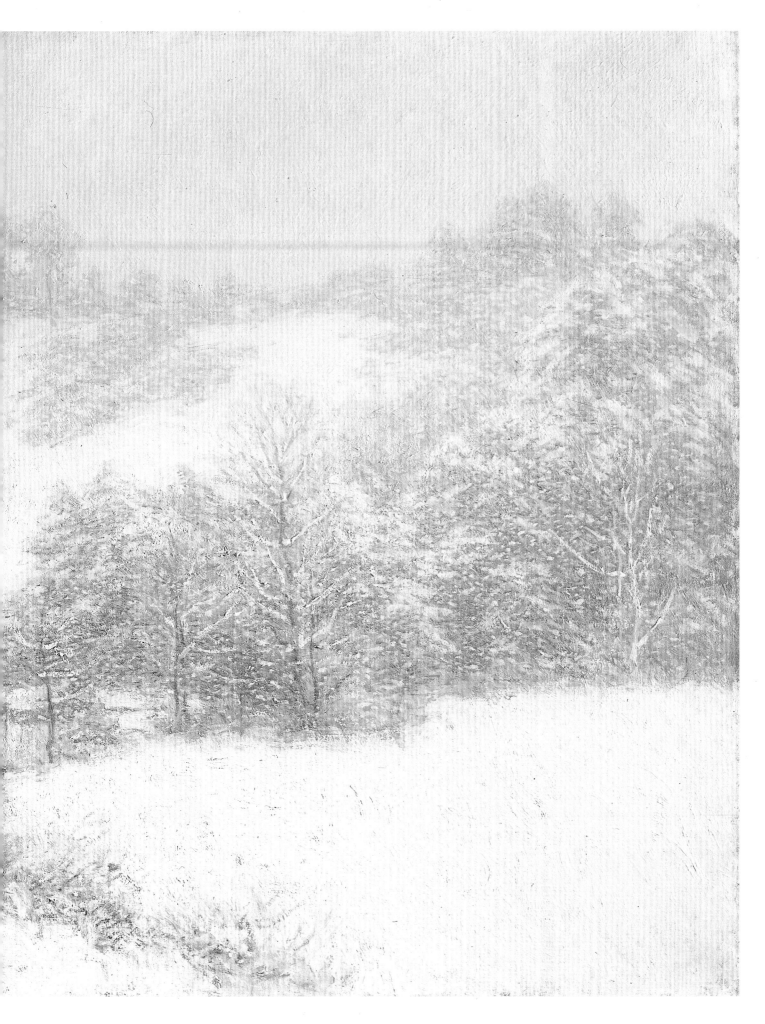

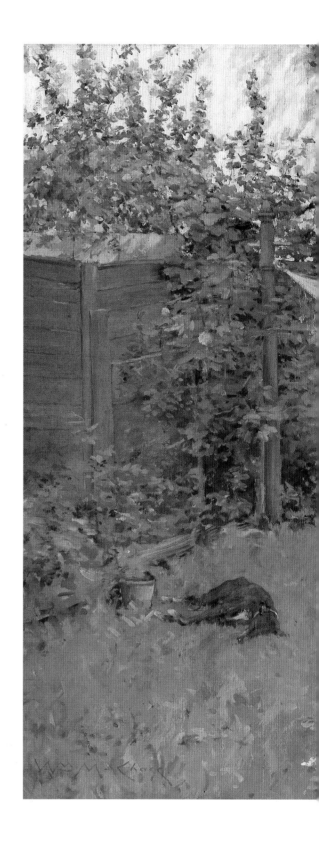

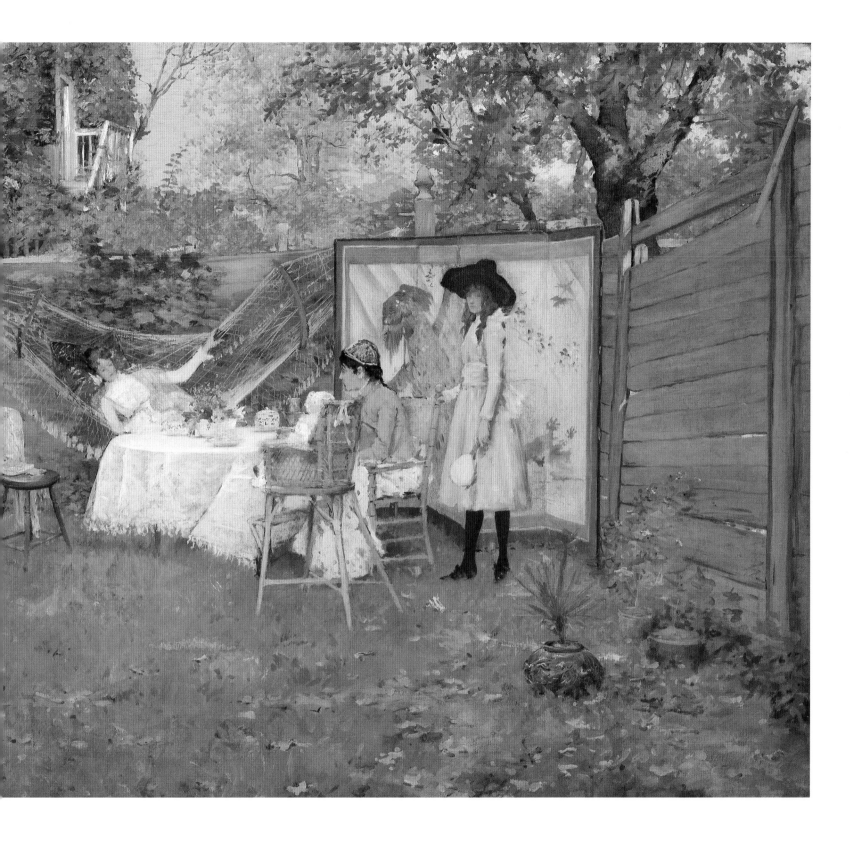

26 William Merritt Chase, *The Open Air Breakfast*, c. 1888. 37½ x 56¾ in. (95.3 x 144.2 cm).
The Toledo Museum of Art, Toledo, Ohio; Gift of Florence Scott Libbey

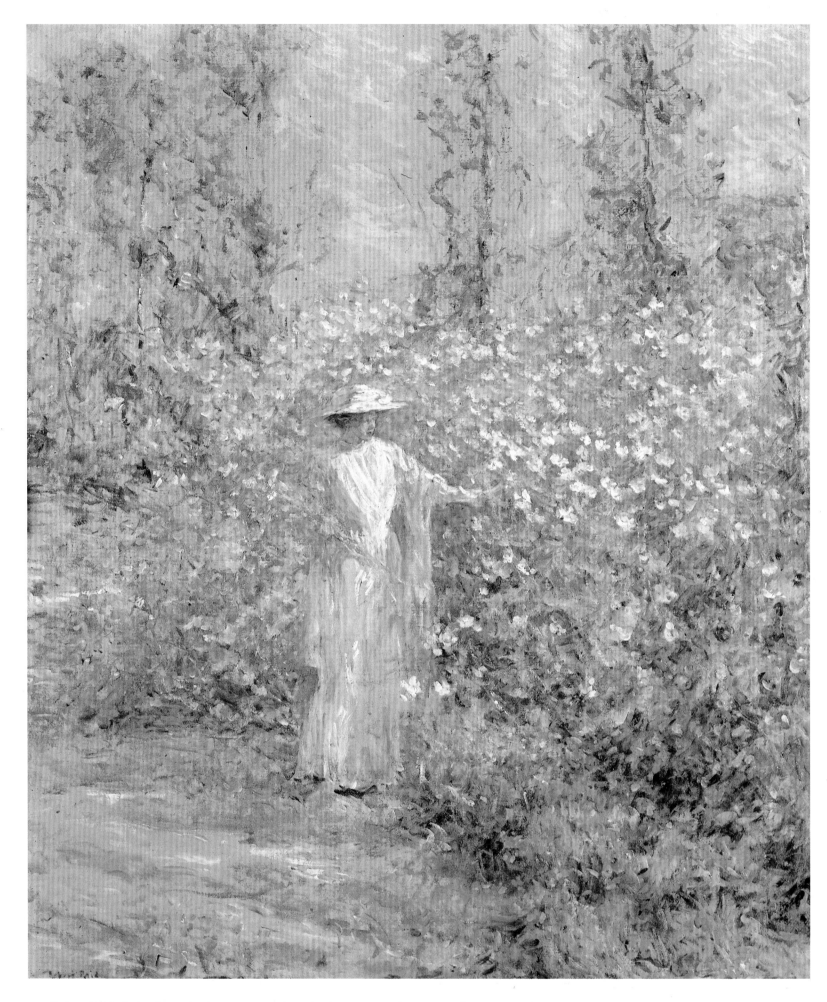

27 Robert Reid, *In the Flower Garden*, c. 1900. 36¼ x 30 in. (92.1 x 76.2 cm). Private collection

CHAPTER 2

The Young Men Back From Europe

Many spectators, and those directly involved in the affair, commented on how the secession of the Ten from the Society of American Artists recalled the groundbreaking events of twenty years earlier, when the Society itself had been founded. At least three of the original Ten—Weir, Twachtman, and Dewing—together with Chase, were active early members of the Society when it fought to legitimize the position of Americans who had been trained in Europe and returned to paint subjects and in styles considered "European."

Dissatisfied with the insularity of American art in general and the devitalized authority of the Hudson River School in particular, a growing number of young American artists sought training in the European academies after the Civil War. In the 1860s a handful of artists, including Robert Wylie, Daniel Ridgway Knight, and Frederick Bridgman, established a comfortable beachhead in the French art world. Weir went to France as a student in 1873, followed by Dewing in 1876, and formed part of a growing community there that included such other aspiring artists as Thomas Eakins, John Singer Sargent, and Mary Cassatt. England, too, attracted its share of Americans, while in Munich, Frank Duveneck and his protégés formed a creative center for Americans that for a time rivalled Paris. Chase, Twachtman, and De Camp were among this group, and worked in the Bavarian capital and in Venice in the mid- to late 1870s.

Many of these artists became thoroughly grounded in sophisticated techniques of figure painting and, on returning to America in the late 1870s (Weir in 1877, Chase, Twachtman, and Dewing in 1878), found themselves attacked for their dependency on foreign styles and for be-traying the quest for that cherished aim of a truly "American" idiom, whose province was considered to be landscape painting alone. In response to accusations of foreignness, the returning artists, who were proud of their hard-won achievements in the European academies, defended their work as the reflection of an historical and cultural legacy shared by artists the world over. The painter turned critic Earl Shinn, for example, pointed with pride to the development of skills that allowed Americans to control complex multifigured compositions at a level never seen before in America. As for the question of nationalism, he said, "it is wholly unreasonable that our young men, inevitably saturated with European culture, should have to develop a 'national' school like the Japanese or the Hindoos. It is not affectation for Americans to choose such [historical] themes; the affectation would be in pretending to be red Indians, and coloring with war paint."[1] Referring more specifically to the imagery of the Hudson River artists and to the notion of the American artist as some kind of backwoodsman, the urbane expatriate painter Bridgman declared: "Boots, red shirts, log cabins, and slouch hats are not national . . . they are uncivilized, repelling, ugly."[2]

On the practical side, the young artists found themselves barred by conservative selection committees from exhibiting at the National Academy of Design in New York, the country's most prestigious and important exhibition society. Even John La Farge, an Academy member, was prevented by his liberal views from exhibiting in 1874 and, a year later, so many young nonmembers were denied admittance to the Academy's major annual (spring) exhibition that they angrily set up a protest exhibition.[3] One Boston critic later described the situation:

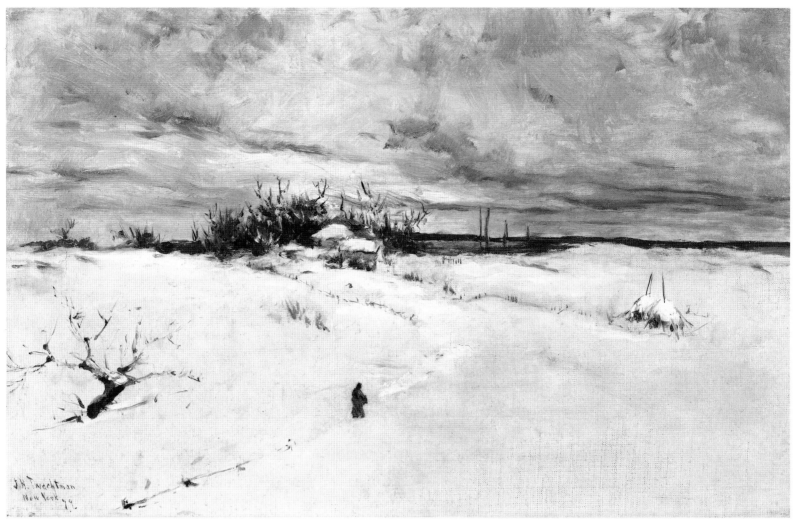

Fig. 19 John H. Twachtman, *Winter Landscape*, 1879. 12¾ x 20⅛ in. (32.4 x 50.8 cm).
Philadelphia Museum of Art: Alex Simpson, Jr., Collection

Kindly European critics have invented a theory that America, being an untamed wilderness, nature was the proper study of American art. Destitute of the schools with their masters and models of European critics, without the monuments of an old civilization, the palaces, castles, and cathedrals, the galleries of old masters, the vistas of a long and great history, the American savages in art must show their inspiration, according to this theory, as the aborigines show their religion, from the woods and waterfalls, from the great rivers and mountain ranges of the American continent. This was a theory happily in accord with a certain self-satisfied modern philosophy of criticism, that the "environment" determines and accounts for everything. But a generation of artists has arisen in America not content to be simple untutored savages in art. Modern inventions, steam, photography and the rest, bringing the world of civilization nearer together and annihilating distance and isolation, would not but work their revolution even in the National Academy in New York—desperate and impervious as has been the resistance of its crusted conservatism—as well as all other institutions. Having become aware of the immense superiority of the European schools, American art students, determined to "get the best", began flocking thither. The photograph and the ocean steamship, as well as the stars in their course, have been against the old cultus so long

dominating the aboriginal American art from its little stronghold in the National Academy. The younger generations, who have had the teaching of the Paris and Munich ateliers, and become saturated with the atmosphere and influences surrounding them, are creating a new American art.[4]

Owing to mounting outside pressure, the Academy's three-man selection committee chosen in 1877 decided to liberalize admissions to that year's exhibition. American audiences were promised their first comprehensive look at the group of young Americans from abroad. Great anticipation was built up in the press and by word of mouth. Once opened, the exhibition was widely reviewed and became an unprecedented box office success, with a paid attendance reported to be about sixty thousand. Many declared it to be the best exhibition of American work ever gathered, and one writer even claimed—with some justice—that it should have been the one to represent the United States at the Centennial exhibition that had recently been held in Philadelphia.[5]

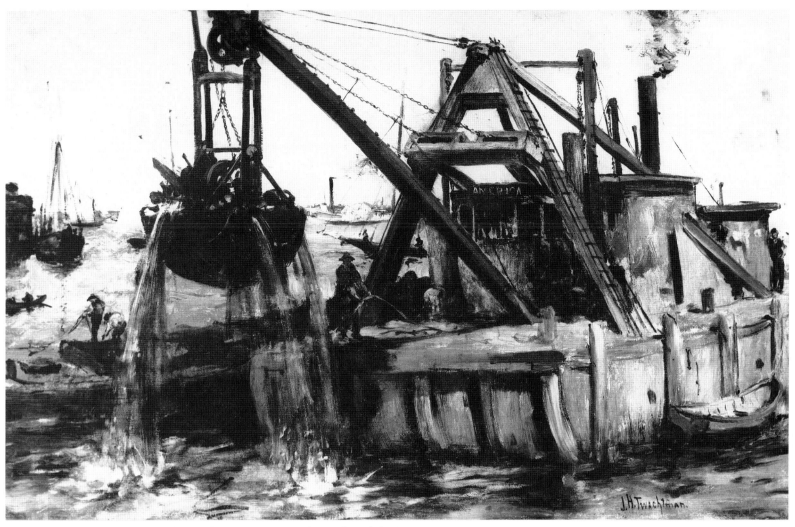

Fig. 20 John H. Twachtman, *Dredging in the East River*, c. 1879/80. 11⅞ x 17⅞ in. (30.4 x 45.4 cm). Courtesy Christie's, New York

Despite its popularity, the exhibition satisfied neither the Academy old guard nor the young outsiders. Clarence Cook, a longstanding critic of the Academy and champion of the young, complained that, with walls crowded everywhere with pictures, the good positions "on the line" at eye level were still occupied by the likes of Thomas Hicks, Daniel Huntington, and William Page, while works by Chase, Duveneck, Frank Millet, and others were hung in corners and under the ceiling. The Academy, he said, did everything to discourage talent, driving the young to Europe for training and then criticizing them for its influence. Instead of fostering exhibitions for education—or "art for art's sake"—the Academy and its exhibitions had come to be merely a place for the sale of pictures, "and the competition is no longer between artists as to who shall paint the best pictures, but between merchants as to who will get the best stall in the market."[6]

The Academicians, far from being content, were themselves in an uproar over the admittance of the newcomers and over the fact that some of their own number had been "skied." Jervis McEntee complained in his diary that "the genuinely American productions" were put aside and prominence given to the "foreign looking art."[7]

Huntington, Academy president, even demanded that the entire show be rehung. Resolutions were passed in retaliation against nonmembers, stipulating that, in the future, each show should be rehung after three weeks, and guaranteeing for each Academician eight feet of preferred space "on the line." This move was so derided that the resolutions were quickly withdrawn, but the message had been made clear. Cook said that anger ran so deep at the Academy that those in control would seek revenge at all costs. The *New York Times* also predicted that the younger men would be snubbed the following year. In fact, all but one of the candidates put up for election to the Academy that year already had been rejected, including Weir, Duveneck, R. S. Gifford, Wyatt Eaton, Millet, and Knight. According to the *New York Times*, "it was understood privately that none of the painters nearly or remotely connected with the new ideas or friendly to certain young painters, and none of those whose

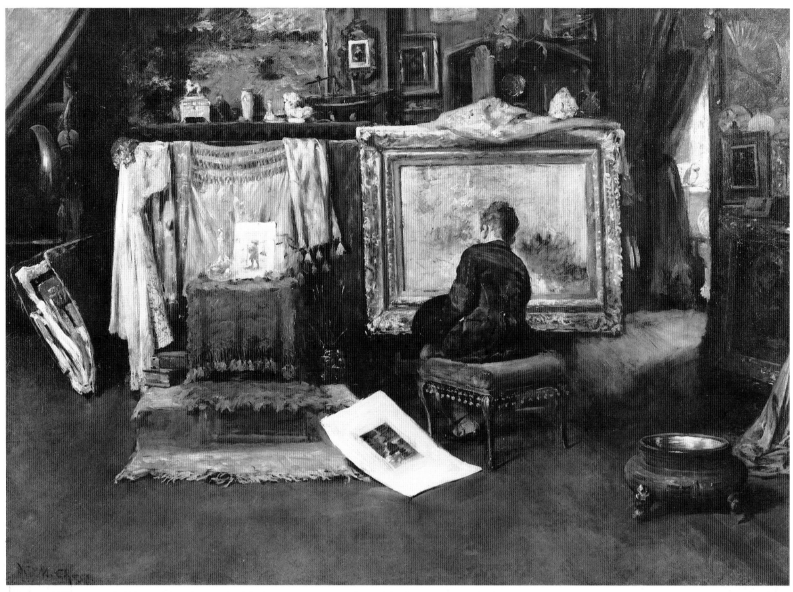

Fig. 21 William Merritt Chase, *The Inner Studio, Tenth Street*, c. 1882. 32⅜ x 44¼ in. (82.2 x 112.4 cm).
The Henry E. Huntington Library and Art Gallery, San Marino, CA

pictures had been well placed by the committee of this year, would have the slightest chance to become academicians. For the battle of next Spring had to be fought with the ballot of the last meeting; every suspected painter might prove one vote more for the liberal minority."[8] Unless the liberals could control policies next year, they said, a rival institution would be started. The recent exhibition had left no doubt that "the public demanded a new regime, new men, new ideas."[9]

In fact, the schism was already underway, as a few days earlier a small group of dissidents had announced a resolution giving birth to the Society of American Artists.[10] By October 1877 the new society had been incorporated and a committee of five established in Paris to screen works for their inaugural exhibition. This was to be an exhibition society committed to all new ideas, in which Americans trained in Germany, France, and England would stand on an equal footing with Americans who had never been abroad, but were free from tradition.[11]

Although not among its actual founders, four of the Ten were among the most active early members of the Society. Weir became a member the first year, Chase and Twachtman in 1879, and Dewing the next year. All showed at the first exhibition, held in March 1878, which gathered together most of the other prominent figures in American painting of the next generation, among them Duveneck, Eakins, La Farge, Sargent, J. Carroll Beckwith, William Morris Hunt, George Inness, Homer Dodge Martin, Thomas Moran, Albert Pinkham Ryder, Louis Comfort Tiffany, James McNeill Whistler, Alexander Wyant, and a host of Paris "expatriates," including Bridgman, William Dannat, and Charles Sprague Pearce.

What distinguished Society paintings from those of the Academy in the public mind was the fact that they lacked the

smooth, detailed finish they were accustomed to seeing. Many were mere studies, it seemed, of possible interest only to the artists. One reviewer of the first Society exhibition advised the artists to put away such "college exercises" and "impressions" and prepare "what are known in the trade as gallery paintings."[12]

Much discussion centered on the question of technique. Even artists with academic training, such as Weir, said the *New York Times* critic, were creating pictures "blocked in quickly, even rudely" in an effort to preserve the essentials of form and "the first fresh impression of their subject."[13] Another writer for the same newspaper observed, only half in irony, that the lack of detail deprived the average viewer of their most important criteria for judging a picture — was it accurate, the table woodlike, the rock hard? A proper amount of detail, on the other hand, assured one that the artist was not lazy and that the audience was getting its money's worth. Neither did one have to worry about whether the artist meant anything by his work or about the quality of his ideas.[14] In response to the artists' complaints that most critics simply did not understand pictorial language, one writer replied that the critic should positively avoid discussing "the style of the painting, the handling of the brush, the laying on of the paint, and such other technicalities," for he wrote on behalf of buyers who neither understood nor probably cared about such things.[15] Another said that anyone not totally lacking in "natural taste" would make a better critic than an artist, who was inclined to be too preoccupied with the extraneous "mechanism" of technique. The artist's aim, he claimed, was "to produce a work of high and enduring pleasure … within the comprehension of any person with a fair degree of taste. Like poetry, art is for the people, not for a special jury of professional experts…. The primary requirement of the poem and of the picture is that it shall tell its own story." Those who complained loudest about public ignorance and unfair treatment by the critics, he said, "generally are those who have no higher aim than to paint to please themselves and a coterie of personal admirers."[16]

What was considered the general "paintiness" of work shown at the early Society exhibitions was such as to draw comparison with other independent art movements, even if these were mostly known by reputation alone. One reviewer, for example, compared the paintings in the 1880

Fig. 22 William Merritt Chase in his Tenth Street studio, c. 1895

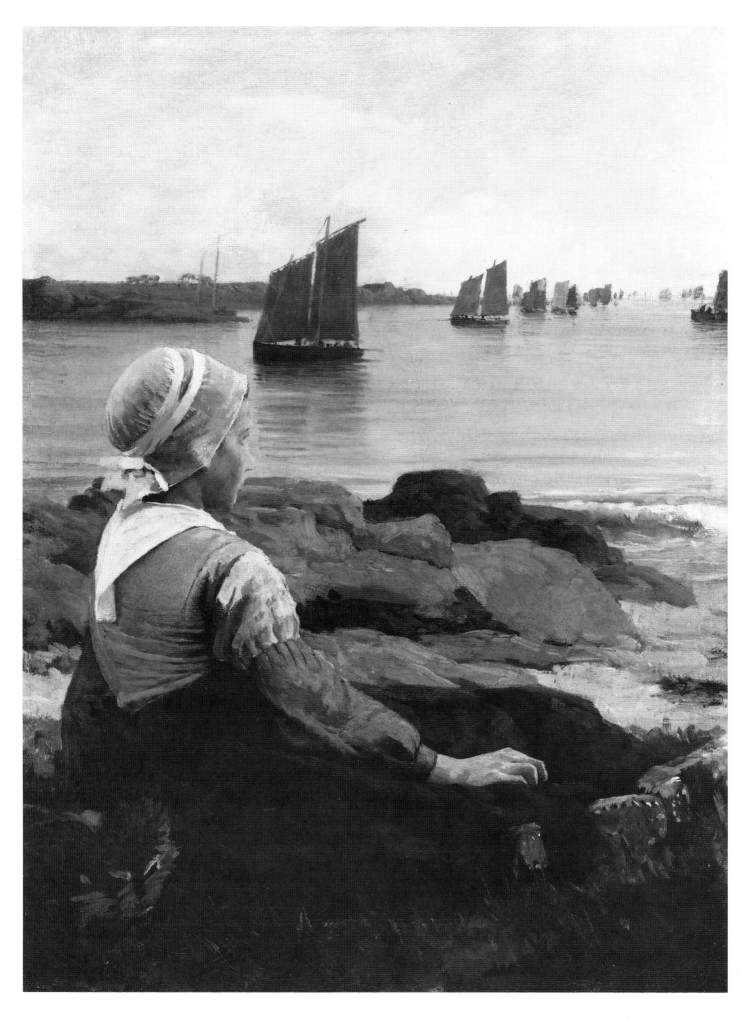

Society exhibition to those of London's Grosvenor Gallery and to the Impressionist exhibitions in Paris, and, because Society artists often left their work in what was called "the expressive and preparatory stage," they were even given the title "impressionists."[17]

In this environment artists as dissimilar as Chase and Eakins were continually subjected to the same criticism for overemphasizing "technique," Chase because he was slapdash and Eakins because the realism of a work such as *Crucifixion* (Philadelphia Museum of Art) was believed too "scientific."[18] Later this same argument was extended to include the Impressionists.

While presenting to the world what appeared to be a united front, the Society actually suffered from something of a split personality, torn between rebellion and a sense of institutional propriety. It never, in fact, broke entirely with the Academy. Statements to the press were conciliatory in tone,[19] and the Society closed its first exhibition five days early, out of "delicacy," to avoid overlapping with the Academy's annual show, in which such Society exhibitors as Chase, Weir, and even Walter Shirlaw, president of the Society, actually participated.

Neither could the Society escape the self-destructive internal dissension which had beset the Academy. Bitter feeling over the rejection of a painting by Thomas Moran, his subsequent resignation, and the furor that arose over the hanging of a large showing of Society pictures sent to Philadelphia in 1879 contributed to the formation of a separate Philadelphia Society of Artists, which organized rival exhibitions in 1880 and 1881.[20] Although founded by, and in support of, European-trained artists, the Society in New York seems to have neglected its colleagues abroad, who were particularly unhappy at being denied even honorary membership. One complained that they had done everything to show their interest, "signed all sorts of papers and made all sorts of promises, only to find that we had no lot nor part in the organization, and were to be invited or not, one year after another, at the caprice of the messenger of the 'American Artists' for any given season."[21] It was hinted that the New York-based artists preferred to promote themselves at the expense of those who worked abroad, and truth is that the Society shows did become increasingly American

in character, while the rival 1881 Philadelphia exhibition was described as having exactly the air of a Paris salon.

A rift, already hinted at during the 1877 Academy show, also developed between the Munich- and Paris-trained factions, and one critic described the first Society exhibitions as battlegrounds for the opposing ideologies.[22] The Munich aesthetic dominated the Society through its president, Shirlaw, and its chief exponent, Chase, as well as through Twachtman and others. Following the leader of the American Munich colony, Duveneck, whose work created a sensation in Boston in 1875, these artists created a bold new style in which forms were rapidly blocked in and left as complete, without any superficial finishing work. With its predilection for black and for strong accents of color, the Munich style comprised a blend of realism with a broad handling of paint after the example of Hals, Velázquez, and other seventeenth-century masters. The Munich artists gained a great deal of attention at the Centennial Exhibition of 1876, and the painter Eastman Johnson even bought one of Chase's works for himself. Weir, who was at the time finishing his studies in Paris, was urged by his brother in America to spend a few months in Munich where, he had heard, the school was "working wonders," even surpassing that of Paris.[23]

The Paris academies, by comparison, followed classical precepts of form based on the methodical buildup of anatomical structure and a neutral color scheme centered on gray. The artist-critic Earl Shinn, himself a product of French training, complained that the Munich faction dominated Society exhibitions, scoring Chase in particular as an embodiment of the "flimsy, theatrical, decorative superficiality" of the Munich style. Chase produced "feats of legerdemain in magical brushwork," but was faulted for a lack of solid anatomical foundation in his figures. His *Coquette* seemed to "boil out of her clothes like froth out of a roemer; she seemed to have no skeleton, no tendons to hold her together; and her proportions were superficially and guessingly drawn, under an impression that 'thereabouts' the curves and points of attachment would occur In fact the fallacy of these decorative Bavarians is, that they represent not the vital secret of life, but represent its theatrical representation. Mr. Chase [and the Munich artists] ... are alike concerned with the superfices of life, rather than with its blood and bones and marrow and soul." Shinn described the French system, as exemplified by Weir and others, as "austere, thorough, and honorable. The ideal is to be planted on anatomical accuracy, as in a Greek statue."[24] One critic of both new schools said the Munich painters were noted for their dash and impulse, but paid for it by

Fig. 23 Edward E. Simmons, *Awaiting His Return*, 1884.
21 x 15¼ in. (53.3 x 38.7 cm).
Mr. and Mrs. Hardwick Simmons

their flawed knowledge of anatomy and the antique. Because of their superficial attractiveness, they were the more dangerous. Those using the French method lacked charm, applying profound discipline to trivial subjects.[25] As a "Munich" artist, opposed equally by Paris-trained critics and artists and by the home traditionalists, Chase first acquired the reputation, which followed him throughout his life, of being a superficial technician, concerned only with surface effects—and this years before such qualities came to be associated with Impressionism as we know it.

Further complicating the history of the Society was the fact that sales at its early exhibitions were dismal, the younger men finding little patronage. The buying public wanted only European pictures and, next to that, perhaps similar works produced by Americans abroad. The *New York Times* complained that, while New York was teeming with artists' studios, indiscriminate buyers preferred to pay enormous sums for inferior European pictures, and left the Americans to a meager support from portraits and minor commissions.[26] So pervasive and enduring was this prejudice against the homemade product that Chase actually reported, twenty-five years later, that two major dealers offered to pay double for his paintings if he would only live abroad and send them back from there.[27]

Weir's situation after he returned from Europe in 1877 might be expected to have been favorable since, as a member of one of America's oldest artistic families, he was well connected, yet correspondence with his brother John proves otherwise. "It is a dogged battle I have been fighting, trying to get some things off and rent paid. So far things hang fire You would have heard from me, but the drubbing up and worrying has made the pleasure of letter writing disagreeable to me. Up to the present time I exist, and have some prospects of getting a portrait; but pictures can't be painted without models, which require money."[28]

Like other ambitious artists ignored by the buying public and faced with the absence of any meaningful stimulus at home, Weir went back to Europe regularly. The summer of 1878 found him in Paris intent on new experiments. He described making "an effort to forget my school work, and work as natural and naive as possible." He admired a show of the Barbizon painters at the Durand-Ruel gallery and the light key of the Florentine primitives,[29] and continued to praise the bright, realistic technique practiced by his friend Jules Bastien-Lepage. On a subsequent trip to Paris, in 1880, Weir purchased Bastien-Lepage's monumental painting *Joan of Arc* (Metropolitan Museum of Art, New York) for the collector Erwin Davis; through exhibitions at home it became a model for a new type of clear, bright painting modified by

realistic principles.[30] Even more important for Weir personally was his meeting the following year with Edouard Manet and, for audiences in America, his purchase of three works by the French master, two of which—*A Boy with a Sword*, c. 1861, and *Woman with a Parrot*, 1866 (both Metropolitan Museum of Art, New York)—were to become in 1889 the first Impressionist works to enter an American public collection.[31] Weir had initially viewed Manet's work with strong disapproval when he was a student in Paris in the mid-1870s.[32] In the meantime, his awareness of the Impressionist circle had expanded at least to the point of acquaintance with the resident American, Cassatt, whose work Weir admired enough to urge her participation in the first Society exhibition.[33] In 1881, however, it seems to have been the advice of Chase, who was in Paris at the same time, that steered him towards Manet. Although it was many years before Weir would accept without reservation the Impressionist aesthetic, the influence of Manet's early style, which soon appeared in his work, proved the intermediate step in his conversion.

Twachtman, who, upon returning from Munich in 1878, had begun a close and lifelong friendship with Weir, similarly suffered from lack of success in America. When he did manage to make a few sales, one to the same Erwin Davis who had bought the Manet paintings, it was only through Weir's intervention; otherwise, he said, "no one else cares a damn for my things."[34] He wandered restlessly back and forth from his native Cincinnati to the east coast and eventually returned to Europe, first to Florence in 1880 to take a teaching job which Duveneck had offered him, then to Venice in 1881, and finally moving to Paris in 1883. Twachtman's three-year stay in Paris coincided with the gathering there of other, mostly younger members of the future Ten. Simmons was already present, having resided since 1881 in Concarneau (see plate 30), where Weir's friend Bastien-Lepage also lived. Benson, Tarbell, and Reid, after being classmates at the Boston Museum school in the early 1880s, came individually to study at the Académie Julian in Paris, Benson in 1883, Tarbell in 1884, and Reid in 1885. Metcalf, too, enrolled at the Académie Julian in 1883 and, during one year in Paris, he also took classes run by the American Dannat, in the company of Tarbell, Reid, and some other Bostonians. Some of the interactions between these artists are documented, about others we can only surmise. We know, for instance, that Benson met Simmons in Concarneau in 1884, and Twachtman is recorded as having joined Metcalf, H. Siddons Mowbray, and others on various social outings. Together, Twachtman and Metcalf may have formed the initial links between the older group based in New York, who

also came variously to Europe in the early 1880s, and the younger artists from Boston.

In artistic terms Chase was the undisputed leader of the new generation of Society artists. He returned from his student days in Munich a modest celebrity, full of energy and confidence, determined to show through his militant attitudes and flamboyant personal style that, as one writer put it, "Art had come to town." He established a studio in New York that, for its size and lavish appointments, became a legend, serving, moreover, not only as the center of his own painting and teaching, but also of many of the organized activities of the young artists' community, including the meetings of the Society. The painter Arthur Hoeber later recalled Chase's studio in the 1880s: "There were glorious nights in that Tenth Street studio when they painted tiles, made monotypes and etchings and discussed art It was true Bohemia when all the world was young and the possibilities were unlimited."[35] The studio became the locus of many of Chase's best paintings of the early 1880s (see fig. 21). These studio pictures, while permeated with his sense of mission and aesthetic values, were also plainly autobiographical. Still later Chase turned to his family for inspiration, sometimes treating them as more or less conventional models—as when, for instance, his wife posed for nude studies (see plate 31)—but more often discovering in their behavior and character the source of a "subject" of deep fascination (see plates 8, 26, 28).

For Chase, as for Twachtman, the 1880s were a period of artistic reevaluation, with both artists separately abandoning the dark Munich style with which at first they had been so closely identified in the Society. Chase said that even as a student in Munich in the 1870s he had visited Paris each year and filled his room with French pictures and French periodicals. However, it was only after he had resettled in the United States and began taking yearly trips to Europe in 1881 that he became truly involved with the most advanced artistic trends to be seen in the French capital. Chase later explained that, while Munich had first led him to abandon history painting in favor of "the representation of people and things that I knew," his work, even the more realistic renderings of local street types, still affected the style of the Old Masters. According to Chase, it was the Belgian painter Alfred Stevens, a master of fashionable genre, who pointed out to him in Paris the dangers of trying to paint in an Old Master style, and Chase concluded that "modern conditions and trends of thought demand modern art for their expression."[36] As he did throughout his life, Chase absorbed influences from a variety of contemporary sources, including Stevens, Antoine Vollon, and the Italian painters Giuseppe

De Nittis, a participant in the first Impressionist exhibition of 1874, and Giovanni Boldini, who had earlier been allied with the *Macchiaioli* group of *plein air* painters in Italy. Yet among Chase's most important discoveries during this period of reexamination was the art of Manet, whose earlier intense interest in Velázquez coincided with his own. At the 1883 Society of American Artists exhibition, Chase's famous *Portrait of Dora Wheeler* (Cleveland Museum of Art), inspired by Whistler's *Portrait of the Painter's Mother* (Louvre, Paris), which had been shown there the previous year, caused a sensation, as it both displayed his new interest in Manet's current work and represented an homage to the elder American painter.

Twachtman, like Chase, grew disenchanted with the Munich style. A rare snow scene of 1879 (fig. 19), which prefigures a later fascination with this theme, stands out as an anomaly within an otherwise uniform series of paintings in which he tried unsuccessfully to adapt the dark Munich tonal values to the light-filled Venetian landscape. Some of his gloomy Venetian views from the late 1870s, in fact, seemed almost a mockery of their subject's potential for color and light, attesting to the rule of belief over experience not infrequent among artists of the period. When Twachtman moved to Paris in 1883 to become a student once more, he said disgustedly of his Munich training: "I don't know a fellow who came from Munich that knows how to draw or ever learned anything else in that place."[37] Twachtman's rejection of the dark, painterly realism of Munich (see fig. 20) in favor of a new regard for drawing seems to have developed under the influence of Whistler and echoed a similar shift made by Whistler when he regretted his own youthful interest in Courbet and affirmed the controlling rule of drawing over all else.[38] Twachtman's relationship to Whistler is not known, but the new landscape style that he developed in France in the mid-1880s, with its stress on compositional discipline, planar abstraction, and the use of broad, pale washes of color, clearly harks back to Whistler's "Nocturnes."

While the attention of many artists was diverted abroad, the Society in New York faced a series of crises. Rival exhibitions took place, as we know, and in 1882 a particularly ominous sign occurred when so many paintings were rejected from the Society's annual show that what amounted to a Salon des Refusés had to be arranged. In 1884, when no other site could be found, a decision to hold the Society exhibition on the premises of the National Academy brought the Society to the brink of collapse. Many members, feeling that it was surrendering its separate identity, withdrew in disgust, and the divided Society, unable to

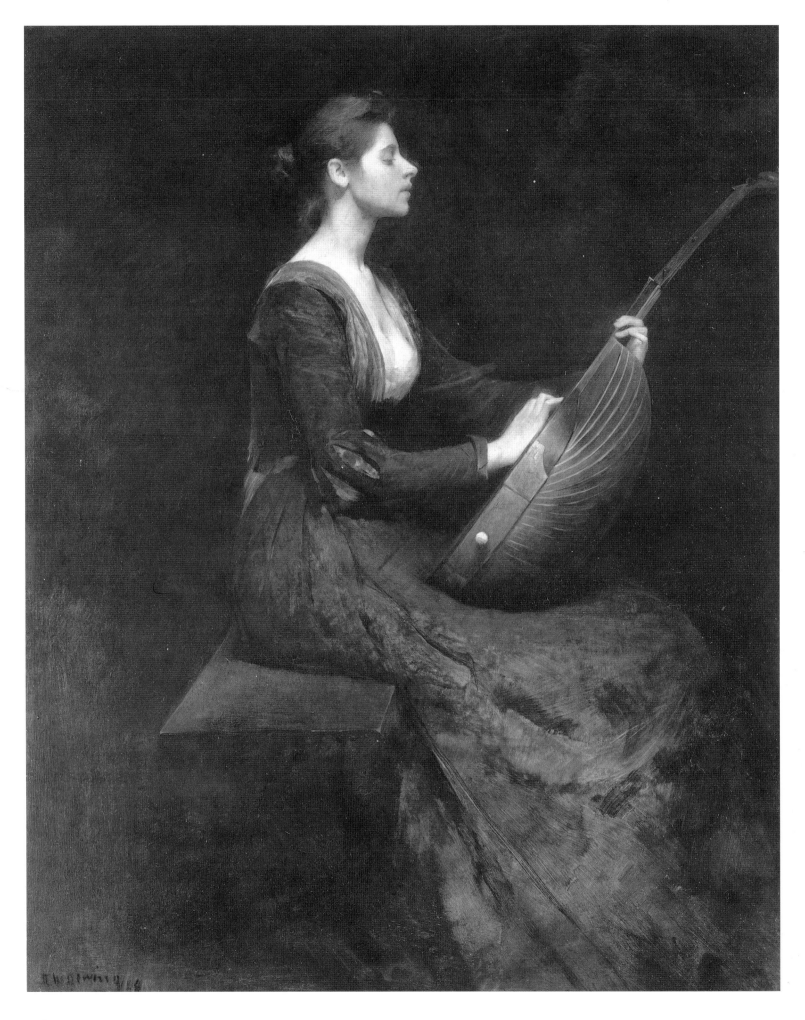

mount an exhibition the following year, was thought by many to be near its end. The original leaders, it was said, had given way to a group of managers primarily interested in promoting themselves or in enlarging and vulgarizing the organization at the expense of principle. "What a chance the young society had! What a future it appears to have thrown away!" exclaimed the *New York Times*. [39]

Twachtman wrote to Weir during this period that the Society had been "driven to the wall" by having to exhibit at the Academy and by its lack of patronage. "The U.S. is a country of fifty millions of people and in all the broad land there is not even one gallery to exhibit in. The annual country fairs, where hams are hung alongside of Corots ... can hardly be considered good art exhibitions. Why not acknowledge that society in N.Y. has no interest in the Society of American Artists and not hold any more shows. They are never patronized in any way excepting possibly the art critic who has told us that some of these men promise good. They have been promising for a long time." [40] Weir, also recognizing that the Society was "cornered," decided to exhibit at the Academy that year, if only to have the chance of selling something before everyone had spent their money. [41]

Seeing the Society thus crippled, one critic called for an end to the organization and launched into a frenzy of abuse against the "charlatanry" and "buffoonery" of the exhibitions and against the "vicious characteristics" of its most conspicuous member, Chase. "'Be huge, be reckless; show that you are above nature and refined art alike; that you are bound by no rule or propriety, and an ignorant public will sure to take you for great, and the learned are so few that it is of no use to bother one's self to work hard for them.' This is the moral of the school of Mr. Chase." [42]

At this low point, however, it was precisely Chase who was instrumental in reviving the Society, subsequent to his second appointment, in 1885, as president, an office in which he was to serve without break for the next ten years. Though it emerged from the debacle of 1884 with more stability, and though it now had an eminent leader, the adventurousness of the Society was inevitably gone. Chase strengthened the Society through a program of expanded membership and through efforts at accommodation with the rival Academy. Society members, too, were absorbed into the Academy at an increasing rate and, by 1886, a quarter of the Society's members had also become Academicians. Weir was elected associate in 1885, and full Academician in 1886, Dewing likewise in 1887 and 1888, while Walter Shirlaw and Augustus St. Gaudens, two of the Society's founders, became Academicians in 1887 and 1888 respectively. Chase was also greeted back as an Academy exhibitor in 1888, after an absence of eight years—sending, among other things, three of his most recent New York park scenes—and it was thus said that the reconciliation between the younger and older men seemed almost complete.

In the meantime, a new challenge had been presented to the Society by the growing interest in French Impressionism, imported from abroad at an expanding rate and eventually practiced by the Society's most progressive members. Several exhibitions brought important works by French Impressionists before the public as early as 1883. The Foreign Exhibition held in Boston that year received little publicity, but some of its paintings, including Manet's *Christ with Angels* (Metropolitan Museum of Art, New York), were long remembered. Tarbell, still a student at the Boston Museum School, executed several of the illustrations for the catalogue. [43]

More conspicuous was the Pedestal Fund Exhibition, which opened in New York in December 1883 to raise money for the building of the Statue of Liberty Pedestal. Chase and Beckwith were in charge of the painting exhibition, which they used to promote their cause of good modern painting. Virtually all the commercially popular European genre and history painters were purposely excluded. Assembled in their place were what one viewer contrasted as "purely artistic pictures," comprised mainly of Barbizon School paintings, but with a special place of honor reserved for the two Manets which Weir had brought back from Paris for Erwin Davis and for Edgar Degas's *Le Ballet* (Hill-Stead Museum, Farmington, Conn.), also owned by Davis. The critic John Van Dyke predicted that "all the good painting of the men who will come into notice during the next ten years will be tinged with impressionism; not, perhaps, as it has been put into words by the critics, but as it has been put into paint by Manet and a few others." [44]

Impressionism came to America in full force with the appearance in New York in 1886 of one of the largest exhibitions of French Impressionist works to have been held anywhere. Organized by the Parisian dealer Paul Durand-Ruel at the invitation of James F. Sutton, head of the privately sponsored American Art Association, the exhibition comprised nearly three hundred Impressionist works drawn

Fig. 24 Thomas Wilmer Dewing, *Lady with a Lute*, 1886.
Oil on panel, 20 x 15 in. (50.8 x 38.1 cm).
National Gallery of Art, Washington, D.C.
Gift of Dr. and Mrs. Walter Timme

from the dealer's own immense stock, including about 23 works by Degas, 17 Manets, 48 Monets, 42 Pissarros, 38 Renoirs, 3 Seurats, and 15 Sisleys, as well as works by Boudin, Forain, Guillaumin, Morisot, and Cassatt. The show opened in early April at the American Art Association Galleries on Madison Square and, after a month-long run amidst intense interest, it was relocated for another month at the National Academy, where it was supplemented by some Impressionist works already in private American hands. A catalogue appeared with essays by Théodore Duret and other sympathetic critics, while the American critic Theodore Child wrote an article on Manet to coincide with the show's opening in which he patiently explained the positive innovations of Impressionism.[45]

Somewhat confusing to audiences then, and to our own understanding of the exhibition's reputation, was the inclusion of some popular non-Impressionist works, such as J. P. Laurens's *Death of General Marceau* and Henri Lerolle's *The Organ Rehearsal* (Metropolitan Museum of Art, New York), which were displayed in the first downstair gallery at the American Art Association and formed the introduction to the exhibition. Though they served to mollify conventional taste—many thought them the only paintings worth seeing[46]—these more traditional works also served to blur the specific meaning of Impressionism. Some of the Manets, for instance, were installed in this first gallery and their painter was therefore treated by one otherwise hostile critic as belonging among the "respectable" artists. In addition, the Impressionist pictures themselves ranged widely, from early to late works of Manet, and to recent ones by Seurat, so that within the great mass of new art it was not always easy to make nice distinctions.

Durand-Ruel, his memory perhaps understandably selective, recalled the exhibition as a complete critical success. "The public and all the amateurs came," he said, "not only to laugh, but really to take account of these famous pictures which had caused so much commotion in Paris."[47] In fact, press reactions to the exhibition were extremely mixed, with some genuine enthusiasts heard among a general chorus of anger and scorn. From the fringe came the voice of religion fulminating against the "Parisian Goths and Vandals," the proponents of "Zola-ism," of "sensualism and voluptuousness," and "of sheer atheism."[48] From more usual sources there was predictable ridicule for a display of what one reviewer quaintly termed "polychromatic dissipation": the effects resembled hard-boiled eggs or a mayonaise of tomatoes. Artists not in sympathy said they could turn out several such canvases every week if they wanted. A reviewer for the *New York Times* stated that Impressionism

belonged to the category of art for art's sake, and called it an "impertinence."[49] He praised some works, but found the majority laughable, disgusting, "unnatural," and "devoid of honesty." "Is this art?" he asked. Still another said that, if Seurat's bathing scene (*Baignade*, 1883/84; National Gallery, London) were placed atop Trinity steeple and viewed from the Wall Street Ferry, it might look very well.[50]

From the other side, one of the more astute reviewers mocked the horror-struck majority camp with deliberate irony: "one is involuntarily reminded of Emerson's celebrated saying about breaking up the tiresome old roof of heaven into new forms. The tiresome old roof of our New York art exhibitions has been broken up very efficiently by the sudden appearance of this ultra-modern group of French painters in our midst. *A bas les bourgeois!* is the cry that echoes from one wall of these galleries to another, and the good bourgeois of New York art, whether professional or lay brothers, are flocking to look at the impressionists and to read their own condemnation inscribed on these monuments of revolutionary art. Communism incarnate, with the red flag and the Phrygian cap of lawless violence boldly displayed, is the art of the French impressionists."[51]

Luther Hamilton hailed the show as one of the most important artistic events ever held in America, and rightly predicted that it would have a permanent influence on the country's art.[52] Clarence Cook also found the exhibition an exhilarating break with the conventional taste for such artists as Ernest Meissonier, Jean-Léon Gérôme, and Adolphe Bouguereau. Most of the adverse criticism he characterized as being too ignorant to matter. Of the divided reactions among artists, he said: "The older men walk about in limp amazement, or with ha! ha! smiles of derision. For them the whole thing is a smart trick on the part of some mischievous young chaps…to get themselves talked about…. The younger men, while by no means unanimous in assent, are at least intelligent in their observations, and sympathetically critical. They have never been trained to hate color, nor are they always insisting on academic correctness in drawing."[53]

As some measure of the context in which the exhibition was seen, one reviewer said that audiences had been largely prepared for the exhibition by past shows of the Society of

Fig. 25 Frank W. Benson, *Summer*, 1890.
50⅛ x 40 in. (127.1 x 101.6 cm).
National Museum of American Art,
Smithsonian Institution, Washington, D. C.
Gift of John Gellatly

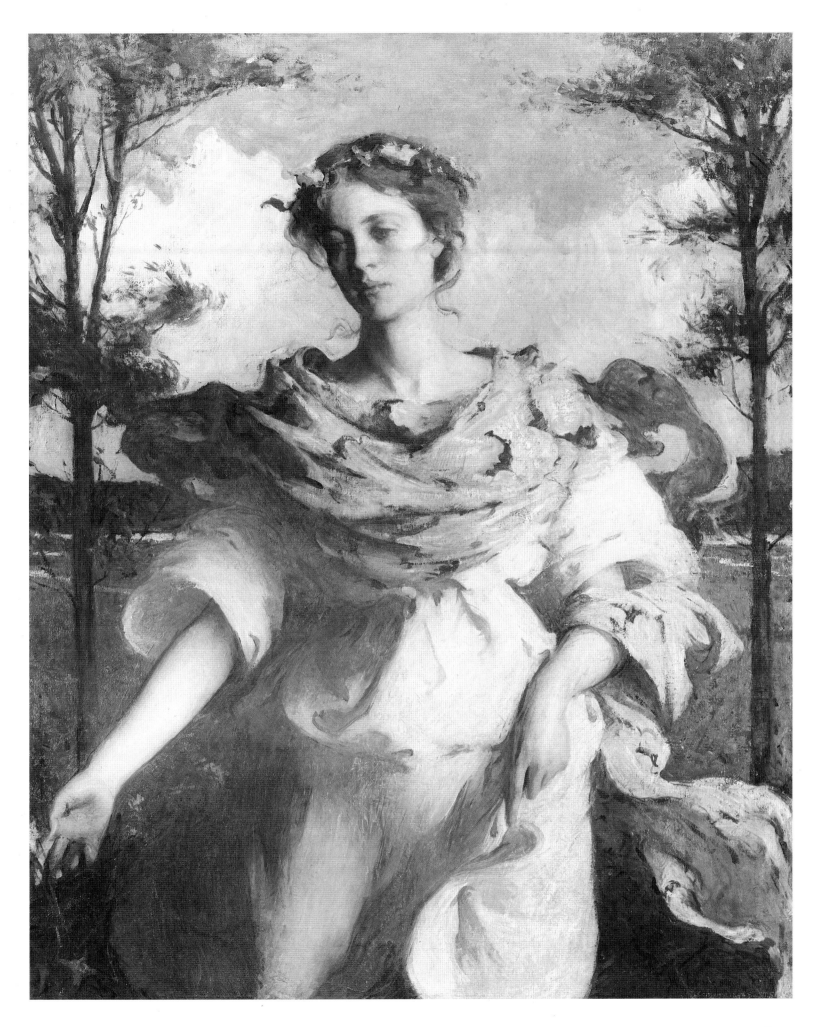

Fig. 26 National Academy of Design Building at 23rd Street and Fourth Avenue, New York, occupied by the Academy 1865–99

American Artists; while another also compared the two by saying that the Paris artists had less regard for the matter of technique than even the more "advanced" members of the Society.[54]

Encouraged by the show's reception and by sales which represented a good percentage of the value of the works displayed,[55] Durand-Ruel immediately planned another exhibition for the following winter. However, rival dealers in New York protested to the government about the special "educational" status that had allowed Durand-Ruel to defer the prevailing 30% tariff on imported works of art, so the second show was delayed until the end of May 1887, too late for the commercial season, and he was prevented in any case from selling works directly. Earlier that month Durand-Ruel had sold at auction, for modest prices, a number of French Impressionist works presumably brought over for the exhibition. The second exhibition went relatively unnoticed despite a sizable showing of Degas, Monet, Sisley, Renoir, Pissarro, Cassatt, and others. Also included

were many paintings by members of the Barbizon school, and ten works by Puvis de Chavannes, the first to be shown in America.[56]

Undaunted by this setback, Durand-Ruel set about establishing a permanent base in New York, aided by his sons. After doing business at various temporary premises, the firm eventually opened a gallery in 1894 at 389 Fifth Avenue in a building owned by their best client, H. O. Havemeyer. Durand-Ruel credited his entry into the American market with enabling him to recoup his fortunes after years of adversity in France. (Although sales of French Impressionist works in America grew steadily, he said, it was largely the sales of Barbizon and Old Master paintings that allowed him to sustain patiently support for the new school.)[57] When the Ten finally broke away from the Society, their first exhibition, in 1898, was held at the Durand-Ruel gallery and, in continuing to exhibit there until 1904, the Ten made the gallery into the principal showcase of American Impressionism.

1 Edward Strahan (pseud. Earl Shinn), "Exhibition of the Philadelphia Society of Artists," *Art Amateur* 4 (Dec. 1880), p. 5.

2 *Art Interchange* 6, no. 6 (Mar. 17, 1881), p. 56.

3 The exhibition, held at Cottier and Company Gallery, included works by Helena De Kay, Maria Oakey (the future Mrs. Dewing), Albert P. Ryder, William Morris Hunt, Helen Knowlton, Abbott H. Thayer, Francis Lathrop, and La Farge. The previous year La Farge, one of the newer Academicians, had seen all eight of his paintings rejected by a National Academy of Design jury dominated by Hudson River School followers. Although he did not openly charge the Academy with prejudice, La Farge forced it to pass a resolution affirming that it did not seek to judge or discriminate between "different Schools and methods in Art." For these and other details, see *Academy: The Academic Tradition in American Art*, exhibition catalogue, National Collection of Fine Arts, Washington, D. C., 1975, p. 73 ff.

 Also in 1875 students of the Academy school, faced with suspension of activities there, formed their own teaching association, the Art Students League. Operating informally at first, the League became allied to the Society of American Artists through formal incorporation in January 1878. Chase was its principal teacher in 1878, and was joined by Walter Shirlaw, J. S. Hartley, Frederick Dielman, and J. Carroll Beckwith.

4 Greta, "Boston Correspondence," *Art Amateur* 4 (Dec. 1880), pp. 6–7. Illustrating how European critics sought national character in American art in much the same way writers here did, Friedrich Pecht wrote of the American entries to the 1883 Munich Glaspalast exhibition: "American pictures acquaint one with everything under the sun excepting American life itself, the peculiarities of which would, naturally, interest one most Just think of the life of the pioneers in the West; of the gold-diggers, miners, trappers; of the collisions with the Indians, Mexicans, Chinese, negroes; of the maritime life of this most restless of nations. While the fiction writers, from Cooper down to Bret Harte, have already worked this rich material in all directions, and excellently well, it still remains to the painters an untouched treasure, and an American Knaus or Defregger would be sure of immortality." *Allgemeine Zeitung*, as translated in *Art Amateur* 11 (Sept. 1884), pp. 76–77.

5 *Nation* 24 (Apr. 5, 1877), p. 207 ff. See also *Nation* 24 (June 14, 1877), p. 352.

6 C. C. (Clarence Cook), "The National Academy," *New York Daily Tribune*, May 19, 1877, p. 3.

7 Archives of American Art, Diary of Jervis McEntee, Mar. 31, 1877, quoted in Lois Marie Fink, "The Innovation of Tradition in Late Nineteenth-Century American Art," *American Art Journal* 10 (Nov. 1978), p. 71.

8 "Art Politics," *New York Times*, May 21, 1877, p. 4.

9 "Protection in Art," *New York Times*, June 17, 1877, p. 6. Earlier Clarence Cook had urged the young painters to "begin afresh for themselves, and start a new exhibition, the foundation of a new academy." *New York Daily Tribune*, June 5, 1877, p. 5.

10 The original group included Cook, the sculptor Augustus St. Gaudens (who was rejected for the 1877 Academy exhibition), Walter Shirlaw, Eaton, Helena De Kay Gilder, and her husband, Richard Gilder, assistant editor at *Scribner's Magazine*. The organization originally called itself The American Art Association (see *Academy*, 1975, p. 80). Meetings were held frequently over the next months and new members actively recruited. By March 1878, when the group held its first exhibition at the Kurtz Gallery on Madison Square, there were twenty-two members, as well as exhibiting nonmembers. See "A New Academy Exhibition," *New York Times*, Oct. 16, 1877, p. 4, and "The American Art Association," *New York Times*, Oct. 30, 1877, p. 4. The officers were Shirlaw, President; St. Gaudens, Vice President; Eaton, Secretary; and Louis Comfort Tiffany, Treasurer.

11 See S. N. Carter, "First Exhibition of the American Art Association," *Art Journal* 4 (1878), p. 124, and *New York Times*, Mar. 4, 1878, p. 4.

12 "The Lessons of a Late Exhibition," *Nation* 26 (Apr. 11, 1878), p. 251. See also "The Coming Exhibition," *New York Times*, April 1, 1878, p. 5.

13 "Society of American Artists," *New York Times*, Mar. 7, 1878, p. 4; for other reviews, see "Old and Young Painters," *New York Times*, Mar. 17, 1878, p. 5, and "The American Artists," *New York Times*, Mar. 28, 1878, p. 4.

14 "A Plea for Finish in Art," *New York Times*, Mar. 17, 1878, p. 6. The choice of this "violent style," the critic added, was an expression of individuality and not merely a new method. See also "The Academy Exhibition," *New York Times*, Apr. 10, 1878, p. 2.

15 *New York Times*, Mar. 31, 1877, p. 4.

16 "Lay Art Criticism," *Art Amateur* 5 (Aug. 1881), p. 46. See also *Art Interchange* 2 (Mar. 19, 1879), p. 44.

17 "Art for Artists," *Art Amateur* 2 (Apr. 1880), p. 90. Although he did not think the Society matched its idiosyncrasy, S. N. Carter (*Art Journal*, 4 [1878], pp. 124–26), in reviewing the first Society exhibition, did invoke the example of the previous year's Grosvenor Gallery exhibition in London, where Whistler, Burne Jones, "'preraphaelites' and 'impressionists' showed us strange subjects strangely interpreted."

18 *Art Amateur* 7 (June 1882), p. 2.

19 It was reported, for instance, that the Society's aim was to "encourage art in general, not hurt the Academy—to lend a helping hand to the younger men, not offend the veterans of the guild," a position which earned them praise for "good sense and moderation." See "A New Academy Exhibition," *New York Times*, Oct. 16, 1877, p. 4, and "The American Art Association," *New York Times*, Oct. 30, 1877, p. 4.

20 After the success of the first exhibition both Boston and Philadelphia requested a showing of the Society's work. A large exhibition was sent to the Pennsylvania Academy in May 1879, but caused bitterness when the local hanging committee gave an honored position to a painting by Moran (*Bringing Home the Cattle, Coast of Florida*), whose rejection from the New York show led to the artist's resignation from the Society, while Eakins's *Gross Clinic* and other paintings shown in New York were banished to a remote gallery. Chase was among the Society members dispatched to Philadelphia to resolve the dispute.

21 Edward Strahan (pseud. Earl Shinn), "Exhibition of the Philadelphia Society of Artists," *Art Amateur* 4 (Dec. 1880), pp. 4–6; also "Works of American Artists Abroad," *Art Amateur* 6 (Dec. 1881), p. 6. This was an early example of the tension that continued to divide the colony of American artists abroad from those at home—distinguished by the French as "Paris Americans" and "American Americans." It was seen most blatantly when the jury for the Paris 1889 Exposition Universelle was felt to have favored the expatriate group in the hanging and in the award of medals, only to encounter retaliation in the medal awards at the 1893 Chicago World's Columbian Exposition. See Fink, 1978, p. 129 ff.

22 Edward Strahan (pseud. Earl Shinn), "The National Academy of Design," *Art Amateur* 1 (July 1879), p. 27; also *Art Amateur* 8 (Feb. 1883), p. 65. Referring to the current dispute over who should teach the life class at the Art Students League in 1879, Beckwith said, "Paris and Munich are at swords point." National Academy of Design, J. Carroll Beckwith diaries, Apr. 1, 1879.

23 John F. Weir to J. Alden Weir, Nov. 20, 1876, Archives of American Art, Roll # 529; quoted in Dorothy Weir Young, *The Life and Letters of J. Alden Weir*, New Haven, 1960, p. 114 ff. Though friendly with Duveneck, Weir considered his work badly drawn and fatally dependent on color. Weir was content to stick with Gérôme, "who knows no tricks." Weir to his parents, Mar. 6, 1877, Archives of American Art, Roll # 71; Young, 1960, p. 121.

24 *Art Amateur* 1 (July 1879), p. 28.

25 "The Lessons of a Late Exhibition," *Nation* 26 (Apr. 11, 1878), p. 251.

26 "Nationality in Art," *New York Times*, Nov. 28, 1878, p. 4: "Those who persist in being Americans are so shamefully neglected, if not even scorned and derided, that it requires something like heroism, to say nothing of the sacrifice of immediate . . . personal interests, to cast off the shackles of a false taste and craven subserviency to the passion for foreign art." See also "The American Artist's Complaint," *New York Times*, Oct. 24, 1878, p. 4, and "The Meaning of American Art," *New York Times*, Dec. 12, 1878, p. 4.

 Five years later the situation was unchanged: "The young men of this Society are really fighting against heavy odds. They are the best painters we have, yet they have small employment." "American Indifference to American Art," *Art Amateur* 8 (May 1883), p. 122. See also "Why No American School Exists," *Art Interchange* 2 (Apr. 16, 1879), p. 60.

 On the subject of French art and American taste, see Lois Marie Fink, *American Art at the Nineteenth-Century Paris Salons*, Washington, D.C., and Cambridge, Mass., 1990; idem, "French Art in the United States 1850–1870: Three Dealers and Collectors," *Gazette des Beaux-Arts* 92 (Sept. 1978), pp. 87–100; idem, "American Artists in France, 1850–1870," *American Art Journal* 5 (Nov. 1973), pp. 32–49; Albert Boime, "America's Purchasing Power and the Evolution of European Art in the Late Nineteenth Century," in *Saloni, Gallerie, Musei e loro influenza sullo sviluppo dell'arte dei secoli XIX e XX*, ed. Francis Haskell, Bologna, 1979, pp. 123–39.

27 E. F. B, "The Art Ideals of William Merritt Chase," *Evening Post*, Apr. 27, 1907, section 5, pp. 1–2.

28 Archives of American Art, Roll # 71, quoted in Young, 1960, p. 140. Weir's brother advised him on several occasions to stay in Europe: "To return to this country now," he said in 1877, "would be a great mistake. There is no interest in art here now—the outlook was never so discouraging. Stay over there as long as you can." John F. Weir to J. Alden Weir in Paris, Feb. 3, 1877, Archives of American Art, Roll # 529; quoted in Young, 1960, p. 118.

29 See Weir's letters of summer 1878, quoted in Young, 1960, p. 142 ff.

30 As is apparent, for instance, in the enthusiasm voiced by students at the Boston Museum School. See H. Barbara Weinberg, "Robert Reid: Academic 'Impressionist,'" *Archives of American Art Journal* 15, no. 1 (1975), p. 3 ff.

31 Weir bought these paintings from the Durand-Ruel gallery and a third directly from the artist (*Les Marsouins*; Philadelphia Museum of Art). For details, see Frances Weitzenhoffer, "First Manet Paintings to Enter an American Museum," *Gazette des Beaux-Arts* 97 (Mar. 1981), pp. 125–29; Young, 1960, p. 145 ff.; and Katherine Metcalf Roof, *The Life and Art of William Merritt Chase*, New York, 1917, pp. 94–95.

32 For remarks on Manet, see Weir's letter from Paris to his brother, Apr. 24, 1876: "I went yesterday to see the works of Manet, who has been creating a great sensation

exhibiting his refused Salon pictures, which are horrible, this is a man trying to create a new school. Another similar one is Col. Farman, who was also refused, who is a lunatic who ought to be locked up." Archives of American Art, Roll # 71. See also Weir's comments on Manet cited in Doreen Bolger Burke, *J. Alden Weir: An American Impressionist*, Newark, 1983, p. 114.

33 In her well-known reply of March 10, 1878, Cassatt thanked Weir for the invitation to exhibit and referred to the French Impressionists' own "despairing fight" to organize. "I always have a hope," she wrote, "that at some future time I shall see New York the artists [sic] ground. I think you will create an American school." See Nancy Mowll Mathews, *Cassatt and Her Circle: Selected Letters*, New York, 1984, p. 137.

34 Twachtman to Weir, Dec. 7, 1883, Archives of American Art, Roll # 125; quoted in Young, 1960, p. 164. Twachtman was particularly depressed at the time because his father-in-law, who was providing financial support, informed the artist that, unless his situation improved, he would have to return to Cincinnati, which he despised.

35 Arthur Hoeber, "American Artists and Their Art," *Woman's Home Companion* 37 (Sept. 1910), p. 50.

36 See Walter Pach, "The Import of Art (An Interview with William M. Chase)," *Outlook* 95 (June 1910), p. 443.

37 Cited in Richard J. Boyle, *John Twachtman*, New York, 1979, p. 14.

38 See Whistler's letter of 1867 to Fantin Latour, quoted in Edward Simmons, *From Seven to Seventy: Memories of a Painter and a Yankee*, New York and London, 1922, p. 133 ff.

39 *New York Times*, June 8, 1884, p. 3.

40 Twachtman to Weir, Dec. 7, 1883, Archives of American Art, Roll # 125; quoted in Young, 1960, p. 164. J. Carroll Beckwith, treasurer of the Society, wrote: "I was terribly disappointed at the look of the Gallery and the few pictures taken in. The Society is doing itself harm"; and, after remarking on the few people at the opening, noted: "Our show is going to be a failure." National Academy of Design, Beckwith diaries, May 23 and 24, 1884.

41 Letter from J. Alden Weir to John F. Weir, posted Mar. 10, 1884, Archives of American Art, Roll # 125; quoted in Young, 1960, p. 164.

42 J. M. T., "The American Artist's Exhibition," *Art Amateur* 11 (July 1884), p. 30.

43 See *Catalogue of the Art Department Foreign Exhibition*, Boston, 1883. *Art Interchange* 11, no. 6 (Sept. 13, 1883), p. 62, called the show a "private speculation of a few gentlemen" and characterized it as a sham operation. For other reviews, see *Art Amateur* 11 (Sept. 27, 1883), p. 80, and *Magazine of Art* 6 (Dec. 1883), p. xlv. For Durand-Ruel's participation, see also Frances Weitzenhoffer, *The Havemeyers: Impressionism Comes to America*, New York, 1986, p. 38.

44 "The Pedestal Fund Art Loan Exhibition," *Art Amateur* 10 (Jan. 1884), p. 41 ff.; see also John C. Van Dyke, "The Bartholdi Loan Collection," *Studio* 2, no. 49 (Dec. 1883), pp. 262–63; *Art Interchange* 11, no. 13 (Dec. 20, 1883), p. 160; *New York Times*, Dec. 24, 1883, p. 4; and *New York Daily Tribune*, Jan. 6, 1884, p. 4.

45 See *National Academy of Design: Special Exhibition—Works in Oil and Pastel by the Impressionists of Paris*, exhibition catalogue, New York, 1886, and Theodore Child, "The King of the 'Impressionists,'" *Art Amateur* 14 (Apr. 1886), pp. 101–2.

46 See, for example, "The Impressionist Exhibition at the American Art Galleries," *Art Interchange* 16, no. 9 (Apr. 24, 1886), pp. 130–31, and *Commercial Advertiser*, Apr. 10, 1886, p. 6.

47 "Mémoires de Paul Durand-Ruel," in Lionello Venturi, *Les Archives de L'Impressionisme*, Paris and New York, 1939, vol. II, pp. 216–17. This optimism was shared to a certain extent by John Rewald, *The History of Impressionism*, 4th rev. ed., New York, 1973, p. 529 ff.

48 *The Churchman*, June 12, 1886, pp. 672–73.

49 *New York Times*, Apr. 10, 1886, p. 5; see also May 28, 1886, p. 5, and "The Impressionist Exhibition at the American Art Galleries," *Art Interchange* 16, no. 9 (Apr. 24, 1886), pp. 130–31.

50 R. R. (Roger Riordan), "The Impressionist Exhibition," *Art Amateur* 14 (May 1886), p. 121. See also *Art Amateur* 15 (June 1886), pp. 2, 4.

51 "The Impressionists," *Art Age* 3 (Apr. 1886), pp. 165–66.

52 Luther Hamilton, "The Work of the Paris Impressionists in New York," *Cosmopolitan* 1 (June 1886), pp. 240–42. See also "The French Impressionists," *Critic* 5 (Apr. 17, 1886), pp. 195–96, which said, "New York has never seen a more interesting exhibition than this."

53 Clarence Cook, "The Impressionist Pictures," *Studio* 1 (Apr. 17, 1886), pp. 245–54.

54 See *New York Times*, Apr. 10, 1886, p. 5 ("The keen edge of Impressionism was taken from us years ago by the young come-outers of the Society of Artists here"), and *New York Herald*, Apr. 10, 1886, p. 2.

55 See Hans Huth, "Impressionism Comes to America," *Gazette des Beaux-Arts*, 6th series, 29 (1946), p. 244. Durand-Ruel listed as purchasers from the exhibition Albert Spencer, H. O. Havemeyer, William Fuller, George Seney (who bought Henri Lerolle's *The Organ Rehearsal* and gave it to the Metropolitan Museum of Art), Erwin Davis, Desmond Fitzgerald, Cyrus Lawrence, and James F. Sutton. See "Mémoires de Paul Durand-Ruel," in Venturi, 1939, vol. II, p. 217, and Huth, 1946, p. 245 ff.

56 See *The Durand-Ruel Collection of French Paintings*, exhibition catalogue, Moore's Art Galleries, New York, May 5 and 6, 1887; *New York Times*, May 6/7, 1887. For the exhibition, see *Art Amateur* 17 (July 1887), p. 32.

57 "Mémoires de Paul Durand-Ruel," in Venturi, 1939, vol. II, p. 214 ff.

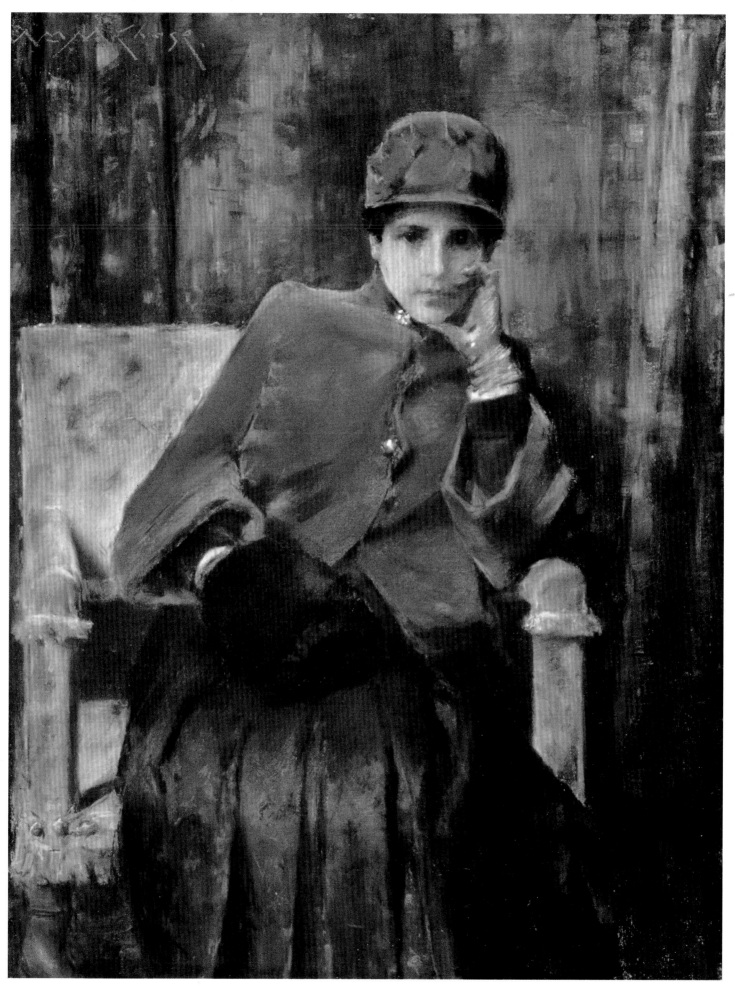

28 William Merritt Chase, *Meditation (Portrait of the Artist's Wife)*, c. 1885.
Pastel on canvas, 26½ x 20¼ in. (67.3 x 51.4 cm). Private collection

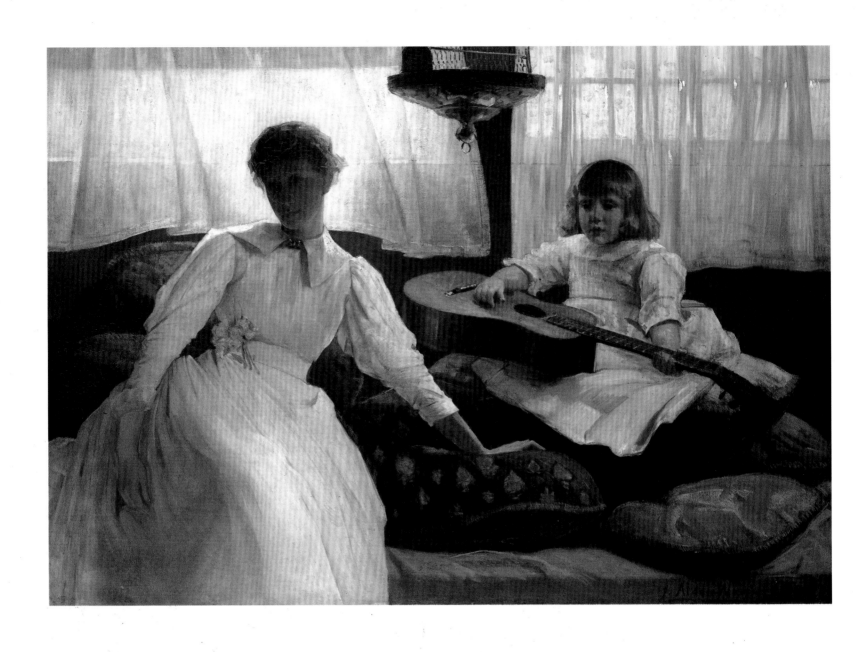

29 J. Alden Weir, *Idle Hours*, 1888.
51¼ x 71⅛ in. (130.2 x 180.7 cm).
The Metropolitan Museum of Art, New York.
Gift of Several Gentlemen, 1888

30 Edward E. Simmons, *Le Printemps*, 1883.
58 x 38 in. (147.3 x 96.5 cm).
Private collection, New York.
Courtesy of Joan Michelman, Ltd.

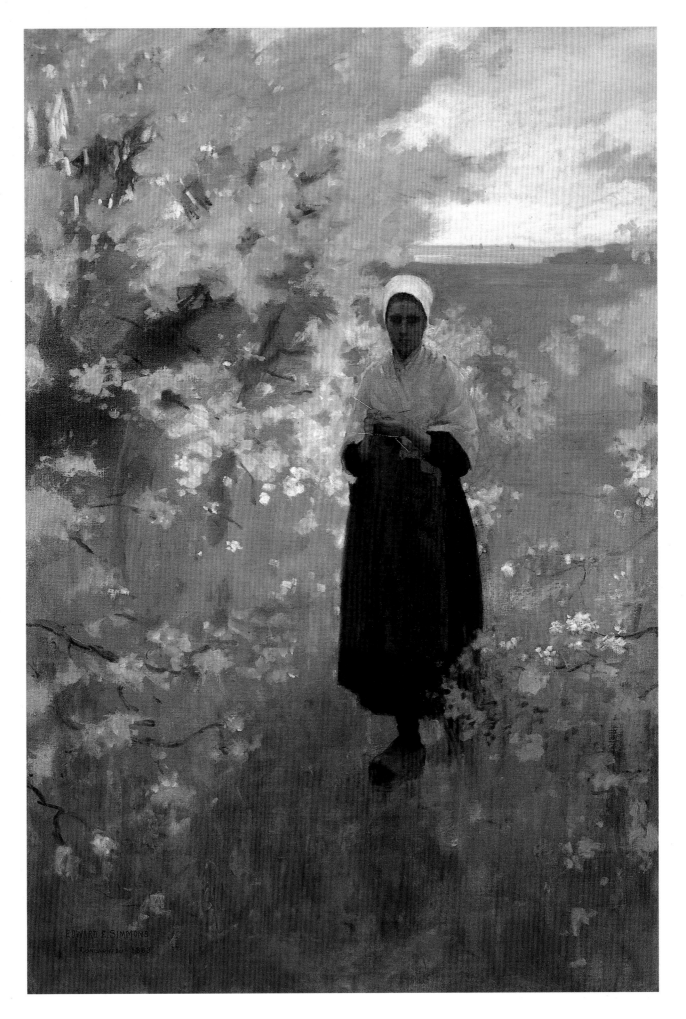

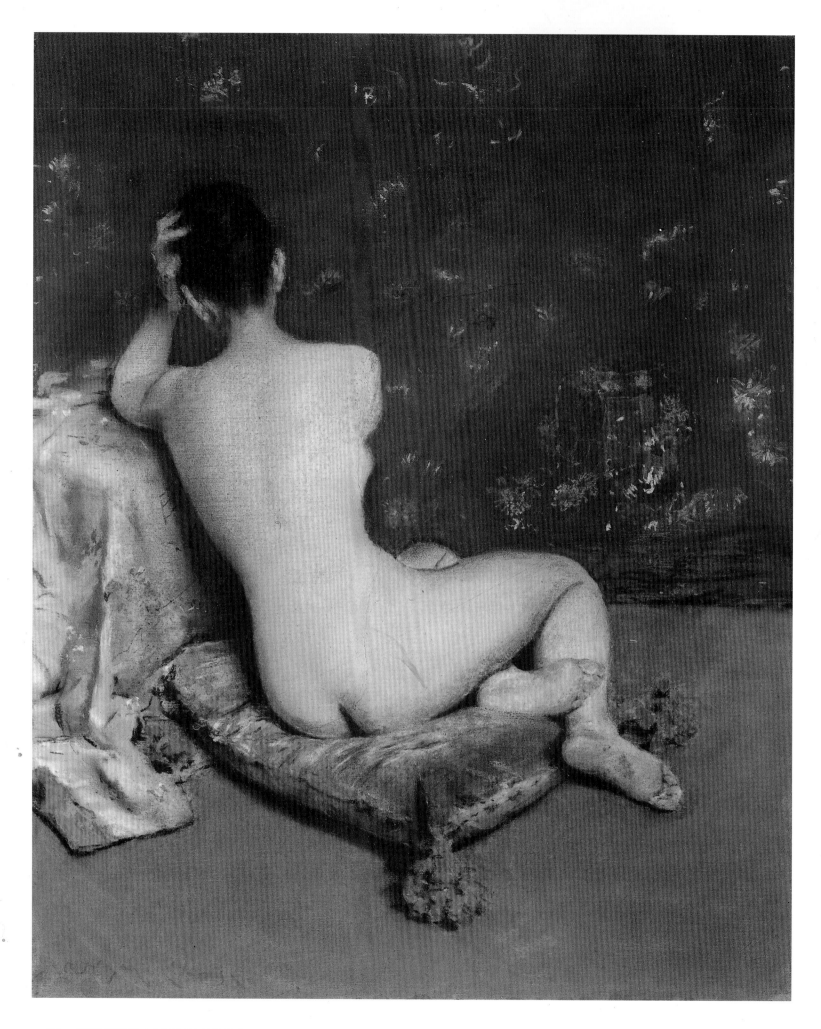

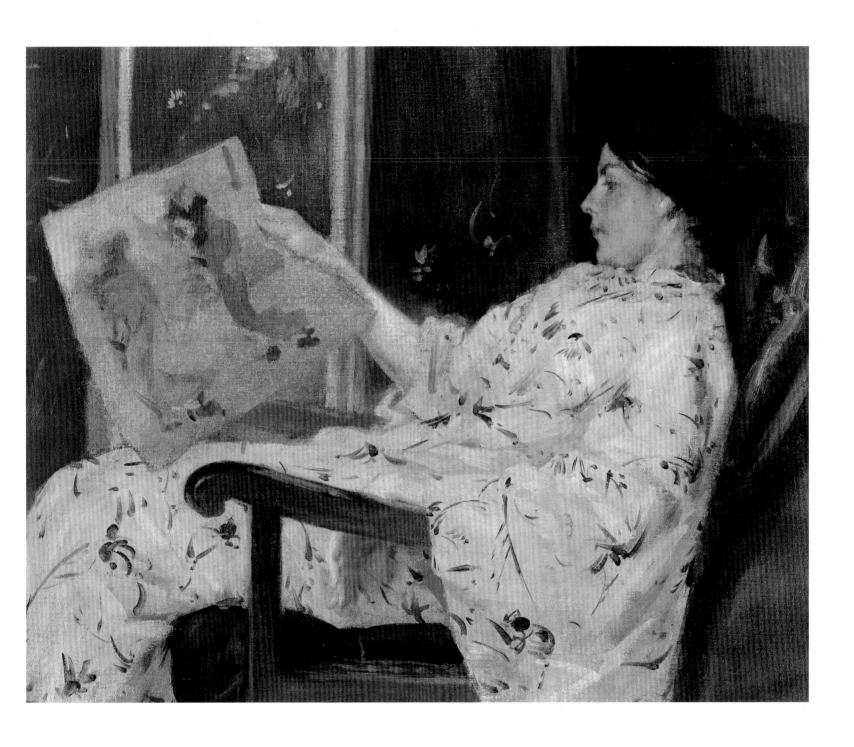

31 William Merritt Chase, *The Model*, c. 1887/88.
Pastel on paper, 20 x 16 in. (50.8 x 40.6 cm).
In the Collection of the Corcoran Gallery of Art,
Gift of Ralph Cross Johnson, 1901

32 William Merritt Chase,
The Japanese Print, c. 1888.
19⅞ x 24 in. (50.5 x 61 cm).
Neue Pinakothek, Munich

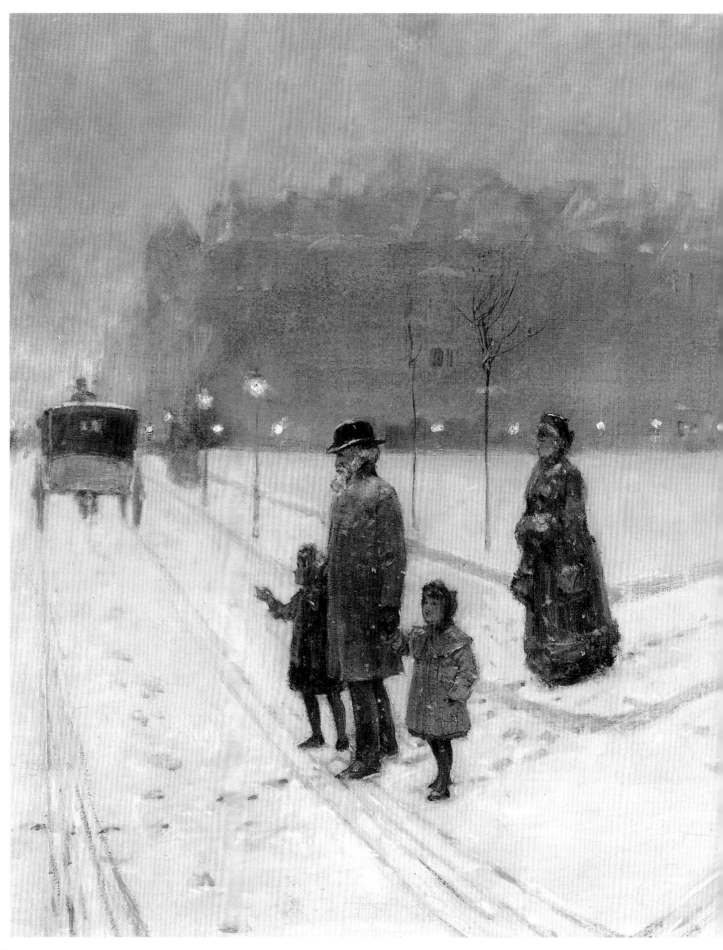

33 Childe Hassam, *A City Fairyland*, 1886. 20 x 30 in. (50.8 x 76.2 cm).
Mr. and Mrs. Samuel P. Peabody

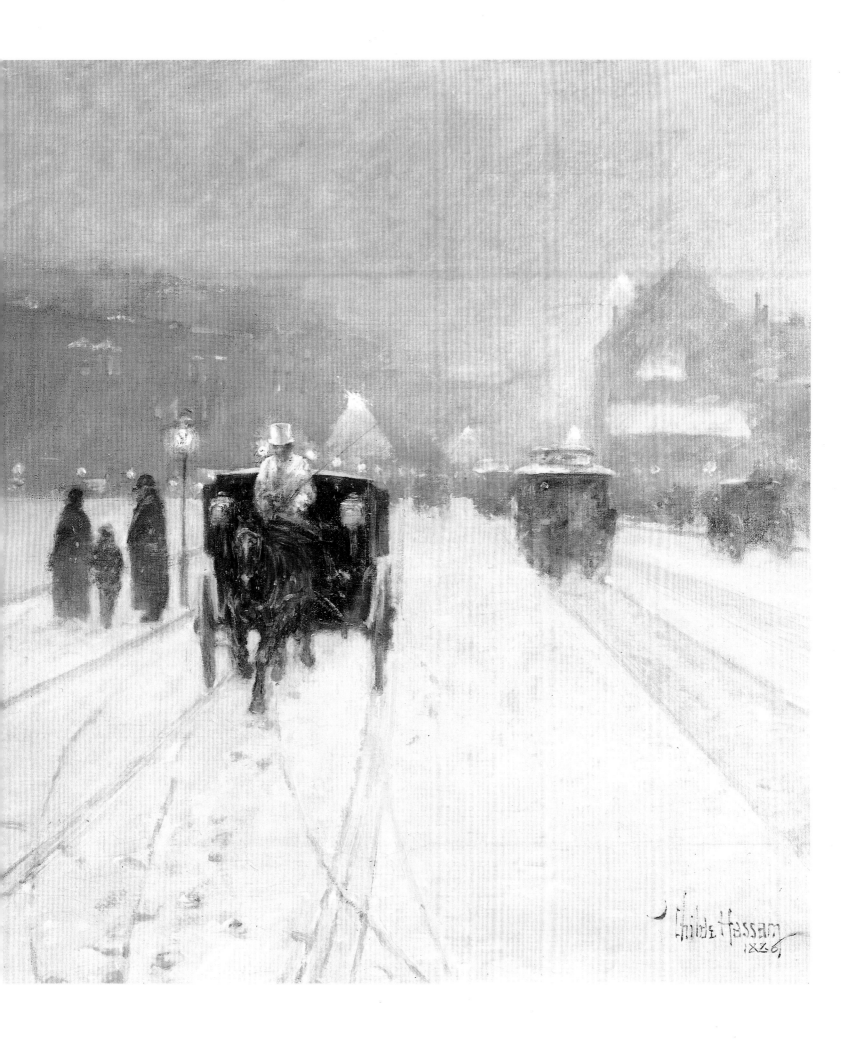

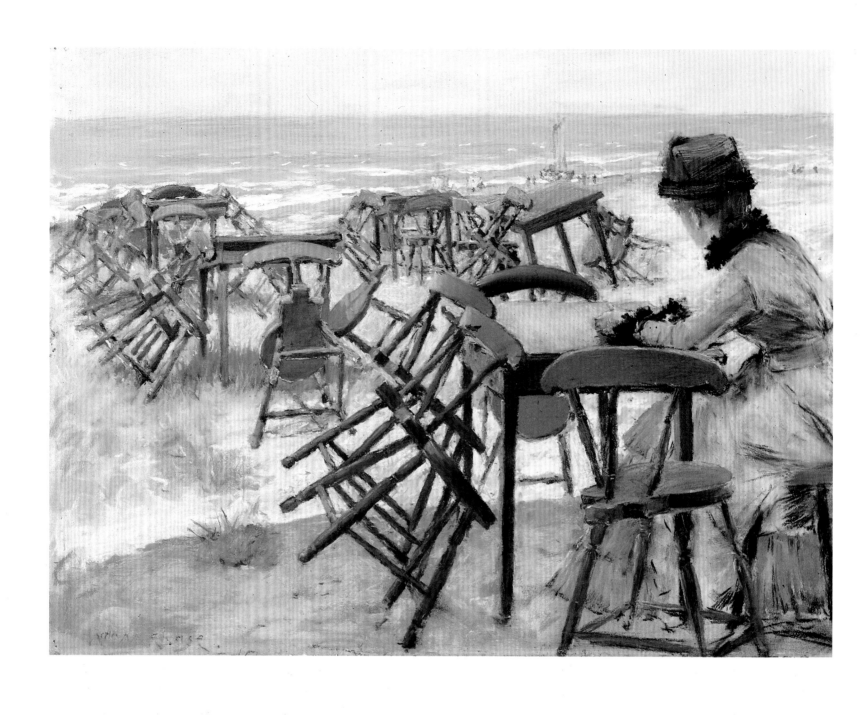

34 William Merritt Chase, *End of the Season*, 1884.
Pastel on paper, 13¾ x 17¾ in. (34.9 x 45.1 cm).
Mount Holyoke College Art Museum, South Hadley, Massachusetts

CHAPTER 3

Impressionism Comes to America

The Durand-Ruel exhibition of 1886 acted as a powerful catalyst for members of the Ten. Starting almost immediately after the exhibition, and continuing throughout the next decade, virtually all of them underwent radical changes in their styles, although the only documented reaction to the show among them was Weir's comment that, on the whole, "it was the most interesting exhibition for an artist to see that we have yet had."[1] Led in large part by members of the Ten, within a few years the Impressionist movement had spread rapidly in America. By 1893 Alfred Trumble was able to refer to a "mob of impressionists," describing in amazement how what seemed like a hopeless cause when first introduced had taken on the appearance of an irresistible tide. Cynical dealers who had once ridiculed Impressionism, he said, touted it as the coming thing.[2]

Chase was the first American painter successfully to incorporate Impressionist values, in paintings shown in his first one-man exhibition at the Boston Art Club in 1886. The exhibition caused a positive sensation among the public and young artists. Seen in New York afterwards, it was praised there as the best exhibition ever held by an American. In Boston, one reporter said, the whole town "went in full force and repeated its visits with enthusiasm, and it is unanimously voted that nothing had been seen here at all like it since [William Morris] Hunt's day. Such frank singleness of delight in cleverness, in painting as painting; such naive confession that the fun of doing it is the main thing; such happy unconsciousness that art had any ulterior objects, any moral mission or historical function."[3] In addition to some of his outdoor scenes painted in Holland, the exhibition included "a number of exquisite little studies of land and water about New York, Coney Island, Long Island and the Lower Bay."[4]

Although Chase had begun to paint outdoors in Holland during the preceding years (see plate 34), and had seen Impressionist work in France, it was only in 1886, about the time of the Durand-Ruel exhibition, that he became fully committed to *plein air* painting in the Impressionist manner, beginning a brilliant series of small paintings of the parks and waterways of New York (see plates 2, 36, 38, 41). These marked a departure from his long habit of studio invention. He began to roam the city with portable equipment of his own design, and painted on the spot. He preferred not to use an umbrella, he said, because "I want all the light I can get." He described this approach as "the only way rightly to interpret nature You must be right out under the sky. You must try to match your colors as nearly as you can to those you see before you, and you must study the effects of light and shade on nature's own hues and tints."[5] Thus, Chase shifted from creating his subjects to finding them, and viewed his artistic role as more that of an interpreter than that of an impresario. The landscapes painted by Chase during summers at Shinnecock Hills, Long Island, where he directed a school between 1891 and 1902, mark the height of his ambitions as a painter of light and air (see fig. 6 and plate 49). The subjects of his park scenes and Shinnecock landscapes reside simply in their sense of place and the moods and sensations they generate, mixing brilliantly the permanent with the essence of a passing moment. His skill in evoking specific conditions of light and atmosphere is often astonishing.

It was Chase's technique of minutely scrutinizing conditions of light and atmosphere that brought him closest to French Impressionism, an approach, considered by many critics to be "realistic," in which values and colors of light were painted absolutely, not relatively, in an analytical and

even scientific manner. Chase's teachings also established his close affinities to the Impressionists. He advised students not to meddle with outdoor pictures after they had been brought back to the studio, and affirmed his preference for "single-sitting impressions" to record momentary and fleeting effects. "Nature rarely repeats herself . . . and one does not always find oneself in the same state of mind," he declared.[6] Like Twachtman, he advised students to observe people in public places. He praised Mary Cassatt and called Claude Monet a "great artist," saying of the Impressionists in 1890: "I don't believe ever in the history of art was open-air, light and air, attempted or done as well as it is today."[7] Yet Chase always went out of his way to avoid the dogma to which French Impressionist painters supposedly adhered in regard to method and color theory. He advised students to use black, or bitumen, if they liked, and to appreciate relative color values rather than making absolute judgments based on whether a painting was dark or light.[8] Though he held that pure Impressionism was "more scientific than artistic," he still admired the style greatly, believing it to be the only really new thing produced in the nineteenth century.[9] As a result of his free, independent interpretation of Impressionism, however, Chase was warned in 1891 that he was "in annual danger of being classed by the young impatient impressionists among the old fogies, because he does not see things in gamboge and purple."[10] He exemplified, it was said, someone who could profit from Impressionism without being overwhelmed by it.[11]

Twachtman returned home from Europe a few months before the 1886 Impressionist exhibition and, over the next several years, he once more changed direction, abandoning the delicate landscape style he had developed in France and turning fully toward Impressionism. Twachtman's mature Impressionist period is associated with his residence at Round Hill, near Greenwich, Connecticut, on a farm with thirteen acres located not far from a property which his friend Weir had acquired in 1882. Twachtman came to the area first as a tenant, possibly as early as 1886, and bought his permanent property only in 1890/91. This is an especially important landmark for Twachtman, because the natural and added features of the property—its house, the gardens, the new bridge built over Horse Neck Brook, with its waterfall (see figs. 27, 28), and Hemlock Pool—many of which are still recognizable today, provided virtually all the artist's subject matter throughout his largely undated series of mature Impressionist paintings (see plates 15, 52, 55, 56).

Twachtman's involvement with Impressionism coincided with his association with the painter Theodore Robinson, whom he had known in France, although he did not adopt the particulars of Robinson's style. Robinson was among a group of Americans—including Metcalf—who about this time established a small colony at Giverny, where Monet resided. Robinson had a uniquely close relationship to Monet and frequented his household. Twachtman and Weir became Robinson's closest friends during his stay at Giverny. After he returned to America in 1892 Robinson paid weekend visits to Twachtman's house in Greenwich, taking part in long discussions involving art, and dined regularly on Sundays with the Weir family; he often spent the Thanksgiving and Christmas holidays as the guest of one or the other.

Twachtman's mature Impressionist paintings represent a highly personal transformation of principles suggested simultaneously by James McNeill Whistler and, through and apart from him, by Japanese art and by Monet. From Whistler Twachtman derived both a sense of restraint and subtlety in the handling of a limited tonal range; from Monet, although he never adopted his use of broken color, came the fascination with sunlight and its use as a focus for exploring the natural world. Twachtman's art was intensely subjective and self-absorbed, his response to nature essentially poetic and concerned with intangible values. In recognizing this, his friend Harrison Morris once referred to his work as "fragile dreams in color." Objects always remained for Twachtman a point of departure, never the goal of that analytical study which conventional Impressionism was often thought to represent.

The challenge he set himself was full of risk and ambivalence, the outcome, one suspects, often unforseeable even to the artist and, as a result, his paintings were not always successful. When someone once observed to him that he seemed to lead an ideal life, sheltered in the country with his painting, he replied: "You don't know what it is to spend your life trying to do something that you can't."[12]

Twachtman's early career in Munich had given him the habit of working aggressively with pigment and, under the spell of Impressionism, he developed a new fascination with the material properties of paint, something that reflected his more general interest in the relationship between physical matter and the means of representing it. His technique became tremendously varied and experimental, as he improvised in his search for new effects. Instead of receding in the process of representation, pigment always remained a palpable presence, every inch of surface an abstract, independent field. Bits of objects, unrecognizable in themselves, became deep and fascinating essays.

Twachtman followed Whistler's dictum that the artist must obliterate the signs of effort, often laboring over his

Figs. 27/28 "Horse Neck Falls" (left) and "Horse Neck Brook" on John Twatchman's farm at Round Hill, Connecticut, 1905. Photographs by Henry Troth

canvases endlessly, reworking them, scraping them down, reusing them. Particularly in his less successful works one sees open signs of a struggle with a reluctant and unyielding medium, of an almost physical attack on the canvas that contrasts strikingly with the delicate finesse of his triumphs. Indeed, the variety of Twachtman's painterly effects was considerable, ranging from delicate passages, displaying a touch similar to that of Whistler or Jean Baptiste Camille Corot, to broad contours stroked with a wide brush, from smooth, matte surfaces reminiscent of the glazes of a Rookwood vase to slashes of paint that form ridged surfaces and the buildup in relief of a thick impasto in which at times the subject becomes almost entirely submerged.

Twachtman often intentionally stressed his pictures, exposing them to sun and rain to flatten the effect and relieve the pigment of superfluous oil, a practice that recalls the questions of wide concern to Impressionist artists and critics as to whether paintings ought to be varnished at all and as to what effect the passage of time would have in mellowing the brilliant colors. Chase even speculated on the possibility

that our view of the Impressionists might change once time had muted their canvases.

Twachtman's move to Connecticut, in close proximity to Weir, resulted in a deepening professional relationship between the two artists, with Twachtman taking the initiative, most obviously, perhaps, by interesting Weir in his new-found passion for pastel. They held an exhibition together at the Fifth Avenue Galleries in New York in February 1889, and the successful sale that followed, combined with a permanent teaching job at the Art Students League, enabled Twachtman to acquire his property at Round Hill and find a measure of personal stability. Weir had already done the same. His marriage in 1883 to Anna Dwight Baker brought him into the orbit of a prosperous family and, though he continued to struggle professionally, he was able with their support to buy a townhouse in New York to complement his existing country residence at Branchville, Connecticut, and, with sales rising, to live in exceptional, though not extravagant, comfort by the standards of most of his colleagues.

Weir's development through the 1880s was more even, its results less controversial, than that of either Twachtman or Chase. He remained essentially a studio painter, confining himself to still lifes in muted color schemes and of great elegance, to portraits, and to intimate figured interiors. The most advanced of the latter, the large composition *Idle Hours* (plate 29), depicting his wife and daughter, shows at once the limits of this style, with its careful modeling of forms and balanced structure, and the artist's quickened interest in effects of natural light and in subjects drawn from his immediate surroundings. Though hardly shocking by later standards, Weir's preference for rich textures of paint, his willingness to generalize form rather than render minute detail, and the ostensibly themeless nature of his figure paintings, placed him in the progressive camp. Not yet an Impressionist, Weir was nonetheless described at the time of his exhibition with Twachtman as one of the new breed of artists who were well known and admired among professionals, but who defied public taste.[13]

Not long after this Weir underwent a truly dramatic transformation. In the spring of 1889 his infant boy, J. Alden, Jr., died, to be followed a few months later by Weir's beloved father. Seeking a change, he decided to travel, and spent June to October in England and Paris. The following year Weir began a radical shift toward the Impressionist style (see fig. 5 and plates 4, 7). Ironically, he was among the few Americans who had seen works by Impressionists directly during one of the group's early appearances, having visited the third Impressionist exhibition in Paris in the spring of 1877. As a dutiful student of Jean-Léon Gérôme at the Ecole des Beaux-Arts, Weir, however, had been appalled by the exhibition, calling it a "Chamber of Horrors," and was angered for days over the money he had wasted on admission.[14]

Undoubtedly inspired by Twachtman's restless example, perhaps also by Robinson and by Hassam, who arrived in New York at this time, and relieved from parental constraint by the death of his artist-father, whom he had always been anxious to please, Weir began in 1890 to concentrate on landscape for the first time, working a great deal outdoors, even in winter, with the help of a portable studio, fitted with a stove and with windows on four sides, that could be moved about his farm. There could be no doubt as to the ultimate stimulus for this new departure. J. Carroll Beckwith, visiting Weir's farm in the fall of 1890, found Twachtman also staying there, and said of the two artists, "they are daft on Monet."[15]

By 1891, on the occasion of his first one-man exhibition at the Blakeslee Galleries in New York, Weir was recognized

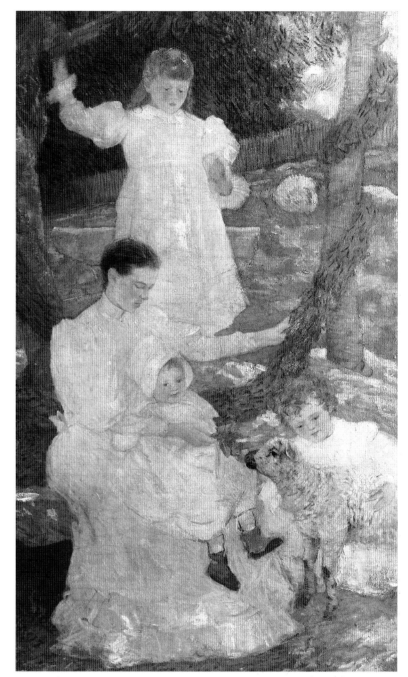

Fig. 29 J. Alden Weir, *In The Dooryard*, c. 1894. 80⅛ x 47⅛ in. (203.5 x 119.7 cm). Private collection

as having "gone over to the apostles of plein air impressionism."[16] Because of his inherited respectability in the artistic community, his acceptance of Impressionism lent real credibility to the movement in the eyes of some critics,[17] but many close to him considered it a recipe for disaster. One distressed friend pleaded with him to give up his "peculiar pictures", which he knew would ruin any chance of sales.[18] His brother John said that he had "thrown up reputation, success, all that *professionally* most people strive for" in exchange for "ridicule and harsh criticism." Weir conceded as much, but replied: "My eyes, I feel, have been opened to a big truth I was trying to see through the

eyes of greater men so that I was hampered by trying to render the things I did not see and unable to get at the things that really existed when one feels as strongly as I did the false position I was in, it is probable he may fly to an extreme [but] I know that when you read this and appreciate how earnest I am, you will be cheered to think that it is not a fad or a wild fancy."[19]

Weir and Twachtman remained linked publicly as leaders of the Impressionist movement in New York, and in 1893 the two of them showed their work at the American Art Association alongside paintings by Monet and Paul Albert Besnard, in an exhibition designed to underscore the relationships among similarly oriented American and French artists.[20] Later that year Weir and Twachtman again exhibited their works together, at the St. Botolph Club in Boston.

Hassam, unlike some of the older members of the Ten, felt instinctively from the beginning that contemporary life was his true subject. "The man who will go down to posterity," he said, "is the man who paints his own time and the scenes of every-day life around him."[21] Hassam described painting his first street scene from a window while living on Columbus Avenue, Boston, in the early 1880s. A visit to Europe in the summer of 1883 may have already acquainted him with the views of city life made fashionable by such artists as James Jacques Tissot, Giuseppe De Nittis, and Jean Beraud, which his early works in Boston, despite their looser, painterly technique, most closely resemble (see plate 33). Yet in early 1885 his work was also linked to the "radical," bright style introduced to Boston by William Lamb Picknell, which was considered the most advanced form of *plein air* realism.[22] Hassam's ultimate conversion to Impressionism took place during a three-year stay in Paris from 1886 to 1889, which began conventionally enough with his decision to study at the Académie Julian. His first paintings in Paris, including *Autumn* and *The Terrace* (private collection), were ambitious Salon-oriented works, but in 1887 Hassam painted *Grand Prix Day* (plate 37), which was his first major work to utilize the themes and sunlit palette of the Impressionists.[23]

It is a striking fact that Hassam's conversion to Impressionism occurred precisely at the moment when Metcalf, an old acquaintance from Boston, was painting in Giverny, close to Monet himself. Metcalf seems to have visited Giverny as early as 1885, which would have made him the first of the large group of American artists that followed, and he was certainly painting there in the spring and summer of 1886, possibly in the company of Theodore Wendel and Robinson. The next year these artists were joined by John Leslie Breck, Theodore Earl Butler, and Louis Ritter,

and, after some of their pictures had reached Boston that year, the pseudonymous critic Greta said that these painters had "all got the blue-green color of Monet's impressionism and 'got it bad.'"[24]

At Giverny Metcalf enjoyed a working relationship with Robinson very much like that he later had with Hassam; they painted in close proximity to each other at the same sites and often worked on intimately related views of the same scene. They even shared a studio after returning to Paris in the winter of 1887. Metcalf repeated his visit to Giverny in 1888, finally returning to Boston in December of that year. Although still tied to the muted coloring of the Barbizon school, Metcalf lightened his palette and adopted looser brushwork at Giverny and, when he returned to Boston, was regarded by critics with mixed approval as one of the company of more progressive, if as yet still unresolved, young painters.

Hassam returned to the United States in 1889, settling permanently in New York where, as he recounted later, Weir and Twachtman were among his earliest friends. He became a frequent visitor both of Weir's farm at Branchville and of the Twachtmans at Round Hill. Hassam soon established the habit, which he followed for most of his career, of painting in the summers in the coastal towns of New England and New York, including Cos Cob, Gloucester, the Isles of Shoals (see fig. 7 and plates 3, 45), and East Hampton, Long Island, while spending winters in New York at work on city views and studio pieces. In the early 1890s the island of Appledore, among the Isles of Shoals off the New Hampshire coast, proved his favorite summer resort, and it was there that Hassam executed his most spectacular and famous series of flowered land- and seascapes (see plate 45). Yet his foremost passion during these years lay in the spectacle of life on the fashionable avenues and squares of New York (see figs. 3, 4 and plates 10, 11). "There is nothing so interesting to me as people . . . observing them in every-day life, as they hurry through the streets on business or saunter down the promenade on pleasure. Humanity in motion is a continual study to me."[25]

Hassam was constantly in the streets, searching out useful motifs and actually painting there. To capture street-level scenes he often painted from a hansom cab, looking out the window and using the small seat in front of him as an easel for his panel or canvas. For a wider, elevated view he placed himself in some second-story window. Often he wandered with a pencil and sketchbook, and described "making notes of characteristic attitudes and movements . . . to observe night effects carefully, I stand out in the street with my little sketchbook, draw figures and shadows, and note down in

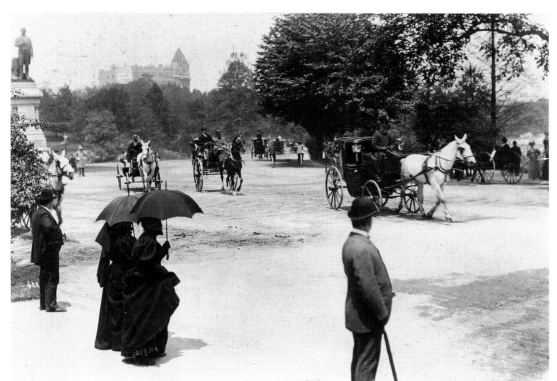

Fig. 30 Carriages on The Drive, Central Park,
New York, 1895

Fig. 31 Hansom Cabs at Fifth Avenue and
Madison Square, New York, c. 1901

colored crayons the tones seen in the sky, in the snow, in the reflections or in a gas lamp shining through the haze."

Hassam's emphasis on transiency and the "poetry" of his city scenes underscored the special qualities he believed inherent in the genuine artist as opposed to the illustrator. "The scientific draughtsman who works long and patiently may learn to draw correctly from a model . . . but it takes an artist to catch the spirit, life, I might say poetry, of figures in motion." He painted the busy streets, he said, not to provide a record, but because "I believe them to be aesthetic and fitting subjects for pictures." He aimed for a unified image, based on spontaneity, that called upon the artist's power to select and compose from the chaos of experience. His pictures were selectively arranged from the groups and individuals that passed by over time: "I do not always find the streets interesting, so I wait until I see picturesque groups and those that compose well in relation to the whole." Referring to a view of Madison Square he was working on at the time, he stated: "Of course all those people and horses and vehicles didn't arrange themselves and stand still in those groupings for my benefit. I had to catch them, bit by bit, as they flitted past Sometimes I stop painting a tree or building to sketch a figure or group that interests me, and which must be caught on the instant or it is gone. Suppose that I am painting the top of the bank building here, and a vehicle drives down to the left-hand corner, just where it seems to me a good place to have something of this sort; perhaps the driver gets down and throws himself into some characteristic attitude; I immediately . . . catch that group or

single object as quickly as I can . . . where you are painting life in motion, you cannot lay down any rule as to where to begin or where to end."[26]

Hassam declared that the true artist should see things frankly, and without the artifice or distortions derived from older schools and studio habit. He was unapologetic about his Impressionist viewpoint and palette and, if those belonging to what he termed the "molasses and bitumen school" thought his canvases too blue, he answered that he liked "air that is breathable." He scorned the idea of painting a wealth of unobservable detail such as made the city views of Beraud read like a descriptive text. He continued:

Good art is, first of all, true. If you looked down the street and saw at one glance a moving throng of people, say fifty or one hundred feet away, it would not be true that you would see the details of their features or dress. Any one who paints a scene of that sort, and gives you such details, is not painting from the impression he gets on the spot, but from pre-conceived ideas he has formed from sketching studio models and figures near at hand. Such a man is an analyst, not an artist. Art, to me, is the interpretation of the impression which nature makes upon the eye and brain. The word "impression" as applied to art has been abused, and in the general acceptance of the term has become perverted. It really means the only truth because it means going straight to nature for inspiration, and not allowing tradition to dictate to your brush, or to put brown, green or some other colored spectacles between you and nature as it really exists. The true impressionism is realism.[27]

Hassam was, and remained, the most faithful interpreter of Impressionism according to French standards and,

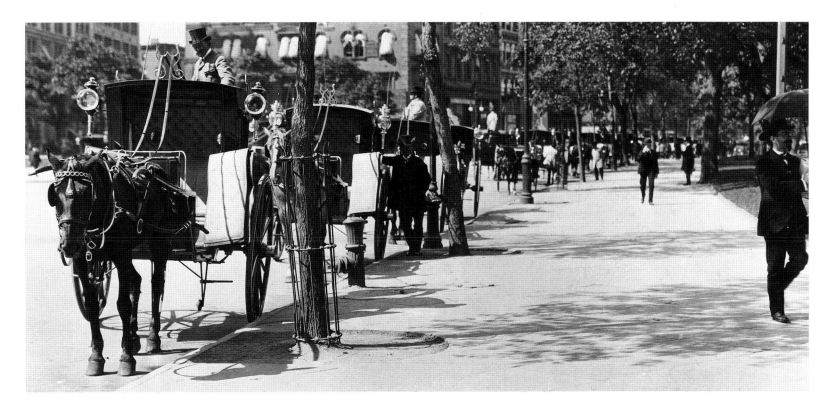

despite his later protestations to the contrary, absorbed a great deal directly from the examples of Monet, Camille Pissarro, and Alfred Sisley. His belief that the Impressionist method encompassed a blend of realism and personal sentiment was shared by most other American artists. Critics tended to look upon Impressionism as an inherently realistic style, because of its analytical, even scientific approach to vision,[28] and blamed it for being impersonal, whereas in actuality the American painters strove to temper its realistic aims by asserting the need for a more subjective, interpretive approach. Robinson, like Hassam, was careful to separate the objective component of Impressionism from the realism of the "note-taker" or "photographer," while stressing the style's interpretive possibilities.[29] Like other American painters accused of being mere imitators of the French, and resenting the charge that Impressionism itself followed a kind of formula or recipe—a notion much stimulated by the emergence of Georges Seurat and the "Neo-Impressionists" after 1886[30]— Robinson resolved, after departing for good from Giverny in 1892, to develop a new variant of Impressionism which he described as something "American and virile" and which, in his view, must reaffirm the role of drawing and modeling.[31]

The challenge of reconciling the traditional virtues of drawing with the dramatically new possibilities of rendering bright light and atmosphere seem especially to have guided Reid's approach to Impressionism, whose impact was such as to split his artistic personality into two seemingly equal halves. Reid's earliest known Impressionist work, a small, casual composition of 1890 titled *Reverie* (plate 40), shows a remarkable ease in dealing with a new style of light and color that until recently had been foreign to him. Like that of many of his contemporaries, Reid's early career through the 1880s was devoted to a Salon-oriented genre style which, in his individual case, was based on an unusual skill in draftsmanship and classical composition. Since Reid's development is still poorly understood, we do not know what personal circumstances may have first led him to Impressionism at the time other colleagues and former classmates from Boston were also thus engaged. From the sketchlike spontaneity of his *Reverie* Reid soon moved to recover the importance of drawn form and the dignity of traditional subject matter, placing them alongside his newfound passion for atmosphere and bright color. In the 1890s Reid painted in a variety of modes, all of which underscored his inherently decorative approach, both in terms of the treatment of his paintings as well as their purpose. Even his concern for light and color was directed less toward objectivity than toward decorative possibilities. His subjects centered mainly on women posed outdoors, sometimes clothed in contemporary dress (see fig. 38 and plates 27, 39), sometimes in classical costume, and in the mid- to later 1890s he painted a series of nymphlike nudes whose only tie to reality lay in their coy eroticism. Related in general character to the more subdued decorative style of Dewing, Reid's canvases often display their figures in a shallow, stagelike setting surrounded by bright patterns of flowers and foliage; in some cases they assume an iconlike presence.

Reid's decorative style and his longing for monumentality undoubtedly relate to his involvement with mural painting, which began when he and other members of the Ten— Weir and Simmons—were given the opportunity to test their new styles of painting as well as their allegiance to Impressionism in mural projects commissioned for the World's Columbian Exposition of 1893. Twachtman also was offered a commission, but refused. The project for decorating the Exposition buildings was directed by Frank Millet, a painter of traditional historical genre who remained friendly with John Singer Sargent and other progressive artists. Part of the decorative program was to find an outlet for modern styles in a traditional art form such as mural painting. Not only were Weir, Reid, and Twachtman invited, all three unmistakably associated with the Impressionist movement, but from Paris even Mary Cassatt was enlisted to execute a mural for the Woman's Building on the theme of "Modern Woman." Cassatt said she chose the central subject of her mural, young women plucking the fruits of Knowledge and Science, to allow the figures to be set outdoors and to allow brilliancy of color, describing how she "tried to make the general effect as bright, as gay, as amusing as possible."[32] Cassatt's personal quest for modernity echoed a widespread, though ultimately futile, aspiration to "modernize" traditional art forms that became something of a *leitmotif* for the vast number of interior decorative

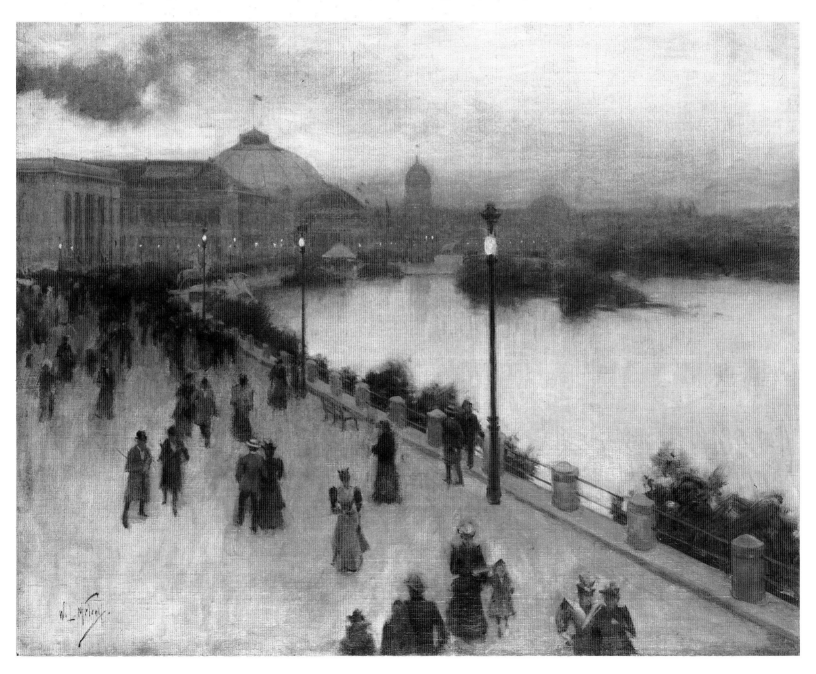

Fig. 32 Willard Metcalf, *Sunset Hour on the West Lagoon, World's Columbian Exposition of 1893*, 1893.
19½ x 24⅛ in. (49.5 x 61.3 cm). Chicago Historical Society, Chicago

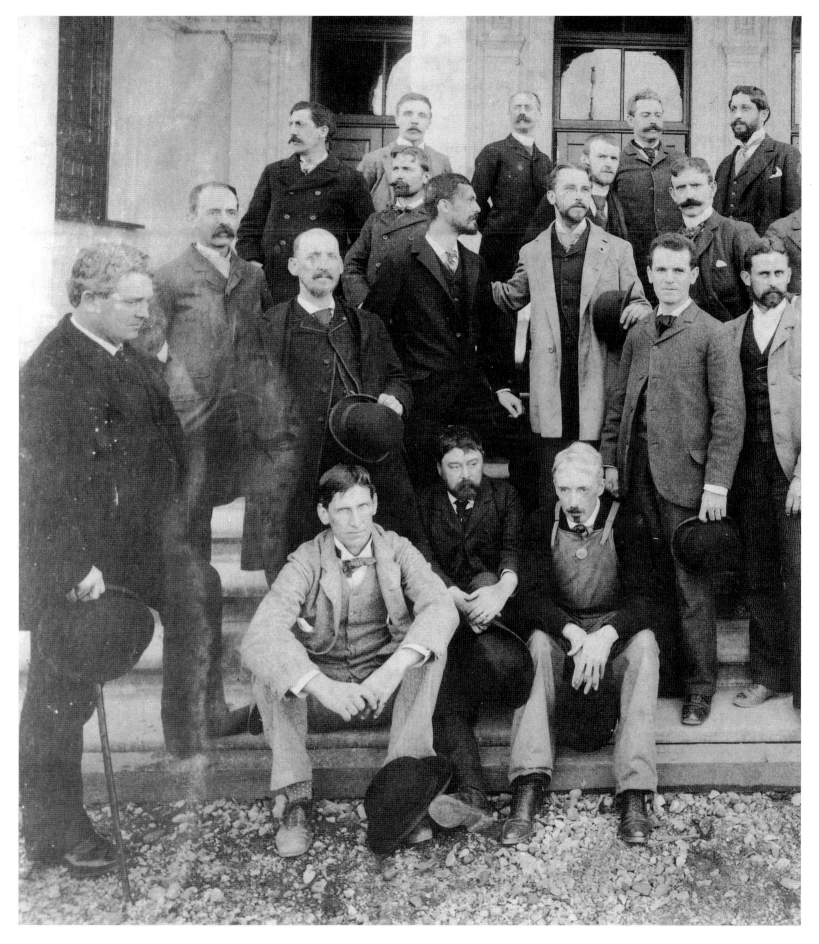

Fig. 33 Artists at the World's Columbian Exposition, Chicago, 1893 (detail). Standing at far left is J. Alden Weir; seated to the right, in light suit, is Edward E. Simmons and, across from him, in light coveralls, J. Carroll Beckwith; in the back row, furthest right, is Robert Reid. Other artists include the sculptor Daniel Chester French (standing behind Weir); next to him, painter George Maynard; and, in the back row, third from left, painter Edwin Blashfield

projects commissioned after the Exposition, ranging from murals for grand government buildings, such as the Library of Congress in Washington, D. C., to ceiling and wall panels in hotels, cafés, and even ocean liners. Though he continued to paint easel pictures, Reid was one of the artists who took part in this movement and, incongruous as it may sound, he was credited a year after the Exposition (1894) with introducing the first "Impressionist" painting into an American public building: a monumental altarpiece representing *The Martyrdom of St. Paul* for a church in New York which combined modern effects of sunlight and open air with a traditional religious theme.[33]

For Weir the Columbian Exposition project proved a passing episode, but Simmons was to remain primarily a muralist thereafter. He said, "my career as a painter was entirely changed at Chicago ... [it] gave me a taste of the joys of decorative painting Painting pictures to be hung on the wall by strings, generally badly placed or in the wrong light, was not satisfactory But given a certain space to beautify, a space one knew about beforehand (the light, height, and color of the wall), and where one was reasonably sure his work would remain permanently—that was worth doing."[34] Simmons's neglect of easel painting endured until late in his career, with the result that his membership in the Ten exhibitions became a question almost of moral backing rather than of active support. In concentrating on mural work Simmons could remove himself from the challenge and potentially disturbing vagaries of Impressionism, just as in 1886 he had abandoned France entirely to seek isolation in the small, then still unknown fishing town of St. Ives on the Cornish coast of England (see fig. 43).

At the same moment in the late 1880s that New York was stirred by the arrival of Impressionism, the Boston members of the Ten—Tarbell, Benson, and De Camp—with the support of forward-looking collectors and writers, such as Desmond Fitzgerald, were helping to transform Boston into America's second great center of the Impressionist movement. Fitzgerald, who even beyond Boston personally knew many of the American painters, including Twachtman and Hassam, and who helped through his writings to popularize the work of Monet, described how, when he first called attention to the French artist's work in the 1880s, "he was hooted at as a crazy admirer of a crazy movement."[35] The local critic William Howe Downes confirmed both this shocking interest and the opposition to it when he wrote in 1888 that there were already extremists in Boston who openly admired what he called "those mad outlaws, the Impressionists!"[36]

By the spring of 1891, however, when the J. Eastman Chase Gallery held a show of paintings by Monet, Sisley, and Pissarro borrowed from Durand-Ruel, it was said that collecting Impressionist paintings had become the fashion in Boston, abetted by painters, such as J. Foxcroft Cole and Frank Porter Vinton, Sargent's good friend, who at the time was delivering public lectures on the new style. Young local painters, "Bostonian disciples of Monet, or Manet," had themselves been in evidence the last year or two.[37] Thousands visited the exhibition of Monet's paintings held at the St. Botolph Club in 1892, in which almost all the works were loaned by local collectors, and further Monet exhibitions were repeated with success in 1895 and 1899.

When Tarbell returned to Boston from France in 1886 he attracted immediate notice with several full-length female portraits that reminded critics favorably of the sweep and casualness of Sargent's work. That year he also made his debut at the Society of American Artists in New York and, on the occasion of their 1888 exhibition, was hailed as a "brilliant performer" for his portrait of a lady in a black dress.[38] Tarbell may, in fact, have come to Impressionism through contact with Sargent, whose reputation and influence in Boston was immense and who, through his friendship with Monet, had adopted Impressionist methods in his painting after 1885. His enthusiasm for the style was said to be infectious[39] and may have been apparent during his first visit to Boston in 1887/88, though it was only during a subsequent visit, in 1890, that his Impressionist-inspired canvases were publicly exhibited. Tarbell's earliest essay into Impressionism dates from the same year, as evidenced by his painting *In a Garden* (plate 42), which was shown at the St. Botolph Club in the winter of 1890. Bold and novel, the picture combines careful draftsmanship with broken color, a clear, bright light predominating over dissolved surfaces which are, nevertheless, circumscribed by carefully drawn outlines. This personal balance between the rendering of bright light and color and the controlling influence of drawing again demonstrates how American artists accepted Impressionism on their own terms.

In 1889 Tarbell was appointed a teacher at the Boston Museum School alongside Benson, and the two artists became co-directors of the school the next year. In 1891 they exhibited together at the St. Botolph Club. As with Tarbell, New York juries responded favorably to Benson from the start. His painting *In Summer* (private collection), preserved only in a fragmentary state, attracted much attention at the 1887 Society exhibition but, significantly, it was at the more conservative National Academy that he first became a prize winner. In 1889 he won the Academy's Hallgarten prize for

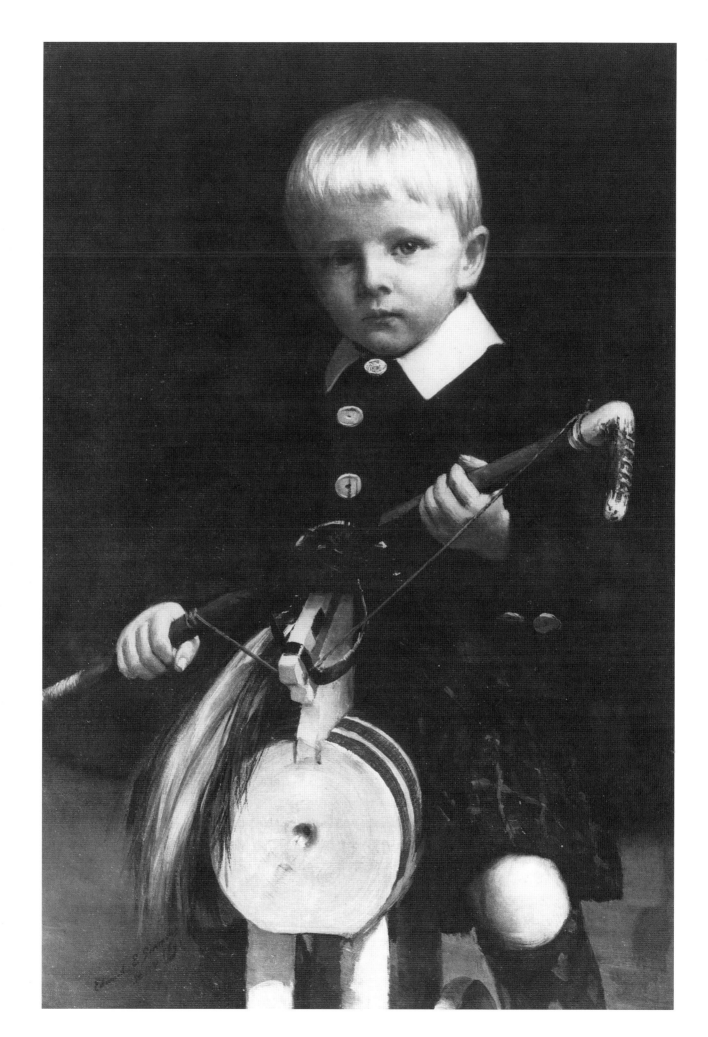

Fig. 34
Edward E. Simmons,
*Young Boy Riding a
Toy Horse*, 1890.
29½ x 19¾ in.
(74.9 x 50.2 cm).
Private collection,
Connecticut

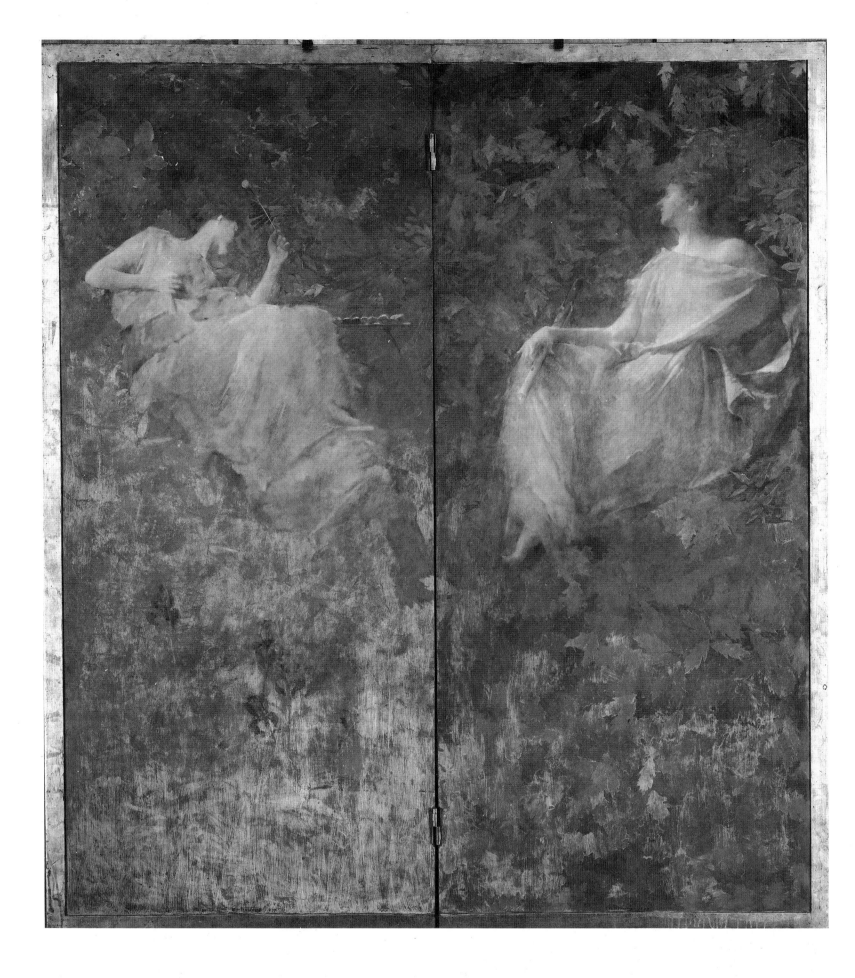

Fig. 35 Thomas Wilmer Dewing, *The Sound of Falling Water and The Hermit Thrush*, 1897. Folding screen, oil on panel, 69¼ x 60¼ in. (175.9 x 153 cm).
Freer Gallery of Art, Washington, D.C. (06.73)

his painting *Orpheus* (now lost) and, in 1891, the Clarke prize for *Twilight* (also lost), a work typical of his interest in the early 1890s in interior scenes illuminated by the rosy glow of lamp- or firelight, generally conservative subjects overlaid by the loose, more advanced techniques of handling paint. Although none of this work truly qualified him as an Impressionist, he was classed among the Impressionists by critics, such as Hamlin Garland, who considered his interest in light and color to be Impressionist.[40]

In a manner parallel to, but more restrained than, Tarbell, Benson underwent a conversion of his own in the early 1890s that liberated him from the constraints of traditional representation and convinced him that "design"—referring to underlying abstract compositional patterns—was the key element in painting. "Picture making has become to me merely the arrangement of design within the frame. It has nothing to do with the painting of objects or the representation of nature." Benson said that this realization "transformed everything." "I grew up with a generation of art students who believed it was actually immoral to depart in any way from nature when you were painting. It was not till after I was 30 and had been working seriously for more than

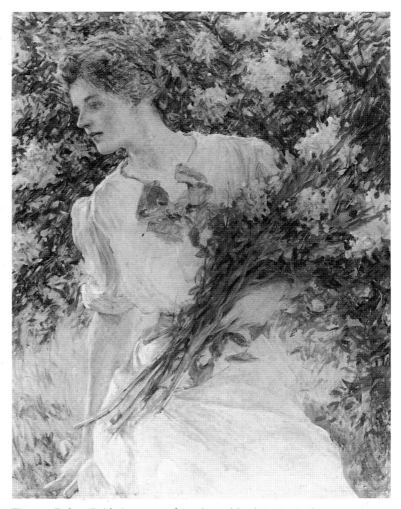

Fig. 37 Robert Reid, *Summer*, n. d. 33⅞ x 25⅞ in. (86 x 65.7 cm). Sheldon Memorial Art Gallery, University of Nebraska, Lincoln, Bequest of Mr. and Mrs. F. M. Hall 1928. H–74

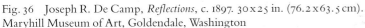

Fig. 36 Joseph R. De Camp, *Reflections*, c. 1897. 30 x 25 in. (76.2 x 63.5 cm). Maryhill Museum of Art, Goldendale, Washington

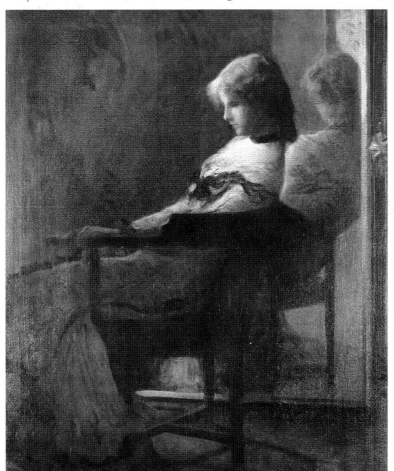

ten years that it came to me, the idea that the design was what mattered. It seemed like an inspiration from heaven. I gave up the stupid canvas I was working on and sent the model home. Some men never discover this . . . design is the ONLY thing that matters."[41] Some of Benson's works in the 1890s, such as *My Little Girl* (1895, private collection), emphasize through their sharp silhouettes a stylish, curvilinear patterning that reflects the artist's new sense of control and abstract order.

Although a painter in Boston since 1884, De Camp did not come to prominence until a decade later, with a showing in 1894 of five works at the St. Botolph Club. Thereafter he was regarded, along with Tarbell, Benson, Wendel, Lilla Cabot Perry, and others, as among the dominant group of Boston Impressionist artists.[42] De Camp's interest in Impressionism was doubtless influenced by the arrival in Boston of those of the Giverny colony who, like himself, were Ohioans formerly connected with the Duveneck circle—Ritter, Breck, and especially Wendel, with whom De Camp maintained a close personal relationship. Bright, boldly col-

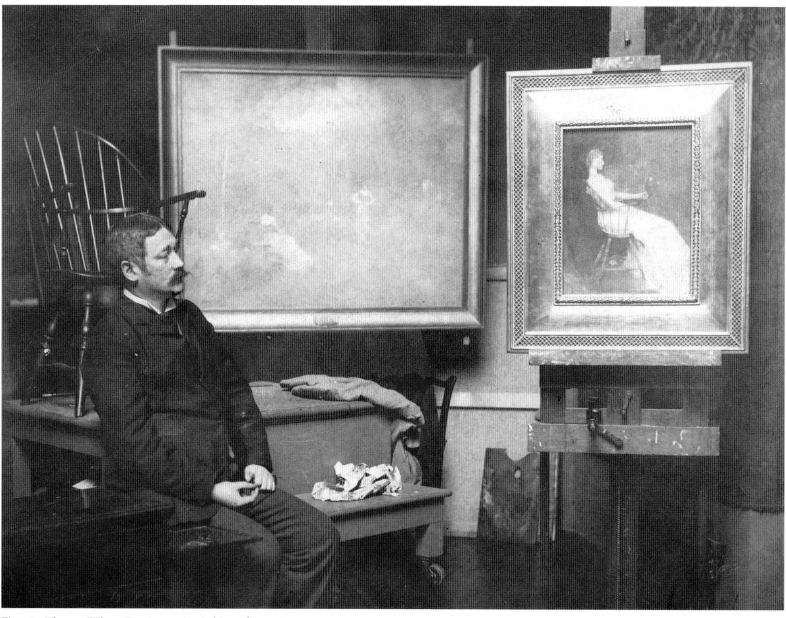

Fig. 38 Thomas Wilmer Dewing posing in his studio, c. 1893

ored compositions painted during this period, such as *The Hammock* (c. 1895; plate 44) and *The Pear Orchard* (c. 1895; plate 19), demonstrate De Camp's interest in the contemporary subjects and colors of Impressionism and, in the case of the latter painting, a possible debt to Cassatt, close as it is in style and theme to her mural for the Chicago World's Columbian Exposition and related compositions. Unfortunately, our knowledge of De Camp's activity at this time is severely limited by the fact that a studio fire in 1904 destroyed most of his early production, a loss that, according to family tradition, included several hundred paintings and was particularly regrettable as it involved work from his most experimental periods.

Whether or not De Camp had the chance to see Cassatt's work at the Exposition is not known. Benson and Tarbell

spent a good amount of time there in connection with a Museum School exhibition they were installing and were able to study not only the recent American experiments, but also a number of the most important French Impressionist works then owned by such famous American collectors as Mrs. Potter Palmer, H. O. Havemeyer, Alfred Corning Clark, John G. Johnson, and Mrs. John L. Gardner. Impressionism was hardly predominant at the Exposition, however, as Tarbell described in an interview: he was revolted, he said, by the official French section, which was dominated by the reigning academic masters, whom he remembered admiring as a student only a few years before. The American section, he believed, completely overshadowed the French, and he particularly admired Whistler, who showed five paintings there. Yet the prize of the exhibition for Tarbell

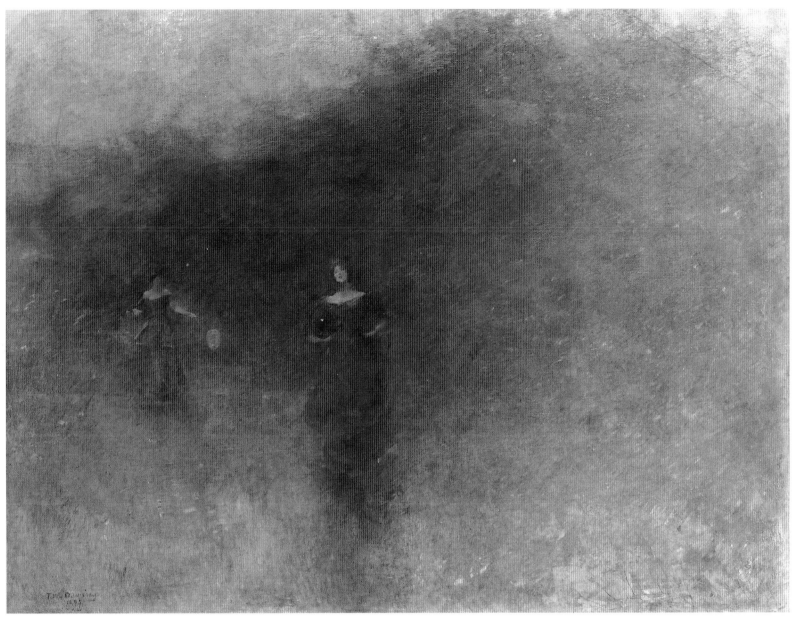

Fig. 39 Thomas Wilmer Dewing, *Before Sunrise*, 1895. 42⅛ x 54¼ in. (107 x 137.8 cm). Freer Gallery of Art, Washington, D.C. (94.22)

Fig. 40 Exedra in the Dewings' garden at Cornish, New Hampshire, with the artist's wife, Maria Oakey Dewing (left), and socialite Annie Lazarus, Dewing's reputed mistress, c. 1892. Photo courtesy Elizabeth E. Gunter

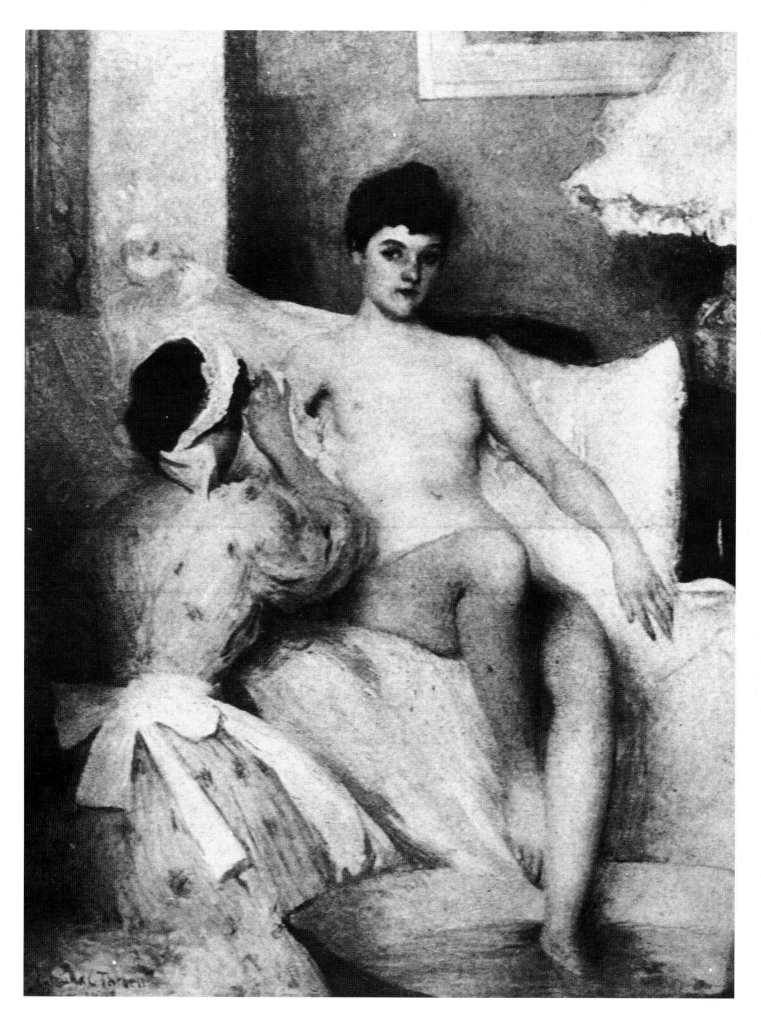

was Degas's painting *The Dancing Lesson* (*The Dance Class*, 1881; Philadelphia Museum of Art), loaned by Alexander J. Cassatt.[43]

Tarbell himself was by now fairly well known and created a great stir at the Exposition with his painting *In the Orchard* (plate 46), painted in 1891. More than fifteen years afterwards the critic Frederick Coburn remembered seeing the painting and marveling that anyone in America could do such work. "I recall vividly a feeling of admiration for a man who had the audacity thus to paint conventional society without artistic conventions. No one in Washington, in the early nineties, was making masterpieces of groups of up-to-date young persons arrayed in white duck. No one at that time, I suspect, had the technical equipment to do so."[44]

Tarbell shocked audiences even more with his painting of a nude in a contemporary context titled *The Bath* (fig. 41), which was exhibited at the Society of American Artists earlier in 1893 and awarded the Society's Shaw prize for figure painting. More circumspect critics objected to its lack of idealism or cited it as an example of the personal egotism characteristic of Impressionist pictures, in which "spiritual insight" was replaced by "an attempt at photographing nature."[45] Others more openly deplored its sensuality, one critic suggesting that, since it was not the custom here for a young lady to be bathed by her maid, the subject must be "the direct opposite of a lady, a conclusion borne out by her vacant face and sensual forms."[46] Not overlooking its French sources in Degas and, more distantly, in Edouard Manet's *Olympia*, the *New York Daily Tribune* called it "a shining example of the disgusting vulgarity with which the French school has infected some of the art of America."[47] Although unusual in its suggestion of contemporary narrative, Tarbell's *The Bath* was only one of a host of nude studies displayed at the Society in this and subsequent years by Reid, De Camp, Chase, and others which were all similarly deplored.

In the late 1880s, at exactly the moment when many other artists were turning to *plein air* work, Dewing also shifted his attention to landscape painting, albeit in a unique form that, surpassed only by Simmons's work, basically disregarded Impressionist principles. As a pupil of the Paris academies, Dewing had until then focused on his exceptional skills as a figural draftsman (see fig. 24), but around 1889/90 he began to develop a new type of painting in which

groups of women were depicted in spacious outdoor settings (see fig. 39 and plates 20, 43). These paintings seem to reflect both the physical and intellectual surroundings of his life at Cornish, New Hampshire, where, as a summer resident since 1885, Dewing had been instrumental in establishing the famous art colony in which ideas of aestheticism or "art for art's sake" were self-consciously and aggressively promoted in nearly all matters of life, from garden design and dinner parties to masques, *tableaux vivants*, and amateur Greek theatricals. It is not inconceivable that the women in Dewing's pictures might actually have lounged in Greek exedrae or strolled the meadows of Cornish in fancy costume—whether painting or actuality, it was all part of the same dream-laden world.

Among Dewing's neighbors at Cornish was the architect Stanford White, who designed many frames for Dewing's paintings and secured for him—as he did also for Simmons, Reid, and Metcalf—a number of decorative commissions for buildings that he had designed or refurbished. A friend and patron to many of the Ten, White, prosperous and well connected, was the driving force behind much of the social and artistic life in which they were involved and which had its informal New York headquarters at the social club known as the Players. White helped Twachtman remodel his farmhouse at Round Hill and assisted in countless other ways, including loans (to Chase) and direct financial support of his artist-friends.

Dewing had no interest in that objective investigation of color and light common to one degree or another among the Impressionists. Quite contrary to the Impressionists' concerns with immediate reality and the problems of light, Dewing discovered his metier in a world of classical themes infused with idealism and romance. One suspects that somewhere in the background specific literary texts may exist for a painting such as *The Song* (plate 43) and others like it, just as Emerson's poems had provided Dewing with inspiration for some of his earlier works. The strong dichotomy between the two figures in *The Song* suggests at least the idea of dual moods, the standing figure abandoned to pleasure, while the other, bowed and somber, wrings her hands in a gesture of angst-ridden tension worthy of one of the great Italian Mannerist painters.

The subjects of many Dewing paintings involved intangible feelings or perceptions and, as implied by such titles as *The Sound of Falling Water and The Hermit Thrush* (fig. 35), *The Recitation*, and *The Song*, center specifically on musical sounds and other aural themes. Like Whistler and artists of the Aesthetic Movement in England, Dewing used color in a manner that contemporaries found analagous to music.

Fig. 41 Edmund C. Tarbell, *The Bath*, 1893.
Location unknown

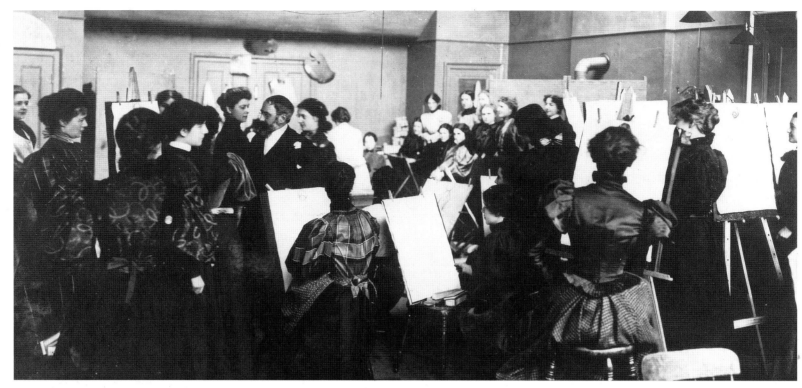

Fig. 42 William Merritt Chase in the Women's Life Class, Chase School of Art, New York, 1897

Speaking of Whistler, one critic described his color as the vehicle of pure emotion, while form, on the other hand, was the conveyor of ideas: "What music does by the ear, color does by the eye," he said. An arrangement of color without reference to form, however beautiful, can possess "only a sensuous and inarticulate beauty, comparable to that of a piece of pure music."[48] Numerous references to this musical analogy were made by Dewing's critics and friends. In 1908 Charles Caffin said of Dewing: "In the building up of his color theme and in its elaboration he works like a musician to a symphonic scheme; and the harmony of his pictures, so rhythmic, vibrating, and melodious, affects one in the way of stringed music."[49] Dewing himself distinguished between the specially evocative nature of these "musical" works and his interior studies, which he thought could be more easily understood for their technical excellence alone. In deciding against exhibiting his outdoor scenes at the Pan American Exposition in 1901, he explained: "They are above the heads of the public ... [they] belong to the poetic & imaginative world where a few choice spirits live."[50]

With this series of paintings Dewing attracted a group of devoted admirers which included the well-known collectors William Evans, John Gellatly—who eventually bought seventeen of his pictures—and, most importantly, Charles Lang Freer who, from the time he met Dewing in 1890 until his death thirty years later, was to remain the artist's most ardent patron and financial supporter. Thanks to their surviving correspondence we are probably better informed about Dewing than about any other member of the Ten.

Dewing's admirers in the 1890s, though small in number, were described as "much above the average in point of cultivation" and as sufficient to ensure the sale of everything he produced, even while still on the easel.[51] Despite this, the few paintings he was able to finish were not enough to support him. Dewing labored over his canvases compulsively, and he liked to remind people that he often destroyed work that did not satisfy him, once telling Freer: "I have destroyed the picture you saw entirely now, and am beginning on a new panel. When this picture gets finished if it ever does, it will have been a d—d fast mile. You perhaps begin to account for the number of wrecks and demi semi good and finished canvasses [sic] around my studio. Each one represents the hard labor of weeks. I always think of them as bringing something in a sale after my demise."[52] The touch of melodrama in this last remark points up Dewing's frequently troubled state of mind, often expressed in self-pity or resentment. While physically a very large man, he seems to have been emotionally fragile, perennially ill at ease both with himself and in the company of others. Although some found him a gentle and soulful personality, others confirmed his reputation for ruthless wit and sarcasm and frequent unpleasantness.[53]

Despite his elite clientele, Dewing's mood grew bleak over the lack of public appreciation of his work and over the state of his finances. At the beginning of 1894 he implored Freer to send him money: "I am reduced to my last cent," he said, "and I don't dare to run up bills as I see no way of paying them."[54] Freer obliged, but Dewing was forced to give up his New York apartment and move to his house in Cornish. Although committed to a rarified form of art, Dewing longed for fame and presumed that, if Americans were too ignorant to appreciate him, he might succeed in Europe. To stay in America now, he declared, seemed "quixotic," convinced as he was that he owed it to those who believed in him to test his reputation in Europe.[55] "I am willing to compete with Whistler and Sargent," he conceded rather grandly, "if I lose I will bow."[56] As if to underscore his decision, Dewing mentioned only a month later that his most recent painting at the Society exhibition was "the best single figure I have done and it is either ignored or faintly abused."[57]

With money advanced from Freer, Dewing sailed for England in the fall of 1894, expecting to be gone two years. Disappointment was to follow. The paintings he took with him to exhibit were apparently accorded no great reception. In November Freer introduced him to Whistler and, from December to March, he worked on and off in Whistler's company, benefitting, he said, from "no end of advice" from the master.[58] Moving to Paris in April 1895, Dewing showed his *After Sunset* (Freer Gallery of Art, Washington,

Fig. 43 Edward E. Simmons, *Bay of St. Ives at Evening*, 1888. 50 x 60 in. (127 x 152.4 cm).
Mr. and Mrs. Hardwick Simmons

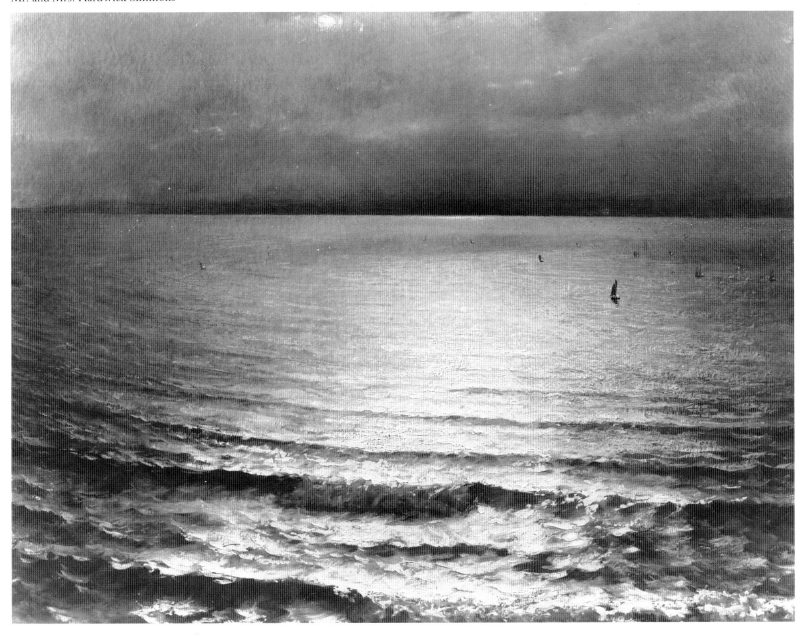

D. C.) at the Salon Champs de Mars, but saw it "skied." Several days a week were spent commuting to Giverny—then full of Americans—with his studio neighbor Frederick MacMonnies, but he seemed unfazed by contact with the Giverny Impressionists. After less than a year abroad Dewing grew homesick and, having apparently spent too much money, was left "faced with a precarious existence of hanging on there or coming home and earning a living."[59] He abruptly returned to America in July 1895, having shed illusions of success in Europe. "I am d—d glad to get back again," he declared. "I will never again leave."[60]

Dewing came back to find, as we have seen, an increasingly divisive situation developing at the Society and a general climate of opinion that worked against the Impressionists and other independent progressive artists. During the years after the Chicago World's Columbian Exposition the muted style of the Barbizon followers predominated in landscape, as did figural paintings that were classical in form and sentimental in spirit. Impressionism, in fact, underwent an eclipse, confirming for many opponents what they had maintained from the beginning, that the style was a momentary fad. By the end of the decade a critic reviewing a show of Monet's work in New York could say, "The Luminarist movement, as a cult, is practically defunct,"[61] while a member of the Barbizon-influenced artist's colony at Old Lyme, Connecticut, described how "brown-yellow pictures were the order of the day ... the Impressionists were looked upon as has-beens."[62]

In the few years before the secession of the Ten this mounting climate of opinion is clearly manifested in the critical reviews of the Society exhibitions, in which opposition to the Impressionists had never been more vehement or self-assured. In 1894 their most vocal critics, at the *Art Interchange*, said that the Society exhibitions were ruled by "crass realism," making them "a disappointment and a mockery, an apotheosis of technical tricks."[63] Their works were held to be examples of "degeneration and egomania" and were likened to the superficial performances of a stage magician: "We admire the tricks of Mr. Reid, or Mr. Weir, or Mr. Twachtman, just as we do the dextrous manipulation of cards or eggs, or rabbits It is all skillful and mystifying. Some people even call it art, but no one can be found to explain it, or to believe it true, or to say there is any poetry or sentiment or suggestion in it."[64] One heated editorial blamed such artists for the public's apathy towards art in general. As Whistler had earlier been accused of ignoring the public by being "wrapped in his own artistic personality,"[65] and as one critic more recently had referred to the American expatriates as "spoilt children,"[66] the Impressionists were similarly derided for ignoring the larger public concerns of science, politics, and philanthropy, while claiming to be more sensitive than ordinary men and requiring a special atmosphere in which to work. These artists ignored the fact "that art is a thing of the people, and that all the great art that has come down from the past had its roots in the people." Instead, the "vicious effect" of Paris training resulted in paintings that were "banal and unsound in moral principle ... the combination of clever technique and weak mental fibre [that] deceives and misleads." Weir and Hassam were cited as examples of this extreme: "They concentrate their whole attention on the matter of light, while their pictures are devoid of poetry, rhythm, suggestion, elevation of thought which the world always has and always will demand from its prophets."[67] Elsewhere the critic Sadikichi Hartmann accused Tarbell and Hassam of fancying themselves the greatest painters alive and, while Tarbell's Boston followers were merely imitative technicians, he said, like inferior actors they adopted the hauteur and idiosyncracies of genius.[68]

Apart from the barrage of critical abuse, the painters also had to contend with the lack of material support. It is often remarked that the Ten members were well established and, by implication, successful artists at the time of their break with the Society. Their many awards, however, reflected only the endorsement of a limited number of fellow artists and, while Impressionism had advanced significantly, it had not yet translated into public success. Despite large attendances at the Society openings, sales remained extremely poor. "We cannot get the fashionables," wrote Beckwith in 1892. "They will pay no attention to art."[69] The radical stance adopted by the artists undoubtedly played a part. Andrew Carnegie visited the Society opening a year before and criticized the exhibition for being "impressionistic," equating this with an effort to avoid work.[70] The subsequent financial support of the Society by Carnegie, George Vanderbilt, C. P. Huntington, John D. Rockefeller, and others during a reorganization in the early 1890s may have been related to the growing conservatism of its membership.[71] An outward sign of change was the transformation of Varnishing Day, traditionally a low-keyed affair, into an all-day society gala modeled on the openings of the Paris Salon.[72]

The artists continued, as a last resort, to sell their works in wholesale auctions in order to sell at all, and the results were rarely satisfactory. At auction in 1891 Chase's pictures, including many of his outdoor figures and park scenes, such as *End of the Season* (fig. 34), were considered the object of a "slaughter,"[73] while in 1896 the auction of 205 works by Hassam realized on average less than $50 apiece.[74] Tarbell

described himself as being poor in 1895, while the same year Robinson, who had earned just a little over $1,000 during the whole of 1894, told of having marked down the prices of his paintings considerably "on account of the times."[75] Beckwith said of the market for pictures in 1896 that "American fellows can positively get nothing for their work. This winter has abounded in auction sales by the painters who have been obliged to raise some money and the prices have sometimes not paid for the frames."[76] The most dramatic evidence of the generally adverse conditions was the forced liquidation of Chase's legendary Tenth Street studio in 1896, an event which represented not only a personal calamity, but also the symbolic end to an era of idealism and hopeful progress that had begun nearly two decades before.[77]

At the Society exhibition later that year one critic noted with approval the scarcity of "merely eccentric and audacious art." Impressionism, when it occurred, was mostly not of the extreme sort, he said, and remarked that the best painters had "taken a hint from Monet without abandoning all other principles of art."[78] The *New York Times* critic likewise thought the exhibition encouraging, "for the inclination has been to break away from the erratic experiments that have marked the work of other years, to depart from the spotty, crude, bizarre efforts that have stood out heretofore in such bold relief While there are many brilliant colorful canvases, there is a notable tendency toward low-toned pictures in great sobriety of color and agreeable harmony."[79]

Benson won that year's Shaw prize for his decorative panel *Summer* (fig. 25) which, significantly, was an older work, painted six years before. Critics praised its bright— but not too bright—palette and its broad, free brushwork without the "extravagance of color or crudeness of manipulation, which characterizes many of the luminists." Some likened it to a Botticelli, and contrasted its return to traditional techniques of painting with the superficiality of such "extreme" artists as Weir and Hassam. It was a happy combi-

nation, at once "scientific" and "imaginative." The same critic also observed the comforting absence of nudes in this exhibition as compared to a few years ago.[80] *Summer*, in fact, was taken as a symbol of the general artistic progress which affected the majority of artists that year. Even though Impressionist pictures were in evidence, it was said that many were now of a kind that could be appreciated even by those with academic standards. Metcalf, who won the comparable landscape prize that year for his *Gloucester Harbor* (plate 6), was praised along with Benson for illustrating this supposed general trend. Weir and Hassam were still considered beyond the pale.[81]

At the 1897 Society exhibition the feeling once more was that the show was more "rational" and serious than usual,[82] and it was even said, by way of compliment, that a stranger would not be able to tell the Society exhibition from the one that had just been held at the National Academy. In a turn-around described as impossible only a few years before, Robert Reid, "one of the chief apostles of impressionism," was awarded the Academy's Clark prize for his painting *Moonrise*, while, ironically, he was denied the equivalent (Shaw) prize at the Society which, after four ballots, went to the academic painter George Maynard. This underscored the shifting ground at the Society, with Reid's lost prize taken as a victory for the conservatives. The sum of the two exhibitions, said the *Art Interchange* critic, confirmed that American art was "rapidly swinging away from rabid impressionism."[83]

While certain members of the Ten had modified Impressionism to a degree considered satisfactory by some, the group as a whole found itself isolated from the mainstream of the Society: while their personal artistic positions were firm, their ever tentative influence in the Society had now been eroded beyond recovery and, in 1897, they set out on what they viewed as their only possible course of action— secession from the Society.

Notes

1 Letter from J. Alden Weir to his brother John, Archives of American Art, Roll # 125; quoted in Dorothy Weir Young, *The Life and Letters of J. Alden Weir*, New Haven, 1960, p. 168.
2 Alfred Trumble, "Impressionism and Impressions," *Collector* 4 (May 15, 1893), p. 213. The author W. H. W., in his article "What is Impressionism?" *Art Amateur* 27 (Nov. 1892), p. 140, said: "Everybody is writing or talking of Impressionism and Impressionists. . . . In Paris and London and New York Impressionism is in evidence among the younger men, and a prismatic glamour is in evidence in every direction."
3 Greta, "Art in Boston," *Art Amateur* 16 (Jan. 1887), p. 28. However positive her remarks, she still observed of Chase's painting that "its technique is very nearly its all in all. Its purpose is simply painting . . . but instead of being a broader view of things than that taken by the despised critic and pitied general public, it is essentially a narrow view, a professional, a trade view." See also "A Boston Estimate of a New York

Painter," *Art Interchange* 17, no. 2 (Dec. 4, 1886), p. 179, and "The Chase Exhibition," *American Art Illustrator* (Dec. 1886), p. 99.
4 "The William M. Chase Exhibition," *Art Amateur* 16 (Apr. 1887), p. 100.
5 "Suburban Sketching Grounds," *Art Amateur* 25 (Sept. 1891), p. 80, quoting Chase.
6 "Address of Mr. William M. Chase Before the Buffalo Fine Arts Academy, January 28, 1890," *Studio* 5 (Mar. 1, 1890), p. 124.
7 *Ibid.*, p. 126.
8 See Jessie B. Jones, "Where the Bay-Berry Grows: Sketches at Mr. Chase's Summer School," *Modern Art* 3 (Autumn 1895), p. 109 ff.
9 See Chase lecture notes, Archives of American Art, Roll # N 69, frame 137. Chase said Impressionism was "the *only new* thing in Art. The school of the Impressionists has been an enormous influence upon almost every painter of this time. The successful

men like Monet succeeded in rendering a brilliant and at times almost dazzling impression of light and air. Most of this work I consider as more scientific than artistic."

10 Charles De Kay, "Mr. Chase and Central Park," *Harper's Weekly* 35 (May 2, 1891), p. 327.

11 William J. Baer, "Reformer and Iconoclast," *Quarterly Illustrator* 1 (1893), pp. 135–41 (reprinted in Harry C. Jones, ed., *American Art and Artists*, New York, 1894, p. 241). Baer wrote: "Too many of our talented men have, in latter years, made appalling changes of conviction.... Impressionism and *plein air*, so called, are truths—great truths—but surely not the only ones."

12 Quoted by Allen Tucker, *John H. Twachtman*, American Artists Series, New York, n. d., p. 8. Twachtman always conceived of his art as an elusive, dreamlike quest. While young, he wrote to Weir: "You do not know how tempting every opportunity is to me and how I long to go in quest of fame and fortune.... In my mind I have finer pictures than ever before. Ten thousand pictures come and go every day and those are the only complete pictures painted, pictures that shall never be polluted by paint and canvas." Letter of Sept. 5, 1880, Archives of American Art, Roll # 71.

13 "Paintings and Pastels by J. H. Twachtman and J. Alden Weir," *Studio* 4 (Feb. 1889), pp. 43–45.

14 "I went across the river the other day to see an exhibition of the work of a new school which call themselves 'Impressionalists,'" he said. "I never in my life saw more horrible things. I understand they are mostly all rich, which accounts for so much talk. They do not observe drawing nor form but give you what they call nature. It was worse than the Chamber of Horrors. I was there about a quarter of an hour and left with a headache." Weir to his parents, Apr. 15, 1877, quoted in Young, 1960, p. 123.

When he met Whistler later that year in London Weir was likewise unimpressed, finding him a grossly affected snob of rather modest talents, instead of the "substantial man" he had imagined. Whistler doubtless did not help matters by deprecating Weir's teacher, Gérôme. Weir to his parents, July 22, 1877, Archives of American Art, Roll # 71 (Young, 1960, p. 133, gives the date of the letter incorrectly, as Aug. 22, 1877).

15 National Academy of Design, J. Carroll Beckwith diaries, Oct. 11, 1890. See also Frick Art Reference Library, Robinson diaries, Dec. 10, 1893, where Twachtman and Weir are described as being just then "rabid" in their enthusiasm for Japanese art.

16 Unidentified newspaper, cited in John I. H. Baur, *Leaders of American Impressionism: Mary Cassatt, Childe Hassam, John H. Twachtman, J. Alden Weir*, exhibition catalogue, Brooklyn Museum, New York, 1937, p. 12 ff. Later that year the *Art Amateur* (25[Sept. 1891], p. 72) reported that "Mr. Theodore Robinson is very much under the influence of the French Impressionists, as are also Mr. J. H. Twachtman, and Mr. J. Alden Weir."

17 One wrote: "when an artist of his worth chooses this latest form of expression in painting, it is significant. Lovers of pictures are recommended to examine these paintings and consider the problems they offer." Quoted in Bauer, 1937, pp. 12–13.

18 Letter from Percy Alden, quoted in Young, 1960, p. 178.

19 J. Alden Weir to John F. Weir, early 1891, Archives of American Art, Roll # 125, quoted in Young, 1960, pp. 175–76; John F. Weir to J. Alden Weir, n. d., Young, 1960, p. 177.

20 The exhibition opened on May 3 at the American Art Galleries. For reviews, see "French and American Impressionists," *Art Amateur* 29 (June 1893), p. 4, and Alfred Trumble, "Impressionism and Impressions," *Collector* 4 (May 15, 1893), pp. 213–14. By this time Weir and Twachtman were regarded as belonging among the leaders of the Impressionist movement in New York, along with Robinson, Hassam, and others. See George Parsons Lathrop, "The Progress of Art in New York," *Harper's Magazine* 86 (1892/93), p. 746.

21 Hassam, quoted in A. E. Ives, "Mr. Childe Hassam on Painting Street Scenes," *Art Amateur* 27 (Oct. 1892), p. 116.

22 *Art Amateur* 12 (Mar. 1885), p. 82. The same critic "Greta" who applauded the frankness and unconventionality of this style was later extremely critical of the Impressionists.

23 The change was noted in works sent to Boston that year for exhibition, when his recent urban scenes were described as being sophisticated but too superficial—"very pleasant, but not art." See reviews of 1887 Boston exhibitions in *Boston Evening Transcript*, *Harper's Weekly*, *Saturday Evening Gazette*, and *Boston Sunday Herald* (Archives of American Art, Roll # NAA 1). While some criticized the change, others thought he had never painted so well.

24 "Boston Art and Artists," *Art Amateur* 17 (Oct. 1887), p. 93. Metcalf collected birds' eggs and recorded finds made at Giverny in May 1885 and in May and June 1886. For details and a bibliography on visitors to Giverny, see Elizabeth de Veer and Richard J. Boyle, *Sunlight and Shadow: The Life and Art of Willard L. Metcalf*, New York, 1987, pp. 37, 40 ff., and n. 13.

25 Ives, 1892, pp. 116–17.

26 Hassam, quoted *ibid.*, p. 116. The painting referred to is probably *Spring Morning in the Heart of the City* (Metropolitan Museum of Art, New York).

27 *Ibid.*

28 L. Lejeune, in "The Impressionist School of Painting," *Lippincott's Magazine* 24 (Dec. 1879), p. 727, said that, in emphasizing surfaces and in trying only to capture effects of sun and atmosphere, the Impressionists made the error of attempting "literal reproduction." W. C. Brownell, in "French Art, III: Realistic Painting," *Scribner's*

Magazine 12 (Nov. 1892), p. 624, noted Monet's faithfulness to absolute values of color and light and found him the "apogee" of realism. Roger Riordan, in "The World Fair Loan Collection," *Art Amateur* 30 (Apr. 1894), p. 130, said of Monet that his art "is the last word—so far—of naturalism."

29 Robinson, in "Claude Monet," *Century Magazine*, n. s., 22 (Sept. 1892), p. 698, said the Impressionist "is a realist, believing that nature and our own day give us abundant and beautiful material for pictures: that, *rightly seen and rendered* [italics mine], there is as much charm in a nineteenth century girl in her tennis- or yachting-suit, and in a landscape of sunlit meadows or river-bank, as in the Lefebvre nymph with her appropriate but rather dreary setting of 'classical landscape'; that there is an abundance of poetry outside of swamps, twilights, or weeping damosels. M. Claude Monet's work proves ... that there is no antagonism between broad daylight and modernity, and sentiment and charm."

Compare this with the statement by the painter Theodore C. Steele, in "Impressionism," *Modern Art* 1 (Winter 1893), n. p.: "The impressionist is also a realist, but he insists more strenuously than the realist upon the reproduction by each artist of his personal impression of nature and this only. Tradition and convention count for less and the individual vision counts for more. The personal is the vital." Steele spoke of the present limitations and tentativeness of a movement which had not reached its full development, and he imagined an art in the future that will be "impressionistic in effect" but that would place more emphasis on individuality, on structural qualities, and on spiritual or poetic significance of subjects.

30 The critic Greta, in "Art in Boston," *Art Amateur* 24 (May 1891), p. 141, wrote that the Impressionists were exhibiting there in force, and reacted skeptically to the theories of Impressionism then being advanced: "As a matter of fact do the dots and dashes of unmixed colors mingle 'optically on the retina?' Do the pictures of the impressionists differ constantly? On the contrary, do not the dots and dashes refuse to mingle optically? Do they not remain virtually a mosaic, tormenting the beholder with a sense of lack of finish, and obtruding the method in place of an effect? Above all, do not the pictures of an imitator of Monet have all a family similarity of color-effect, so that you instantly recognize them as 'that stuff', as far as you can see them? Is there, then, any emancipation in the new style, except for the strong man who emancipates himself anyway? Is there anything in it for the rank and file of painters but the substitution of one set of conventions and prescriptions for another? And is it a gain for art, for beauty, for charm or refinement of popular taste, to substitute for harmony and tone wanton and impudent vagaries and crudities? Is it not an affectation of individualism where it is only the same old imitation and conventionalism after all, but in coarser forms and on lower planes both of technical accomplishment and artistic sensibility?"

31 He used this phrase in letters to Harrison Morris, May 17 and Oct. 27, 1895, Pennsylvania Academy of the Fine Arts archives, director's correspondence. Said Robinson at the time: "Let us shake off European trammels and standards a bit and 'see what we shall see.'" In diary entries made after he had returned from France Robinson worried alternately about the perceived superficiality ("I have a horrible fear that my work pleases women and sentimental people too much") and the "spottiness" of his work (Dec. 31, 1892, and Apr. 14, 1894), concluding that "altogether the possibilities are very great for the moderns, but they must draw without ceasing or they will 'get left' and with the brilliancy and light of real out-doors—combine the austerity, the sobriety [?], that has always characterized good painting" (Nov. 21, 1894). He restated this idea a few months before he died: "I'm more and more struck with the importance and beauty of good drawing in landscape—one should take no end of pains and draw roads, lines of land and trees as carefully as Holbein drew the different features of the face" (Feb. 8, 1896).

32 See John D. Kysela, S. J., "Mary Cassatt's Mystery Mural and the World's Fair of 1893," *Art Quarterly* 29, no. 2 (1966), p. 138. Cassatt fought with Frank Millet over the terms of her contract and negotiated through her friends Mrs. Potter Palmer, in charge of the Woman's section of the Exposition, and Sara Hallowell, secretary to the director of Fine Arts.

33 St. Paul's Roman Catholic Church, New York. See *Art Interchange* 33, no. 2 (Aug. 1894), p. 45, and *New York Daily Tribune*, Feb. 3, 1895, p. 21.

34 Edward Simmons, *From Seven to Seventy: Memories of a Painter and a Yankee*, New York and London, 1922, pp. 208, 214–15.

35 In *Loan Collection of Paintings by Claude Monet and Eleven Sculptures by Auguste Rodin*, exhibition catalogue, The Copley Society, Boston, March 1905, pp. 3–4. He said at the time there were about fifty Monets in one collection alone in New York, while another had twenty-five; one in Chicago contained twenty-two and that in Boston about thirty.

36 William Howe Downes, "Boston Painters and Paintings, VI: Private Collections," *Atlantic Monthly* 62 (Dec. 1888), p. 782. A similar light is shed on the situation by a report in the *New York Times*, Jan. 27, 1899, p. 7, that the New York collector William Fuller, after buying his first early Monet, *On the Cliff*, used to show it only secretly to a few trusted friends. The painting may have been *La Roche Guibel, Port Domois* of 1886; see Daniel Wildenstein, *Claude Monet: Biographie et Catalogue raisonné*, Lausanne and Paris, 1979, vol. II, p. 204, no. 1106. For the sale of Fuller's collection of Monets at the American Art Association, New York, see the *Sun*, Mar. 14, 1903.

37 Greta, "Art in Boston," *Art Amateur* 24 (May 1891), p. 141. For the exhibition, see Desmond Fitzgerald, et al., *Catalogue of Paintings by The Impressionists of Paris, Claude*

Monet, Camille Pissarro, Alfred Sisley, exhibition catalogue, Chase's Gallery, Boston, Mar. 17–28, 1891. As early as about 1875 J. Foxcroft Cole is said to have recommended the purchase of a Pissarro to the Boston collector Henry Angell. See *The Great Boston Collectors: Paintings from the Museum of Fine Arts*, exhibition catalogue, Museum of Fine Arts, Boston, 1984, p. 28.

38 For early notices, see *Art Amateur* 18 (Apr. 1888), p. 110, and 17 (June 1887), p. 5, and *Nation* 46 (Apr. 26, 1888), p. 353.

39 For Sargent's Impressionist work, see D. Hoopes, "John S. Sargent: Worcestershire Interlude, 1885–89," *Brooklyn Museum Annual* 7 (1965/66), pp. 74–89, and Carter Ratcliff, *John Singer Sargent*, New York, 1982, pp. 91 ff., 107 ff. J. Carroll Beckwith remarked, while at Giverny in 1891, that "Sargent's enthusiasm" had perhaps made him more receptive to Monet's work, which he admired greatly. National Academy of Design, Beckwith diaries, Sept. 4, 1891. On visiting Paris in June 1891, Beckwith had first been critical of what he termed the "extremists" among the Impressionists for producing "things brilliant in color but with no drawing" (June 27, 1891). From August 8 through early September he was at Giverny, where he observed Monet at work on his poplar series, called on him together with Robinson, and later dined with the French master (Aug. 30, Sept. 4, and Sept. 5, 1891). The following spring, while a member of the Academy of Design jury, Beckwith wrote: "I am distinctly the one champion of the Impressionists and stirred up a good deal of comment" (Mar. 11, 1892). His enthusiasm seems to have eventually cooled, however, for, after seeing the first Ten exhibition in 1898, he remarked: "I went this morning and saw much able work of the sumary [sic] suggestion order which may be the future of art but I doubt it" (Apr. 8, 1898).

40 See Hamlin Garland, "Impressionism," in *Crumbling Idols: Twelve Essays on Art Dealing Chiefly with Literature, Painting and the Drama*, 1894, repr. Cambridge, Mass., 1960, ed. Jane Johnson, p. 104.

41 Benson Papers, Essex Institute, Salem, Mass., MS EBL Advice MSS (MS Box 1 Central File), p. 14, Apr. 24, 1948. Writing about Tarbell's work, the Boston painter Philip Hale offered this definition: "Design . . . is arranging the outlines of the light and dark masses of a picture so that they shall make handsome arabesques of patterns, one against the other. The design of a good picture is of the same nature as the design of a good wall paper or a good brocade." Philip L. Hale, "Edmund C. Tarbell: Painter of Pictures," *Arts and Decoration* 2 (Feb. 1912), p. 131.

42 See Frederick W. Coburn, "Joseph De Camp's 'The Guitar Girl,'" *New England Magazine* 39 (Oct. 1908), p. 239.

43 See "The Fine Arts," *Boston Evening Transcript*, May 26, 1893, p. 5. The article referred to the title of the painting as *Ballet Master*, but the official catalogue title was *The Dancing Lesson*. The painting had also been shown in Durand-Ruel's 1886 New York exhibition. For some reviews of the Exposition, see William Forsyth, "Some Impressions of the Art Exhibit at the Fair, III," *Modern Art* 1 (Autumn 1893); William Coffin, "The Columbian Exposition, II," *Nation* 57 (Aug. 10, 1893), pp. 96–98; "Art at the World's Fair, III: The American School and its Brightest Ornaments," *New York Daily Tribune*, June 19, 1893, p. 5; ". . . IV: The Fruits of French Discipline and Realism," *ibid.*, June 21, 1893, p. 7; ". . . IX: The Loan Exhibition of 'Masterpieces by Foreign Artists,'" *ibid.*, July 15, 1893, p. 7; "The World's Fair Loan Collection," *Art Amateur* 30 (Apr. 1894), p. 130; "American Painting," *ibid.*, 29 (Aug. 1893); *ibid.*, 29 (Nov. 1893), p. 134.

44 Frederick W. Coburn, "Edmund C. Tarbell," *International Studio* 32 (Sept. 1907), p. 86.

45 Royal Cortissoz, "Egotism in Contemporary Art," *Atlantic Monthly* 73 (May 1894), pp. 647-48.

46 *New York Times*, Apr. 15, 1893, p. 9; *Harper's Weekly* 37 (Apr. 22, 1893), p. 372.

47 "Exhibition of the Society of American Artists," *New York Daily Tribune*, Apr. 15, 1893, p. 6. See also "American Artists," *New York Daily Tribune*, Apr. 22, 1893, part III, p. 11, where it was similarly said that *The Bath* aped the French studios whose tone was of "unbounded license and a reproach to the nation . . . nothing more vulgar than 'The Bath' or Mr. Reid's 'Study' [a woman seated in firelight, evidently nude] has ever been shown by an American artist in this city."

48 Charles W. Dempsey, "Advanced Art," *Magazine of Art* 5 (1882), p. 359.

49 Charles H. Caffin, "The Art of Thomas W. Dewing," *Harper's Magazine* 106 (Apr. 1908), p. 724. Kenyon Cox also remarked in writing about Dewing that the "sole purpose" of art was "to be lovely, as music is lovely." Kenyon Cox, "Thomas W. Dewing," undated typescript, Archives of American Art, Dewing file. Royal Cortissoz, too, a good friend of Dewing, wrote in the *New York Tribune*, Mar. 19, 1915, p. 9: "Mr. Dewing's variations are like those of a musician, ranging up and down a scale which is nominally restricted yet seems illimitable, for he does with form and color what his colleague of the piano, say, does with tone—he subtly touches the imagination."

50 Dewing to Charles Lang Freer, Feb. 16, 1901, Archives of American Art, Roll # 77.

51 *Art Amateur* 31 (Nov. 1894), p. 114. Charles De Kay, in "The Ceiling of a Cafe," *Harper's Weekly* 36 (Mar. 12, 1892), p. 258, said that his works were little known outside this circle, partly because they needed to be viewed alone and partly because Dewing allowed only a small number to be sent to the exhibitions.

52 Dewing to Freer, Feb. 14, 1893, Archives of American Art, Roll # 77.

53 Probably the best single account of him is given in Ezra Tharp, "T. W. Dewing,"

Art and Progress 5 (Mar. 1914), pp. 160–61, where he is described as "a tall, fierce, bristling man, bitterly ready to quarrel, using a witty tongue so as to cause bitterness in others. Little contradictions are everywhere on his surface. You feel the old New England severities in him and at the same time a kind of Greek grace. It would be hard to guess, when his tongue is reckless, that he has the strongest feeling for the ordinary obligations; hard to guess, when you listen to him in story and song, that his work is the only thing he's interested in all the time, his one passionate interest, that he has felt everything he has observed. At his studio by half-past eight, he sits there for ten months of the year, every day as long as the light lasts, sitting hunched and doubled up, in a low chair despite his enormous size, so that he shan't see the tops of things too much."
Dewing himself related several examples in the early 1890s of "unpleasant relations," which included fights with other painters and with collectors, and even concern over having offended his lifeline Freer. He fought with Will Low, Abbott Thayer, and others, and, in an incident with the collector William Evans, lost his temper over the sale of a picture (and did not care to place his pictures with him again). See his letters to Freer of Aug. 18, 1893, Mar. 6, 1894, and Apr. 10, 1894; Archives of American Art, Roll # 77.

54 Dewing to Freer, Jan. 10, 1894, Archives of American Art, Roll # 77.

55 Dewing to Freer, Feb. 17, 1894, *ibid.*

56 Dewing to Freer, Feb. 20, 1894, *ibid.*

57 Dewing to Freer, Mar. 19, 1894, *ibid.*

58 Dewing to Sanford White, as quoted in Susan Hobbs, "Thomas Dewing in Cornish, 1885–1905," *American Art Journal* XVII, no. 2 (Spring 1985), p. 19. See also Dewing's recollection of his visit to Whistler in a letter of Feb. 17, 1919, to the dealer Robert Macbeth. Archives of American Art, Roll # NMc42.

59 Dewing to Freer, Aug. 29, 1895, Archives of American Art, Roll # 77.

60 Dewing to Freer, Oct. 14, 1895, *ibid.*

61 In a review of the 1899 Monet exhibition at the Lotos Club, New York, "Claude Monet," *Art Collector* 9, no. 8 (Feb. 15, 1899), pp. 116–17. For another review, see *New York Times*, Jan. 27, 1899, p. 7.

62 Lillian Baynes Griffin, in *New Haven Journal Courier*, July 5, 1908; Archives of American Art, Roll# N70-13.

63 *Art Interchange* 32, no. 4 (Apr. 1894), p. 116. See also *Art Interchange* 32, no. 5 (May 1894), p. 135.

64 "The Observer," *Art Interchange* 34, no. 5 (May 1895), p. 140.

65 *Critic* 2 (Apr. 22, 1882), p. 129.

66 Charles De Kay [Henry Eckford], "A Turning Point in the Arts," *Cosmopolitan Magazine* 15 (1893), p. 273ff.

67 "The Observer," *Art Interchange* 36, no. 3 (Mar. 1896), p. 73. See also the editorial decrying the utter lack of support for American art in *Brush and Pencil* 2 (June 1898), p. 143, where it was said that artists with their lopsided concern for science and technique failed the public: "we fail to touch the throbbing heart of the masses by our problems of impressionism, our accurate studies of plein-air effects, our symphonies of color, and our utter lack of subject."

68 Sadikichi Hartmann, "The Tarbellites," *Art News* 1 (Mar. 1897), pp. 3–4.

69 National Academy of Design, Beckwith diaries, Apr. 30, 1892. A decade later Herbert Croly, in "New York as the American Metropolis," *Architectural Record* 13 (Mar. 1903), p. 204, having pointed out the fundamental divorce between that wealthy American "society" and literary and artistic sets, said: "As a rule [the artists] feel themselves peculiarly isolated in American social life. Their work is neglected: their purposes are misunderstood: their achievements are undervalued: and all this happens in New York as it does elsewhere. But in New York they at least form a set of their own. They can associate with people to whom their purposes and their language are comprehensible: they get the benefit of that informal and largely technical comment which is the only kind of criticism which does them much good; and they can keep in touch with the best work of their fellow artists."

70 National Academy of Design, Beckwith diaries, Apr. 25, 1891: "The day was pleasant and the Galleries comfortably filled with nice people. Mr. Carnagie [sic] made me mad by slandering the show for being impressionistic. Saw no good in it, trying to do things without work. Ugh. Only two pictures were sold but I hope it was a success. We dined pleasantly at the Weirs."

71 In the early 1890s the Society became part of a new umbrella organization known as the Fine Arts Society, in which the Society itself, the Art Students League, the Architectural League, and the Society of Painters in Pastel joined to share quarters and galleries in the new Fine Arts Building. Newly capitalized with $200,000 from about three hundred artists and architects, and with contributions from wealthy patrons, the new organization was said by the organizing committee to be "destined to become the art power of the country." See George Parsons Lathrop, "The Progress of Art in New York," *Harper's Magazine* 86 (1892/93), p. 750.

72 *Art Interchange* 36, no. 4 (Apr. 1896), p. 96, reported that opening hours were from ten in the morning to ten at night, that a restaurant was on the premises, and that, for a charge of $1.00, the public was admitted along with the usual company of artists and press, hopefully making it "as successful a show of fashion, brains and beauty as the one abroad." See also *New York Times*, Mar. 28, 1896, p. 5.

73 See "The Slaughter of Mr. Chase's Pictures," *Art Amateur* 24 (Apr. 1891), pp. 115–

16, which called the poor results a "public scandal." See also Charles De Kay, "Mr. Chase and Central Park," *Harper's Weekly* 35 (May 2, 1891), pp. 327–28, who said that the scenes of New York were viewed with indifference, not nearly as welcome as would be views of Niagara or of Paris; and *Sun*, Mar. 1, 1891, p. 14.

74 *Art Interchange* 36, no. 3 (Mar. 1896), p. 68.

75 Tarbell, discussing the sale of a picture, said, "and I am so poor that I must have [?] his coin?" Tarbell to Harrison Morris, Jan. 16, 1895, Pennsylvania Academy of the Fine Arts archives. Robinson wrote to Morris on Apr. 17, 1895: "As I told Miss Griffith, I had 'marked down' all my pictures considerably on account of the times. Thus for a picture at $250, I asked two years ago $300 or more. So I can't make a reduction on most of them—especially as they are rather expensively framed. I must have $300 for the 'Lady at the Piano.'" Robinson, in his diary entry of Dec. 31, 1894, reckoned that he earned $1080.25. The following spring (Apr. 11, 1895) he reported finding Weir "'hard up' and a little disgruntled." Benson, too, suffered financially, remarking to Weir of a $1,000 prize he won at the Boston Art Club: "I never needed it so much in my life." Benson to Weir, Jan. 10 [1896], Archives of American Art, Roll # 125.

76 National Academy of Design, Beckwith diaries, Feb. 13, 1896.

77 For the exhibition and sale, see *Art Amateur* 34 (Feb. 1896), p. 56; *New York Daily Tribune*, Jan. 3, 1896, p. 7; and *New York Times*, Jan. 1, 1896, p. 14; Jan. 3, 1896, p. 4; Jan. 5, 1896, p. 21; Jan. 9, 1896, p. 9; Jan. 12, 1896, p. 24; Jan. 19, 1896, p. 23. Chase's own paintings sold for amounts termed "absurdly low," some at a price of $25 or $30 and none mentioned as being purchased for more than $100. In summing up, the *Times* writer thought that, "on the whole it was probably a disastrous sale." The proceeds were undoubtedly intended to help pay for a house Chase had just bought on Stuyvesant Square, of which J. Carroll Beckwith said that Chase had "put all he could into it." National Academy of Design, Beckwith diaries, Jan. 16, 1896. Chase was chronically short of money and, at the Pennsylvania Academy of the Fine Arts, where he taught from 1896 to 1909, he left a trail of notes attesting to the fact.

Nicolai Cikovsky, Jr., in *William Merritt Chase: Summers at Shinnecock, 1891–1902,* exhibition catalogue, National Gallery of Art, Washington, D.C., 1987, p. 42, maintained that Chase's dismantling of the studio was "an act of doubt and disillusionment, of eroded confidence and purpose, and, in a quite literal way, of disintegration." These things may have played a part in the aftermath, but the truth is that he was also broke. None of the newspapers would say so direct'v ıst as two years earlier Thomas Dewing was described in print as being "in the ull tide of success" (*Art Amateur* 31 [Nov. 1894], p. 114), when we know from private correspondence that he was utterly discouraged and pleading for money. As an example of how the press put the best face on such events, *Leslie's Weekly* 82 (Jan. 16, 1896), p. 41, explained that the closing of Chase's studio occurred because "his collections had become too large and extensive for private ownership" and that he intended to give up teaching to devote more time to private work. Chase's willingness to give up teaching, it was said, indicated "that he is satisfied with the condition of affairs in our art world today." As for his real intentions, Chase immediately left for Europe with a class of students, returned to New York, where he opened a private school of his own, and simultaneously accepted a teaching appointment at the Pennsylvania Academy.

78 *New York Daily Tribune*, Mar. 28, 1896, p. 7.

79 *New York Times*, Mar. 23, 1896, p. 3.

80 *Art Interchange* 36, no. 5 (May 1896), p. 116 ff. See also *Art Amateur* 34 (May 1896), p. 129.

81 *New York Daily Tribune*, Apr. 15, 1896, pp. 6–7.

82 *Art Interchange* 38, no. 5 (May 1897), p. 119.

83 *Ibid.*, p. 123.

35 John H. Twachtman, *Meadow Flowers*, c. 1895. 33 x 22 in. (83.8 x 55.9 cm).
The Brooklyn Museum, 13.36. Caroline H. Polemus Fund

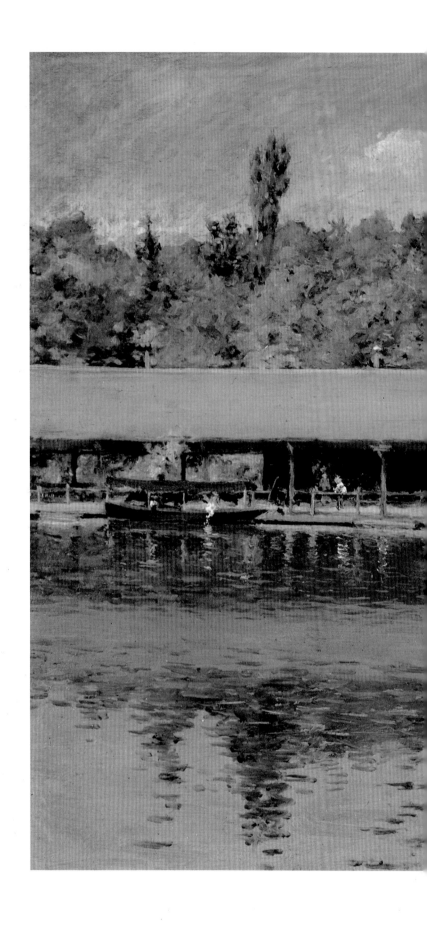

36 William Merritt Chase, *Boat House, Prospect Park*, c. 1887.
Oil on panel, 10¼ x 16 in. (26 x 40.6 cm). Private collection

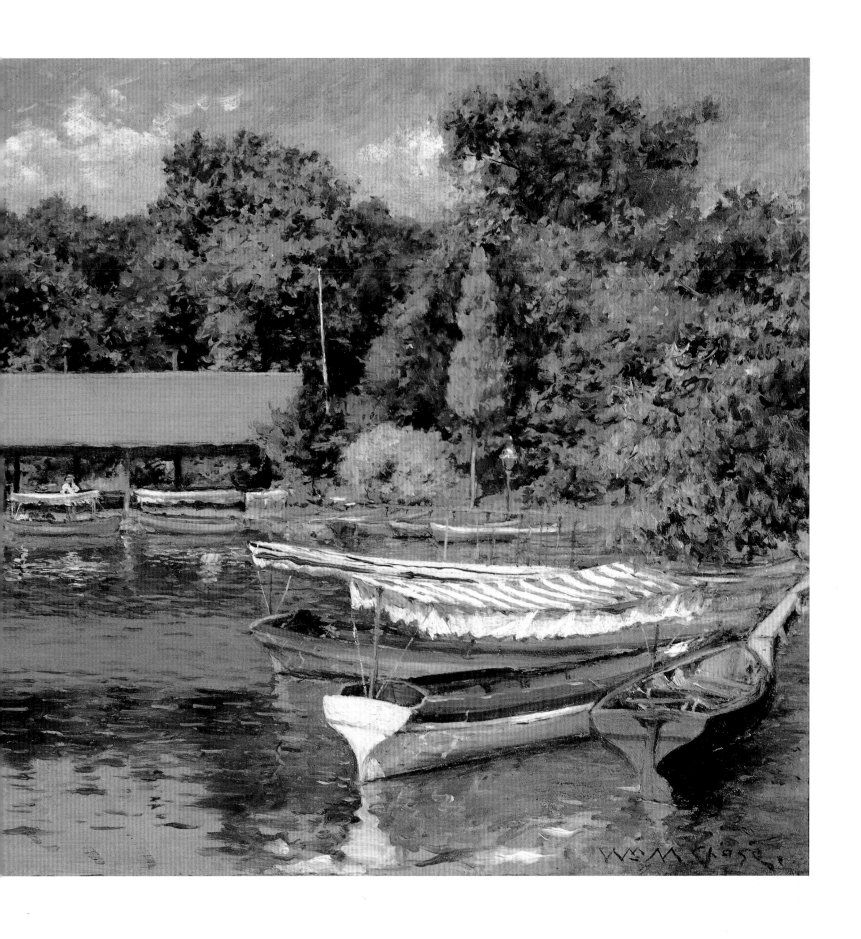

37 Childe Hassam, *Grand Prix Day*, 1887.
24 x 34 in. (60.9 x 86.3 cm).
Museum of Fine Arts, Boston.
Ernest Wadsworth Longfellow Fund

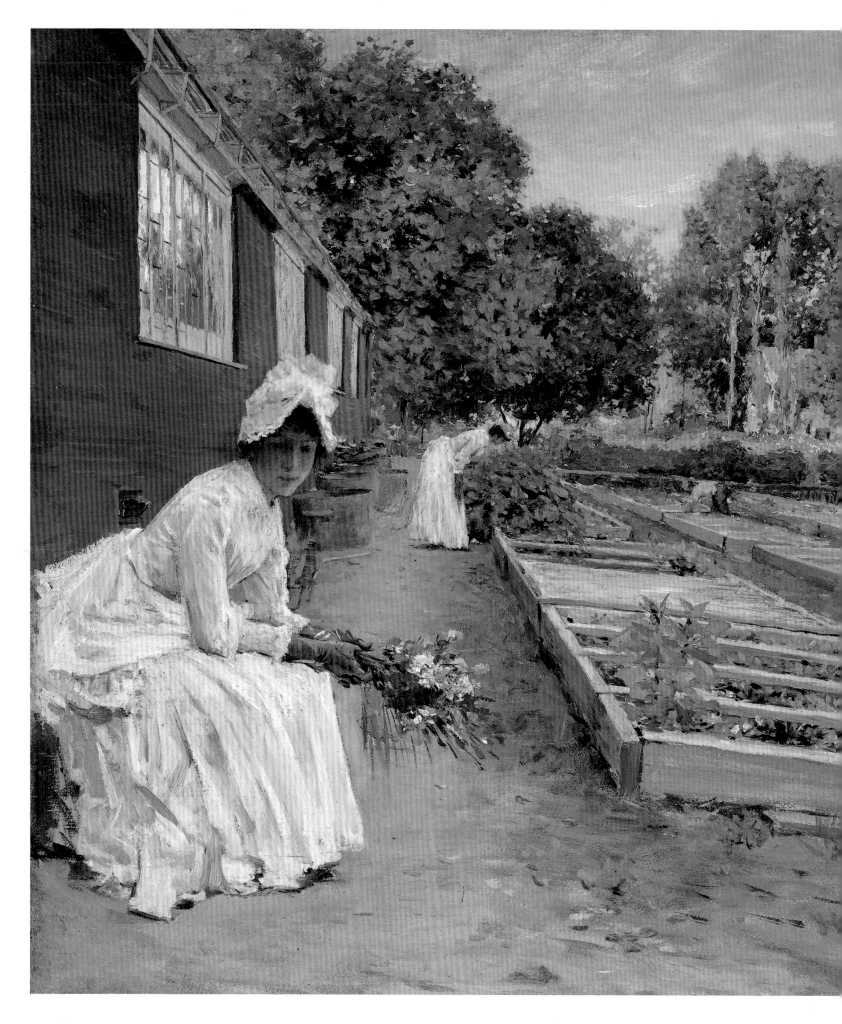

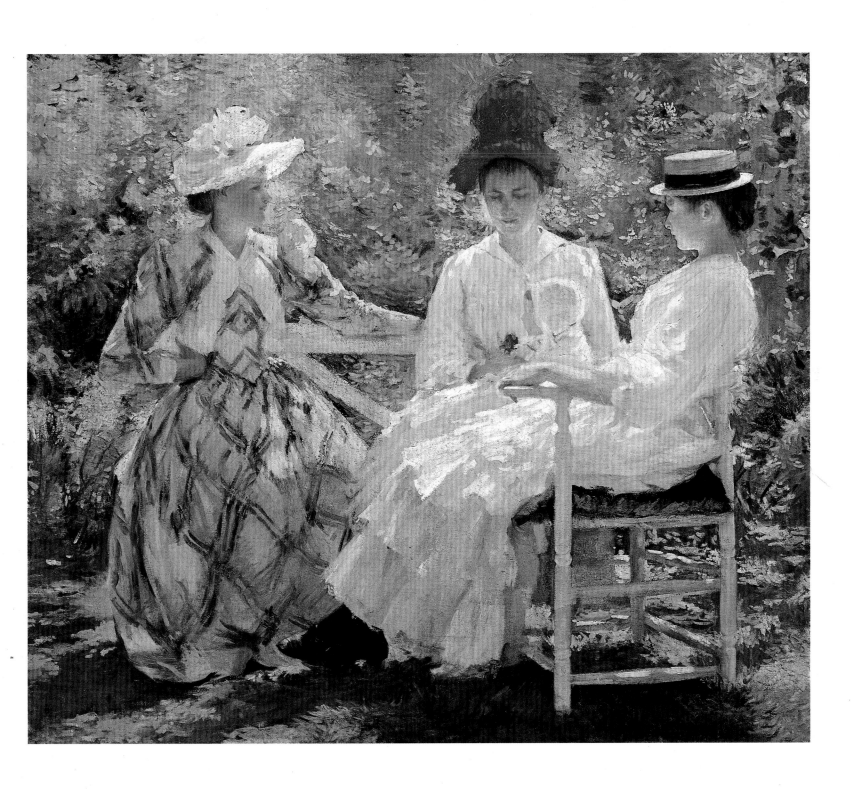

41 William Merritt Chase, *Afternoon in the Park*, c. 1890.
Pastel on canvas,
19 x 15⅜ in. (48.3 x 39 cm).
Collection of Deborah and Edward Shein

42 Edmund C. Tarbell, *In a Garden*
(originally *The Three Sisters – A Study of June Sunlight*), 1890.
35⅛ x 40⅛ in. (89.2 x 101.9 cm).
Milwaukee Art Museum, Gift of Mrs. Montgomery Sears

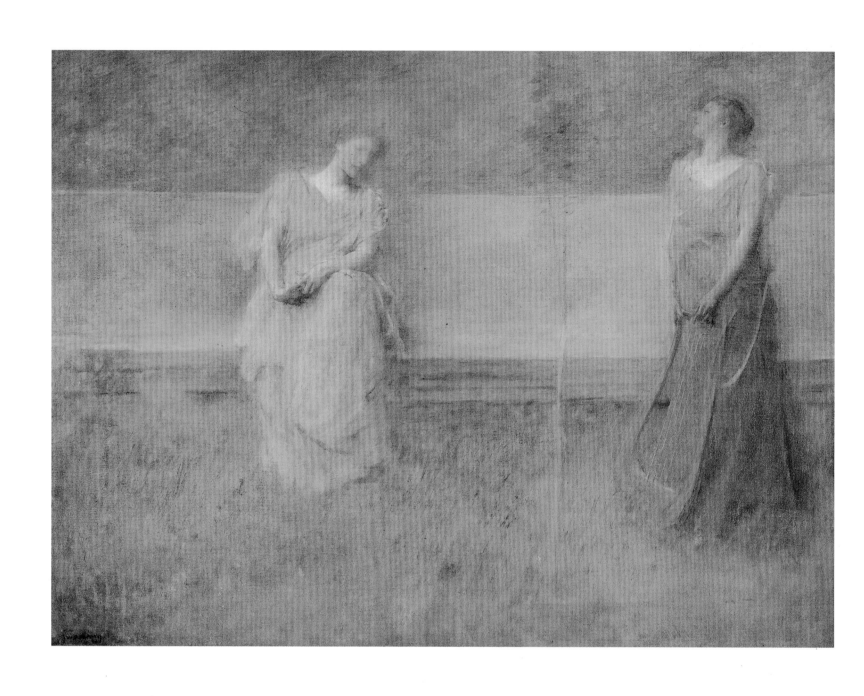

43 Thomas Wilmer Dewing, *The Song*, 1891.
26½ x 34 in. (67.3 x 86.4 cm).
Collection of Deborah and Edward Shein

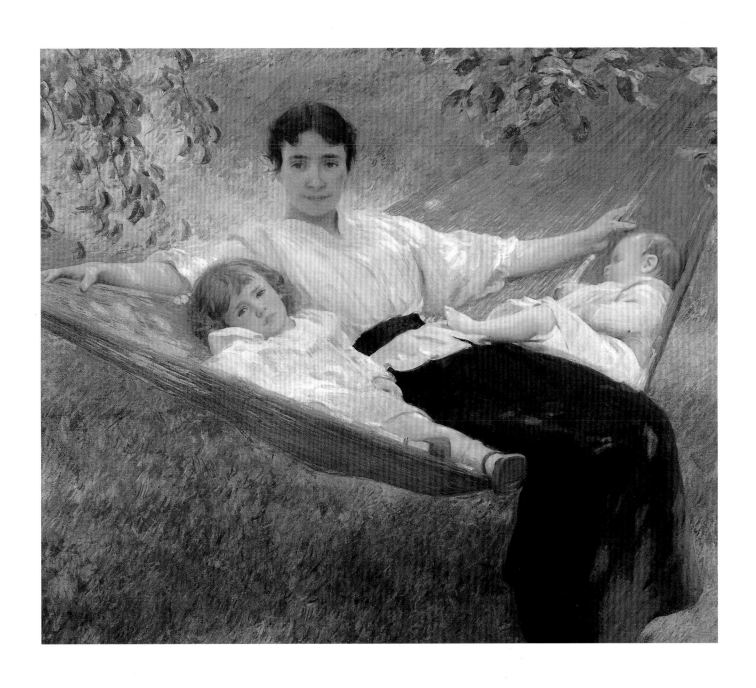

44 Joseph R. De Camp, *The Hammock*, c. 1895.
44 x 50 in. (111.8 x 127 cm). Private collection

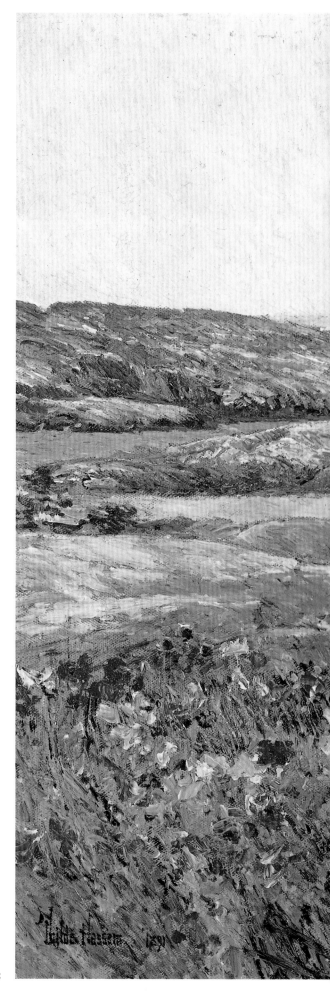

45 Childe Hassam, *Poppies, Isles of Shoals*, 1891.
19½ x 24 in. (49.5 x 61 cm).
Collection of Mr. and Mrs. Raymond J. Horowitz

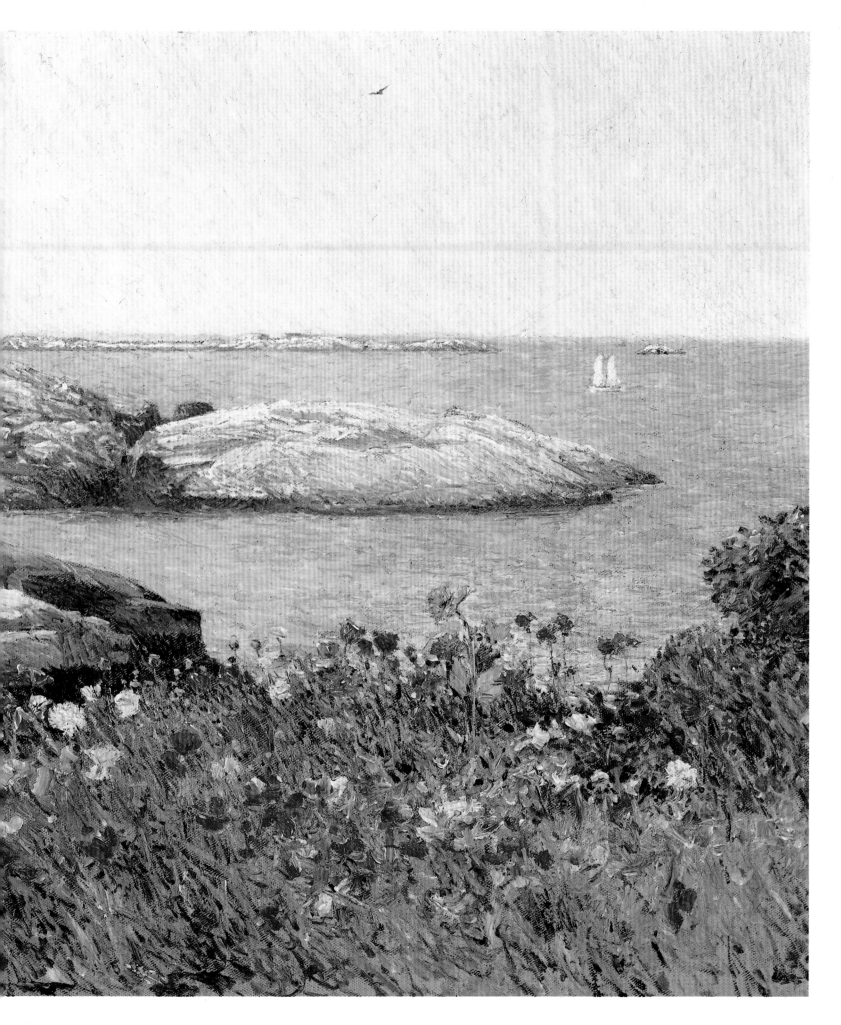

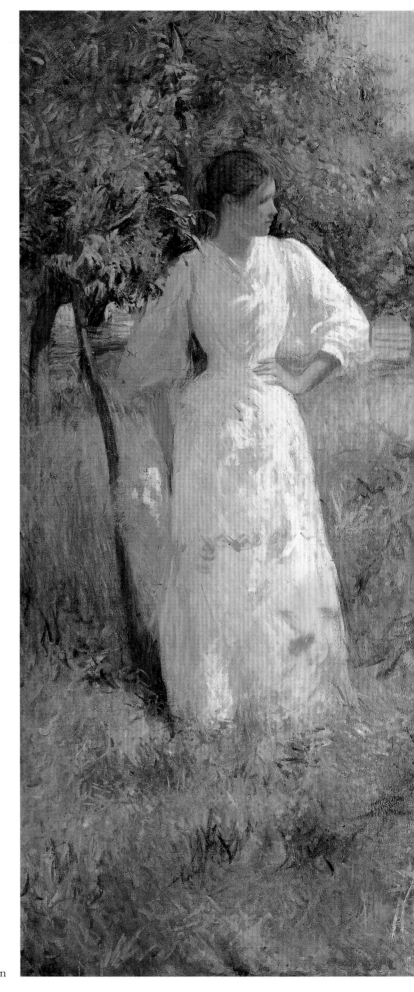

46 Edmund C. Tarbell, *In the Orchard*, 1891.
60¼ x 65 in. (153 x 165.1 cm). Private collection

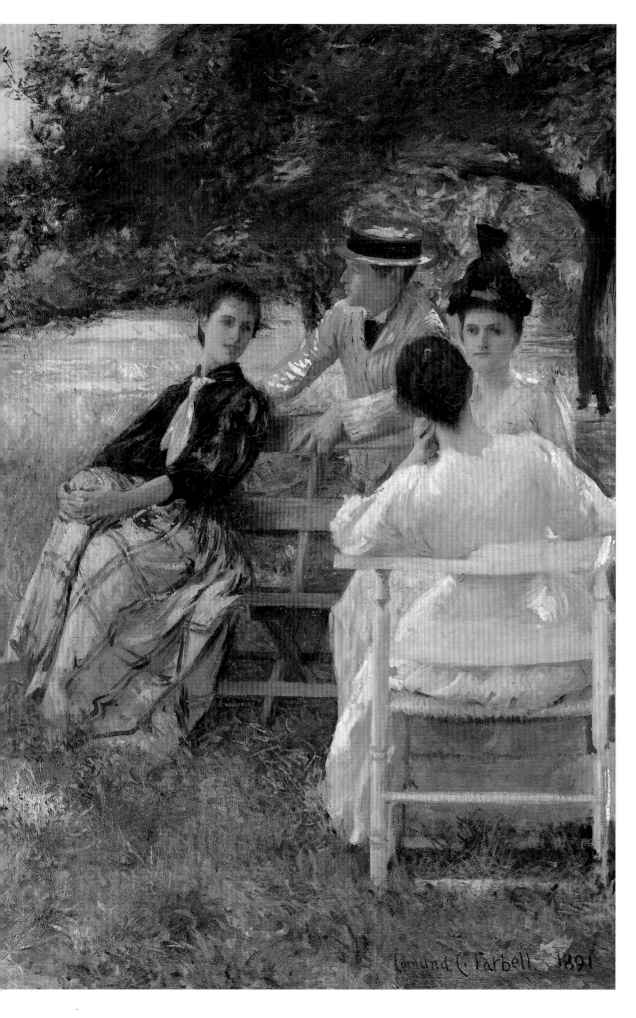

Edmund C. Tarbell 1891

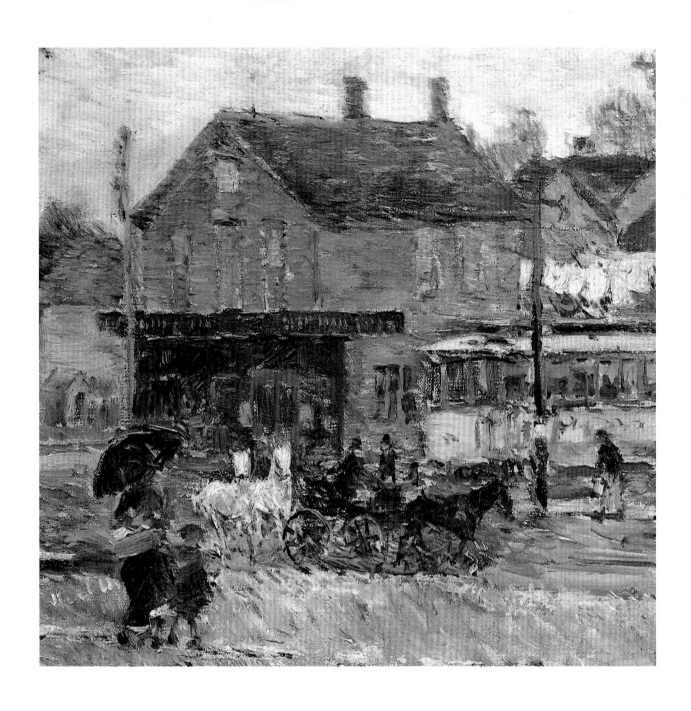

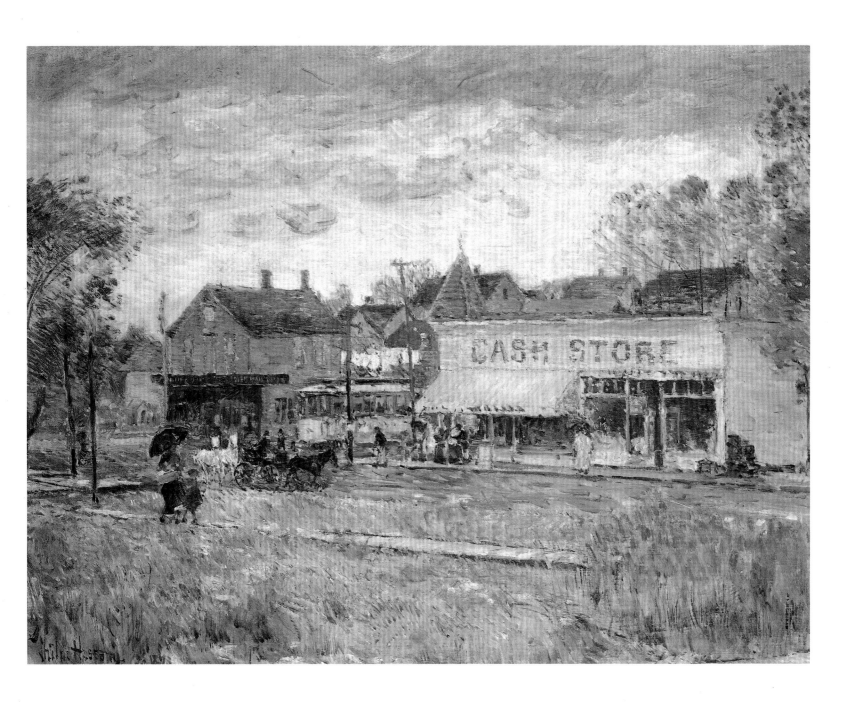

47 Childe Hassam, *End of the Trolley Line, Oak Park, Illinois*, 1893.
17½ x 21¾ in. (44.5 x 55.3 cm). Private collection.
Photo courtesy Jordan-Volpe Gallery, New York

48 J. Alden Weir, *U.S. Thread Company Mills,*
Willimantic, Connecticut, c. 1893/97.
20 x 24 in. (50.8 x 61 cm).
Collection of Mr. and Mrs. Raymond J. Horowitz;
Partial and Promised Gift to the National Gallery of Art

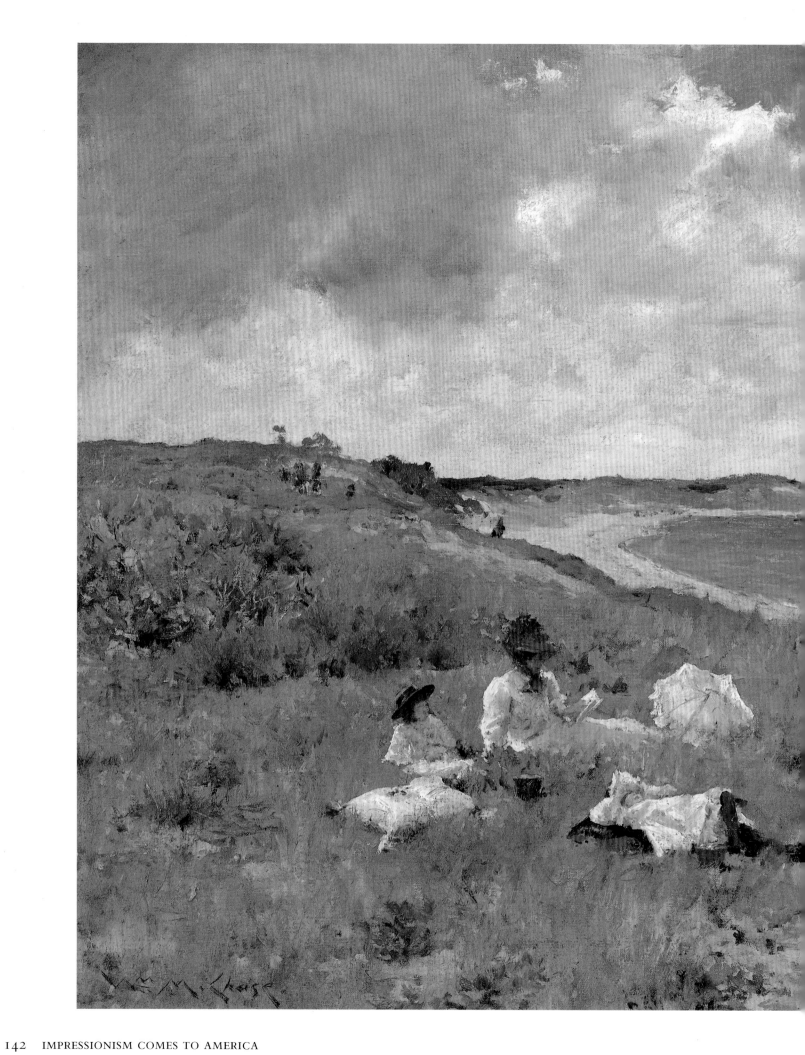

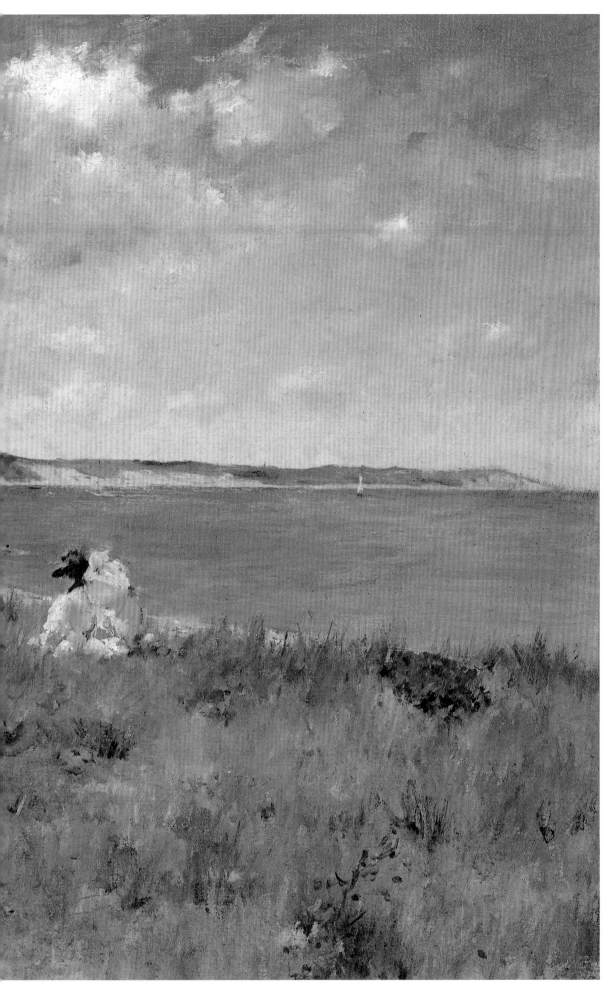

49 William Merritt Chase,
Idle Hours, c. 1894.
25½ x 35½ in. (64.8 x 90.2 cm).
Amon Carter Museum,
Forth Worth (1982.1)

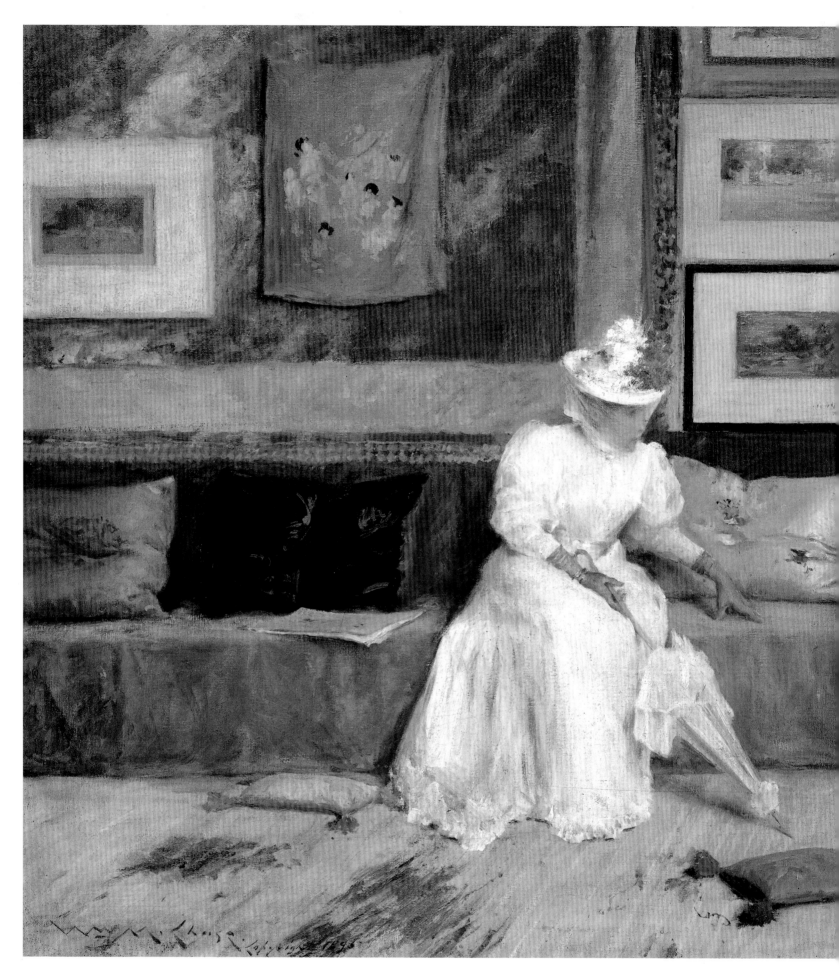

50 William Merritt Chase, *A Friendly Call*, 1895. 30¼ x 48¼ in. (76.8 x 122.5 cm). National Gallery of Art, Washington, D.C.; Chester Dale Collection

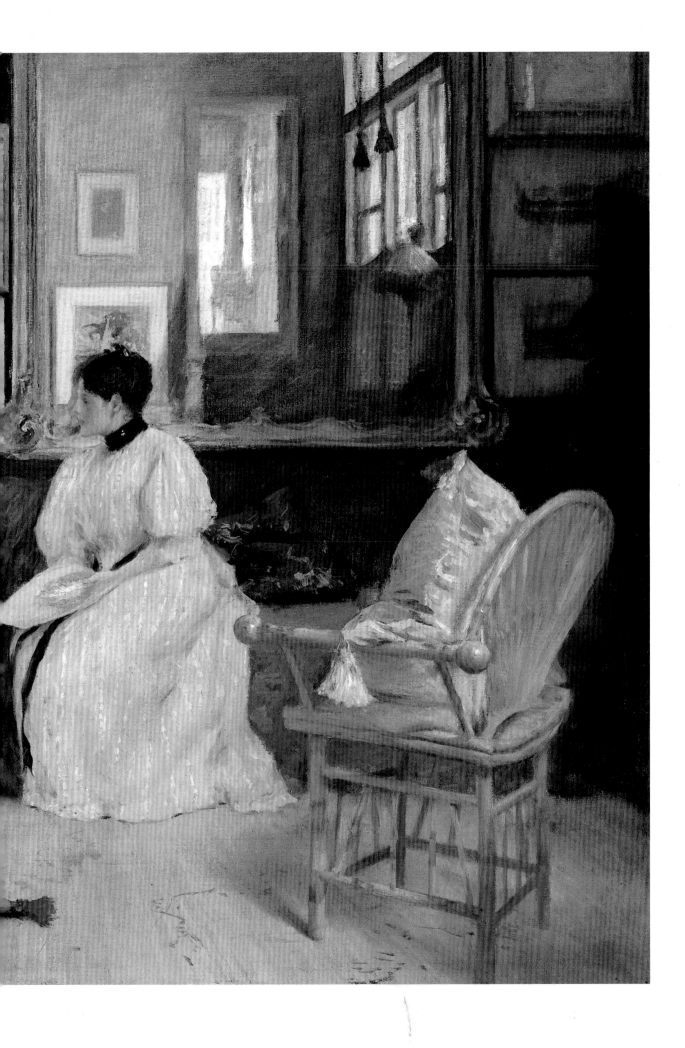

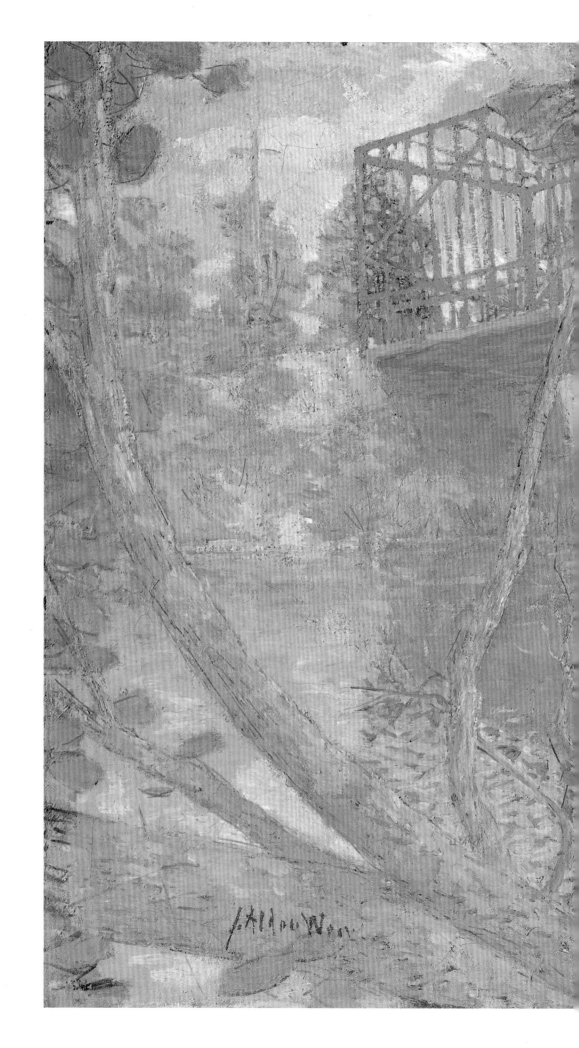

51 J. Alden Weir, *The Red Bridge*, c. 1895.
24¼ x 33¼ in. (61.6 x 84.5 cm).
The Metropolitan Museum of Art, New York.
Gift of Mrs. John A. Rutherford, 1914

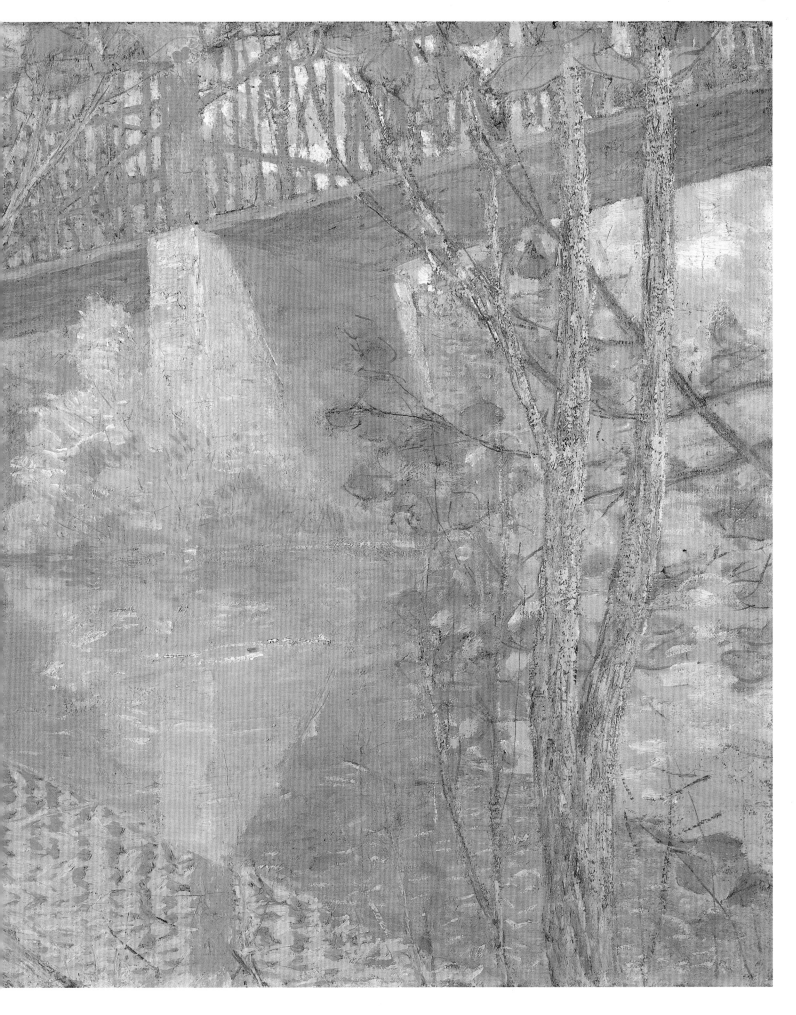

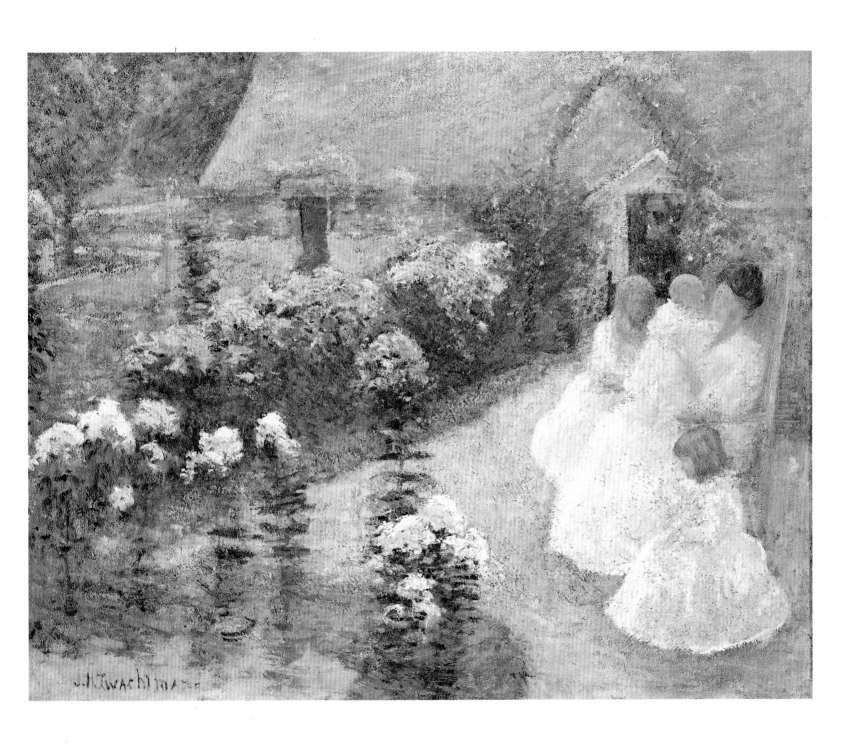

52 John H. Twachtman, *On the Terrace*, c. 1897. 25¼ x 30⅛ in. (64.1 x 76.5 cm).
National Museum of American Art, Smithsonian Institution, Washington, D.C.
Gift of John Gellatly

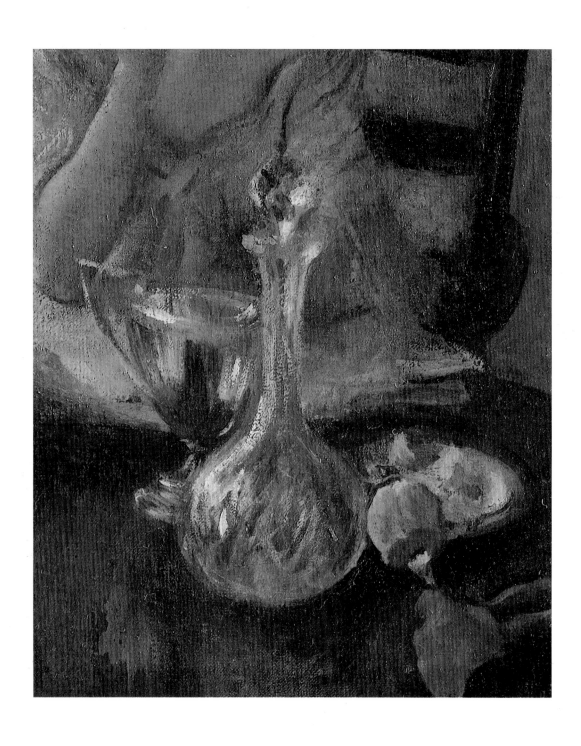

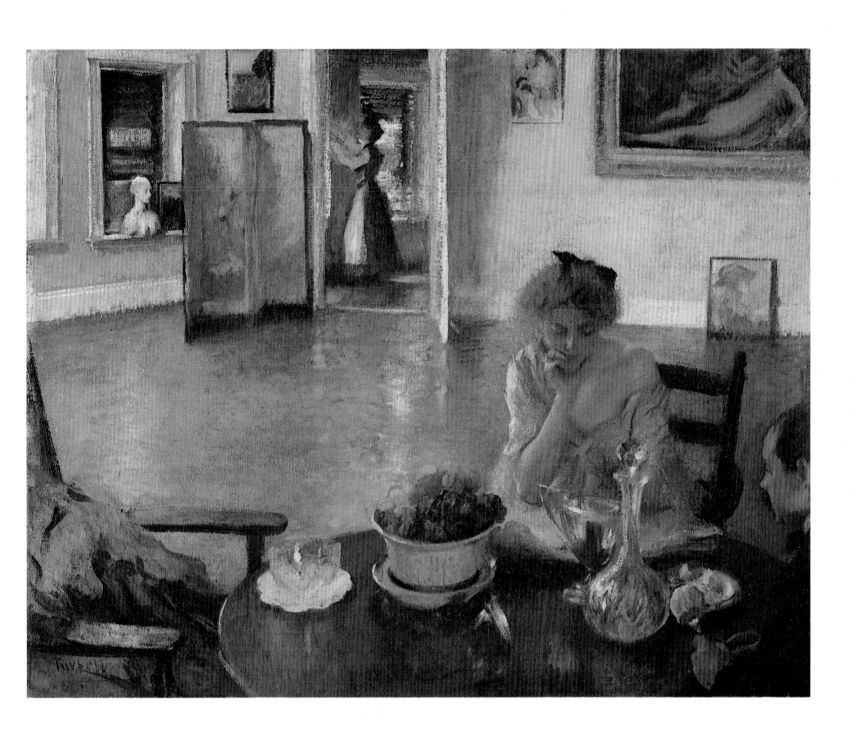

53 Edmund C. Tarbell, *The Breakfast Room*
(originally *In The Breakfast Room*), 1902/3.
25 x 30 in. (63.5 x 76.2 cm).
The Pennyslvania Academy of the Fine Arts, Philadelphia.
Gift of Clement B. Newbold

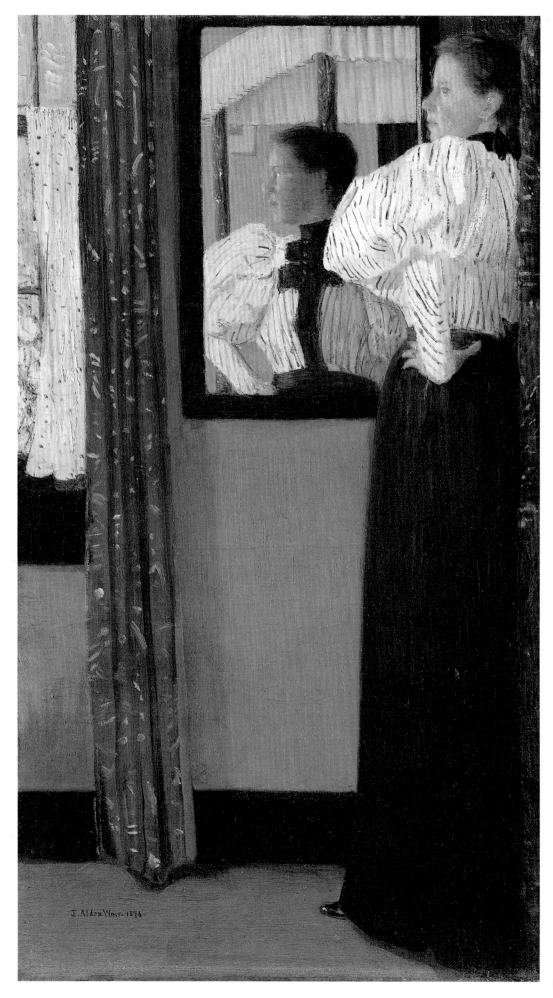

54 J. Alden Weir,
Face Reflected in a Mirror, 1896.
24¼ x 13⅝ in. (61.6 x 34.6 cm).
Museum of Art,
Rhode Island School of Design;
Jesse Metcalf Fund

CHAPTER 4

The Ten's Exhibitions, 1898–1908

The first showing of the Ten opened to the public on March 30, 1898, at the Durand-Ruel gallery on Fifth Avenue. In contrast to the makeshift spaces usually available for such purposes, Hassam described Durand-Ruel's as "a real picture gallery of moderate size"[1] in a large, old New York mansion that had a high ceiling and natural overhead lighting (see fig. 44). While the favorable physical conditions may have influenced the group's decision to exhibit there, not the least incentive was Durand-Ruel's well-known reputation as the foremost advocate of avant-garde painting in France. The association with Durand-Ruel could only serve, therefore, to enhance the reputation of the Ten as leaders of the Impressionist movement in the United States.[2]

The exhibition filled a single gallery which had been carefully arranged. Following the original plan, each member was assigned by lot an equal portion of wall space which he hung as he wished, while the south wall was reserved for works by all members. To those accustomed to the crowded disarray of most exhibitions, the effect of carefully composed groupings was striking, conveying as it did a sense of tranquility and unity throughout. (One critic revealed that those pictures that seemed discordant with the rest had actually been withdrawn.) Another striking feature was the discrete manner of framing, which led an admirer to dub the group the "Plain Frame School."

Accompanying the show was a small, skillfully produced catalogue with vignettes sketched by each of the artists. Its stylishness was much admired but, probably because there were last-minute changes, matching the catalogue entries with the paintings proved extremely confusing. Perhaps for that reason no catalogue appeared the next year, or for several thereafter, the paintings simply being identified by gallery labels.[3]

Reaction from the critics, though varied, was mainly free of the rancor that had marked reports of the group's secession. Most reviewers were at least respectful, and many surprisingly positive in their overall assessments, despite often unflattering individual comments. In terms of numbers, Weir, Hassam, Twachtman, and Reid dominated the show, accounting for well over half the forty-five paintings included. The *New York Daily Tribune* critic, Royal Cortissoz, who was later an ardent supporter of the Ten, made it clear that he found the show interesting and challenging, although he disliked the Boston painters in particular and Impressionism in general. De Camp's two nudes were termed "ugly and poorly painted"; Benson and Tarbell, he said, "both subside into triviality with a completeness that is astonishing"; Weir left him baffled and unmoved; while Hassam's Impressionism signified the sacrifice of value "for some fugitive and unimportant effect." Twachtman, though more skilled, joined Hassam in "wreaking himself upon his task with a devotion out of all proportion to its value." At the opposite end he found in Dewing an artist whose marriage of technique and "spiritual force" seemed to embody the very meaning of good art. Reid, meanwhile, was described as one who had gained seriousness and maturity after formerly "playing thoughtless tricks with his paints and brushes, after the fashion of reckless impressionists."[4]

In judging the group as a whole, reviewers observed among the variety of personalities what the *New York Times* called a general atmosphere "of modern French impressionism." In also recognizing the dominance of Impressionism, a critic for the *Evening Mail and Express*, however, felt that Hassam and Twachtman carried it "to extremes." All remarked how Simmons, Dewing, and Metcalf differed from the rest, representing what seemed to be the "anti-

Fig. 44 Interior of the Durand-Ruel gallery at 389 Fifth Avenue, New York, c. 1900

thesis" of Impressionism. Most observers would have agreed with Cortissoz's characterization of the Ten as "secessionists, but not revolutionists."[5] It was generally conceded that all the Ten were serious artists worthy of interest, and this simple recognition represented a very real victory for the group. Although the title page of their catalogue bravely bore the legend "The First Exhibition," no one, least of all the artists, knew whether or not the exhibitions could become a regular event. By not being dismissed out of hand, the Ten were at least assured of a serious, if not always receptive, audience, and thus could take encouragement. Sales during the exhibition amounted to a single painting each by Reid, Twachtman, and Hassam. It was reported, however,

that the show more than covered expenses through the gate money, and so would be repeated the following year.[6] Henceforth the Ten exhibitions became part of a new trinity of annual exhibitions alongside those of the Society of American Artists and the Academy.

After closing in New York, two thirds of the exhibition—thirty-three paintings—were shown at the St. Botolph Club in Boston, and there, according to the always unfriendly *Art Interchange*, "The remnants of the exhibition did not impress Boston any more than the whole did New York, although curiosity led a good many people to go to see them."[7] In actuality, the press notices of the Boston showing were slight, but not unfriendly, with remarks confined largely to

determining each artist's position along the Impressionist scale.[8]

The second Ten exhibition, held in 1899, was considerably smaller than the first, but what it lost in size it seems to have gained in impact. The *Art Interchange* said the artists represented "the extreme of modern impressionism," while to another critic their art was a "cult" representing the "ultra of the impressionist school."[9] Many agreed that, despite its size, it was a better show than the first. Metcalf was absent, Dewing, Benson, and Tarbell each contributed one work, and Simmons two, leaving the bulk of the showing once more to Hassam, Weir, Twachtman, and Reid who, together, contributed fifteen of the twenty-three canvases that made up the exhibition.

In order to optimize conditions under which their paintings were to be seen, and to prevent the red plush gallery interior from adversely reflecting on their paintings (as they felt it had in 1898), the interior was refitted according to a uniformly light color scheme by covering the red carpet with gray straw "Japanese" matting, and the walls with whitish-gray cheesecloth. Twachtman may have been influential in this interior scheme, since he had used similar hangings in his show at the Wunderlich gallery in 1891, although light-colored walls had also been used more recently at the Society exhibition of 1896, where they were accounted for by the dominance of "followers of Monet" and the "French Luminarists."[10] The Ten did not always insist on these changes, but seem to have used them for the rest of their Durand-Ruel exhibitions. In 1904, for example, we know that they took similar measures, covering the center seating with dull brown-pink velvet and removing the red carpet entirely to expose the bare marquetry floor.[11]

Fig. 45 Joseph R. De Camp, *Jetty at Low Tide*, c. 1900. 22 x 30 in. (55.9 x 76.2 cm). Daniel J. Terra Collection, Terra Museum of American Art, Chicago, 12. 1981

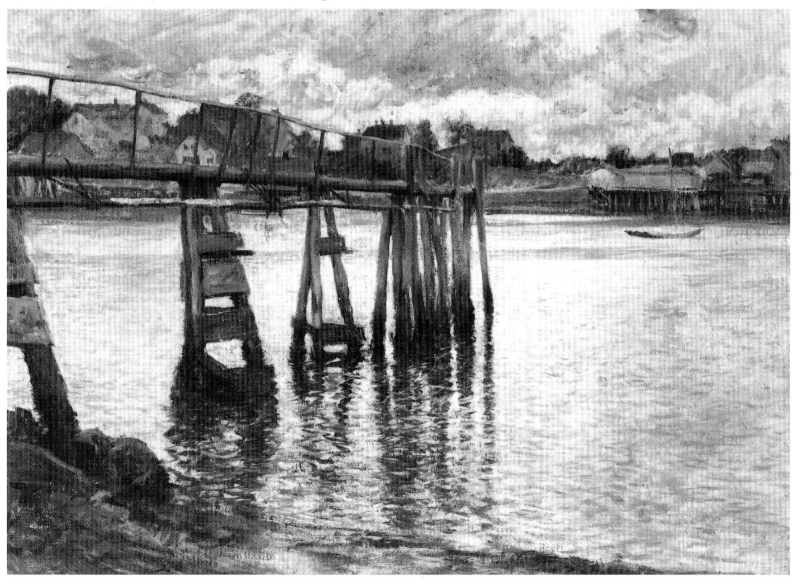

The environment first created in 1899 was considered a great novelty and occasioned much comment. The *New York Times* critic called it "the cleverest and . . . the most artistic little art exhibit that the New York art public has seen in many years. The quiet harmony of color and tone which invests the gallery is most attractive, and creates at once a pleasant impression on entering it, while it is also in touch with the return of Spring."[12]

In some of the Durand-Ruel exhibitions, as indeed throughout the history of the American Impressionist movement, the issue of Impressionism as an imitative and foreign art form also became a factor in contemporary criticism. Many of the paintings Hassam displayed in 1898 and 1899 were scenes of Brittany, Florence, and Rome which he had produced during his trip to France and Italy in 1897 (see plate 9). These were subjects accepted without comment as apparently consistent with Hassam's Impressionist treatment, but when, in 1900, a critic for the *Sun* regarded Hassam's similarly treated view, *Gloucester*, he said that, although admirable for its brilliant sunlight effects, it might as well have been a view of Naples or Capri "so un-American is the general effect."[13] Increasingly, however, there were others who defended the artists as being not imitators but colleagues of the French artists. Said the *New York Times* reviewer in the same year:

Such painters as Twachtman, Hassam, Reid, and Weir, in particular, are not weak because they follow the teachings of Monet. There is a curious and popular delusion in America on this point, and in the rural districts especially, the average art lover flees from what he terms an impressionistic canvas as he would from a mad bull. When, therefore, it is said that the influence of the modern French impressionists is seen in this exhibition, the statement is made in a complimentary sense. Those who have had the opportunity of studying the works of Monet and his followers, particularly of the Giverny school, during the past decade have come to see a great light on the subject of impressionism and are prepared to frankly acknowledge that these painters are perhaps more truthful interpreters of the ineffable and indescribable charm of nature . . . than the world, save possibly through Corot and Daubigny, has ever before known.[14]

As the Ten became more accepted in the course of the Durand-Ruel exhibitions, the diminishing number of hostile critics turned to a more personal form of attack. In the *New York Times*, for example, a particularly derisive series of reviews began in 1901 and continued for several years, giving the group supposedly comic titles, such as the "Sacred Ten" and the "Council of Ten," and arranging its members according to their Impressionist tendencies into the "vibratory seven" led by the "archvibrator" Hassam.[15] In one reference to the distance needed to view an Impressionist paint-

ing it was suggested that a revolving chair be set up in the middle of the gallery from which all pictures could be comfortably viewed at once.[16] Beyond ridicule came the more serious, but by now ancient, objection to the Ten's failure to engage popular and uplifting subjects, with the claim that they preferred to remain "little masters of technique." Said the *New York Times* critic in 1902: "The singular spectacle is therefore offered of a fraction of the art world . . . containing acknowledged masters of the brush, who have nothing to say about religion or politics or everyday life or domestic events of the comedy and tragedy of a great city. They appear to live in some realm apart from mankind Painting as these artists regard it is not a language for the public in which they utter things the public cares to hear, but a Latin understood of the few that possess the necessary schooling, a Court cant which employs words that are caviare to the multitude."[17]

Another form of attack had to do with the fact that the Ten deliberately timed their shows to coincide with the opening of the Society's annual exhibition, which usually took place in March,[18] thus reinforcing both their rivalry with the parent organization and the sense of injury that its supporters continued to feel. Reviewers persisted in scolding them for being poor citizens, and argued that their work did not justify their separate existence.[19]

Despite much public notice, the Durand-Ruel exhibitions failed to bring the Ten any greater commercial success than previously. Simmons related how he and Twachtman once tramped up and down Fifth Avenue all afternoon with their paintings under their arms, vainly offering to sell them to the galleries for $25 apiece so that they could pay their dues at the Players Club, and how Twachtman nearly assaulted one of the merchants who offered him $15 for a painting.[20] Shortly before he died in 1902 Twachtman described his sense of futility in a reply made to a request that he send paintings to one of the important annuals:

You know very well that I should like to send to your show, but I don't see how I can afford to. I can not afford to buy frames for one tenth of the things I have. My pictures have been sent to all the cities in the land and are returned after an absence of from three to six months. Pray tell me what benefit there is to me. I have been doing this stunt for the last twenty five years with large frame bills unpaid. This very month three of my pic-

Fig. 46
J. Alden Weir, *The Gray Bodice*, 1898.
30¼ x 25¼ in. (76.8 x 64.1 cm).
The Art Institute of Chicago;
Friends of American Art Collection, 1911. 536

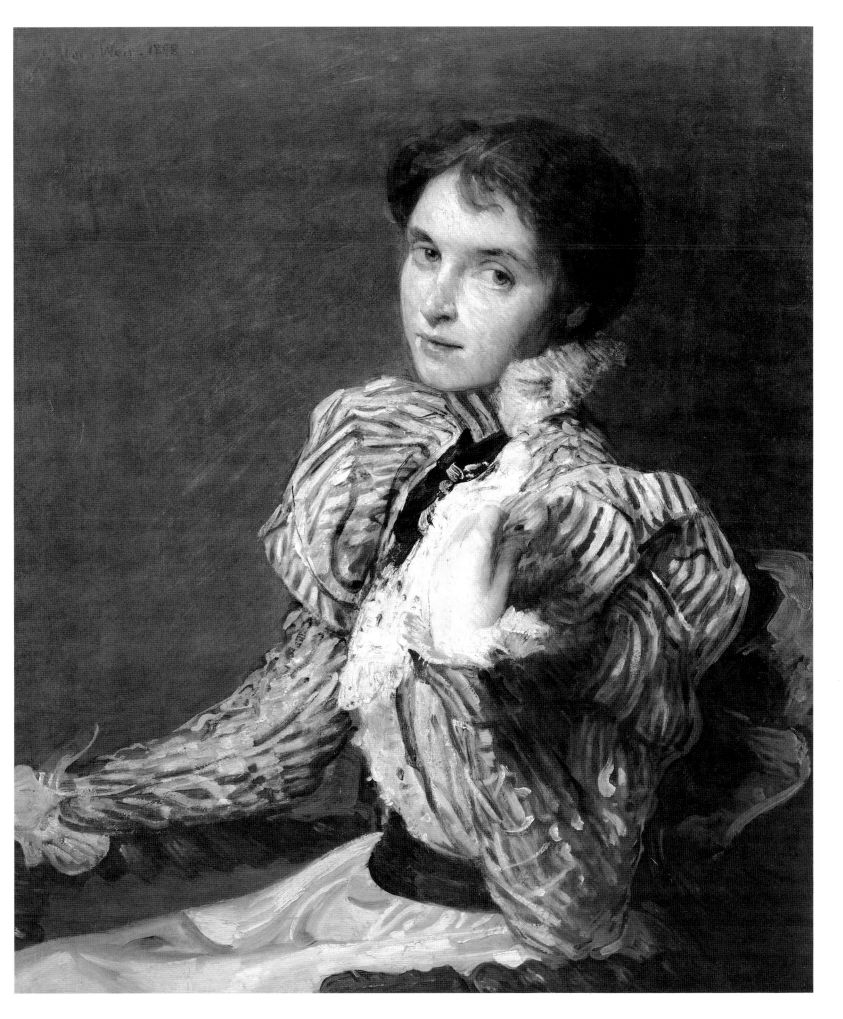

tures will be sold at auction to pay part of a frame bill contracted six years ago. I had to go to the storage place and give names to these three pictures. I can tell you that it was a damned sad task to perform. And you want me to continue at that sort of business? I am going to pack all of my completed canvases and put them in a storage warehouse and drop the exhibition racket entirely. Do not think that I am soured or bitter toward anybody or toward the world at large. No—I have just as much interest in my work as ever and never worked harder than I did last summer and shall do this winter. Look at the matter from my point of view—as a matter of business and you will have to agree with me. [21]

Yet Twachtman did not carry out his threat to stop exhibiting, and a year later again noted that he had shown eighty-five pictures that year without selling one.[22] He was, however, right about his continued commitment to his painting. Despite constant neglect and adversity, Twachtman showed no signs of wearying of purpose or of embracing a compromise that might easily have made his paintings more saleable (see plates 16, 55, 56). His integrity in artistic terms was complete. In tributes written after his death many of Twachtman's colleagues in the Ten emphasized the lifelong neglect he had suffered in what Hassam called "the unrelenting, constant war that mediocrity wages against the unusual and superior things."[23] Elsewhere, Hassam recalled how Twachtman was regularly refused at the National Academy exhibitions, and was poorly hung when he was accepted; Weir, who had nominated Twachtman for the Academy for many years without success,[24] said that even in the year of his death Twachtman's paintings had been rejected from the Academy annual.[25]

There were signs that Twachtman's fortunes may have been turning just before his death. Prices of his works were rising, and it was said that his audiences were growing larger.[26] In 1901 there were several major showings of his work, in Chicago, Cincinnati, and at Durand-Ruel in New York, and in the last letter that he wrote to his wife Twachtman actually gave oblique expression to a feeling of optimism.[27]

The death of Twachtman in 1902 ended an important phase in the Ten's history. His place as a member of the group was kept by a selection of works and memorial wreaths placed in the Ten exhibitions of 1903 and 1904, but time was to show that the loss of his effort, and of the aggressive spirit which he brought to the group, was deeply felt. Over the next years, from about 1903 to 1905, a series of changes affecting both the members individually and the group collectively began to move the Ten in a decidedly new direction. The group that emerged around 1906 was quite different from the one that had been established in 1898.

Compounding the loss of Twachtman was the fact that two other members became marginal participants in the group. In 1901 Reid took on a huge commission to design stained-glass windows for a church in Fairhaven, Massachusetts, which, together with other mural work (for the Boston State House), kept him from easel painting. His contributions to the Ten exhibitions between 1902 and 1905 consisted largely of studies for his current projects.[28]

Simmons, too, had other things to occupy him and became largely an absentee member. He lived in Paris for two years between 1904 and 1906, while working on a mural project for the Minnesota State Capitol, and failed to exhibit in no less than eight of the New York Ten exhibitions that took place between 1901 and 1915. Even when he did make an appearance through an occasional portrait or marine scene, he rarely, if ever, showed recent work and, even in the group's large retrospective of 1908, exhibited works done in the 1880s and early 1890s.[29]

Twachtman's death seems to have especially affected Metcalf, who was a great friend and even resembled him in the makeup of his own smoldering personality. Metcalf had produced and exhibited very little in the later 1890s and, in the early years of the new century, his personal life grew increasingly unsettled through bouts of heavy drinking and the steady carousing that typified his lifestyle, as it did that of his companions Reid and Simmons, whose lives revolved around the Players and similar clubs. After Twachtman's death Metcalf's personal decline moved rapidly towards a crisis. His health was poor, he was penniless from gambling debts, overspending, and lack of employment, and, in the midst of all else, in 1903 an unhappy and ambivalent relationship with his live-in mistress Marguerite Hallé—the model for *The Convalescent* (fig. 51)—culminated in her attempted suicide, which finally pushed Metcalf into marriage. Apparently at breaking point, Metcalf fled New York several months later with his wife, went to his elderly parents' home in rural Clarks Cove, Maine, and settled there for what was to become a period of retreat and personal rehabilitation. During his stay at Clark's Cove Metcalf again worked hard at his painting and completed several dozen canvases, before returning to New York in the fall of 1904. Metcalf referred to this as the start of his "Renaissance," a

Fig. 47 Edward E. Simmons, *Return of the Battle Flags into the Custody of the State after the Civil War* (detail), 1900–2. Massachusetts State House, Boston

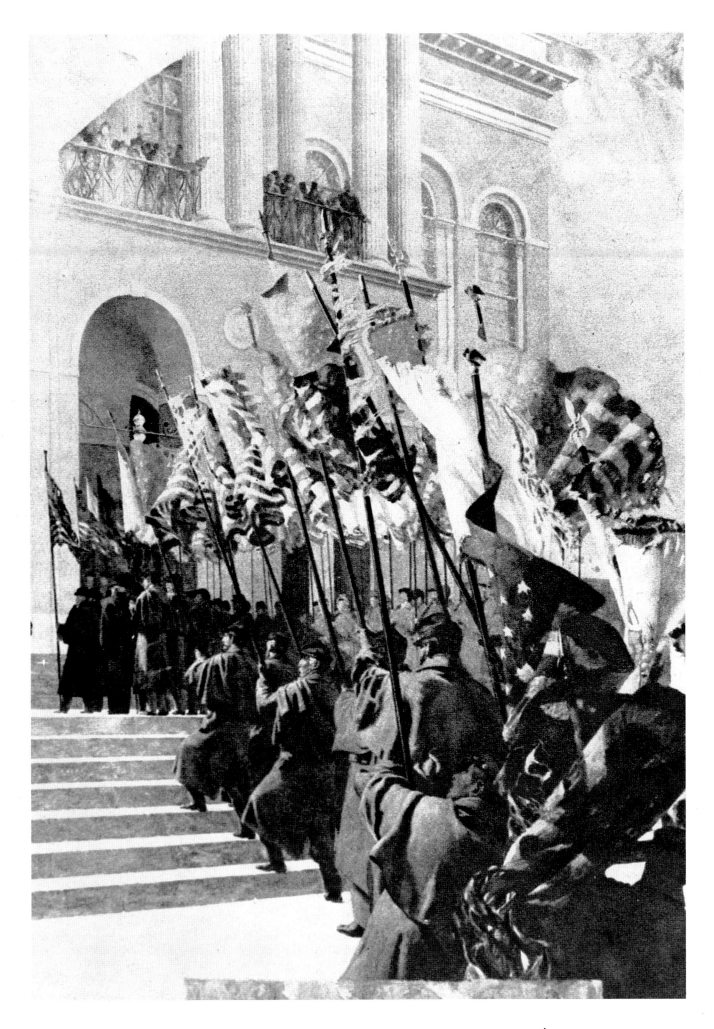

term that perhaps applied more accurately to his personal than to his aesthetic rebirth, which had already begun.

Metcalf seems to have strengthened his ties with Hassam around the time Twachtman died, and paintings such as *The Boat Landing* (plate 14), with its vigorous, broken brushwork, and *Battery Park—Spring* (plate 58), with its concentration on urban landscape, may have reflected Hassam's influence. Beginning in 1903, the two artists began to spend summers at Old Lyme, Connecticut, working there together in 1905, 1906, and 1907; in 1906 they were joined by Simmons, who brought his son and new wife. Hassam was something of an alter ego for Metcalf, and their working relationship over the years resembled the one Metcalf had shared with Theodore Robinson at Giverny in the late 1880s, when they both painted similar subjects. During his stay at Old Lyme in 1906, Hassam painted a number of nocturnes, explaining in a note to Weir in July that the weather had been too poor to do any good outdoor work.[30] Metcalf, too, he said, was working hard on a moonlight scene, which may have been the romantic view of Florence Griswold's inn completed under the title *May Night* (fig. 53) that was to prove one of his most popular works. Some of Metcalf's seascapes and views of poppy fields frankly duplicate those of Hassam and, in one instance, on a visit to Paris in 1913, Metcalf sought out the identical vantage point to produce a variation of Hassam's *Pont Royal, Paris* (Cincinnati Museum) that had been painted more than fifteen years earlier.[31]

Still, Metcalf possessed his own distinct language. It was during the year or so preceding his personal crisis, and above all at Old Lyme, that he began to concentrate on depicting simple scenes of New England landscape and, notwithstanding a few later exceptions, permanently shed his identity as a figure painter. The work that Metcalf did in Maine in 1904, and his later Old Lyme paintings, showed a movement toward greater representational values which, together with the New England subjects, struck an immediate response with audiences. By late spring 1905 exhibitions of his previous year's work in a one-man show at Fishel, Adler & Schwartz in New York, at the Ten exhibition, and in several other group exhibitions, had yielded him a considerable amount of critical praise and the sale of seven paintings. This marked the beginning of a new era of purpose and prosperity for Metcalf. In his review of the Ten show in Boston in November 1906 Philip Hale noted that Metcalf's brilliant but sporadic performances over the past fifteen years had now turned to something much more individual and purposeful.[32] At the St. Botolph Club the same month Metcalf sold ten of the eighteen canvases he showed

in a one-man exhibition. In early 1907 *May Night* won the Corcoran gold medal prize and was shortly afterwards purchased by that gallery for $3,000. Other prizes followed, including the Pennsylvania Academy Temple gold medal for *The Golden Screen*, also purchased by the Academy for their collection. In July 1907, while again at Old Lyme, Metcalf's wife deserted him for one of his young pupils, and Metcalf left, in effect never to return, eventually recuperating at Benson's farm in North Haven, Maine. In the fall Metcalf went back to New York. Life there had inevitably changed. Stanford White, the center of energy for so much of the artistic life on which Metcalf and some others of the Ten had depended, was now gone, murdered a year before by the jealous husband of his mistress, Evelyn Nesbit Thaw. The desertion by his wife represented, in a sense, Metcalf's final break with his former life—or nearly so, for later that year, in an act of ritual separation, he burned several dozen of his earlier paintings.

In the spring of 1904, shortly after the Ten's annual exhibition, Durand-Ruel moved from its gallery on Fifth Avenue to new premises on 36th Street. At this point the Ten severed their connection with Durand-Ruel and, from 1905 onward, exhibited at the Montross gallery, with which they remained affiliated for virtually the remainder of their career. The move to Montross may have been determined by Dewing who, through his work for his patron Charles Lang Freer, knew the commercial side of the business, and who had personally used Montross as his dealer since the mid-1890s. The Ten must have changed galleries for practical reasons of space and location, but it was also true that any former advantage in associating with the pioneering Impressionist gallery had ceased to be of much importance. Like Metcalf, other members of the Ten had begun their rise to public prominence during the first years of the new century and their success, particularly among the Boston painters, rested upon their move away from the gallery's relatively uncompromising Impressionist position toward a more conservative stance. At this point the group may even have been glad to shed the association. For its part Durand-Ruel was content to concentrate on French artists and to leave the Americans to others.[33] One eventual result of the change was that, beginning in 1907, the gallery owner Newman Montross took charge of hanging the Ten exhibitions, a task which until then had been carried out by the artists themselves.[34] He also made the gallery available for numerous one-man shows.

It was during the first Montross gallery exhibition in 1905 that Chase was elected to fill Twachtman's place as a member of the Ten, although he did not begin exhibiting

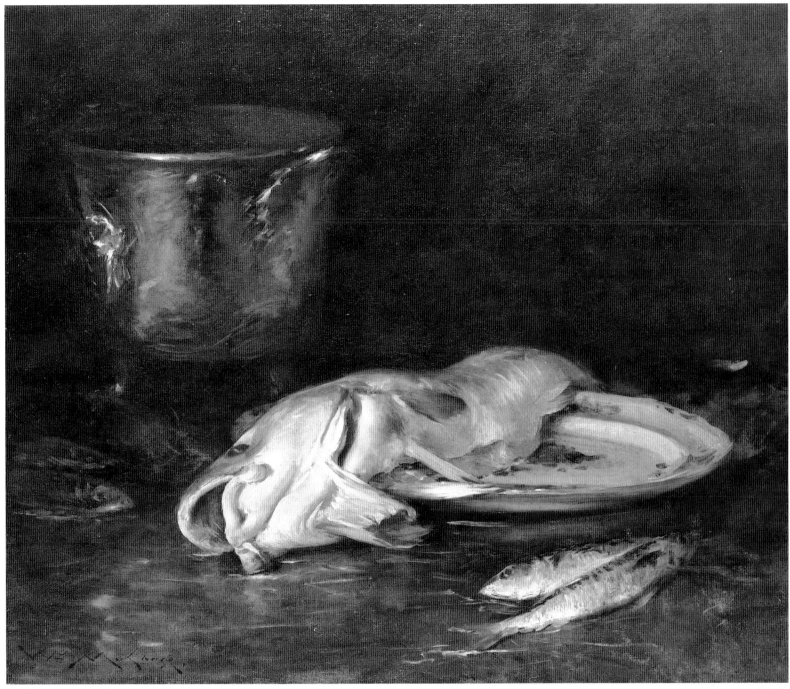

Fig. 48 William Merritt Chase, *An English Cod*, 1904. 36¼ x 40¼ in. (92.1 x 102.2 cm).
In the Collection of the Corcoran Gallery of Art, Museum Purchase, 1905

with the group until the following year.[35] Chase represented an eminent, blue-chip addition, whose long personal and stylistic association with the other artists would have made him an ideal candidate from the beginning.[36]

His long association, as president and current member, with the Society of American Artists suggested to some that Chase could act as a bridge between the Ten and the Society.[37] Yet this was a moot point for, as one critic pointed out, the old differences had grown vague, had not influenced the public in any case,[38] and the Society was already nearing a merger with the Academy, its old nemesis. Chase, however, did venture the opinion at the time of the Society-Academy merger that the time was past for artists to operate in many little organizations and said that the differences among them had been exaggerated.[39]

The sentiment for unity among artists' organizations in New York was also reflected in reviews of the Ten exhibitions. By about 1904 there was considerably less antagonism of any kind shown toward the group, with fewer of the usual remarks about its failure to justify its existence. This reached the point of some rather absurd denials in 1906, when it was even claimed that there had never been a griev-

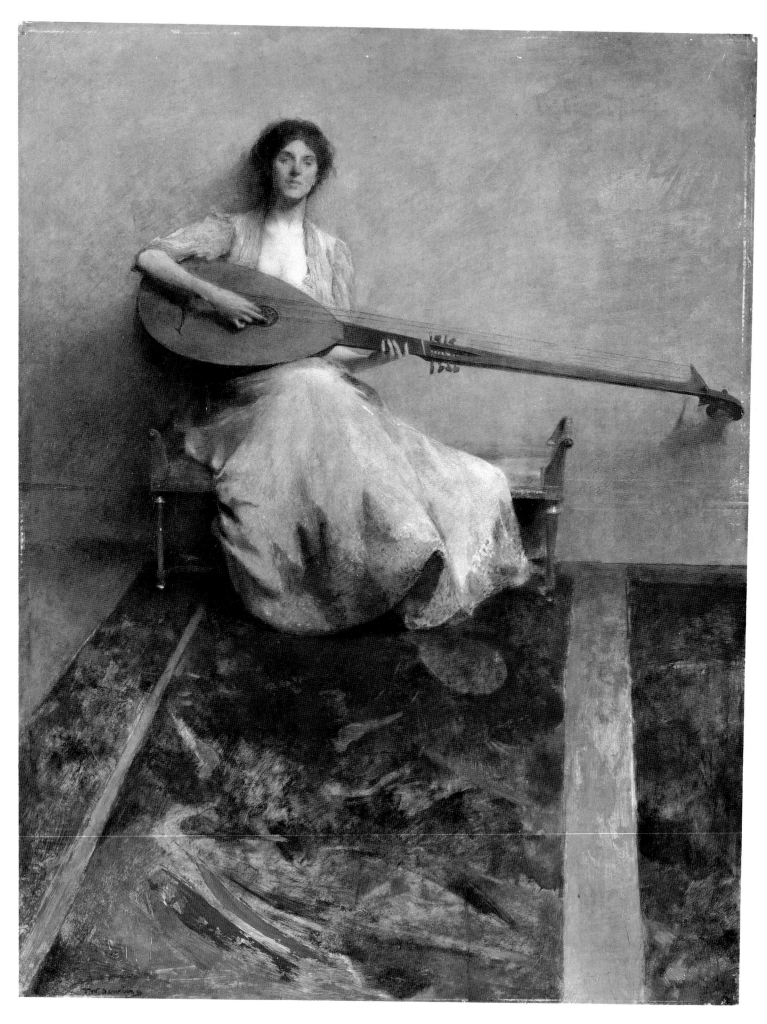

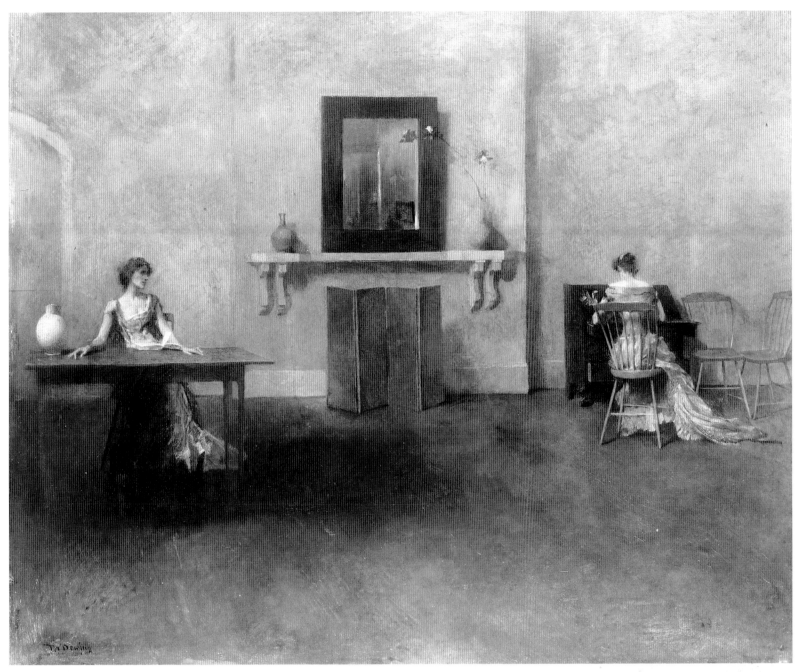

Fig. 50 Thomas Wilmer Dewing,
The Letter, 1908.
Oil on panel, 19⅝ x 24 in. (49.8 x 60.9 cm).
The Toledo Museum of Art,
Toledo, Ohio;
Gift of Florence Scott Libbey

Fig. 49 Thomas Wilmer Dewing,
The Lute, c. 1904.
Oil on panel, 36 x 48⅛ in. (91.4 x 122.2 cm).
Freer Gallery of Art,
Washington, D. C. (05.2 a b)

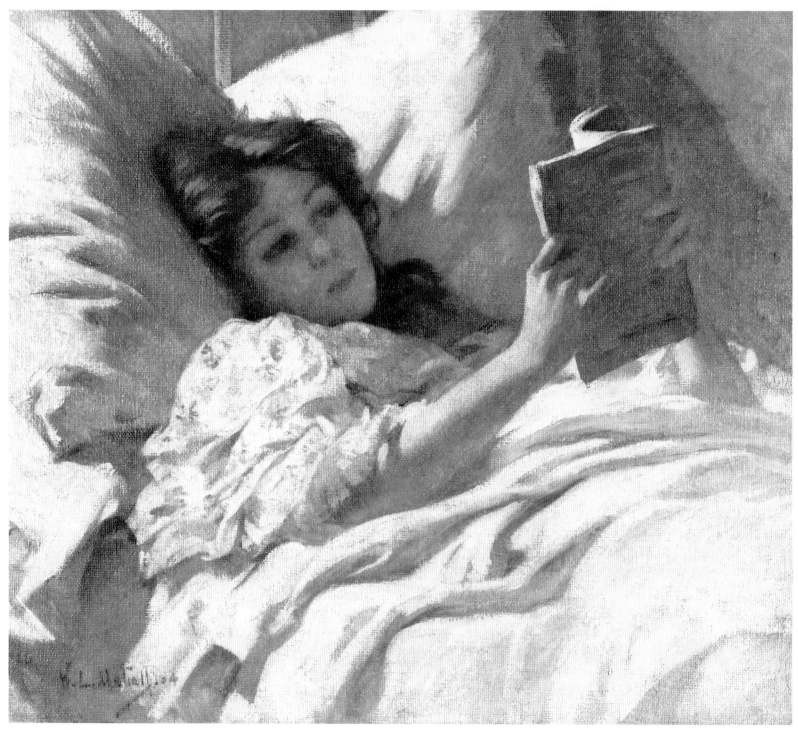

Fig. 51 Willard Metcalf, *The Convalescent*, 1904. 25 x 29 in. (63.5 x 73.7 cm). The J. B. Speed Art Museum, Louisville, Kentucky; Gift of Mrs. Louis Seelbach

ance or a secession in the first place and that these "Independents" were simply a group of like-minded artists who wished to exhibit together.[40]

The merger of the Society and the Academy in 1906 left New York again with only one official exhibiting body, but any conceivable opposition that the Ten still might have symbolized disappeared when three of its members—Hassam, Reid, and Tarbell—became Academicians that year. No less than seven of the Ten were now affiliated with the Academy. Only De Camp, Simmons, and Metcalf were left

out, and the latter would certainly have been elected had he not on principle withdrawn his name when he was nominated in 1907. Under these circumstances, it was difficult for anyone to maintain that the Ten still represented a protest movement.[41]

The popularity of the Ten had been growing steadily, and in 1905 their exhibition even had to be extended beyond its original closing date.[42] With Chase included in the group, an ambitious new exhibition schedule was instituted and, from February 1906 through March 1907, the Ten sent exhibitions

on tour to destinations that included Detroit, Chicago, Milwaukee, St. Louis, Providence, Philadelphia, and Pittsburgh. At the same time articles on individual members started to proliferate in art journals, and directors in charge of the major annual exhibitions eagerly solicited their participation.[43]

In 1906 the critic for the *Globe and Commercial Advertiser* thought the Ten exhibition was one of their best and probably the finest show of the New York season; Metcalf, Hassam, and Weir were said by the *Post* to appear in "new and inspiring phases"; and *Art News* reported that Metcalf had never done better work.[44] Ten years ago, said a critic that year, an American collector demanded Diaz, Daubigny, Cabanel, Meissonier, or Corot, but now the heart of his collection would be made up of American artists—as many Twachtmans as he could get, Sargent, Chase, Tryon, Hassam, and so forth, and Whistler if he were lucky.[45] In 1907 the *Sun* reporter found that the group's exhibition "again demonstrates without any possibility of dissent that the Ten American Painters are making history"[46] and, in the same year, Benson's *Against the Sky* and Metcalf's *May Night* (fig. 53) were awarded prizes by the Corcoran Gallery.

Museums began to acquire works by the Ten: Reid's *Fleur de Lys* was bought by the Metropolitan Museum of Art in 1907, Benson's *Portrait of My Daughters* (plate 67) by the Worcester Art Museum, Massachusetts, and Tarbell's *Preparing for the Matinee* (now in the Indianapolis Museum of Art) by the St. Louis Art Museum. The Boston Museum of Fine Arts in 1908 paid a significant tribute by purchasing for their permanent collection Benson's *Eleanor* (plate 64), De Camp's *The Guitar Player* (plate 71), Metcalf's *May Pastoral* (plate 68), and, the following year, Tarbell's *Girl Reading*, acquisitions which were easily construed as a kind of official imprimatur for these men. The decision followed the Ten's 1908 retrospective exhibition, held in Philadelphia, which the critic William Howe Downes called simply "the best exhibition of American paintings ever held,"[47] and whose ultimate virtue he described as the Boston school's absolute technical perfection.

The regular New York showing of the Ten that year was an especially poignant occasion because in February 1908 a new group, led by Robert Henri and styling itself "The Eight," had held their first controversial exhibition and continued to dominate attention afterward when they were granted a wall of their own at the Academy annual (dubbed by hostile critics "the wall of freaks"). Meanwhile, Tarbell was honored at the same Academy with the prominent hanging of, and a medal awarded to, his conservative portrait of L. Clark Seelye, President of Smith College (Smith College Museum, Northampton, Massachusetts). In the wake of this commotion the Ten exhibition appeared to the *Evening Post* critic, Charles De Kay, as something of a letdown compared to the group's early reputation for controversy, saying that they were now "completely outroared by the young lions of the profession."[48] The *Sun* critic also pointed out that the impact of the group exhibition was blunted by the fact that no less than five one-man shows by members of the Ten had already taken place that year. Nevertheless, the exhibition was heavily attended and produced many sales.[49] Most critics were eager to praise and, in light of The Eight, looked upon the Ten as a source of admirable stability. Joseph Edgar Chamberlain, finding their work calmer, but in no way diminished in quality, said: "It would be hard to imagine a stronger show or a more interesting one."[50] Another critic, Arthur Hoeber, also thought that "no better roomful of pictures has been seen in modern times" and ecstatically held their work to be a cause for optimism over the future of American painting.[51] The *New York Times* critic echoed this sentiment, saying that the group represented "American art on the side of sanity and beauty."[52] G. Pène du Bois, writing for the *New York American*, especially admired Tarbell's *Girl Cutting Patterns* (plate 69) and felt that the Ten's pictures were "academically complete and perfect" and embodied "absolute classicism."[53]

Whether conceived as a countermeasure to The Eight's scheduled exhibition at the Pennsylvania Academy of the Fine Arts in March, or whether arrived at through the friendly relations that John Trask, the Academy manager, maintained with Tarbell and Benson, the idea arose to hold a special retrospective exhibition at the Pennsylvania Academy to mark the tenth anniversary of the Ten. Plans for the exhibition were discussed during the winter months and it was eventually scheduled to run from April 11 through May 3, 1908, following the group's regular annual in New York. Each of the artists was asked to send ten of his best works produced over the years. In all, ninety-four paintings were brought together in three galleries and in part of the Academy's north transept, representing at once the largest, most comprehensive, and most selective exhibition of the Ten ever held. The deceased Twachtman was represented by his painting *Sailing in the Mist*, which already belonged to the Academy. All the Ten members went to Philadelphia at the beginning of April to hang the show. There they had their photograph taken together (fig. 52) and dined with the Academy president on the 8th.[54] (No formal opening was scheduled.)

Trask expected great things of the exhibition and, in negotiating with the group, promised an audience of not

less than fifteen thousand people. However, despite a good deal of advance publicity and favorable comments from those who viewed it—the *Philadelphia Inquirer* said that "for beauty, for distinction and for real aesthetic value, [it] is bound to be recognized as reaching the highest point yet touched by our native painters"[55]—from the standpoint of attendance the exhibition proved a disaster. A decision to impose a separate admission charge was probably to blame, for, out of a total of nearly fifteen thousand people who actually visited the Academy during the period, only 723 paid to see the exhibition. No paintings were sold, and afterwards the Ten were asked by the Academy to make up the loss on the unsold catalogues.[56]

The 1908 shows were watershed exhibitions for the Ten, irretrievably dividing them from the advanced work of The Eight and marking new, late styles for several of the artists that seemed both to confirm their positions as defenders of the *status quo* and to distance them from the particular idiom of their own Impressionist beginnings. The reviewer for the *Philadelphia Press* said straightforwardly that, for rising young artists, the Ten represented the past, pointing out that half of them were nearing sixty.[57] In an article on Benson in the *International Studio* Minna C. Smith described him as having been once "one of our radical painters" but now

his plein-air standard is planted these many days deep in conservative soil . . . to the twenty-year-olds of today, brought up on fresh air, reared in the knowledge of sunshine, ignorant of midnight oil or of unventilated pre-Centennial ideas about art, our excitement over impressionism is as a tale that need not be told. To them the plein-air movement is, quite simply, a paternal influence upon American art, and the secession of the Ten American Artists in 1897 an historic event, too, almost as deep in the mists of time as the formation of the society itself, the Society of American Artists, now reabsorbed into the Academy. As the conservative son of Salem, his radicalism reabsorbed, his paintings show Benson at his best, a painter of distinguished, good-looking or beautiful people.[58]

Benson did not actually become an Impressionist painter until after the Ten was founded. In this sense the Impressionist tendencies of the group—perhaps especially through Twachtman, Hassam, and Reid—seem to have created a convert in their own midst. Though generally unacknowledged, the influence of Chase's earlier paintings was also important to Benson's mature style, as it was to the other Boston painters. In his studio pictures of the 1880s Chase established many of the qualities later developed in the Boston School interiors and, in his Shinnecock landscapes and studies of his family in the 1890s, anticipated many features of Benson's art, including his concentration on intimate family scenes and brilliant sunlight effects.

Benson first painted his children in an outdoor setting in 1898, and returned to the theme with new boldness a year later in *The Sisters* (IBM Corporation, Armonk, New York), in which he first successfully mastered the effects of open air and brilliant colors. In 1900 Benson spent his first summer at North Haven, Maine, an island in Penobscot Bay where he eventually bought a house, and produced a series of sparkling outdoor paintings depicting his wife and daughters (see plates 22, 59, 64, 75). These pictures combined portraiture with a bright Impressionist palette in a formula that brought him immediate success. The lively, modern charm of a bright and spacious natural setting, together with his idealized view of humanity, was described by one critic as the coming together in Benson's art of his ideals of life and art.[59] For though the characters and settings are genuine enough, their sense of age and moment perfectly captured, these are not realistic scenes in any usual sense. There are no tensions, no vanities, no anxieties, no frustrations, nothing, in fact, to disturb the tranquility of the serene beings who inhabit them. What they achieve is a vision of a kind of Victorian Arcadia: the equivalent in human terms of the bucolic landscape. Benson's idealized American family album, illustrating a world of cultivated ease and untroubled contentment, was, in fact, carefully staged, with the daughters tended by maids who saw to their best dresses and helped them pose, and with photographs taken to fix a pose and general outline. Like Robinson, Benson did not hesitate to use the camera as an aid to painting and as a help in "discovering" compositions. Whether he actually painted directly from photographs, as Robinson reproached himself for doing, is doubtful. In at least one case he did convert a single group photograph of his family into two separate compositions,[60] but all indications are that actual painting took place only in the models' presence. Compared to the candid examination of types and scenes from ordinary life favored by the American realists, Benson's paintings were indeed a world apart.

Equally apart from Benson stood Dewing's "little world complete in itself,"[61] the phrase used by Kenyon Cox to describe the artist's utter detachment from contemporary life or reality. Dewing took pride in this distinction, cultivating in his work an individuality which one admirer described as "too exquisite for vulgar comprehension."[62] Although he had never really relinquished his interest in single figure studies, by around 1904 he had shifted away from the outdoor paintings that brought him marginally near the Impressionist orbit to an almost exclusive concentration on interior scenes that recall once more the exercises of traditional academic practice (see figs. 49, 50 and plates

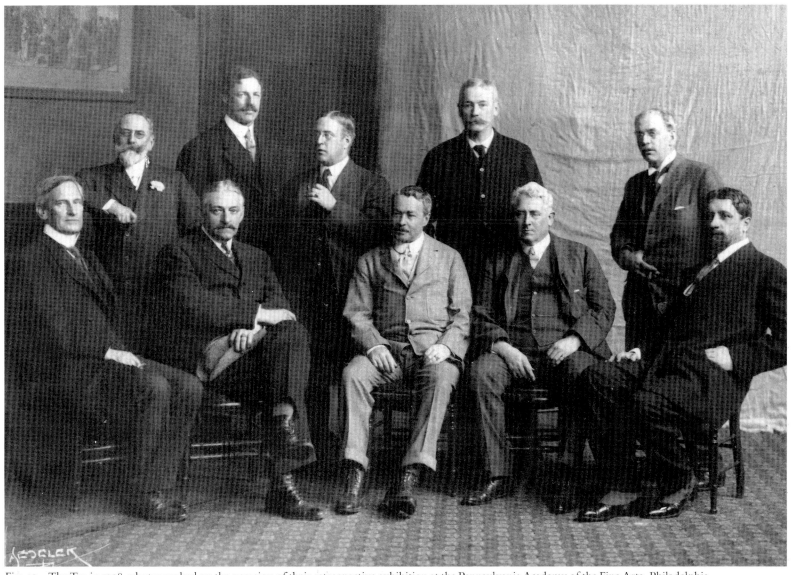

Fig. 52 The Ten in 1908, photographed on the occasion of their retrospective exhibition at the Pennsylvania Academy of the Fine Arts, Philadelphia. Seated, left to right: Edward E. Simmons, Willard L. Metcalf, Childe Hassam, J. Alden Weir, Robert Reid; standing, left to right: William Merritt Chase, Frank W. Benson, Edmund C. Tarbell, Thomas W. Dewing, Joseph R. De Camp

62, 66, 78, 80). Contemporaries often commented on Dewing's models, who played such an important role in his paintings. Charles Caffin said they were selected, not for their conventional beauty, but as models of physical and intellectual refinement: from them Dewing evolved a formal scheme of shapes and color that realized, as Whistler had, the oriental ideal of abstract beauty. "Thus starting as a realist," Caffin explained, "and working with the model continually in front of him, he finally gets beyond the simple objective appearances and evokes from them that essence of beauty which the Japanese call Kokoro—that portion, temporarily manifested in matter, of what they conceive to be the universal and eternal spirit." It was this abstractness, said Caffin, that finally gave Dewing's art that quality of "aloofness" which he considered the hallmark of great art: "The figures, even the accessory objects, seem to be

detached from ordinary usage and suggestion. They live apart in a medium of their own; they are no longer personal, individual; they are not figures and objects; they are Presences."[63]

Sadakichi Hartmann thought he recognized in Dewing's models the tangible representatives of a type of rarified, "emancipated" woman he had known in Boston, whom he felt was captured by Dewing not only in her aesthetic elegance, but also in her "psychological suggestions (produced by indolence in an artistic atmosphere) with a vague mixture of the Parisian demi-monde."[64] Filled with these half-real, half-phantom figures, set in rooms of cell-like austerity with an exactness that is both "artistic" and sometimes mechanical, Dewing's self-imposed prison of the imagination seems to convey a subjective sense of personal isolation and anxiety apart from his conscious aesthetic aims.

Dewing's interest in studio interiors, and his experimental paint handling tied to traditional figure studies, may have influenced Tarbell to move in a similar direction. Some indication of this may be found in the comparison Philip Hale, an influential member of Tarbell's artistic circle, made in 1902 between Dewing's interiors and the work of the Dutch master Jan Vermeer.[65] Specifically, he noted qualities in Dewing that were at once "intensely modern and American" and rooted in traditional representational skills. Tarbell continued in the early years of the century to utilize Impressionist techniques for bright outdoor scenes, for which his family posed—for example, *Schooling the Horses* and *Girl with Sailboat* (plates 17, 73)—while simultaneously pursuing his interest in studio-based interiors after the example of Degas, as in *The Breakfast Room* (plate 53). In 1904, however, Tarbell laid the groundwork for a new involvement with the traditional virtues of painting with his composition *Girl Crocheting* (Canajoharie Library and Art Gallery). Shown at the Ten exhibition of 1905, *Girl Crocheting* was singled out by De Kay, who called it a "masterpiece" for its reminiscences of the old Dutch genre pictures.[66] It was followed by a succession of similar pictures, of which *Three Girls Reading* (plate 70), *New England Interior* (fig. 1), and *Girl Cutting Patterns* (plate 69) are among the finest. Immensely complex and "picturesque," these paintings are infused throughout with subtle interplays of chiaroscuro, texture, silhouette, and perspective. Their emphasis on formal values and the absence of dramatic action are such that the scenes tend to take on the quality of extended still lifes—so much so that one contemporary even accused Tarbell of treating his figures like pieces of furniture.[67]

Tarbell's new "Old Master" style, which he referred to as his "second manner," appealed both to the critics and to the public. Among the conservatives, the painter Kenyon Cox, a strong opponent of Impressionism and the Ten, hailed Tarbell's transformation with an air of triumph. Tarbell's new paintings, he said, were "essentially conservative, based on the soundest and sanest painting of the past" and were work "of the lineage of Vermeer and Chardin, yet with a modern and contemporary accent—a much needed proof that what was always good is good still, and that painting may be very much alive without being revolutionary." Cox did not miss the opportunity to note that Tarbell had once been one of the best of the *plein air* painters and a virtuoso of the brush.[68]

Many others applauded what they also perceived as Tarbell's new and positive blending of modern and traditional values. His good friend, the painter Philip Hale, said Tarbell had brought together "modern suggestiveness with older structural qualities"[69] and, in reviewing the Ten show in 1906, even suggested that it may have been a "defect" for painters like Edouard Manet (and Tarbell in the past) to neglect the fine modeling of form and color in their attempt to reproduce surface light with cold impartiality. The *Sun* critic likewise described Tarbell's new style as "a refinement of so-called impressionistic art,"[70] while another called his treatment "typical of the kind of artistic salvation we in America have worked out for ourselves. It is in all a conservative art, free from excesses."[71]

The names of many early Dutch painters were invoked to account for Tarbell's new style, so that the artist's admirers seemed to grow sensitive on the question of his indebtedness to others, especially Vermeer. His friend Harrison Morris remembered seeing Tarbell at work on one of these paintings in a studio whose walls were lined with unframed photographs of the Dutch and Flemish masters. Tarbell set up numbers of these before his easel, he reported, hoping to gain inspiration in a general way rather than from specific models.[72] Morris found these paintings permeated by the artist's own ambience and by the genteel, antiquarian culture of Boston. Apropos this point, the critic for the *Sun* said of *New England Interior* at the 1907 Ten exhibition: "You say Vermeer or Terburg. Tarbell has imprisoned within this frame a separate national, rather sectional sentiment. It is American and it is New England."[73]

De Camp underwent a transformation similar to Tarbell's, so that by 1908 he, too, could no longer be considered an Impressionist in conventional terms. While at the turn of the century De Camp was still painting outdoor scenes in "high-pitched color schemes," described by one reviewer in 1902 as canvases in which "especially the air and water and the costumes of the figures fairly exhale light,"[74] after 1904 he likewise turned his attention to indoor studio pictures, emphasizing careful draftsmanship and the subdued, glowing tones of the Old Masters. When his painting *The Guitar Player* (plate 71) was exhibited in 1908, J. E. Chamberlain called it "romantic-classic" in sentiment, and pointed out the degree to which De Camp had changed since the founding of the Ten.[75]

By 1907 even Hassam, most steadfastly Impressionist of the Ten, was being accused of reverting to old values. Critics noted the more "academical" nature of his work, and missed the sense of spontaneity and lack of restraint they had admired in his paintings of the 1890s. Actually, by the end of the century Hassam had already begun to shift his attention toward indoor figure work, also adding figures, usually nudes, to his summer landscapes. Moreover, he started to apply a more obvious measure of control to his design and to model forms deliberately with a buildup of thick strokes

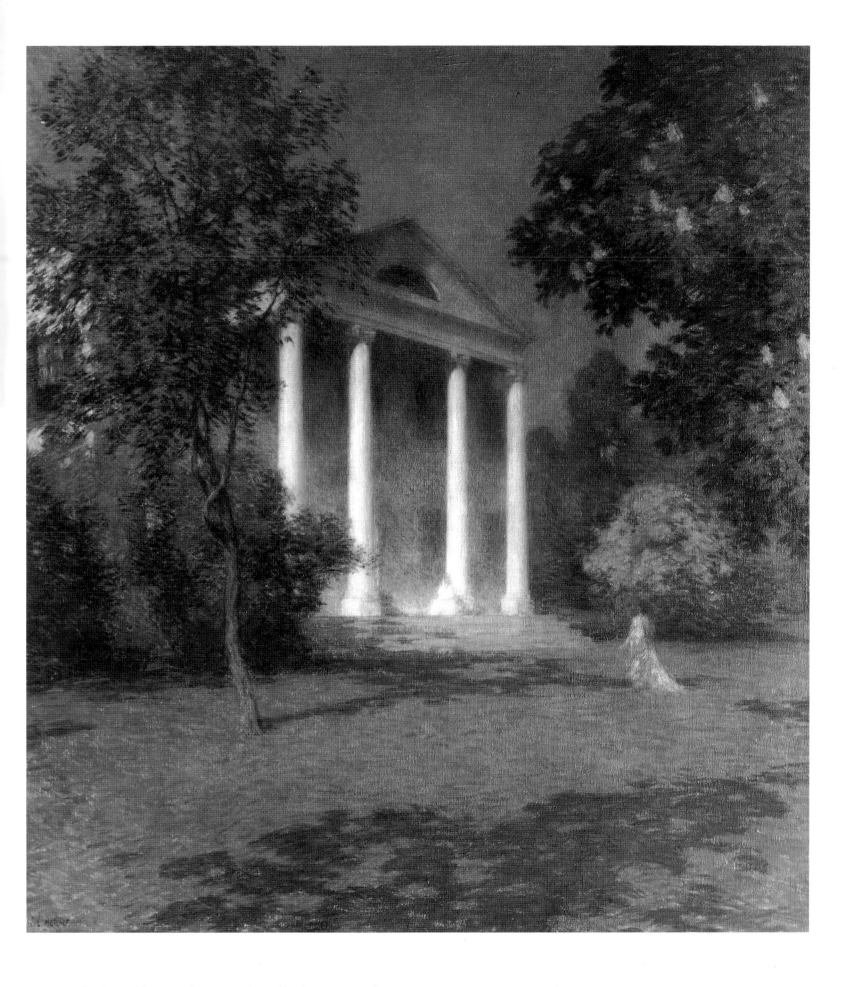

Fig. 53 Willard Metcalf, *May Night*, 1906. 39½ x 36⅜ in. (100.3 x 92.4 cm).
In the Collection of the Corcoran Gallery of Art, Museum Purchase, 1907

of pigment. In the years 1905 to 1907 especially, Hassam produced a number of wooded landscapes or seascapes in a classicizing vein with pseudo-mythological subjects, including a "Lorelei," a "Leda," and an "Aphrodite."

The paintings of these years, possibly because of their more conservative approach, brought some of the Ten a new measure of prosperity. The reputation of Tarbell's figure compositions attracted many lucrative portrait commissions and, for the first time, brought him commercial success. At one point Tarbell wrote to Philip Hale, "I am all of a sudden successful. I have portraits to paint," and in 1908 Hale acknowledged the fact that for Tarbell, Benson, and De Camp "the fat years have come," contrasting their success to the spiteful efforts that had held them back over the past ten years.[76] A Philadelphia critic wrote of the Ten in 1907, with only some exaggeration, that it was no longer true that good artists had to be poverty-stricken. "All of them are prosperous. One at least had an income in 1906 from his painting of at least $40,000, taking known commissions and sales. Not one probably gets through any recent year with less than $7,000 or $8,000 and upwards to his credit without feeling that the public is neglecting him."[77] In 1910 the sculptor Bela Pratt wrote to a former model he and Tarbell had shared: "Neddy [Tarbell] and I have both grown good natured since we have become so prosperous.... I fear we are getting old and losing our snap. Frank Benson and

Joe De Camp also are more mild."[78] Metcalf, who in 1906 had been unable to pay either his summer rent at Old Lyme or the framing bill for his forthcoming Boston show, finally achieved a resounding success at the St. Botolph Club exhibition that fall, where he sold many pictures. In 1907 his income had nearly tripled, and was to remain generally substantial for the rest of his career.

Others of the Ten, however, continued to struggle to make ends meet. "I'm *devilish* hard up," Chase wrote in 1903 to his employers at the Pennsylvania Academy in one of a series of similar notes that continued throughout his Academy tenure. Simmons was so strapped for cash that, during the Ten's retrospective in 1908, he wrote Trask, hoping to urge a sale: "Is there no combination which you and I could make which would end in selling one of my canvases to somebody—even a corporation? ... The price that I put upon my canvases can be considered as a mere attempt. Why could we not dispose of one of them for some very much reduced value and share the results?"[79] Dewing also experienced a series of financial crises, as he asked several times in the fall of 1902 and the spring of 1903 to borrow money from Freer "till I can get on my feet, which will be next winter I am sure.... Everything has been against me this winter, but I shall be all right." In 1908, after returning from the hanging of the Philadelphia retrospective, he again thanked Freer for sending him a $1,000 check, which would "save my life."[80]

Notes

1 Childe Hassam, "Reminiscences of Weir," in *Julian Alden Weir: An Appreciation of His Life and Works*, The Phillips Publications, No. 1, New York, 1922, p. 68.
2 Nothing indicates any prior involvement with the gallery on the part of members of the Ten. The gallery's receipt book, for example, contains no entries for works by them received or sold between 1893 and 1898. Just after their first exhibition Hassam was not even sure Durand-Ruel wanted to handle American works, as he said in a letter of June 29, 1898, in which he discussed sending some of his paintings to the Pennsylvania Academy annual exhibition: "All these things were done last year abroad—and picked out by myself—and other painters as my best things. They were left over there to be framed so they have never even seen this side.... I do hope that they can be hung in a group. I feel that last year with the exception of one or two things my pictures were very badly placed (as Weir and Twachtman told me) owing no doubt to lack of time but more perhaps to the absolute want of sympathy with my work by the committees. The pictures can stay with the framemaker or I will see if Durand-Ruel doesn't want them for the summer. They have so much of their own, however, that I don't think they care to exhibit American pictures." Pennsylvania Academy of the Fine Arts archives, director's correspondence.
3 For some comments on the catalogue, see Orson Lowell, "Three Important New York Exhibitions," *Brush and Pencil* 2 (May 1898), p. 91, and *Art Interchange* 40, no. 5 (May 1898), p. 117. The wording of the book's collophon, stating "This Little Book, Modelled After Les Collections Guillaume was made for Ten American Painters at 139 Fifth Avenue," shows that the group name was intended as a genuine title and was not merely a descriptive phrase, as some have suggested.
 In 1899 a printed announcement listed the artists but no paintings. The press reported that no catalogue was printed that year. For the 1900 and 1901 exhibitions no catalogues exist in the Durand-Ruel archives or elsewhere. Beginning in 1902 a checklist accompanied the Durand-Ruel shows, as was the case with later exhibitions

at Montross and other locations. Fortunately, the contents of the uncatalogued shows can be reconstructed from press reviews.
4 *New York Daily Tribune*, Mar. 30, 1898, pp. 6–7.
5 *Ibid.* It was a statement repeated by him seventeen years later with a sense of comfort in light of the modernists; see *New York Tribune*, Mar. 19, 1915, p. 9. For previous quotations, see *New York Times*, Mar. 30, 1898, p. 6, and *Evening Mail and Express*, Mar. 30, 1898, p. 7.
6 "Art Notes," *Art Interchange* 40, no. 5 (May 1898) p. 117.
7 "Art Notes," *Art Interchange* 40, no. 6 (June 1898), p. 144.
8 See, for instance, *Boston Evening Transcript*, Apr. 27, 1898, p. 16.
9 See *Art Interchange* 42, no. 4 (Apr. 1899), p. 97, and "The Ten Painters," *Collector and Art Critic* 1 (Apr. 15, 1899), p. 4.
10 For Twachtman's exhibition, see *New York Evening Post*, Mar. 9, 1891, p. 7. White cheesecloth covered the walls, and the frames were also white which, according to the reviewer, gave the room a "ghostly look." For the Society exhibition, see *Art Amateur* 34 (May 1896), p. 129. Much earlier, similar arrangements had been made for the 1886 Water-Color Society exhibition held at the Academy in which the walls were covered with "a light-colored Japanese fabric." See *Art Amateur* 14 (Mar. 1886), p. 76.
11 This presumably was possible because Durand-Ruel was soon scheduled to vacate the premises. See "Ten American Painters," *Independent* 56 (Apr. 14, 1904), p. 853. The mention of the "dark lees-of-wine hangings of the galleries" at Montross in 1912 (*American Art News* 10 [Mar. 23, 1912], p. 9) indicates that these practices were eventually discontinued.
12 *New York Times*, Saturday Review of Books and Art, Apr. 8, 1899, p. 240. The *Artist* 25/26 (May–June 1899), p. vii, called it "a thoroughly artistic environment," and the *Commercial Advertiser* (Apr. 4, 1899) said of the new arrangement: "there is a quiet harmony and completeness in a color way that are very agreeable to the eye and unusually

reposeful." See also "The Ten Painters," *Collector and Art Critic* 1 (Apr. 15, 1899), p. 4.

13 *Sun*, Mar. 20, 1900, p. 6.

14 *New York Times*, Mar. 17, 1900, supp. p. 174. Henri Pène du Bois, in the *New York Journal*, Mar. 19, 1900, p. 6, said of the Ten: "They have rejected the rules of the old academies; they have disengaged themselves from the clandestinely illuminated landscapes that the Romanticists and the Realists retained. They have set aside ancient ideas of composition. That is not all; they use black when it pleases them and content themselves, when it pleases them, with the rainbow. They divide tones, they let the complementaries of two colors in juxtaposition act simultaneously and reciprocally on these two colors; they have studied Seurat, Signac, Luce and Van Rysselbergh. Monet has not imitators in them, but colleagues."

15 "The Ten Bolters," *New York Times*, Mar. 7, 1901, p. 8.

16 *New York Times*, Apr. 22, 1903, p. 9.

17 *New York Times*, Apr. 2, 1902, p. 8.

18 In 1901 the Ten were invited to send their show to the Pennsylvania Academy in the spring, and appeared willing until it was realized that there were scheduling conflicts with the Pan American Exposition to be held in Buffalo that year. In discussing the dates, Metcalf stated, "you see we want to show here at the same time with the S. A. A." Metcalf to Harrison Morris, Feb. 6, 1901, and Feb. 28, 1901, Pennsylvania Academy of the Fine Arts archives, director's correspondence.

19 For example, the *Commercial Advertiser*, Mar. 16, 1900, p. 6, expressed disappointment with the work of men supposedly of "pronounced revolutionary ideas." This had been part of the criticism of the Ten from the beginning. The *Sun*, Apr. 1, 1902, p. 6, doubted their reasons for remaining separate, while the *Commercial Advertiser*, Apr. 21, 1903, p. 6, said they were not being good citizens.

20 Edward Simmons, *From Seven to Seventy: Memories of a Painter and a Yankee*, New York and London, 1922, p. 324.

21 Twachtman to Harrison Morris, Nov. 11, 1900, Pennsylvania Academy of the Fine Arts archives, director's correspondence.

22 Harrison S. Morris, *Confessions in Art*, New York, 1930, p. 131.

23 "John H. Twachtman: An Estimation," with essays by T. W. Dewing, Childe Hassam, Robert Reid, Edward Simmons, and J. Alden Weir, in *North American Review* 76 (Apr. 1903), pp. 556–57.

24 Hassam claimed Weir had done so for twenty-eight years, but that would have been impossible. See Archives of American Art, Roll # NAA 1.

25 Allen Tucker, *John H. Twachtman*, American Artists Series, New York, 1931, pp. 10–11. It was even rumored that it was the rejection of Twachtman's paintings at the Society that had triggered the secession of the Ten in the first place. See Royal Cortissoz, in *New York Daily Tribune*, Oct. 6, 1935, p. 10.

26 See Charles De Kay, "John H. Twachtman," *Arts and Decoration* 9 (June 1918), pp. 73–76, 112 ff., and *New York Times*, Mar. 22, 1903, p. 9.

27 "I feel encouraged – like Heine I see the laurel climbing to my window!", quoted in Carolyn C. Mase, "John H. Twachtman," *International Studio* 72 (Jan. 1921), pp. lxxv.

28 The *Philadelphia Inquirer*, Apr. 12, 1908, p. 7a, reported that Reid went almost five years without producing easel pictures.

29 Among these were *Darby and Joan*, *High Sea*, and *Mother and Child* (all unlocated). There were many comments about his delinquency. Arthur Hoeber, in *International Studio* 35 (1908), p. 25, said he used to do good work "but recently and, indeed, almost never in these days does he do himself justice in these displays of the Ten." The *Sun*, Apr. 23, 1908, p. 6, referred to him as "heedless Edward."

30 "Metty is working hard at a moonlight. We are all doing moonlights. The weather has been so bad that we have been forced to it." Hassam to Weir, from Old Lyme, July 7, 1906, Archives of American Art, Roll # NAA 2.

31 Metcalf's *Pont Royal, Paris* is reproduced in Elizabeth de Veer and Richard Boyle, *Sunlight and Shadow: The Life and Art of Willard L. Metcalf*, New York, 1987, fig. 281.

32 *Boston Sunday Herald*, Nov. 11, 1906, p. 1 (Woman's Section).

33 The Durand-Ruel gallery receipt book for the period from 1893 to 1905 (excluding the Ten exhibitions) shows that sales of their works were not particularly good. Twachtman consigned to the gallery the following works: *Landscape* on Apr. 2, 1900; *Effet de neige* on Jan. 17, 1902; and two paintings titled *Winter* on Feb. 12, 1902, all of which were retrieved for the artist's estate by Thomas Dewing on Feb. 18, 1903. Twachtman also consigned on Feb. 12, 1902, a painting whose title is illegibly recorded (# 7069) and which was returned to the artist on Feb. 28, 1902.
Reid consigned *The Red Coat* and *The Echo* on Mar. 25, 1898, which were returned to the artist Apr. 19 of that year; *Landscape* was consigned on Apr. 19, 1898, and returned Apr. 6, 1900; *Fleur de Lys*, *The Canna*, and *Azalea* were consigned on Apr. 22, 1899, and returned Mar. 8, 1899.
Metcalf consigned *Woman and Child* and *Landscape* in Jan. 1901, which were returned to the artist May 6, 1901.
Hassam consigned the following works on Jan. 16, 1903, which, unless noted, were returned to him on Mar. 6, 1903: *Summertime*, *Isles of Shoals*, *Gloucester*, *Outer Harbor* (sold? to B. Guggenheim Feb. 3, 1903), *The Salt Haymarket*, *The Children*, *October Sunshine and Haze*, *Nocturne Princeton*, *Cos Cob*, *An Island Garden* (returned to Katz Jan. 26, 1903), *The Old House*, *Up the River Late Afternoon*, *The Stairway*, *Clouds*, *Old Bridge*, *November*, *Marine*, *Near the Sea* (returned to the Lotos Club Feb. 25, 1903).

The single record of a sale in the gallery's separate stock book (outside the Ten exhibitions) was for Hassam's *Brooklyn Bridge*, bought from W. H. Blake on Mar. 21, 1901, and sold to J. P. Silo Mar. 7, 1907.

34 That year the results of the group's hanging were so distressing that the gallery owner was asked to rehang the show. He sent away the four or five artists present and hung it himself, retaining the privilege every year thereafter. See *Sun*, Mar. 22, 1907, p. 8. This fact is also related by Gustav Kobbein, in *New York Herald*, Mar. 11, 1917, section 3, p. 10. Simmons, 1922, p. 222, said with mild pique that Montross placed the pictures that would sell best in the most favorable positions.

35 See *Globe and Commercial Advertiser*, Mar. 31, 1905. Chase responded to the offer in a letter to Hassam of April 2: "I like to keep good company. I am therefore glad to be one of the members of 'Ten'. It shall be my endeavor to show such things as will be in keeping with the admirable kind of picture you and your colleagues have shown — much to your credit — each year since the society was organized." Hassam papers, Archives of American Art, Roll # NAA2.
After Twachtman's death there were many annoying reminders from the press that the group's number no longer matched its name. The Ten may have discussed a replacement in 1904, for there was a report of the group being enlarged that year. See *Evening Mail and Express*, Mar. 19, 1904, p. 5.

36 There is nothing to indicate whether or not Chase had been asked privately to join at the outset. He probably would have disqualified himself by virtue of his long tenure as Society president. Also he was then at a precarious stage in his career and, with a large family to support, his new private school just underway, and a recent professorship at the conservative Pennsylvania Academy, he may not have wished to embark on a venture that, after all, amounted to a mere gesture. Chase's inclusion in the Ten in 1905 has to be regarded as a sign of respect for his unique status in the art world, and as an acknowledgment of past accomplishments rather than of his current activity.

37 See "Paintings at the Society," *New York Times*, Apr. 11, 1905, p. 11, and "Ten American Painters," *Collector and Art Critic* 3, no. 5 (Apr. 15, 1905), p. 71, where the writer urges the Ten to reunite with the older groups.

38 "Paintings at the Society," *New York Times*, Apr. 11, 1905, p. 11. See also *American Art News*, Apr. 8, 1905, p. 4, where news of Chase's election prompted questions as to how this would affect his relationship to the Society.

39 "Get Together, Says Mr. Chase to Fellow Artists," *New York Times*, May 21, 1906, p. 3.

40 *New York Herald*, Mar. 25, 1906, p. 4 (Literature and Art section).

41 The critic for the *Globe and Commercial Advertiser*, Mar. 14, 1906, p. 4, said that the situation "borders on the humorous. Seven of the Ten, prominently identified with the Academy of Design, [are] retiring from the Society because of its too great conservatism."

42 See *American Art News* 3 (Apr. 15, 1905), p. 4.

43 As an inducement in one case, when the Ten exhibition was to open immediately after a show at the Pennsylvania Academy, the Academy promised to have their paintings specially crated on the closing night of the Pennsylvania exhibition and delivered next day in New York for their own show. Undated letter to Chase from John Trask, Pennsylvania Academy of the Fine Arts archives.

44 *Globe and Commercial Advertiser*, Mar. 14, 1906, p. 4; *Evening Post*, Mar. 16, 1906, p. 7; "Ten American Painters," *American Art News* IV, no. 23 (Mar. 17, 1906), p. 2.

45 "The National Note in Our Art: A Distinctive American Quality Dominant at the Pennsylvania Academy," *Craftsman* 9 (Mar. 1906), p. 754.

46 *Sun*, Mar. 22, 1907, p. 8.

47 "The Ten Painters," *Boston Evening Transcript*, May 9, 1908, section 3, p. 2.

48 *Evening Post*, Mar. 20, 1908, p. 7.

49 *Sun*, Mar. 25, 1908, p. 6.

50 *Evening Mail*, Mar. 19, 1908, p. 6.

51 *Globe and Commercial Advertiser*, Mar. 17, 1908, p. 6.

52 *New York Times*, Mar. 28, 1908, p. 6.

53 *New York American*, Mar. 18, 1908, p. 10.

54 Dewing mentioned the events in a letter to Freer of April 10: "The Show of the 'Ten' is very interesting. My pictures are placed exactly where they look the best. The 'portrait' lady after [?] a charcoal has never been seen in public before and made quite a sensation. We all dined with Mr. Lewis & had our photograph taken in a group." Archives of American Art, Roll # 77.

55 *Philadelphia Inquirer*, Apr. 12, 1908, p. 7a. Trask stated to the Academy's exhibition committee that comments from visitors were extremely positive.

56 "From J. D. Trask. Report to the Committee on Exhibitions, May 11, 1908," Pennsylvania Academy of the Fine Arts archives. De Camp sold his *The Guitar Player* (plate 71) to the Boston Museum of Fine Arts during the run of the show, but avoided the usual commission to the Academy, claiming that the sale had been arranged beforehand.

57 *Philadelphia Press*, Apr. 12, 1908, p. 12.

58 Minna C. Smith, "The Work of Frank W. Benson," *International Studio* 35 (Oct. 1908), p. xcix.

59 Charles H. Caffin, "The Art of Frank W. Benson," *Harper's Magazine* 119 (June 1909), p. 111.

60 The photograph, in the Essex Institute, is reproduced in *The Bostonians: Painters of*

an Elegant Age, 1870–1930, exhibition catalogue, Museum of Fine Arts, Boston, 1986, p. 68, fig. 24. It formed the basis of *Sunshine and Shadow* and *Family Group* (both lost).

61 Kenyon Cox, "Thomas W. Dewing," typescript, Archives of American Art, Dewing file.

62 Charles H. Caffin, "Exhibition of Works by Thomas W. Dewing," *Artist* 27 (Apr. 1900), p. xxii.

63 *Idem*, "The Art of Thomas W. Dewing," *Harper's Magazine* 106 (Apr. 1908), p. 714 ff.

64 Sadakichi Hartmann, "Thomas W. Dewing," *Art Critic* 1 (Jan. 1894), p. 35.

65 *Boston Daily Advertiser*, Apr. 24, 1902, p. 4.

66 *New York Times*, Apr. 16, 1905, section 4, p. 8.

67 *Evening Mail*, Mar. 21, 1907, p. 5.

68 Kenyon Cox, "The Recent Work of Edmund C. Tarbell," *Burlington Magazine* 14 (Jan. 1909), p. 254 ff.

69 Philip L. Hale, "Edmund C. Tarbell: Painter of Pictures," *Arts and Decoration* 2 (Feb. 1912), p. 156.

70 "Typically American Picture Ranks High," *Sun*, Apr. 28, 1912, p. 5.

71 Unidentified clipping reviewing Tarbell's 1912 Copley Society exhibition, quoted in Bernice Kramer Leader, "The Boston School and Vermeer," *Arts Magazine* 55 (Nov. 1980), p. 172.

72 Morris, 1930, pp. 65–66.

73 *Sun*, Mar. 22, 1907, p. 8.

74 *Mail and Express*, Apr. 2, 1902, p. 9, and *Sun*, Apr. 1, 1902, p. 6.

75 John Edgar Chamberlain, *Evening Mail*, Mar. 19, 1908, p. 6. Charles De Kay, in *Evening Post*, Mar. 20, 1908, p. 7, said that in his *Cellist* the "warm tones and powerful chiaroscuro characterize an unwonted style in which the former Mr. De Camp is hard to recognize."

76 For Tarbell's letter, see Archives of American Art, Roll # D 99, and for Hale's commentary, first published in the *Boston Herald*, see *American Art News* 6 (Apr. 25, 1908), p. 4.

77 *Philadelphia Press*, Mar. 17, 1907, p. 10.

78 Bela Pratt to Mrs. Wise, May 25, 1910, Archives of American Art, Roll # 75.

79 Chase to Trask, Apr. 23, 1908, Pennsylvania Academy of the Fine Arts, General Office Files.

80 See letters of Oct. 14, 1902, Mar. 29, 1903, and Apr. 10, 1908; Archives of American Art, Roll # 77.

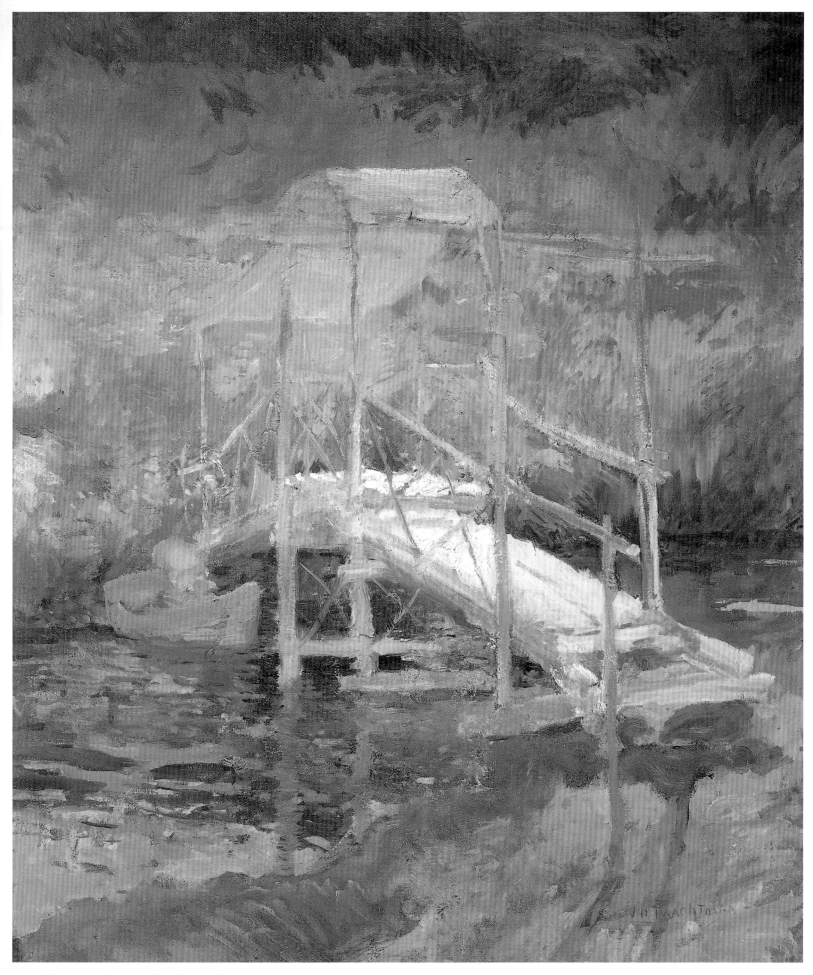

55 John H. Twachtman, *The White Bridge*, c. 1900. 30 x 25 in. (76.2 x 63.5 cm).
Memorial Art Gallery of the University of Rochester. Gift of Emily Sibley Watson.

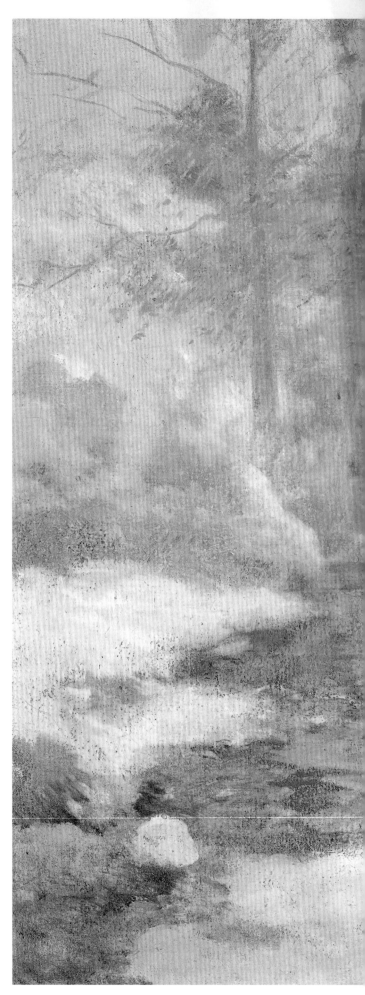

56 John H. Twachtman, *Winter Harmony*, c. 1900.
25½ x 32 in. (64.8 x 81.3 cm).
National Gallery of Art, Washington, D. C.;
Gift of the Avalon Foundation

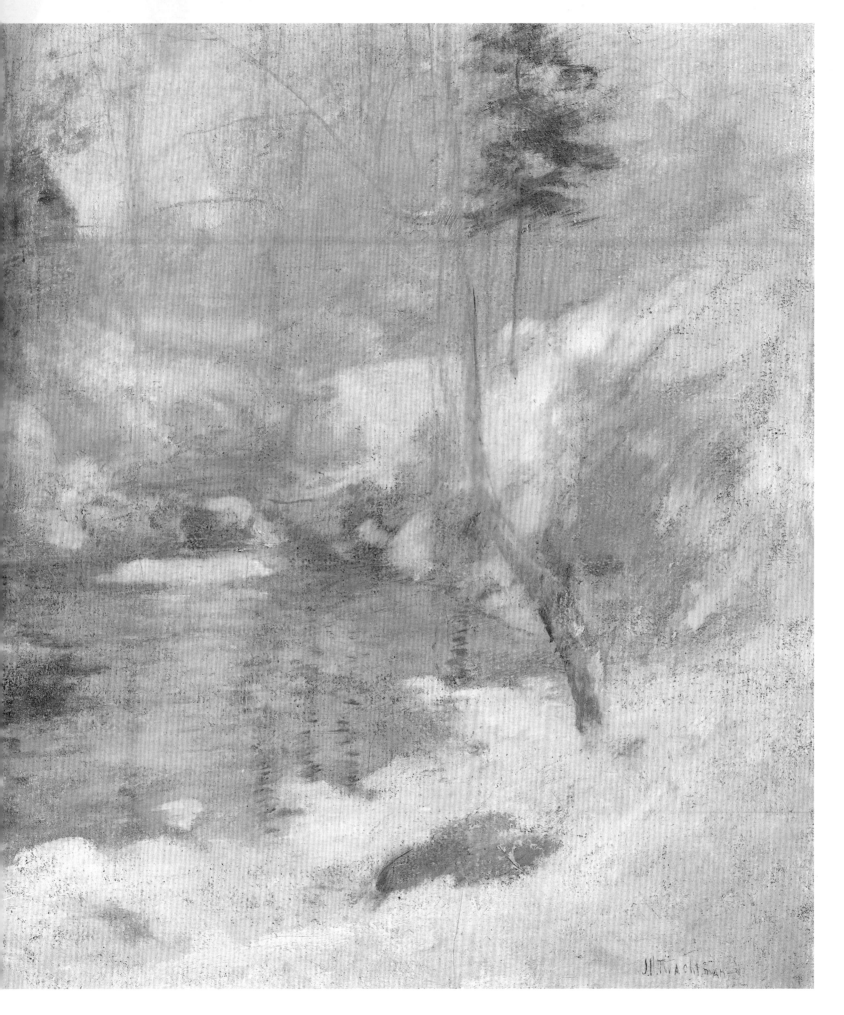

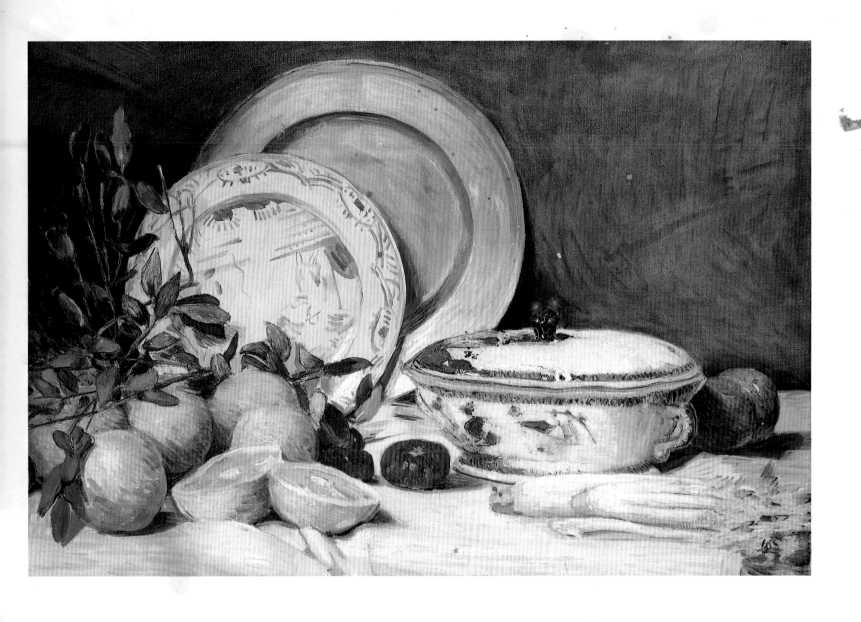

57 J. Alden Weir, *Still Life*, c. 1902/5.
24¾ x 36⅛ in. (62.9 x 91.8 cm).
Indianapolis Museum of Art, James E. Roberts Fund

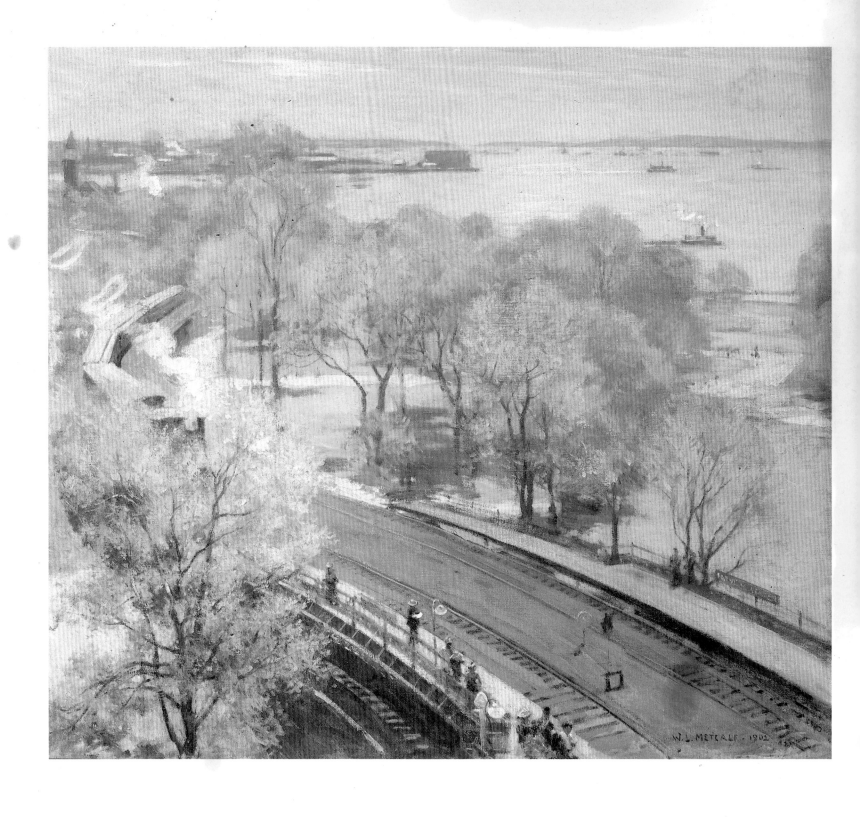

58 Willard Metcalf, *Battery Park – Spring*, 1902.
26 x 29 in. (66.1 x 73.7 cm). Private collection

59 Frank W. Benson, *The Hilltop*, 1903.
71 x 51 in. (180.3 x 129.5 cm).
Malden Public Library, Malden, Massachusetts

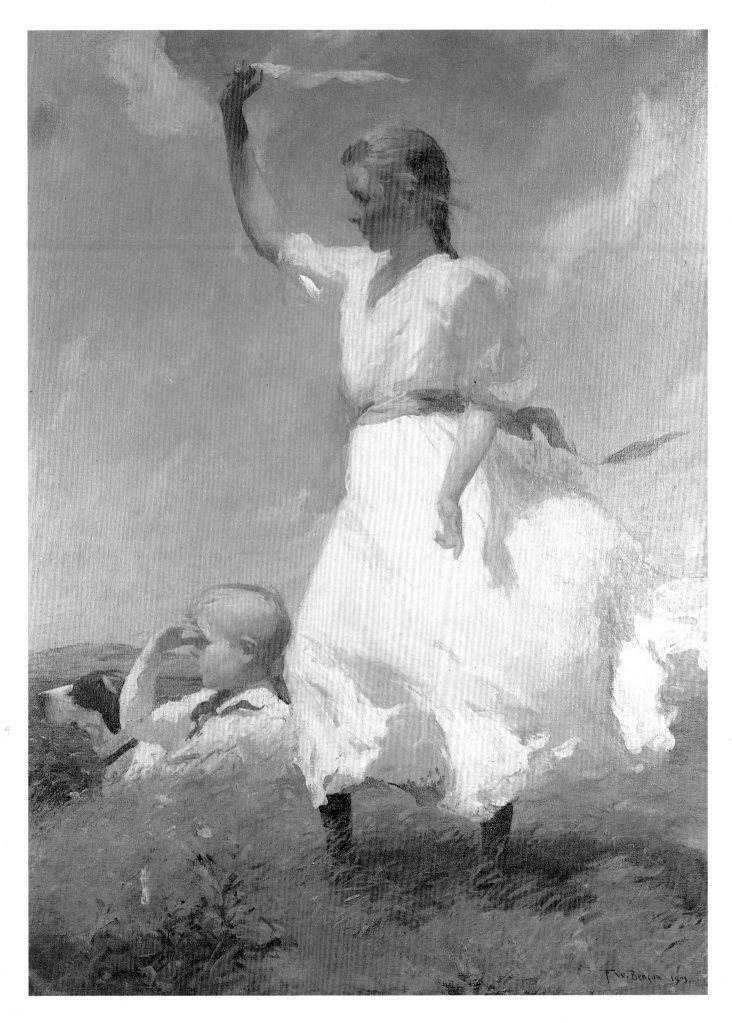

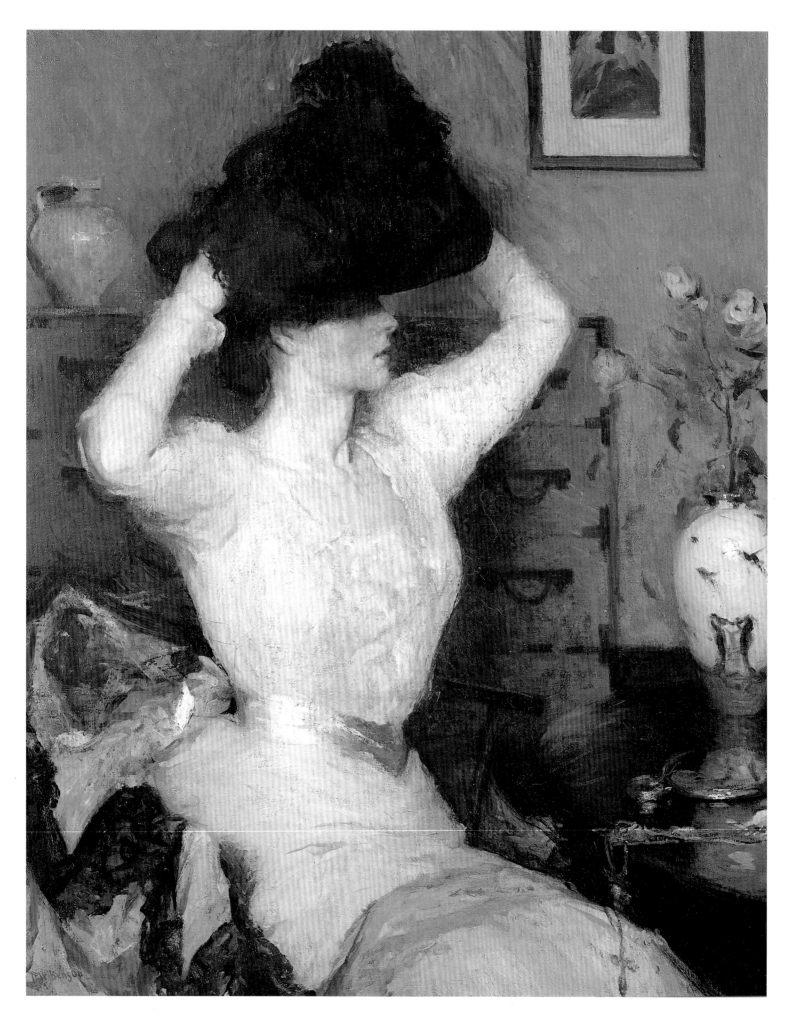

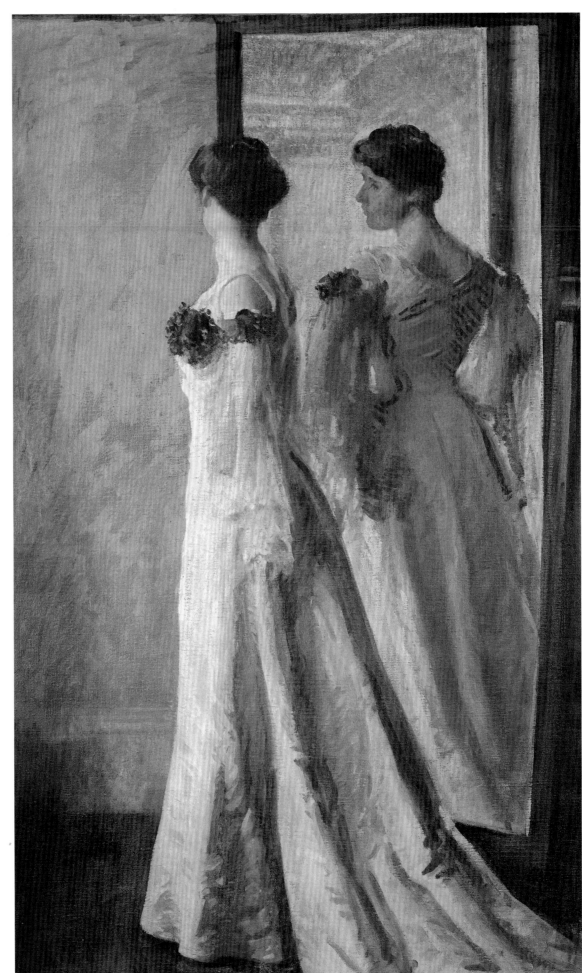

60 Frank W. Benson,
The Black Hat, 1904.
40¼ x 32 in. (102.2 x 81.3 cm).
Museum of Art,
Rhode Island School of Design;
Gift of Walter Callender,
Henry D. Sharp,
Howard L. Clark,
William Gammell, and
Isaac Bates

61 Joseph R. De Camp,
The Heliotrope Gown, 1905.
52 x 32 in. (132.1 x 81.3 cm).
Private collection

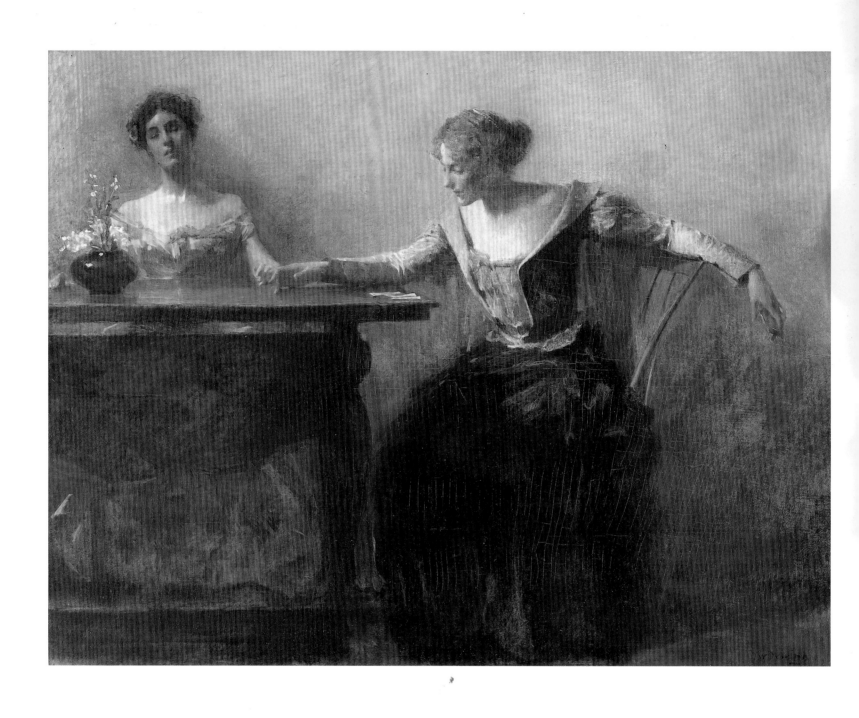

62 Thomas Wilmer Dewing, *The Fortune Teller*, c. 1904/5. Oil on panel, 15¾ x 20 in. (40 x 50.8 cm).
Jordan-Volpe Gallery, New York

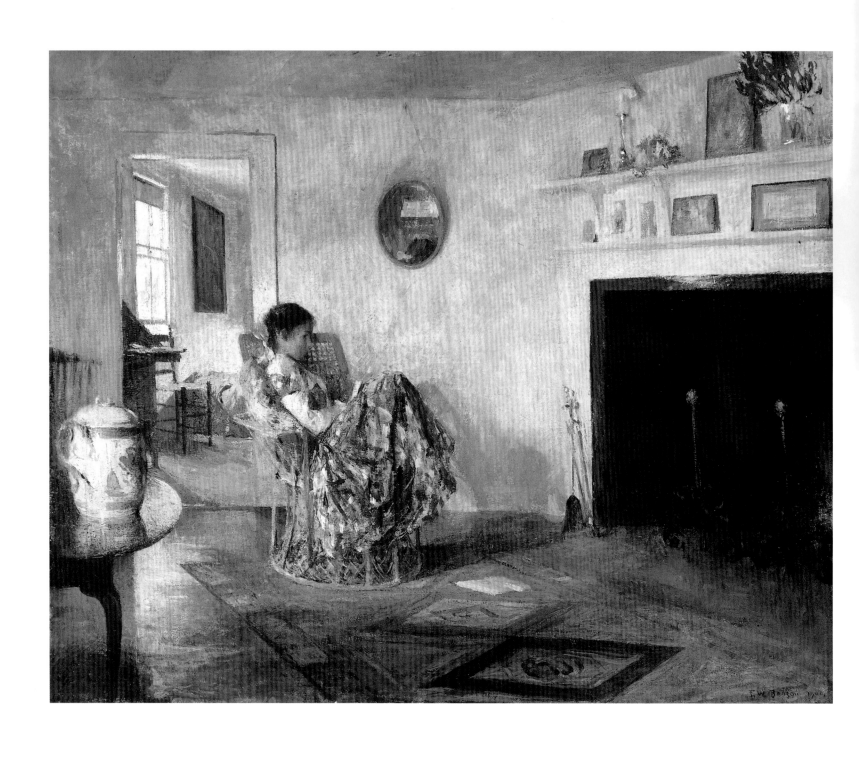

63 Frank W. Benson, *Rainy Day*, 1906. 25 x 30 in. (63.5 x 76.2 cm).
The Art Institute of Chicago; Gift of the Friends of American Art

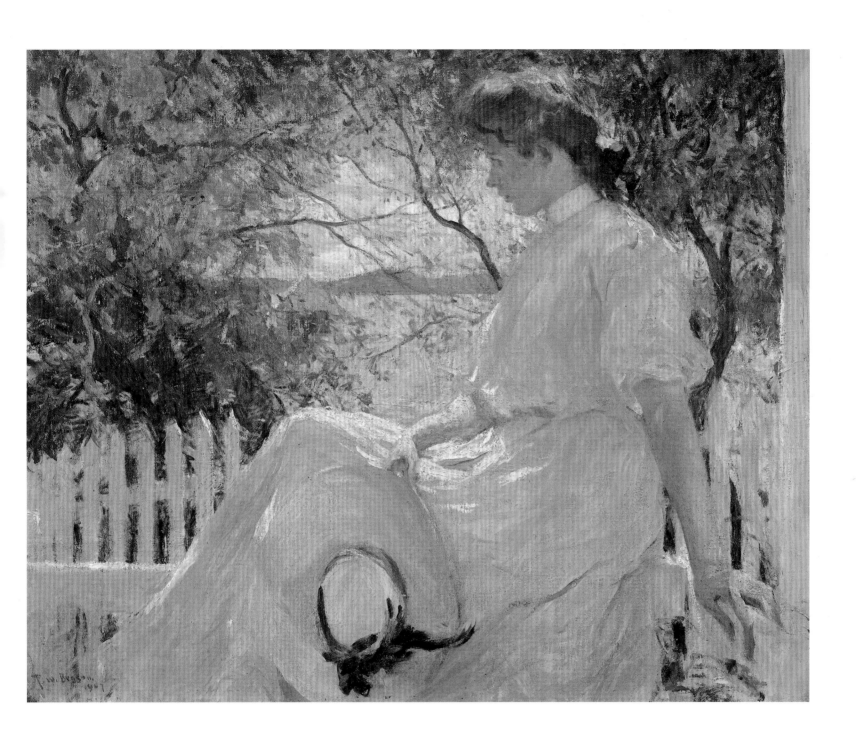

64 Frank W. Benson, *Eleanor*, 1907. 25 x 30 in. (63.5 x 76.2 cm).
Museum of Fine Arts, Boston. Charles Henry Hayden Fund

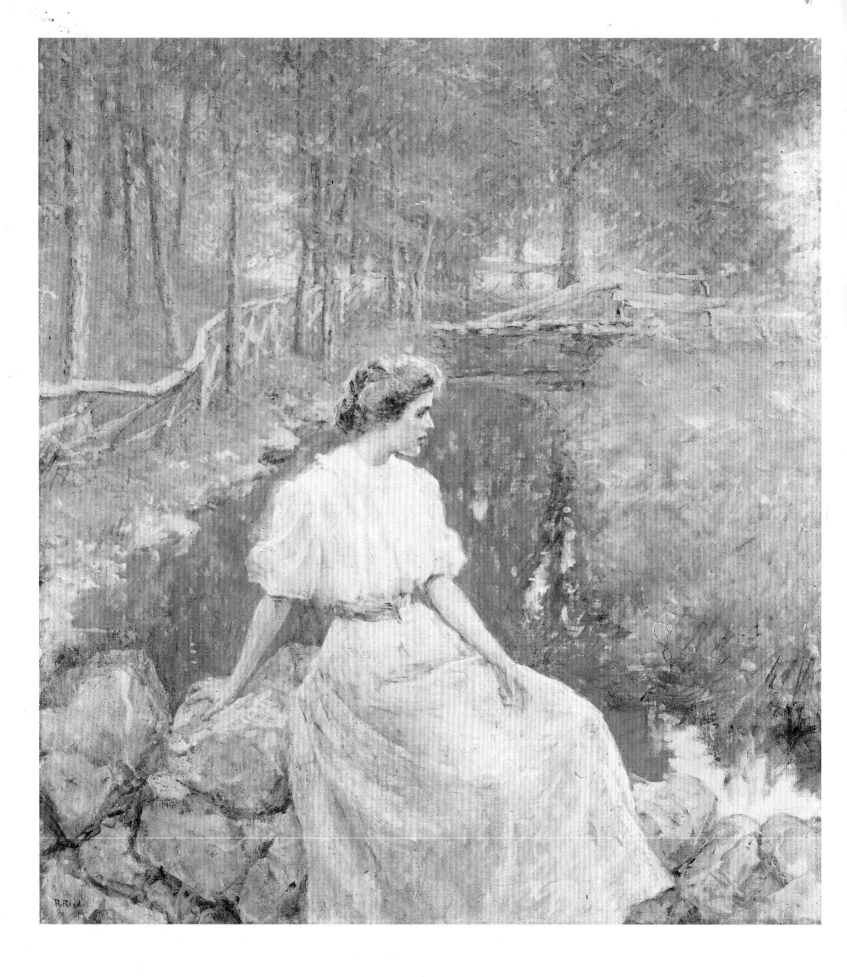

65 Robert Reid, *Spring*, c. 1906. 30 x 25 in. (76.2 x 63.5 cm).
Ruth Sharp Altshuler

66 Thomas Wilmer Dewing, *The Palm Leaf Fan*, 1906. Oil on panel,
24 x 17½ in. (61 x 44.5 cm). Jordan–Volpe Gallery, New York

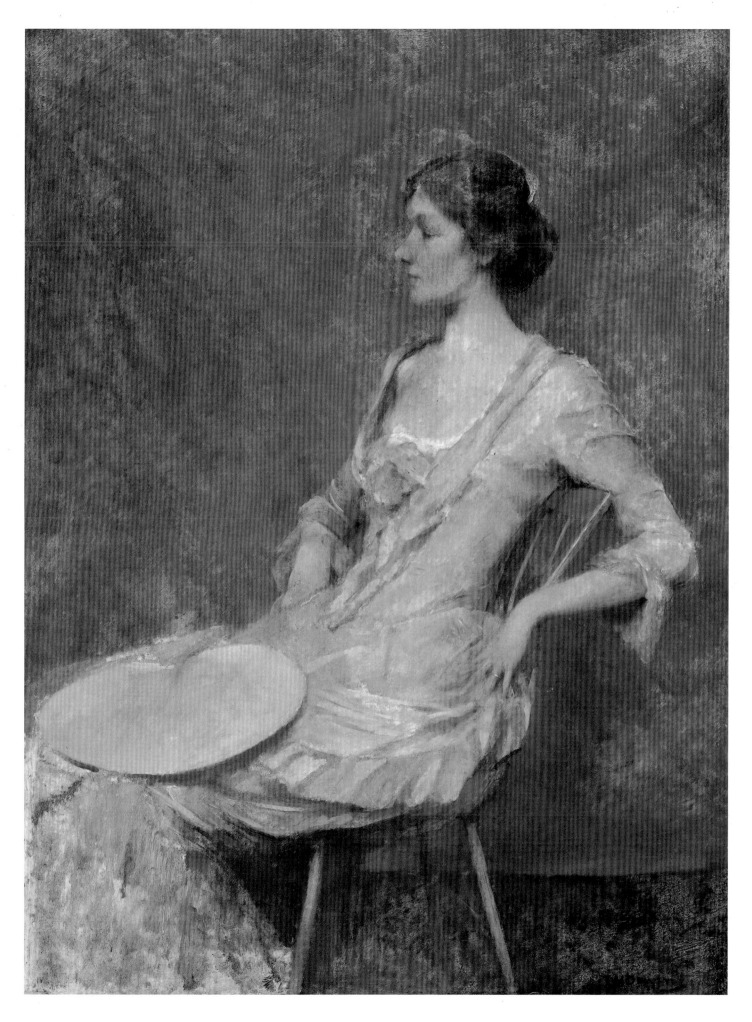

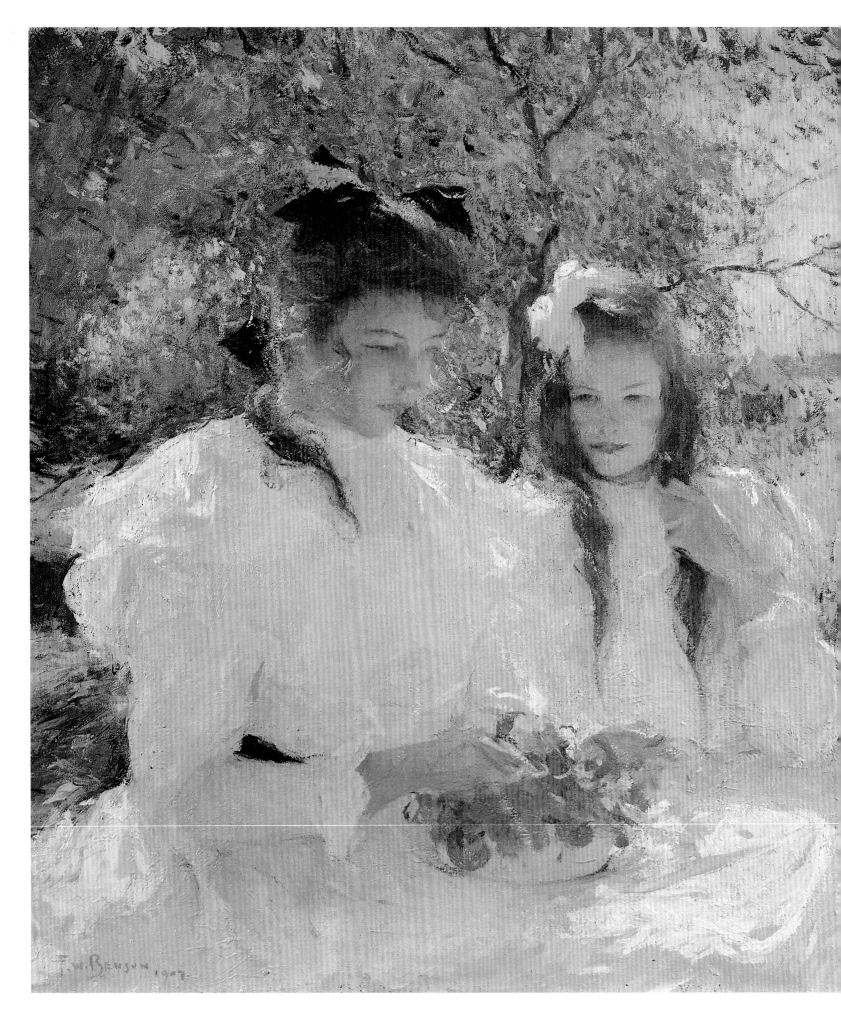

F. W. Benson 1907

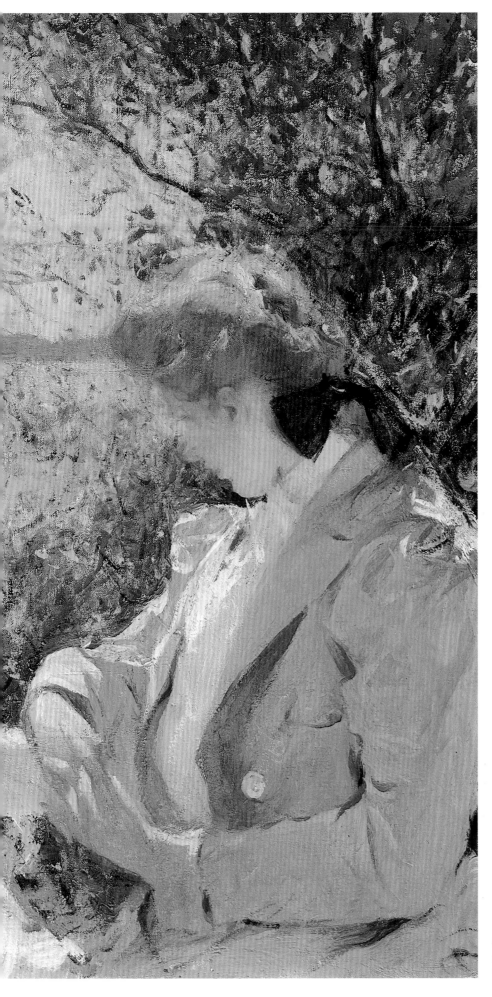

67　Frank W. Benson, *Portrait of My Daughters*,
1907. 26 x 36⅛ in. (66 x 91.8 cm).
Worcester Art Museum, Worcester, Massachusetts

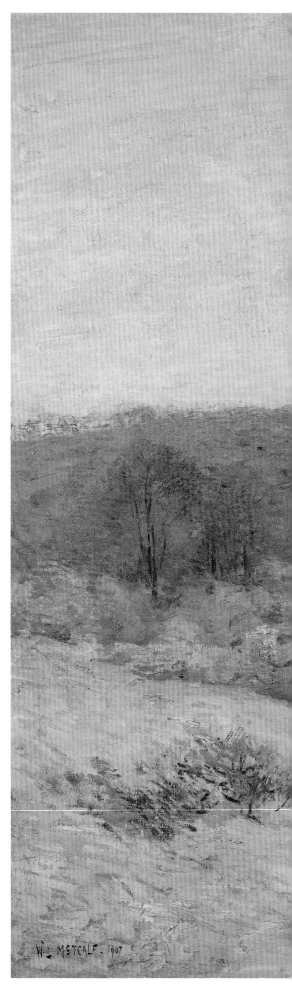

68 Willard Metcalf, *May Pastoral*, 1907.
36 x 39 in. (91.4 x 99.1 cm).
Jordan-Volpe Gallery, New York

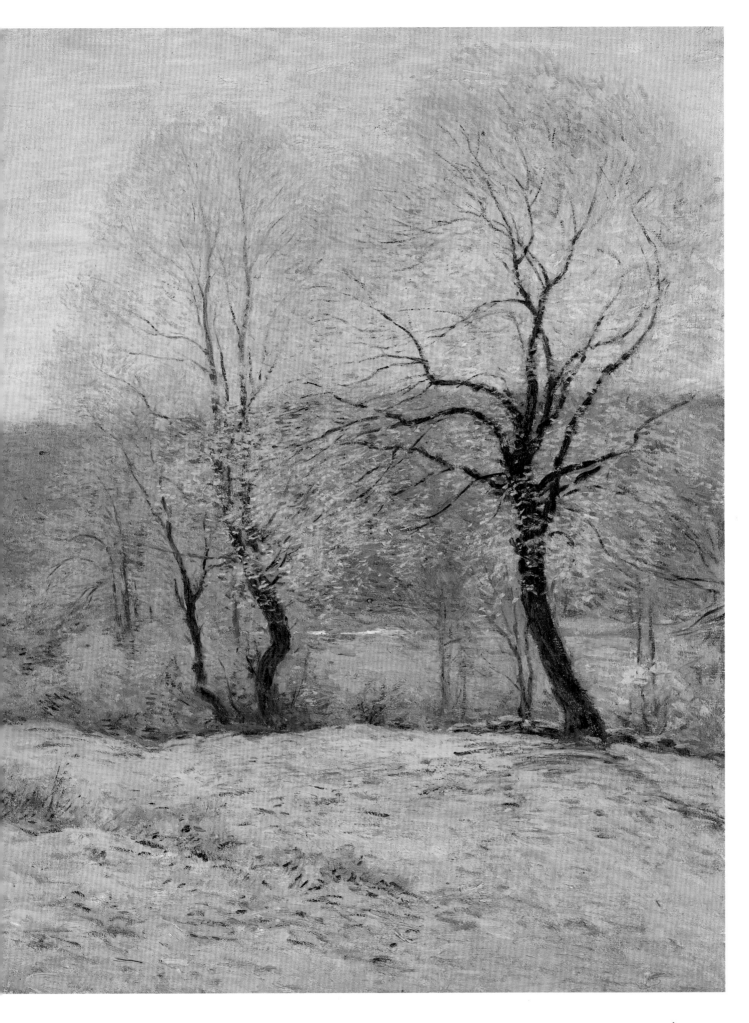

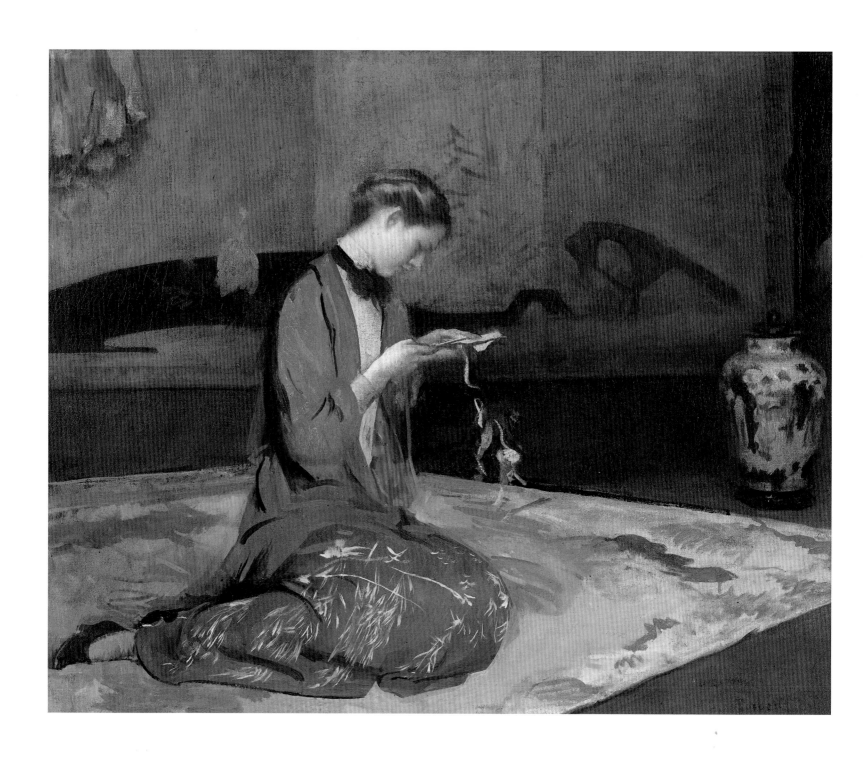

69 Edmund C. Tarbell, *Girl Cutting Patterns*, 1907/8.
25 x 30 in. (63.5 x 76.2 cm). Private collection

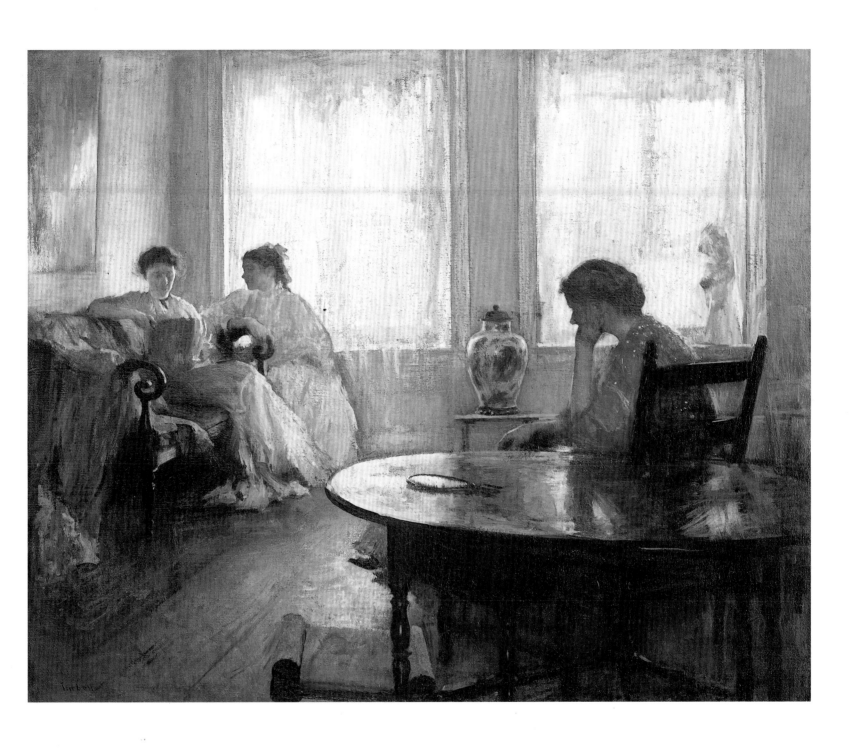

70 Edmund C. Tarbell, *Three Girls Reading*, 1907. 25 x 30 in. (63.5 x 76.2 cm).
Collection of Deborah and Edward Shein

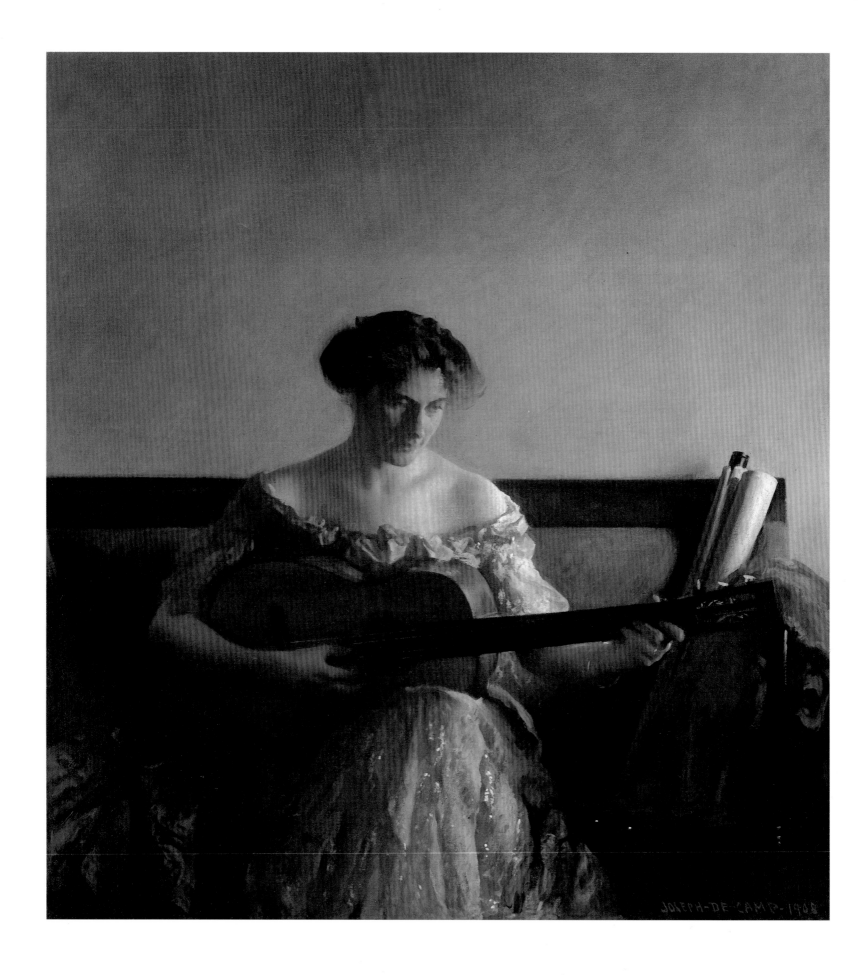

71 Joseph R. De Camp, *The Guitar Player*, 1908.
50½ x 46½ in. (128.2 x 118.1 cm).
Museum of Fine Arts, Boston. Charles Henry Hayden Fund

72 J. Alden Weir, *The Black Hat*, 1898.
30 x 17¾ in. (76.2 x 45.1 cm).
Private collection

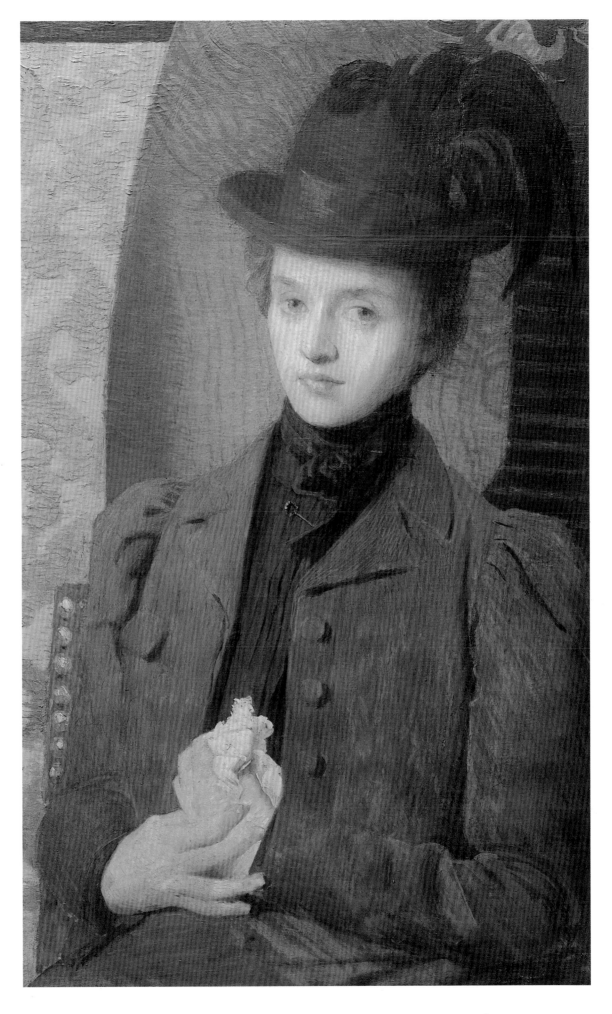

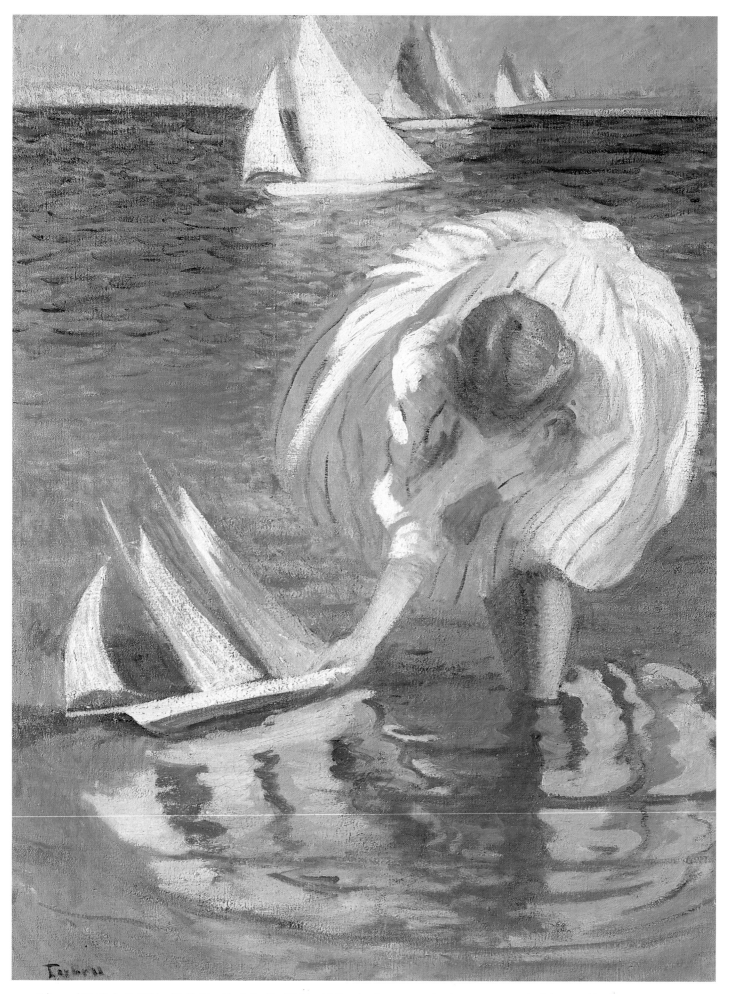

73 Edmund C. Tarbell, *Girl with Sailboat* (originally *Child with Boat*), 1899. 40 x 30 in. (101.6 x 76.2 cm). Private collection

CHAPTER 5

The Challenge of Modernism, 1908–1918

During the last years the Ten existed as a group the rise of the American realist and abstract painters so completely changed the terms of artistic discourse in America that the Ten were left to occupy a position that had suddenly become obsolete. In 1916 the *Sun* critic delivered a kind of valedictory. "'The Ten,'" he said, "are impressionists who once banded together in a sort of protest against the Academy. They were the 'protest' of a generation ago, and as far as the protest concerns ideals it must be allowed that they won the point long since. There is nothing in what 'The Ten' produce that would be now considered offensive at the Academy—in fact Weir is president of the academy.... As the idea that 'The Ten' still represents a protest lingers in the public mind the effort is annually necessary to offset the impression."[1] Of Impressionism itself, he declared: "It was a cause. It is, alas, ancient history. At present people of intelligence do not worry about it. Impressionism is a fixed, settled, accepted quantity, as far as the intelligent are concerned. A new 'cause' occupies the thinkers who contend for and against the offerings of the young 'modernists' ... [but] it would be idle to contend that the average citizen cares for impressionistic work or even knows what it is. When we recall that impressionism is already out of date as a subject for conversation between the well informed it gives one a startling sense of the separation between art and the people, to realize that the community has not even yet arrived at the ideals of forty years ago."

The first organized attack on the position of Impressionism and the Ten came from an equally radical group of artists, eight dissident painters in New York and Philadelphia, led by Robert Henri, who were later known as the "Ashcan School," from the gritty urban subjects they illustrated, or as "The Eight." The story of their organization reads famil-

iarly. Henri, a member of both the Society of American Artists and the Academy, initially worked within the structure of the Academy and served as jury member in 1906; in the spring of 1907 he withdrew his works from the Academy exhibition in a gesture of support for George Luks, whose paintings had been rejected, and, together with his colleagues, announced the formation of their new exhibition group.

The Eight patterned themselves closely on the organization of the Ten, though according to one of its members, John Sloan, it was the press who gave them the similar name. The group's statement of purpose, by which they agreed to operate without formal organization or jury, to exhibit annually, and to adopt hanging arrangements according to equally divided wall space, followed the concepts laid down by the Ten.[2] Not the least of the similarities shared with the Ten was the composite nature of The Eight which joined together in one organization artists as different from each other as Dewing was from Hassam or, for example, as Maurice Prendergast or Ernest Lawson were from Luks or Sloan.[3]

The first exhibition held by The Eight, in February 1908, caused a sensation. An estimated seven thousand visitors saw the show and provided a considerable number of sales. Except for the commercial success, it was an ironically close replay of the founding of the Ten, with many of the same ideas and condemnations applied to the realists as had been to the Impressionists a decade earlier. At first there seems to have been a certain amount of rapport between the members of the Ten and the new group. In 1906, for example, Weir, Metcalf, and Reid joined with Henri, Sloan, and others of the circle to form an exhibition society to show watercolors and etchings.[4] A year later, however, found Chase and

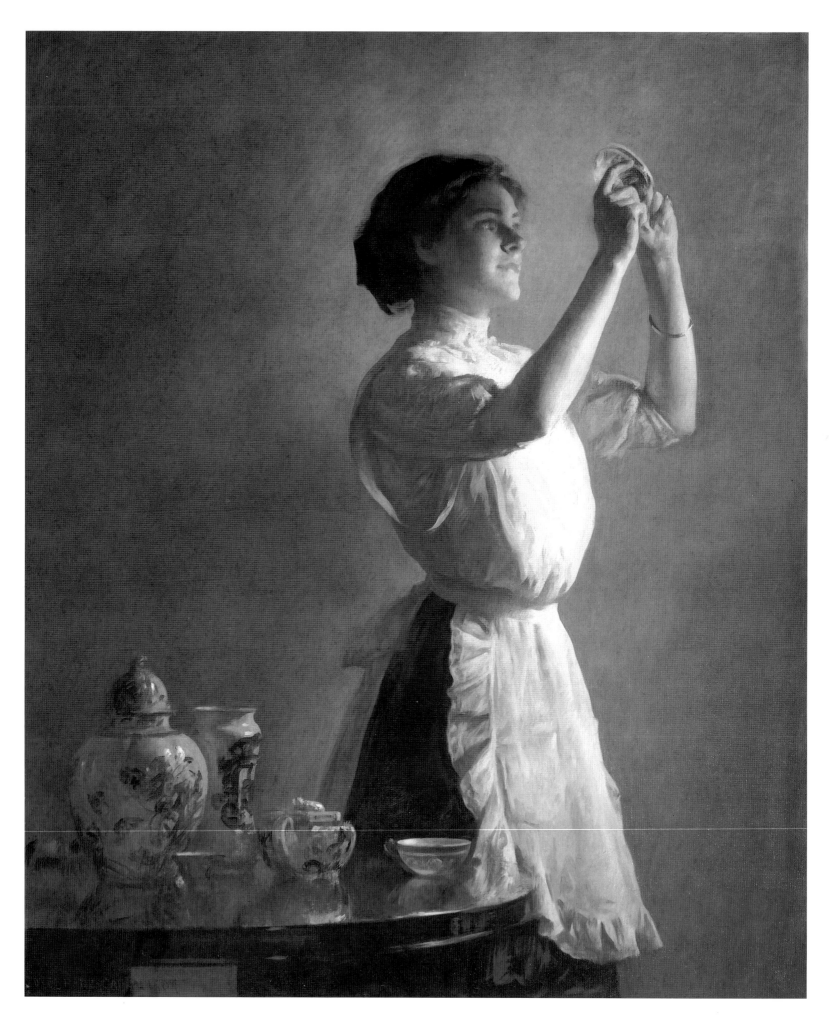

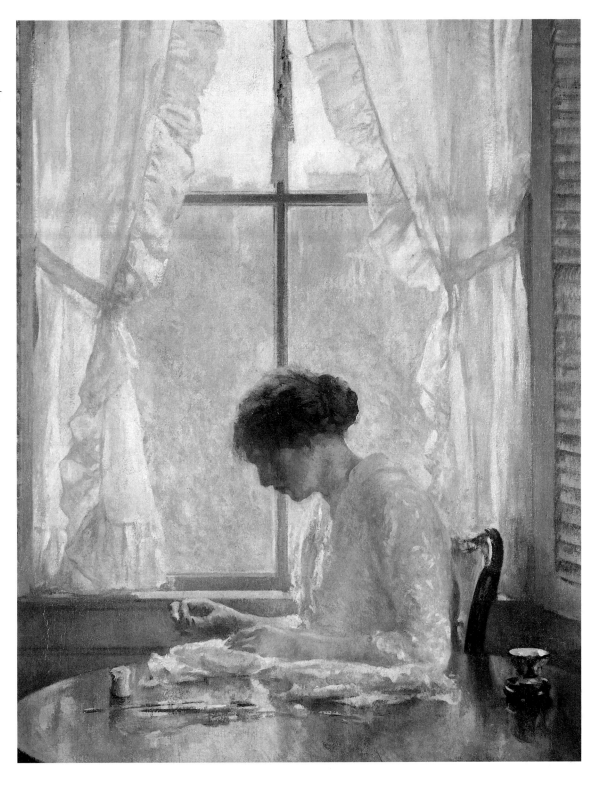

Fig. 54 Joseph R. De Camp,
The Blue Cup, 1909.
50⅛ x 41¼ in. (127.3 x 104.9 cm).
Museum of Fine Arts, Boston. Gift of
Edwin S. Webster, Lawrence J. Webster
and Mrs. Mary S. Sampson, in memory of
their father, Frank G. Webster

Fig. 55 Joseph R. De Camp,
The Seamstress, 1916.
36¼ x 28 in. (92.1 x 71.1 cm).
In the Collection of the Corcoran Gallery
of Art, Museum Purchase, 1916

Henri struggling for control of the direction of the New York School of Art, where they both taught, and indirectly of the Pennsylvania Academy, where Chase was increasingly besieged. As the principal teacher at the Academy in Philadelphia, where the leaders of The Eight were based, Chase had always remained an outsider, often reviled by the conservative press for his "wild impressionism." Among the younger artists, however, he was disliked not for any supposed radicalism, but for the perceived superficiality of his style. In New York, at the New York School of Art

which Chase had founded and where he had brought Henri, then an Impressionist, to teach, Chase reputedly objected to the vulgarity of the subjects painted by Henri and his pupils, while Henri was also known to remark disparagingly about Chase. The situation came to a head in November 1907, when Chase resigned from the school and went back to teaching at the Art Students League. Sloan explained that Henri had become the popular drawing card among the younger students and that "Chase's nose is out of joint."[5] Two years later, when Chase was finally forced out of the

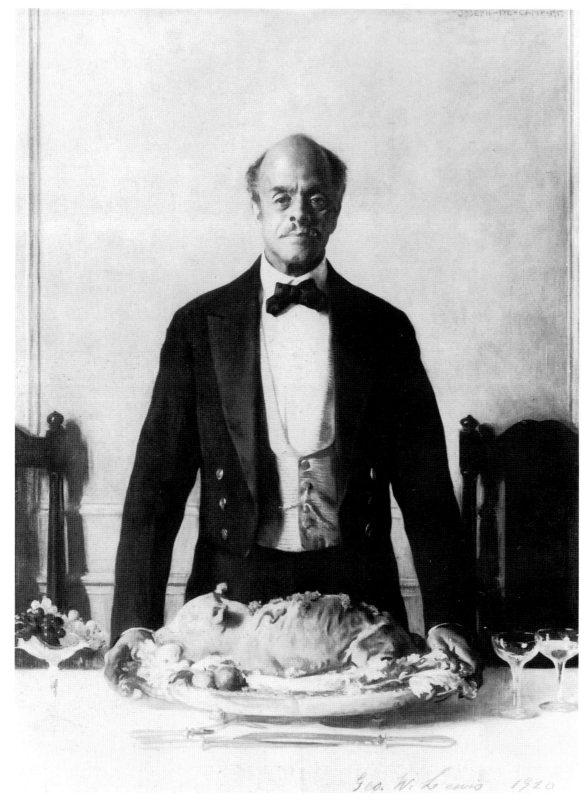

Pennsylvania Academy too, Sloan was among many who received the news with pleasure.[6] He, like others in his group, judged the work of the Ten to be superficial and devoid of life and reality. Later in his career Sloan recalled how in the 1890s he and his friends opposed Impressionism because, "with its blue shadows and orange lights...it seemed 'unreal.'" Chase and John Singer Sargent were meanwhile criticized as being "superficial" technicians.[7]

Following on the heels of The Eight, the appearance of even more controversial abstract European und American modernist painters eroded the authority of the Ten. Works by modernist artists were first seen at Alfred Stieglitz's "291" gallery in New York in 1908—a show of drawings by Henri Matisse—and, in the spring of 1909, in exhibitions of paintings by Alfred Maurer and John Marin, as well as at the Haas gallery, where Max Weber exhibited. When the

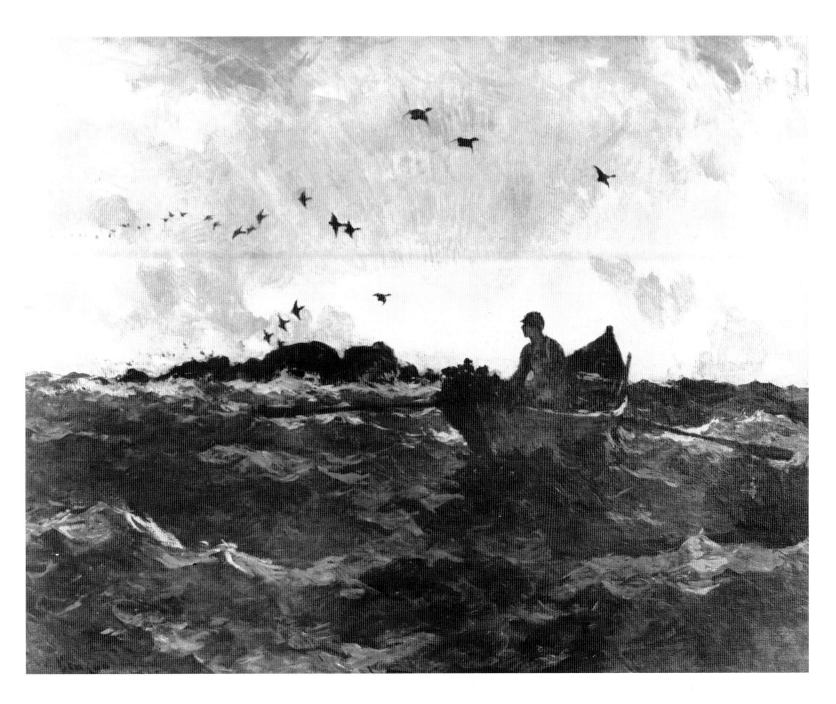

Armory show opened in February 1913 in the Sixty-ninth Regiment Armory in New York, these and other artists permanently changed the face of American art. Alongside radical European paintings by Matisse, Vasily Kandinsky, Pablo Picasso, and Georges Braque, the American avant-garde was now represented by Maurer, Marin, and Joseph Stella, among others.

Both the critical and the commercial environment of the New York art world was also drastically altered. Within a few years dozens of new galleries and organizations were established to show Post-Impressionist, Cubist, Futurist, and other modernist artworks from Europe and America. Exhibitions of the advanced new styles were counted literally in the hundreds, and even the older, established galleries took part. [8]

The Armory show also included many French Impressionist and Post-Impressionist works, as well as works by the Ten. Twachtman was represented, and Hassam and Weir both sent a considerable number of paintings. The Eight were heavily represented as well, including William Glackens who, in an interview that took place during the show, acknowledged modernism's debt to Impressionism and the Ten:

Theodore Robinson, Hassam, Weir and Twachtman were the first to bring here or to show the influence of the French impressionists under the leadership of Monet. They brought into our art a new theory of color, a color that was honestly derived from the color of nature. They brought into the country, in fact, a truth that we had not fully realized. They sent our landscapists out into the open, sent them out after a new view of nature and

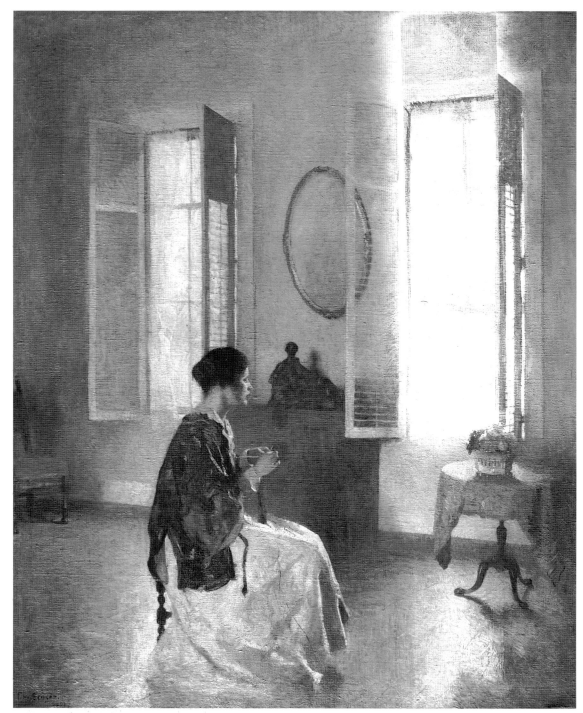

Fig. 58 Frank W. Benson,
The Open Window, 1917.
52¼ x 42¼ in. (132.7 x 107.3 cm).
In the Collection of the Corcoran Gallery
of Art, Museum Purchase, 1919

Fig. 59 Robert Reid, *Lady with a Hat*
(originally *The Furs*), c. 1910/11.
36¼ x 30 in. (92.1 x 76.2 cm).
The Chrysler Museum, Norfolk, VA

cleared away the murkiness of the studio landscape. The impressionistic color was accepted immediately but, unfortunately, not the new spirit of that new color. The academicians—I mean the school men—accepting it remained academicians. They reduced the color into a formula, as they ever do, concocted without particular regard to nature. It became as academic, as abstract as they.[9]

The Ten opened their annual exhibition in the spring of 1913 while the Armory show was still in progress. Weir had a large representation, but Metcalf's *The Winter's Festival* (plate 25), a Cornish winterscape, was probably most publicized. Metcalf even came down from Cornish to see both

the Armory show and the Ten's exhibition. Hassam did not think much of the Ten exhibition and remarked that nothing was selling.[10] The reviews the Ten received were not only mostly positive, but also surprisingly free of direct comparisons to the modernists, although the *New York Times* alluded to the group significantly as a sign of continuity in a changing world.[11] Royal Cortissoz, after criticizing the Ten's two previous exhibitions, found the 1913 show full of vitality and youthfulness, though he disapproved of Benson's *Grey Room* (private collection) as being more a tableau than a study from life.[12] In Boston the show was particularly well reviewed. The *Evening Transcript* critic thought the show was

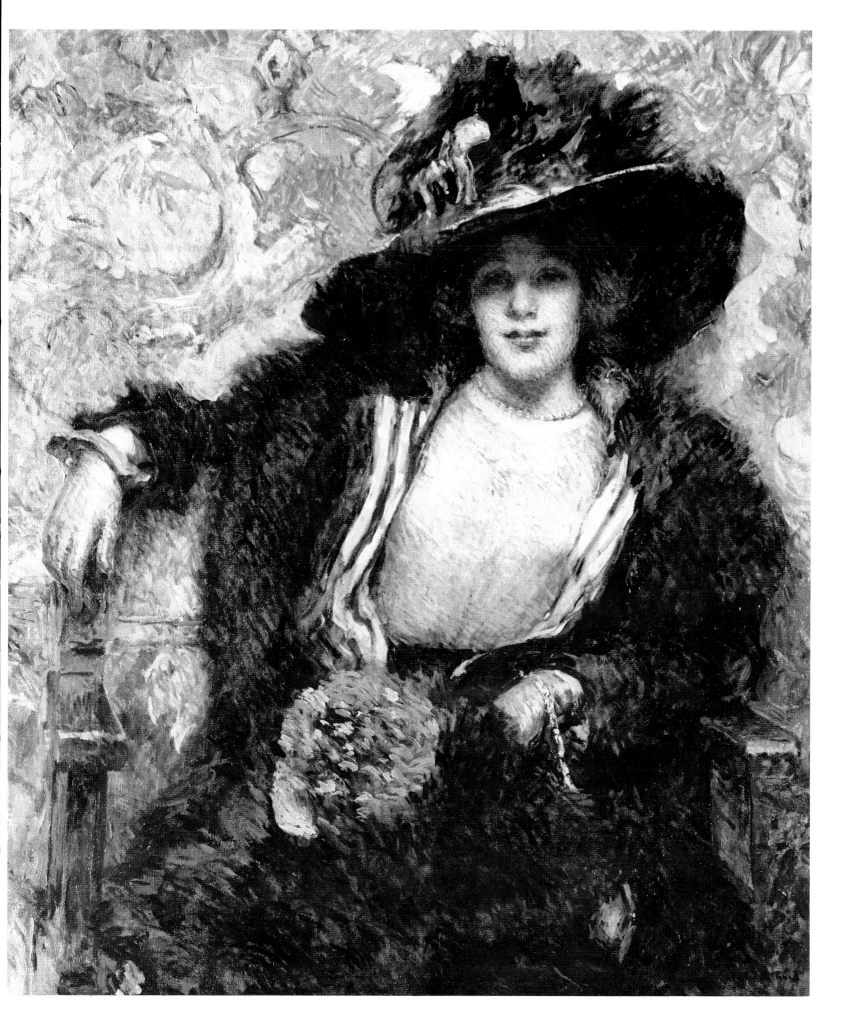

as good as any the Ten had put together,[13] while the *Sunday Herald* critic called it "the most important exhibition of the season."[14]

Only the critic for *International Studio*, describing the New York exhibition as an occasion for "sadness and introspection," was able to articulate the epochal changes which had taken place since the Ten was founded. He characterized most of the group as "exponents of French impressionism and French academic influences modified by the study of light and atmosphere. It is the language of Monet or of [Albert] Besnard which they have adapted to local needs and conditions." However, a generation had passed, he said, since those ideas were new, and he blamed the group for having not progressed beyond their original program, pointing out that they had been susceptible to many influences from within the group but strangely impervious to those from without. In terms of contemporary art, the article summarized: "In certain instances they are positively unsympathetic, not to say hostile, to the more recent manifestations of contemporary endeavor."[15]

As the impact of the Armory show made itself felt over the following years, this opinion became ever more widespread among critics, although even as early as 1911 Guy Pène du Bois, referring respectfully to the Ten as the "aristocrats of American art," had said they were no longer "revolutionists at heart." They had largely realized the struggles and ideals of an older generation and were now "a group apart, old enough and fixed enough to settle comfortably on their little hillock and watch the world of art in its widespread and constant upheavals with unsullied contentment."[16] After the Armory show it was no longer possible to overlook the fact that modern trends had undermined the group's radical reputation, though the latter continued to linger in the public mind.

In 1914 the critic for the *Sun* gently pointed out that the Ten were not really at odds with anyone, not even the Academy. "Their point is won," he said. "The public accepts them and their work is the 'fashionable' work of the day," so why not bring about a rapprochement between the Academy and the Ten? The members of the group were all academicians, while the academicians were all Impressionists, and, by merging, they would form a stronger front against the tide of modernism that they both opposed.[17]

The Armory show had a direct effect on the Ten and their annual exhibitions. In 1914, a year after the show, only seven of the Ten participated in the group's exhibition. Reid and Simmons were away in San Francisco, installing murals for the coming Panama-Pacific Exposition. There were several reports that Dewing had not been able to finish his painting

in time, but the critic Arthur Hoeber implied that Dewing had boycotted the exhibition because his old friend Montross had used his gallery to show modernist paintings the previous February.[18] In fact, as Montross's involvement with the new art continued, the Ten deserted him and moved their exhibitions of 1915 and 1916 to the nearby Knoedler gallery.[19]

Hassam described the 1915 Ten exhibition to Weir as "a rotten show on the whole," and predicted they would get "Murray Hill from most everybody who knows anything."[20] There were, in fact, many comments that year about the declining strength of the group. Said the critic for the *Mail*: "The decemvirate is waning—perhaps not absolutely, but relatively. And some of the members are waning absolutely."[21]

In the group's last two regular shows of 1916 and 1917 there were even gestures toward more advanced styles, including Simmons's open-air views of excavations in New York and Reid's sketchy (but conventional) "portrait impressions." At about this time Hassam, too, was inclining toward the vivid colors and bold patterning of modernist works. In reviewing the 1917 exhibition for the *Sun*, Henry McBride, a champion of the modernist cause, made the startling claim regarding Hassam's portrait *Kitty Hughes* (Ball State University, Muncie, Indiana) that, "quite unconsciously, no doubt, Mr. Hassam has been imitating the two dimensional manner of Man Ray."[22]

It also became more common in the late exhibitions to find Ten pictures which had appeared in earlier large annuals or in the Ten shows themselves. Simmons in 1912 showed his *Boston Public Gardens* (plate 13), painted nearly twenty years earlier, and in 1917 his picture *Morning* (unlocated) from the early 1890s. In the same year Reid repeated his *The Trio* (The Berkshire Museum, Pittsfield, Massachusetts) from the first Ten show in 1898, and Hassam even showed a watercolor of 1888 from his early days in Paris: *Place de la Trinité, Paris* (unlocated).

The Ten held their twentieth and last regular exhibition in 1917, again at the Montross gallery, perhaps for sentimental reasons, and as in recent years there were considerable numbers of watercolors, pastels, and silverpoints to round out the complement of paintings. Benson showed four drawings representing him in his new role as illustrator of sport-

Fig. 60
Childe Hassam, *Fifth Avenue*, 1919.
23¼ x 19¼ in. (59.1 x 48.9 cm).
The Cleveland Museum of Art,
Anonymous Gift, 52.539

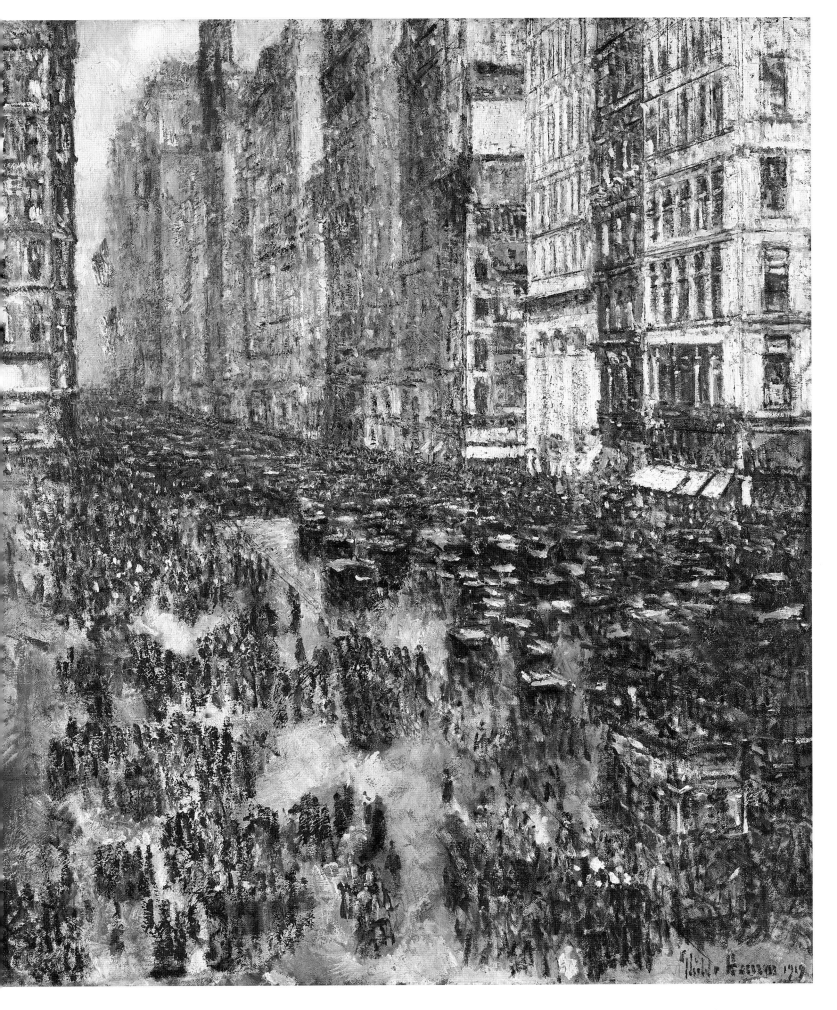

ing scenes and wild fowl, with only one work, *The Open Window* (fig. 58), made to order in the old manner. Cortissoz was particularly interested in the use of silverpoint by Dewing, De Camp, and Metcalf, a technique the critic found perfectly suited to their abilities because, as he said, they "know how to draw."[23]

The reviews of the exhibition brought to the fore a number of the formal criticisms made of Impressionism since the advent of other modern styles. In 1915 the painter Guy Pène du Bois attacked the Boston members of the Ten as exemplifying the worst traits of artistic complacency. Unlike The Eight, he claimed, they were more interested in beauty than in fact, but that which passed as beauty among them was really only good taste. And the truths that they dealt with were only polite truths, avoiding the vital, and possibly upsetting, truths of real life. In sum, their work was an edifice of empty phrases, its outstanding virtue "refinement," a quality inconsistent with "the defiant independence which has produced great art in the face of tremendous privation and, worse still, opposition."[24]

McBride, reviewing their 1917 exhibition, brought up the old objection of Impressionism's European sources, and criticized the Ten for having tried to "translate" for the American audience the works of the great European Impressionists (among them Whistler), likening their work to the originals as so much dried fruit to fresh. It was "no

Fig. 61 Frank W. Benson, *The Silver Screen*, 1921. 36¼ x 44 in. (92.1 x 111.7 cm). Museum of Fine Arts, Boston. A. Shuman Collection

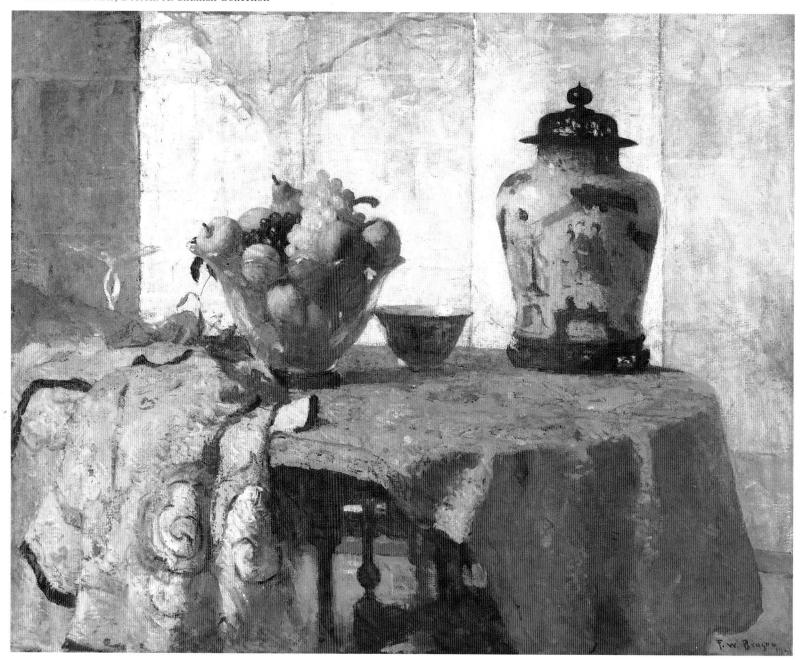

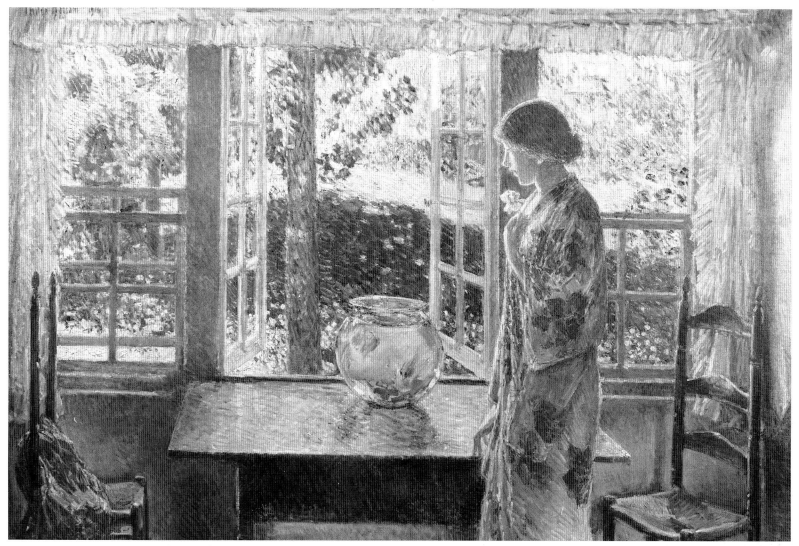

Fig. 62 Childe Hassam, *The Goldfish Window*, 1916. 33½ x 49½ in. (85.1 x 125.7 cm).
The Currier Gallery of Art, Manchester, New Hampshire: Currier Funds, 1937.2

longer necessary for any of our artists to tell us what the impressionists thought in France twenty years ago," he said. "We should much prefer to have them think for us and to us of the present."[25]

While the reputation of the group was in evident decline during these years, seemingly shorn of initiative or new ideas, individually some members of the Ten continued to develop new and interesting episodes in their careers. Several found commercial success in portraiture. In 1909 it was said that most of Benson's winter work consisted of portraiture. Tarbell, too, increased his output to such an extent that in 1918 it was said that he was perhaps best known as a portraitist.[26] De Camp also eventually gave virtually all of his time to what might be regarded as "official" portraits of businessmen, educators, and other commissioned subjects (see fig. 56). Between them, De Camp and Tarbell were finally called on to paint official portraits of presidents Theodore Roosevelt, Woodrow Wilson, Calvin Coolidge, and Herbert Hoover.

After being forced from the Pennsylvania Academy in 1909,[27] Chase, who had avoided commercial portrait work for much of his life, also increased his output of portraits, maintaining for the purpose separate studios in New York and Philadelphia. At the same time Chase also developed a new landscape style that dated from about 1907, the year he left the New York School of Art and bought a villa in Florence, where he summered in the years that followed. Most of the landscapes he showed in the late Ten exhibitions were views of Florence and Venice painted during these Italian summers. These richly painted but stark canvases, almost always devoid of human figures, have a reclusive, solitary air. They are intensely private exercises, revealing an artistic personality isolated and self-absorbed. Practically his only other subject during these years, beyond his commercial portraits, were the equally detached, but beautifully painted still lifes—especially of fish—which were included in nearly all the last Ten shows (see fig. 48). Critics said they would have made the reputation of any other artist, and so they

would have, but not measured against Chase's own former achievements.

A critic in the 1920s, when Hassam was still very active, said that the artist had embodied two personalities. The first was "Hassam the Younger who died about 1916 after a lingering illness," a brilliant colorist, keen observer, and in the general sense a "modern" artist. He was followed by "Hassam the Elder" who "inherited the master's technique... [but] became literary, arrogant, and finally dull."[28] Hassam's work undeniably showed great fluctuations in manner and quality from the end of the first decade into the teens. He could at times be perfunctory or merely awkward, yet he was also capable of stunning, innovative performances, such as *The Water Garden* (plate 21), in which the delicate, fluid notation of his earlier outdoor views is exchanged for vivid colors in rich impasto surfaces that arrive at a new sense of permanence, even monumentality, and enamel-like brilliance. Among his favorite subjects was a series of "windows," begun about 1907 and carried through the teens, that included *The Goldfish Window* (fig. 62). Parallel works by the Boston members of the Ten were devoted to what became a more or less set academic problem of treating figures in the juxtaposition of indoor and outdoor light, as Tarbell demonstrated in his Vermeer-like interiors and as Benson did in *The Sunny Window, Light from a Window,* and *The Open Window* (plates 77, 79 and fig. 58), and De Camp in *The Window* and *The Seamstress* (figs. 17, 55).

Hassam's consistently best late work, however, occurred in the so-called "flag series" executed between 1916 and 1918, in which he followed his natural instincts for picturesque imagery and loosened, if not entirely freed himself from, the intellectuality of conception that tended to thicken and stifle his compositions (see plate 74). Here was *plein air* painting once more, so consciously done that Hassam actually noted the date and time of day on some of his pictures. His earliest work in this series was inspired, he said, by the Preparedness Day parade held in New York in May 1916, prior to America's entry into the First World War, and by the Fourth of July celebrations the same year. Hassam was undoubtedly affected by the patriotism which called up these displays throughout the streets of New York, but, like the unconvincing symbolism in his mythological paintings, the matter of personal content here is small compared to the power of pure visual pageantry. Only one or two of the flag paintings were shown in the last Ten exhibitions, appearing first as a group at the Durand-Ruel gallery in 1918, at the end of the War and after the last regularly scheduled Ten exhibition. Their intense colors and bold patterning suggest the new influence of modernist works, however much the basic theme may have been inspired by similar works painted many years earlier by Monet.

Hassam also continued to paint city views which document the changing character of New York from a city of brownstone houses and pedestrian walks to one of skyscrapers and elevated railways. In his later city views, such as *Fifth Avenue* (fig. 60), something of the human scale is lost: the streets become gaping canyons, individuals become indistinct blurs in a shifting mass of humanity. Like that of Chase, his late artistic vision is emotionally detached.

Several critics noted the renewed strength shown by Reid in the Ten exhibition of 1910 when, with *Pink Carnation* (unlocated) and *Blue and Yellow* (plate 5), he introduced a new type of studio picture that he was to develop in further versions over the next several years. These so-called "screen" paintings show models in kimonos posed against elaborate Japanese screens, and demonstrate a new elegance and severity of design in combination with the most delicate variation of colors. In discussing the related picture, *Lady with a Hat* (fig. 59), which was shown in the 1911 Ten exhibition, the critic for the *Boston Evening Transcript*[29] described it as a very personal application of the principles of Impressionism, in which the purple-black furs, vibrant with light, and vivid, iridescent colors archieved qualities quite unlike anything seen either in America or abroad.

In 1915 Reid began to experiment with what he called "portrait impressions," which were rapidly sketched portraits on coarse, unprimed canvas. These portraits were exceedingly popular, and one reviewer[30] mentions them as having "recouped" the artist's fortunes, although it is not clear whether this remark was meant in a material or critical sense.

In the late years of the Ten age and illness also began to take their toll on the artists. By 1908 Chase, Dewing, Weir, and Simmons were nearly sixty. Weir suffered from heart trouble from about 1911 or 1912, which reduced his output. A convalescent trip to the Bahamas in 1913 produced several outstanding pictures, including *Nassau, Bahamas* (plate 81), but such fresh and original work became increasingly rare. Though at age fifty still young by today's standards, Benson, in about 1910, began suffering from migraine attacks, hearing and vision problems, and a variety of other ailments. De Camp also suffered painful bouts from what were diagnosed as stomach ulcers which, from about 1907 until he died in 1923, left him increasingly debilitated.[31] Chase died in October 1916, dealing a serious blow to what was already a fading enterprise.

After their twentieth consecutive annual exhibition in 1917, the Ten had apparently hoped to mark the end of their

Fig. 63 Frank W. Benson, *Reflections*, 1921.
43¾ x 35 in. (111.1 x 88.9 cm).
The Henry E. Huntington Library
and Art Gallery, San Marino, CA

group career with one final exhibition. In 1918 Hassam told John W. Beatty, director of the Carnegie Institute, that the Ten would not be exhibiting that year, but that "probably next or year after it will end up with a retrospective at the Metropolitan."[32] The New York show never materialized and, with that, most of the Ten members quietly decided against any further exhibitions. Yet the idea of a retrospective was revived at the end of the year by C. Powell Minnigerode, the director of the Corcoran Gallery in Washington, D.C., with the encouragement of Tarbell, then head of the Corcoran's art school. Several members, including Metcalf and De Camp, were reluctant to revive

the group,[33] but were eventually persuaded. Within a short time an exhibition of about forty paintings was put together and shown at the Corcoran Gallery in February 1919. It was a very much smaller and far less representative collection than that which had been assembled for the group's tenth anniversary in 1908. One could see that their hearts were not in it. There was little new work. Freer lent from his collection two Dewing pastels and two paintings by Metcalf, *The White Lilacs* and *White Pasture* (both Freer Gallery of Art, Smithsonian Institution, Washington, D.C.); four paintings by the deceased Chase were loaned by the Knoedler gallery; Benson showed *Red and Gold* (fig. 14), seen at the 1915

Fig. 64 Edmund C. Tarbell, *The Lesson*, 1924. 24 x 31 in. (61 x 78.8 cm).
Collection of Phyllis and Irwin Chase

exhibition; Reid again showed *The Trio*, which had appeared in the first Ten exhibition of 1898 and been used again in 1916; Simmons's *Mother and Baby* from the 1880s was lent by the Buffalo Academy. Only De Camp, with *Red Kimono* and *Blue Bird*, and Tarbell, with *Mary and Venus* and *Girl Writing* (fig. 65), seem to have exhibited recent paintings of their own. The Washington audience apparently liked the exhibition well enough, and Minnigerode, who was friendly with most members of the group, offered brave praise, but it was very plain to any outsider that the exhibition was essentially a nostalgic gesture. *American Art News* said it was a "stale" show, and it was.[34]

The Ten had remained a little too long. The eulogy for each of them, to a greater or lesser degree, might be said to have already been delivered along with that for Chase a few years earlier, when Duncan Phillips wrote of him in his still unmatched words:

Time was when William M. Chase was regarded by his fellow country-men as a radical artist. That was the time when America hungered for art, but did not know its meaning, when the paintings most admired were of a story telling character, illustrative of a historical theme, a bookish idea or a household sentiment. That was the time when the organized art-bodies of provincial America intrenched themselves to resist the invasion of the young men back from Europe, the student adventurers, who seemed so arrogantly determined to impose their foreign ideas upon the simple cre-dulity of their fathers.... Today they call Chase reactionary, they who fight sham battles, brandishing paper pistols. And yet the position where he held his own against all comers marks the battle front of forty years ago, where the victory was won which made possible the present and the future of American painting.[35]

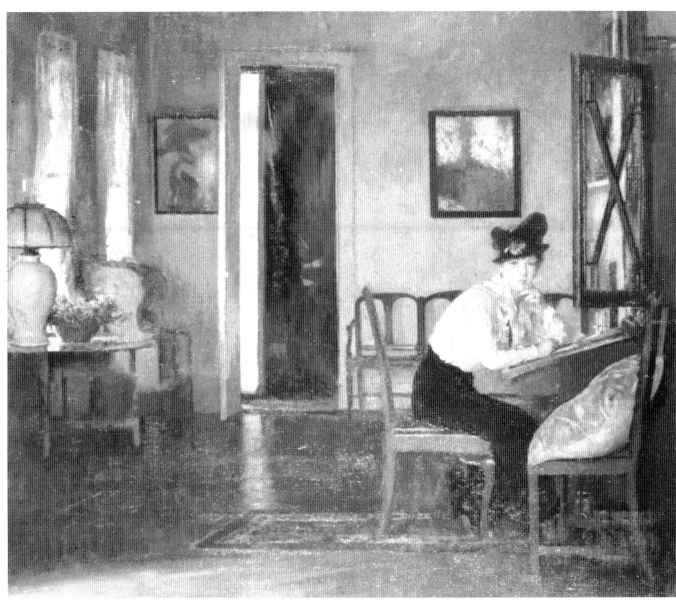

Fig. 65
Edmund C. Tarbell,
Girl Writing, 1917.
31¾ x 35½ in.
(80.7 x 90.2 cm).
Philadelphia Museum
of Art: Alex Simpson,
Jr., Collection

Notes

1 *Sun*, Mar. 19, 1916, section V, p. 8.
2 See William Innes Homer, *Robert Henri and His Circle*, Ithaca and London, 1969, p. 130 ff.
3 In announcing the formation of their group, the writer for the *Sun*, May 15, 1907, recognized that nowhere could one find men "so absolutely dissimilar" as in this group, united, it seemed to him, only by their convictions that technique in art was merely the means to an end and that the true subject of art was "life itself."
4 See Bruce St. John, ed., *John Sloan's New York Scene from the Diaries, Notes and Correspondence 1903–1913*, New York, 1965, pp. 5, 32–33; also Homer, 1969, p. 121. The policies of this organization, which never held any exhibitions, included a membership restriction and other points in common with the Ten.
5 St. John, 1965, p. 167 (diary entry for Nov. 21, 1907).
6 St. John, 1965, p. 333 (diary entry for Sept. 13, 1909). Sloan wrote: "Hear that Chase has retired from the schools of the Penn. Academy of the Fine Arts. Anshutz is now the head instructor—good!"
7 From Sloan's diaries, quoted in Homer, 1969, p. 82. See also Sloan's statement on Henri, quoted in *Robert Henri, Painter*, exhibition catalogue, Delaware Art Museum, 1984, pp. xi–xii.

Sloan's diaries are scattered with remarks about the Ten painters. See especially St. John, 1965, pp. 77 and 115, where, in an entry for Mar. 29, 1908, he remarked of the Ten exhibition: "It looks like New York taste today—like Spring hats with less utility—seems so lacking in enthusiasm." The hostility was overt when Sloan and Henri were organizing the Exhibition of Independent Artists in 1910. Walter Pach proposed that Chase, Weir, and Hassam be asked to join, and Sloan, in his own words, opposed the idea "violently," agreeing in the end only that they should be informed of the event but

not actually asked to participate. As it turned out, only Hassam did exhibit. St. John, 1965, pp. 398–99.
8 See Judith Zilczer, "The World's New Art Center...," *Archives of American Art Journal* 14, no. 3 (1974), p. 2 ff.; also *The Advent of Modernism: Post Impressionism and North American Art, 1900–1918*, exhibition catalogue, Atlanta, GA, High Museum of Art, 1986, p. 30 ff.
9 "The American Section: The National Art—An Interview with the Chairman of the Domestic Committee, Wm. J. Glackens," *Arts and Decoration* 3 (Mar. 1913), p. 162.
10 Hassam to Weir, Mar. 21, 1913, Archives of American Art, Roll #NAA 2: "Your pictures in the Ten look very fine. The portrait of Dorothy is in the center on the end wall. You will be back in time to see the show. It closes April 5th. I don't think much of the gallery as a whole—but let that go. The International closed with a record attendance and miles of rubbish written about it. There is no news here. Nothing selling in the Ten."
11 *New York Times*, Mar. 16, 1913, part VI, p. 15.
12 *New York Daily Tribune*, Mar. 16, 1913, section II, p. 6. Cortissoz thought that the Ten exhibitions of 1911 and 1912 had become perfunctory, and noted the few examples of the high-keyed open-air work that had once predominated. In Boston the critic J. Nilsen Laurvik felt the same about these two shows, saying that the members had become an echo of their former selves, and that they needed a transfusion of new blood. *Boston Evening Transcript*, Mar. 23, 1911, p. 16, and Mar. 23, 1912, part 2, p. 8.
13 *Boston Evening Transcript*, Apr. 12, 1913, section 2, p. 3.
14 *Boston Sunday Herald*, Apr. 13, 1913, p. 21. With a few exceptions, from about 1909 to 1913 press reviews were overwhelmingly positive. The group's annual shows had become a fixture of the New York and Boston art seasons, and it was said often that

they were eagerly awaited. The *Evening Mail*, Mar. 25, 1910, p. 8, referred to the group as the "The immortal Ten," while the *New York Times*, Mar. 27, 1910, p. 8, called them a "classic group." In 1912 the *Globe and Commercial Advertiser*, Mar. 16, 1912, p. 4, said that by general consensus the Ten shows were the best exhibitions of American art held each year, while the *World*, Mar. 26, 1911, p. M7, declared that they were easily the rivals of the large annuals in Washington and Philadelphia.

15 *International Studio* 49 (May 1913), p. 52.

16 Guy Pène du Bois, "The Idyllic Optimism of J. Alden Weir," *Arts and Decoration* 2 (Dec. 1911), p. 56.

17 *Sun*, Mar. 22, 1914, p. 12, and Mar. 29, 1914, section 8, p. 2.

18 *Globe and Commercial Advertiser*, Mar. 23, 1914, p. 8. The show in question was *Exhibition of Paintings and Drawings*, organized by Arthur B. Davies and Walt Kuhn and originally shown at the Carnegie Institute in December 1913. Artists included Prendergast, Allen Tucker, Stella, Charles Sheeler, and Henry Fitch Taylor.

19 The break with Montross is sketched in the dealer's obituary, *New York Times*, Dec. 11, 1932, section 1, p. 34: "After Mr. Montross moved to 550 Fifth Avenue he found himself in the centre of controversy. His 'Ten' and modern art had come face to face. Mr. Montross took the side of modern art and his 'Ten' moved out." Said Montross of his involvement in the new art: "I consider it wiser to open the door from the inside rather than to have it thrust in your face from outside." "Modernist Exhibition at Montross Galleries," *New York Times*, Jan. 30, 1914, p. 8. See also Henry McBride's review of the Matisse exhibition held in January 1915 in which he spoke of Montross's conversion, and said: "All the 'moderns' love to have [Kenyon] Cox and Chase detesting Matisse." *Sun*, Jan. 24, 1915, quoted in Daniel Catton Rich, ed., *The Flow of Art: Essays and Criticisms of Henry McBride*, New York, 1975, p. 77.

20 Hassam to Weir, Mar. (postmarked 18th), 1915, Archives of American Art, Roll #NAA 2: "Your pictures look fine in the Ten. It is a rotten show on the whole and it will get Murray Hill from most everybody who knows anything. They are all there and the gallery is crowded—too many—they are very large canvases as a rule. Chase and Bob [Reid] take the bun. Simmy is a close third."

21 *Evening Mail*, Mar. 19, 1915, p. 12; see also James Britton, "'The Ten' and the Academy," *American Art News* 13 (Apr. 3, 1915), p. 2.

22 *Sun*, Mar. 11, 1917, section 5, p. 12.

23 *New York Daily Tribune*, Mar. 11, 1917, section 3, p. 3.

24 Guy Pène du Bois, "The Boston Group of Painters: An Essay on Nationalism in Art," *Arts and Decoration* 5 (Oct. 1915), p. 458.

25 *Sun*, Mar. 11, 1917, section 5, p. 12. Elsewhere, William Howe Downes, in the *Boston Evening Transcript*, Apr. 6, 1917, p. 14, said that nothing of the group's former importance survived and that they had long ceased to be anything special. The critic for *Arts and Decoration* 7 (Apr. 1917), p. 315, claimed that most of the group were just tired Academy painters and that, except for Weir and Hassam, "the flame is flickering or dying out."

26 John E. D. Trask, "About Tarbell," *American Magazine of Art* 9 (Apr. 1918), p. 227.

27 In 1909 Chase was said to have a handsome income from portraiture, but he was also quoted as saying, "I am a great spender." See James William Pattison, "William Merritt Chase, N. A.," *House Beautiful* 25 (Feb. 1909), p. 50 ff. He actually maintained three studios in New York at the time—one for society portraits, one for himself, and one for students.

28 *Art News* 27 (Apr. 20, 1929), p. 9.

29 J. Nilsen Laurvik, in *Boston Evening Transcript*, Mar. 23, 1911, p. 16.

30 "Annual Display of 'The Ten,'" *American Art News* 15 (Mar. 10, 1917), p. 2.

31 His friend Bela Pratt, in a letter of May 25, 1910, said he had been ill much of that winter. Archives of American Art, Roll # 75. See also the comments by Rose V. S. Berry, in "Joseph De Camp: Painter and Man," *American Magazine of Art* 14 (Apr. 1923), p. 182.

32 Hassam to John W. Beatty, Mar. 18, 1918, quoted in Gail Stavitsky, "Childe Hassam and the Carnegie Institute: A Correspondence," *Archives of American Art Journal* 22, no. 3 (1982), p. 5 and n. 13.

33 In response to Minnigerode's overtures for an exhibition, Metcalf described the feelings within the group: "While I fully realize the importance such an exhibition would assume under your charge, and the very possible interest it might arouse in your public, I personally have become so lukewarm in the matter of any enthusiasm for the continuation of its [the Ten's] existence, that I naturally feel disinclined to assist in the resurrection of what has become a natural death: a feeling in which I have been made to understand that I was not entirely alone. The exhibition was not held last year ostensibly on account of war activities; but really it was the outcome of an understanding, at least on the part of most of the members, that we had had our last exhibition; through the failure to carry out the wished for plan, namely, a large retrospective, one in which we had hoped to present our maximum weight, as well as to collectively make our last bow to the public; and in the failure of this project, the whole matter of continuance became a dead letter . . . and I think that were it not for the flurry of excitement your kind invitation is sure to cause with some, I think we would surely have taken the count, and we may even yet; in fact a member expressed himself to me a few days ago, as of the opinion that we were through." Letter of Dec. 30, 1918, Metcalf File, Corcoran Gallery of Art Archives.

34 Minnigerode wrote each of the participants. To Benson he said: "The Ten show here is a great success and makes a corking fine impression in our new special exhibition gallery. It would have been a great loss to everyone interested in the development of painting in this country if this notable exhibition should have been abandoned. I hope it will keep up forever." Essex Institute, Benson Papers, letter of Feb. 9, 1919. For local reaction to the exhibition, see Leila Mechlin, in *Washington Sunday Star,* Feb. 2, 1919, p. 20, and Feb. 9, 1919, part 3, p. 12, and *American Art News* 17 (Feb. 15, 1919), p. 6.

35 Duncan Phillips, "William M. Chase," *American Magazine of Art* 8 (Dec. 1916), p. 45.

74 Childe Hassam, *Celebration Day, 1918*, 1918. 35½ x 23½ in. (90.2 x 59.7 cm).
Christopher T. May, trustee for May Family Trust

75 Frank W. Benson, *Summer*, 1909.
36⅜ x 44⅜ in. (92.4 x 112.7 cm).
Museum of Art, Rhode Island School of Design; Bequest of Isaac C. Bates

76 Frank W. Benson, *Lily Pond*, 1923.
44 x 36 in. (111.8 x 91.4 cm).
Jordan–Volpe Gallery, New York

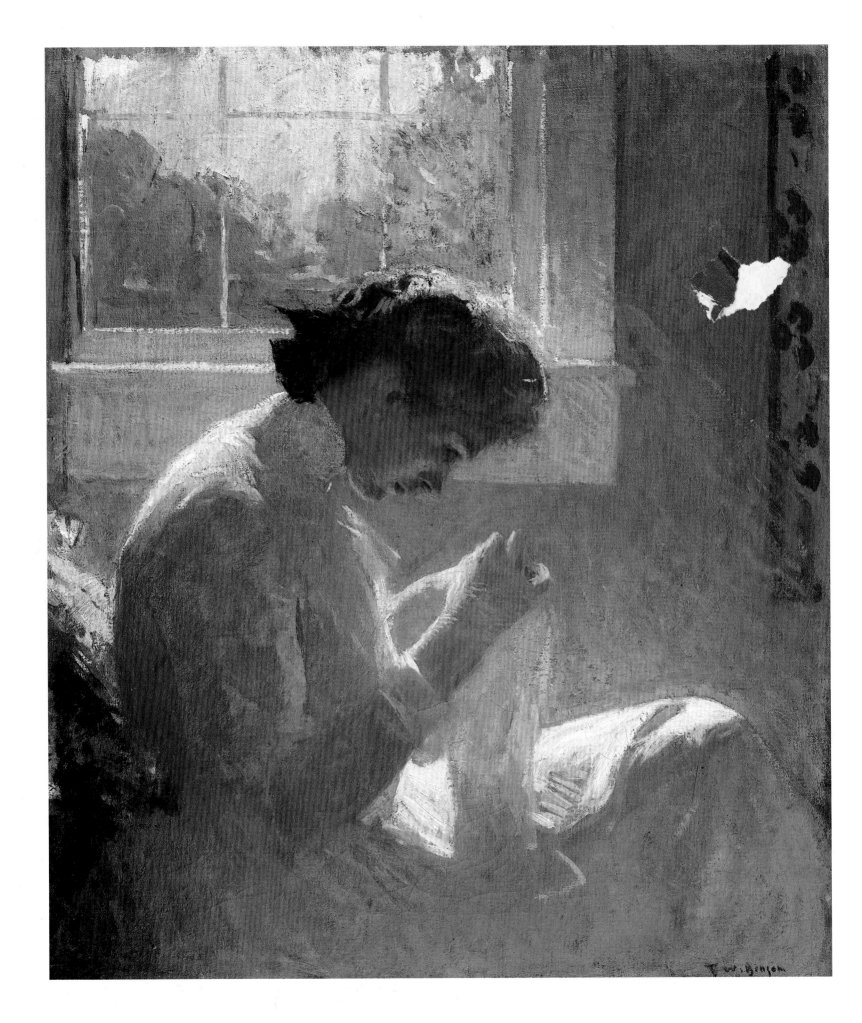

77　Frank W. Benson, *The Sunny Window,* 1919. 30 x 25 in. (76.2 x 63.5 cm). Private collection. Photo courtesy Jordan-Volpe Gallery, New York

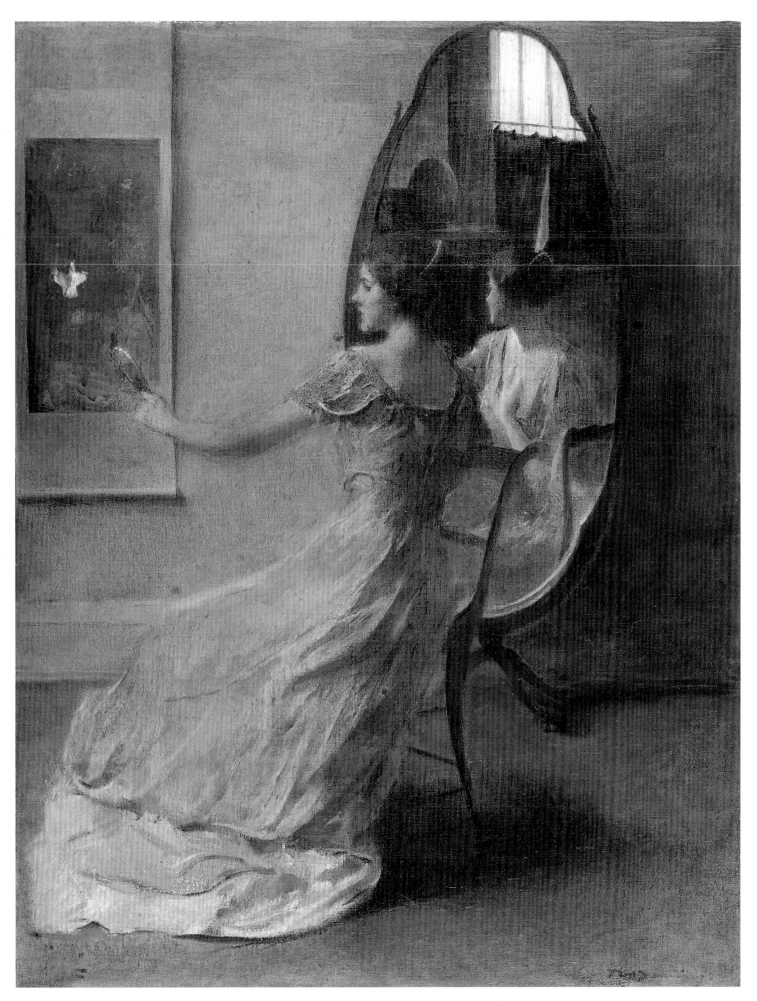

78 Thomas Wilmer Dewing, *Before the Mirror*, c. 1908/10. 19 x 25 in. (48.2 x 63.5 cm). Private collection

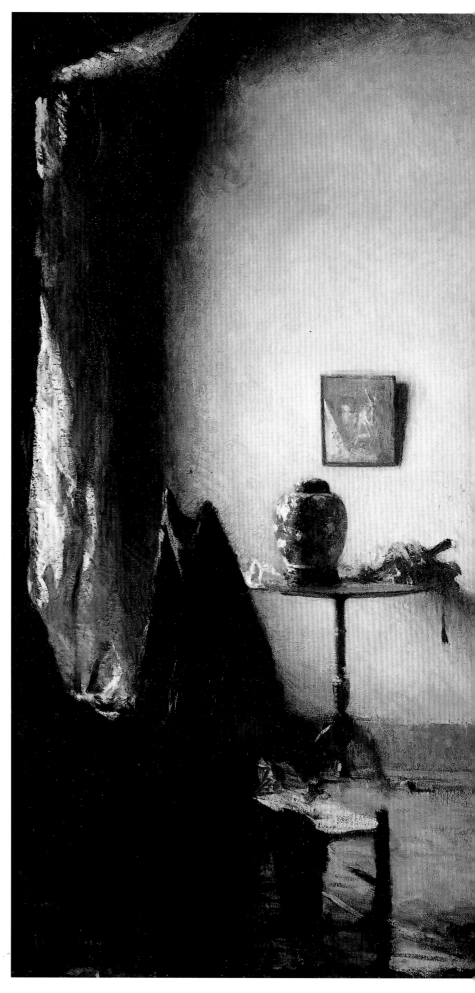

79 Frank W. Benson, *Light from a Window*, 1912.
32 x 40 in. (81.3 x 101.6 cm). Private collection

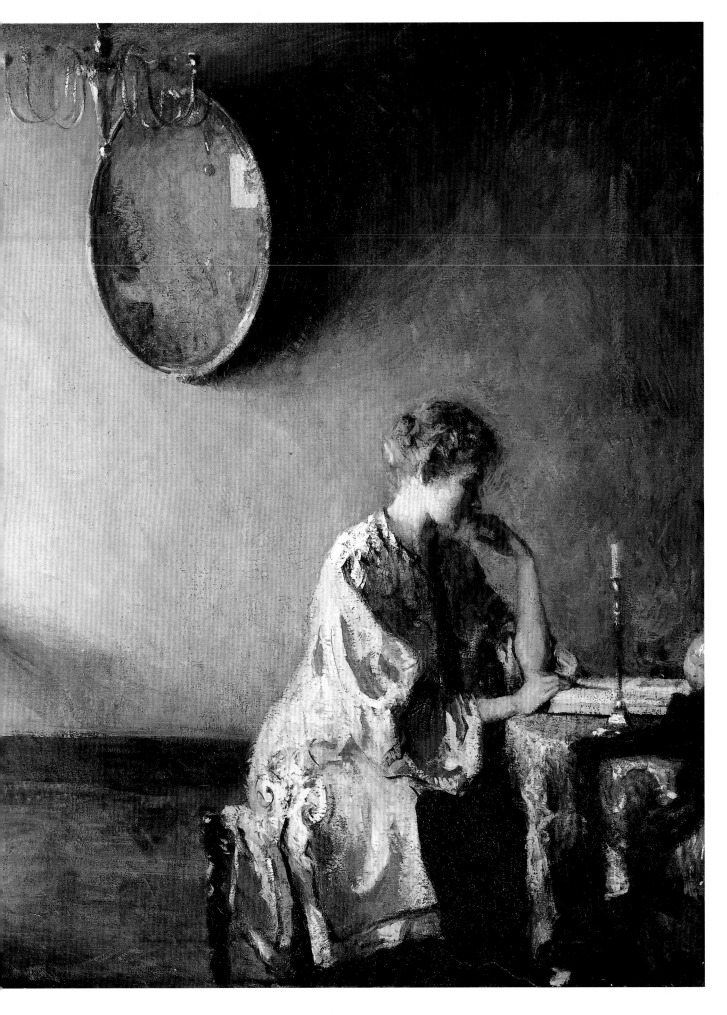

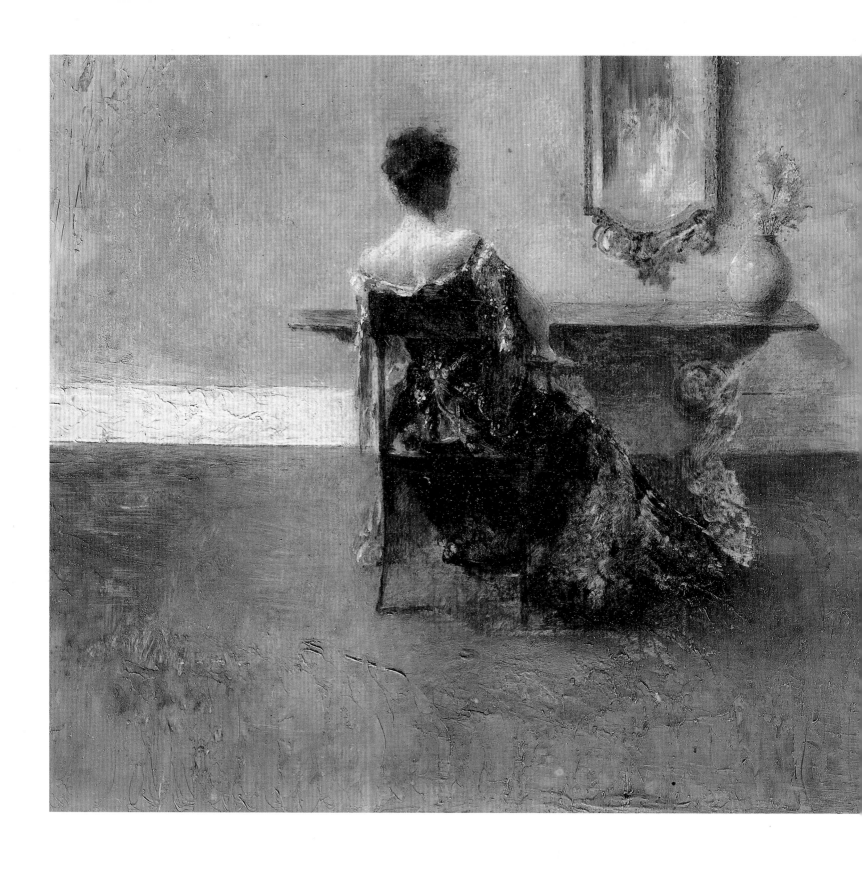

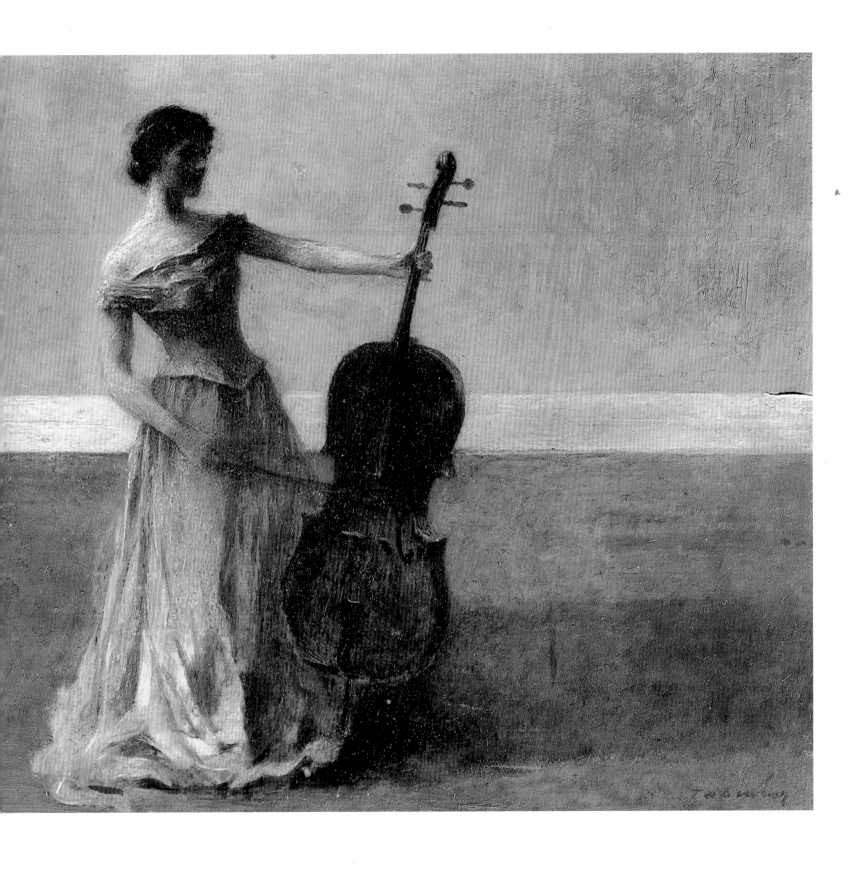

80　Thomas Wilmer Dewing, *An Interior*, c. 1915. Oil on panel, 12 x 26 in. (30.5 x 66 cm). Private collection

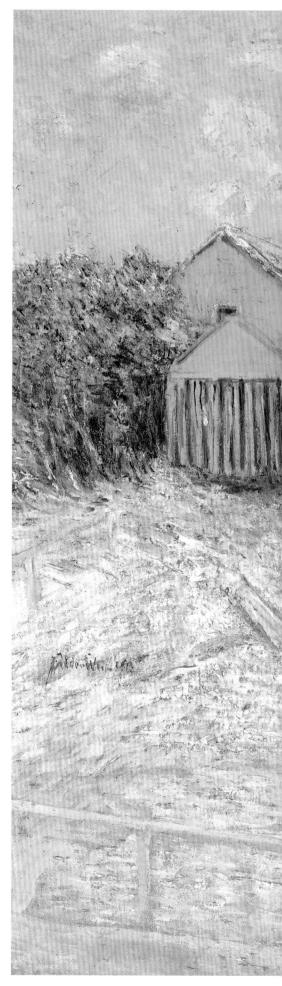

81　J. Alden Weir, *Nassau, Bahamas*, 1913.
32¼ x 36¼ in. (81.9 x 92.1 cm). Private collection

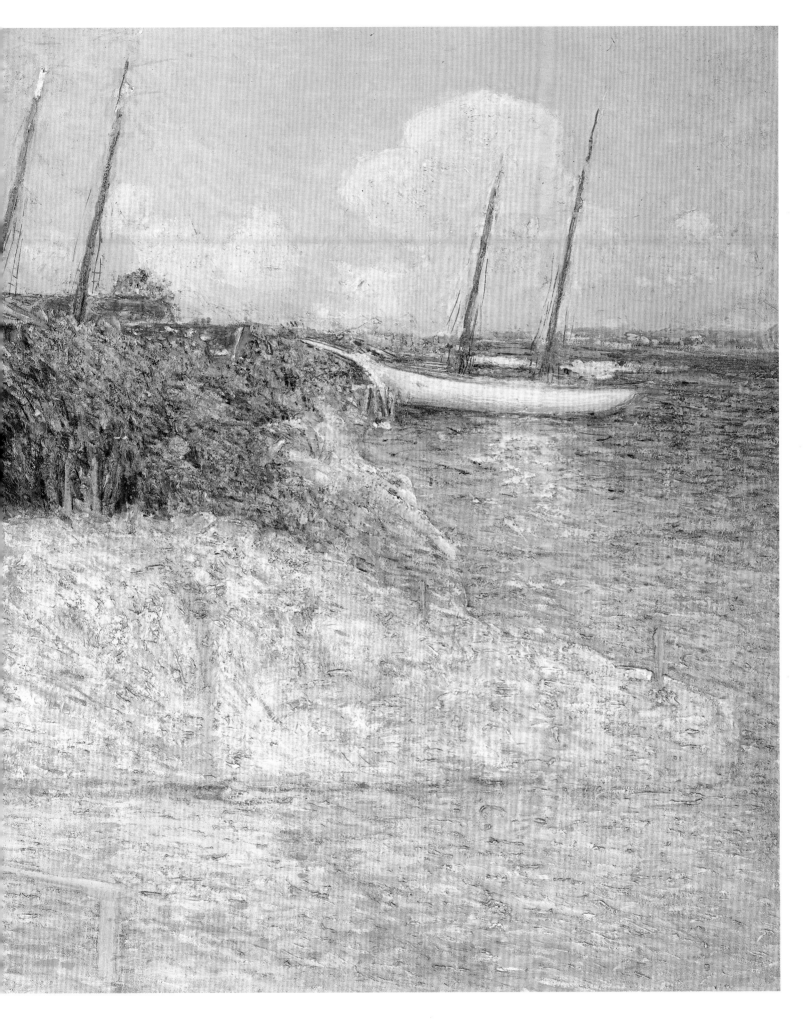

82 Willard Metcalf, *Winter Afternoon*, 1923.
26 x 29 in. (66.1 x 73.7 cm).
Private collection, Houston, Texas

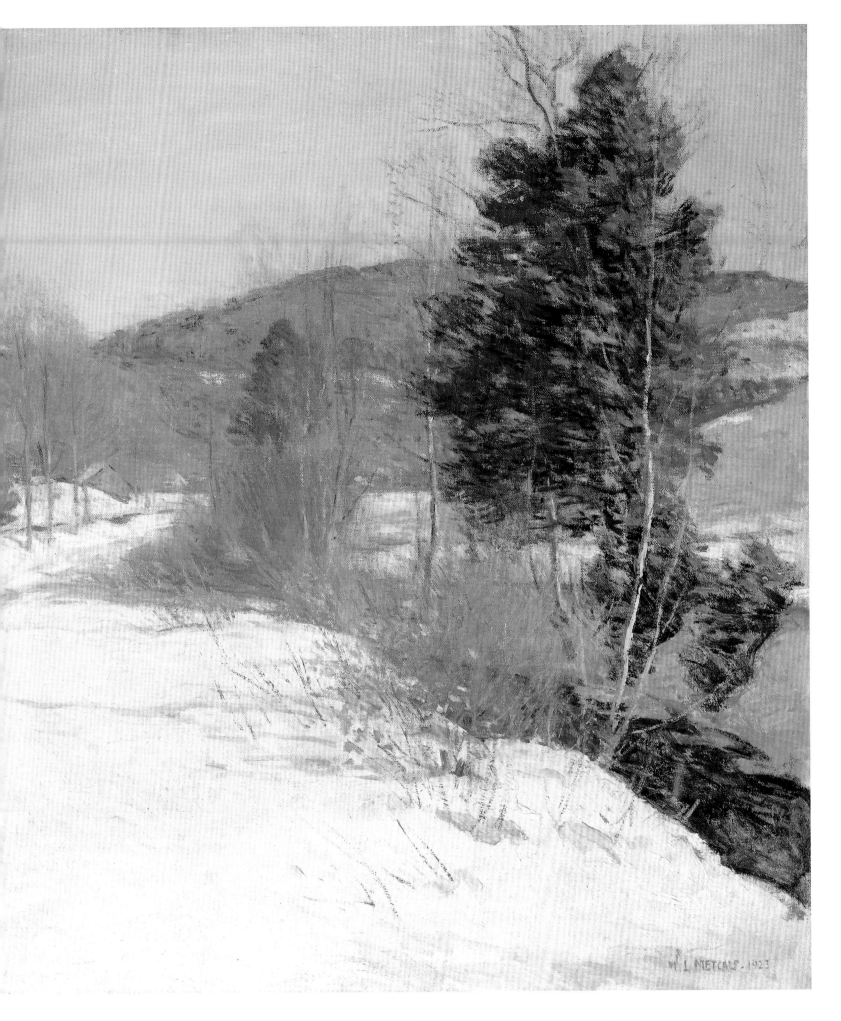

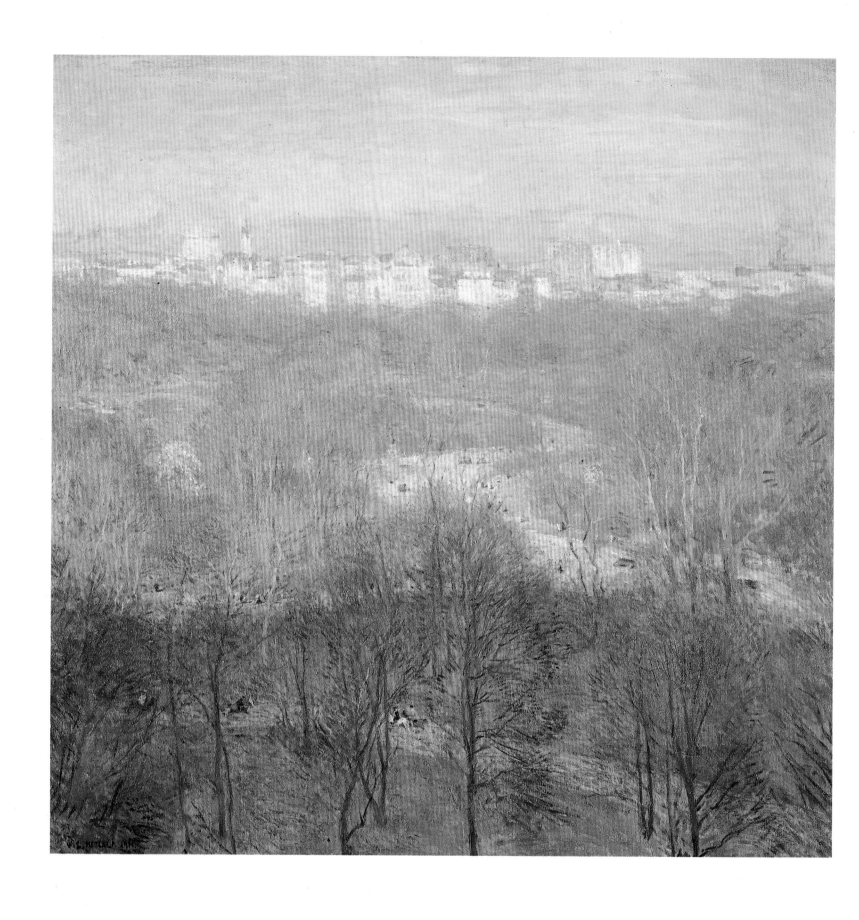

83 Willard Metcalf, *Early Spring Afternoon, Central Park*, 1911. 36 x 36⅛ in. (91.4 x 91.8 cm).
The Brooklyn Museum, 66.85. Frank L. Babbott Fund

Appendices

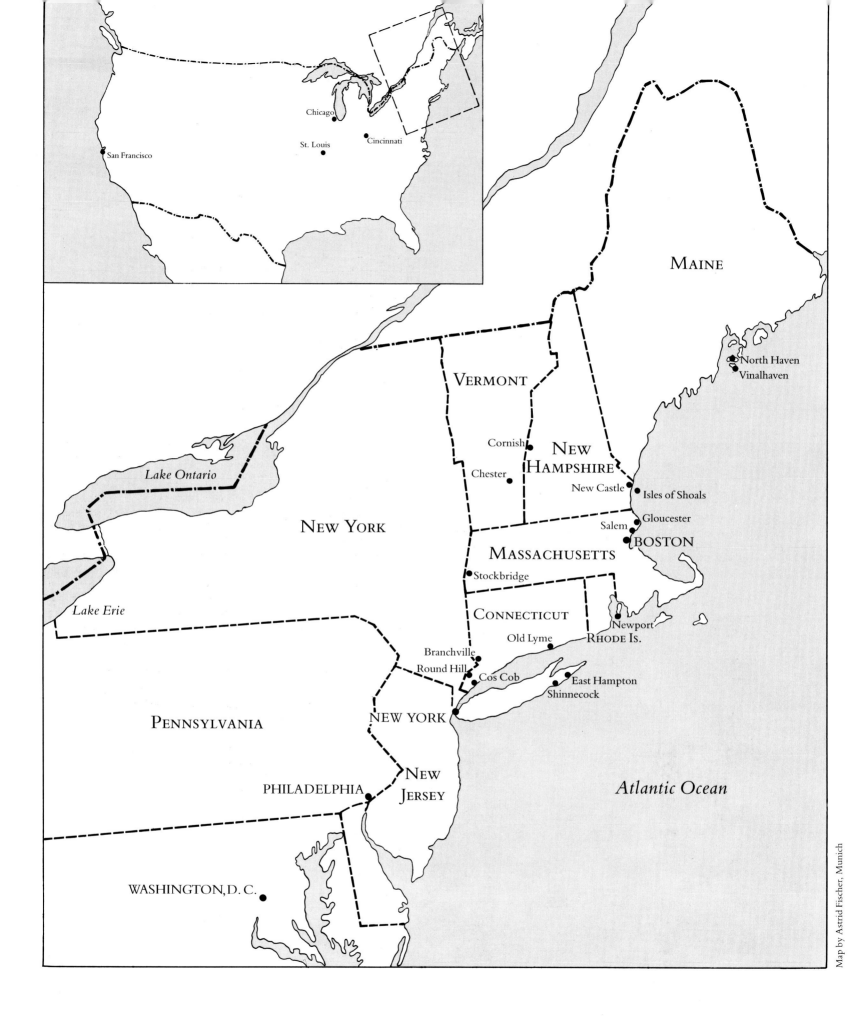

Chicago

St. Louis

Cincinnati

San Francisco

MAINE

VERMONT

Cornish

Chester

NEW
HAMPSHIRE

New Castle

Isles of Shoals

NEW YORK

Lake Ontario

Gloucester

Salem

BOSTON

MASSACHUSETTS

Stockbridge

Lake Erie

CONNECTICUT

Newport

Old Lyme

RHODE IS.

Branchville

Round Hill

Cos Cob

East Hampton

Shinnecock

North Haven

Vinalhaven

PENNSYLVANIA

NEW YORK

NEW
JERSEY

PHILADELPHIA

Atlantic Ocean

WASHINGTON, D. C.

Map by Astrid Fischer, Munich

Documents

I. The Ten "Charter"

[a] We the undersigned agree to resign from the Society of American Artists upon the signatures of the whole ~~twelve~~ Ten being attached.
> (Signed) J. Alden Weir / Willard L. Metcalf / Edward Simmons / T. W. Dewing / Childe Hassam / Robert Reid / Edmund Tarbell / Frank W. Benson / Joseph De Camp / J. H. Twachtman

[b] We the undersigned agree to cooperate and consolidate for the purpose of holding an annual exhibition of work—each member pledging himself to exhibit. And we moreover agree to admit no other man to this group without an unanimous consent.
> (Signed) Willard L. Metcalf / T. W. Dewing / Childe Hassam / Edward Simmons / Robert Reid / J. Alden Weir / Edmund Tarbell / Frank W. Benson / Joseph De Camp / J. H. Twachtman

New York, Dec. 17, 1897

II. Commentary from Ten members, 1898

[a] Unidentified Ten member, quoted in the *Commercial Advertiser*, Jan. 8, 1898, p. 1

We resigned from the Society because we felt that as it is constituted now the Society of American Artists no longer represents what was intended in the beginning. Many of the members have done little or no real work in art, many of them have not shown work in the annual exhibition for years and consequently we feel that the Society of American Artists does not represent exclusively enough what is generally artistic. The supreme disadvantage for art that this condition brings about is that it lowers the standard of the exhibitions. Genuine artists would not seek primarily to exhibit what they thought would sell, but what they thought was really good. But as the Society is now organized, with its large leaven of business and society painters, art in the best sense is getting to be a more and more vanishing quantity, and the shop element is coming more and more into the foreground. As the organization has been managed for the last two years it might (as was said by one of the men who stayed) be called the Society of Mediocrity.

Consequently many of us painters have felt that we have been carrying too long this load, which is really external to our interests, and we have resigned with the intention of forming another society as soon as practicable. Our society will be small, confined to the painter workers, and the exhibitions will be limited to the three or four best pictures of each of the members chosen by each individual painter.

It is interesting to note that this movement has its parallel in both France and Germany, and that in each case the more vital art seems to be represented by the secessionists. In France it is a new Salon, popularly known as that of the Champ de Mars, which has taken precedence over the old Salon of the Champs Elysées. In Germany too, the secessionists, whose society is called the *Secession*, seem on the whole to be exhibiting at present the best things.

[b] Unidentified Ten member, quoted in the *New York Herald*, Jan. 9, 1898, p. 7

In a word, we have resigned from the Society of American Artists because we do not believe that the society as now conducted is advancing the interests of art. A clique is endeavoring to control it. The men composing this clique are interested more in making a paying business venture of the exhibitions than in following the true bent of art and educating the public. They want to bring the exhibition down to the level of the picture buying public, and they have no sympathy with true art.

I do not say that it is reprehensible to paint pictures that will sell, but I do say that the public taste—usually very bad—should not dominate the exhibitions. I believe in exhibiting good pictures, and those are not the sort usually that the public are anxious to buy at present. Later on when they know better they will buy.

We have organized the "Group of American Painters", and will probably hold an exhibition this Spring. Each artist will be allowed to contribute a certain number of paintings. There will be no jury and no hanging committee. The public can buy or not, as they like. I want to say that in seceding from the society we still bear only the friendliest personal feelings toward our late associates.

[c] Unidentified Ten member, quoted in the *New York Daily Tribune*, Jan. 9, 1898, p. 9

The trouble with the Society of American Artists can be put in a nutshell. There is too much business and too little art in the society as at present constituted.

The new society aims to raise the tone of art and restore it to the height from which it has fallen. There has been too much commerce among painters of late years, and the higher ideals of art to a great extent have been lost sight of. While we are completely organized we have as yet elected no officers, and it is possible that there will be none.

This body of men is organized for the purpose of holding an annual exhibition of the paintings of the members, and it seems probable that the exhibition will be arranged in the following way: Having decided upon the gallery, the walls will be divided into ten equal spaces, which will be numbered and the members will then draw lots for them. There will be no place of honor, no jury and no distinction not equally enjoyed by all. Each member will place his own pictures in the space that falls to him by lot.

[d] J. Alden Weir, quoted in the *New York Daily Tribune*, Jan. 10, 1898, p. 7

We regret the publicity of the matter very much, since it seems to have led to somewhat exaggerated and inaccurate statements on both sides: but it will certainly end in better work, better hung. The same tendencies have cropped out in the Society of American Artists that originally in the Academy caused the society to come into being. It is too catholic, too general, and too large. This movement is no sudden impulse, for it has been growing these four or five years past. The Society of American Artists in its earlier days was more consistent in its aims, but now it has grown so large that it has no direct purpose. We are sorry for the publicity, as we desired to leave in a quiet and dignified manner. Our intention is to have an annual exhibit, and, being a small body of men, working in a certain direction in art, we are more likely to be consistent.

[e] Joseph De Camp, quoted in the *New York Herald*, Jan. 11, 1898, p. 7

The direct reason for our withdrawal was the feeling that with the increase of commercialism in the Society of American Artists it had outlived its usefulness and original intention. The step was taken without pique or desire to cripple in any way the original society. This secession was planned about three years ago, but for various reasons it was delayed until a better opportunity presented itself.

There was a time when it was deemed an honor for an artist to be enrolled among the membership of the society, as he then had an opportunity to display his work before critical audiences, but that time has passed. The composition, with a few exceptions, of the society, has reached such a state that so-called artists, who could never be admitted to the original society, are admitted openly.

[f] Edmund Tarbell, quoted in the *New York Herald*, Jan. 11, 1898, p. 7

The membership of the Society of American Artists has been largely augmented by additions from time to time of men of mediocre ability. These men at a recent meeting came in and voted themselves into the positions on the Committee of Awards.

The men who withdrew think, I believe, as I do, that it was not right for these men who have never achieved any notable work themselves to constitute themselves a committee to pass [judgment] upon the work of men who are generally recognized as artists of merit.

[g] Text of statement signed by the Ten and submitted to the Society of American Artists on Jan. 12, 1898, as quoted in the *Commercial Advertiser*, Jan. 13, 1898, p. 4; the *New York Daily Tribune*, Jan. 13, 1898; and the *Evening Post*, Jan. 13, 1898, p. 7

In withdrawing from the Society of American Artists we had hoped to do so without undue publicity, or causing any ill-feeling, but not succeeding in this, some statement seems to be called for from us as a body. A high standard in art is apparently impossible to maintain in an institution like this Society, as at present organized, from its imperative need of attracting the public in order to meet its large expenses. Recognizing this, and feeling the uselessness of longer continuing a protest against abandoning the earlier ideals of the Society—which were perhaps only possible when it was smaller—a protest in which we are forced to believe that we are in a minority, it has seemed wiser to resign, and it is for these reasons that we have done so.

[h] Robert Reid, quoted in the *Commercial Advertiser*, Jan. 14, 1898, p. 1

Our plans are not yet ready to be made public. Our first "call to arms" is for Saturday night, and then perhaps an announcement will be made of the details of our future campaign. Quite enough publicity has been given the affair already, I think. We are not nearly so dangerous as the public is trying to make out. We haven't any wonderful ideas of elevating art or founding a school or educating the public. We are simply a dozen men who want and intend to give an exhibition. When, where or how it is to be held are questions which will be decided at the meeting on Saturday. We do not care to make announcements, as it is a serious matter and needs no advertising. No officers are to be elected, as no society is to be organized.

III. Commentary from Society of American Artists members, 1898

[a] George Barse, Jr., Secretary, quoted in the *Sun*, Jan. 9, 1898, p. 2

Most of the resignations came to me on Dec. 20, and, strange to say, almost all were written on the notepaper of the Players Club. This makes me think that it is an organized effort to antagonize the interests of the society, and I am led to think by the tone of some of the letters that the writers are dissatisfied with the way in which the society is run. They say that there was too much business and too little real art. I suppose that they refer to the way in which we have borrowed pictures to enhance our exhibitions and the price of admission which has been charged, but those steps were necessary in order to put the society well on its feet, and the results have shown that we did the right thing. It is my opinion that these men have left the society because they did not have the sympathy they wished, or because, in other words, they could not do as they pleased.

Their letters of resignation will be considered at a meeting of the society on Monday night, and at this meeting the vacant places in the jury will be filled. I don't think that this movement is at all serious, and I expect to see all ten back in the society sooner or later. Five of them, by the way, are in arrears for dues.

[b] George Barse, Jr., Secretary, quoted in the *New York Herald*, Jan. 9, 1898, p. 7

It is true that we have received the resignations of ten members of the society. We have not yet received the resignation of Mr. Thayer. The resignations were tendered on December 20, and will be acted upon by the Board at its meeting next Monday evening.

I am sorry that these gentlemen have felt obliged to withdraw. At one time they were in the majority on the jury. Just now they are not—although five of them are members of that body and two are on the Advisory Board of the society. The fact that they are not in control just now probably influences their present action. We have given them a chance to reconsider their resignations, but we must have their answers by Monday. Then we will accept the resignations of those whose dues are paid in full.

The society is in a sound financial position today. It declines to be dominated by "fads." That is all there is to it. For the gentlemen who have resigned I have a warm personal regard. For their "advanced" ideas I must record myself as differing with them. I think that there will be enough good artists left in the society to make sure the high standard of our past exhibitions will be maintained.

[c] John La Farge, President, quoted in the *New York Daily Tribune*, Jan. 10, 1898, p. 7

The resignations of the gentlemen mentioned have not yet been accepted, and as the president of the society, I represent them as well as other members. The group of men who have tendered their resignations are highly appreciated as artists in the society, and, more than that, some of them are so kindly thought of that, if acting separately, they would probably influence the society to partake largely in their views. There has been at no time at any general meeting, or at any of the times when either the jury or the commissions have come together, any statement by these gentlemen of their preference for any given course, so that their reasons would seem to be somewhat personal and not specific. The goodwill of the members remains the same towards them, and I believe that they are quite aware that, even if they leave us, their pictures would be received and placed as well as if they remained members.

[d] J. Carroll Beckwith, quoted in the *New York Daily Tribune*, Jan. 10, 1898, p. 7

I have been a member of the Society of American Artists for the last seventeen or eighteen years, and I have been associated for ten years with its administration. The aims and objects of the organization are of the very highest, artistically. It has always paid its debts, which have often had to be met by the assessments and annual dues which have been placed on the members. In its effort to educate public taste it has endeavored to show every class of good art work. There can be no just complaint on the part of the members for lack of liberality, and the greatest feeling of harmony has heretofore existed. It is with the utmost regret that the members see these men withdraw; but the society will continue with unabated enthusiasm, and it is to be hoped that these men will return and help on the aims and objects that the society has always maintained.

[e] Kenyon Cox, Vice-president, quoted in the *Commercial Advertiser*, Jan. 10, 1898, p. 1

... the seceders have no cause to complain of the bad treatment by the Society. They have received most of what the Society has had to give. They have, until very recently controlled the jury, have had their pictures favorably hung and have been foremost generally in the affairs of the Society. Most of them are impressionistic painters, and while impressionism continued to be looked upon as the beginning and end of art, they, naturally, received rather more consideration than now, when people are beginning to see that there are other things. Yet on the last jury they had five members, which is not a small number.

I do not see any particular point in what they say about the "commercialism" of the Society being a reason for their resignation, for the Society has never been rich; indeed, has always been in rather of an uncertain condition financially. Certainly a man like John La Farge represents something much higher than mere commercialism.

It is hard to find out what their reasons are, except the general statement that they are dissatisfied with the methods of the Society. At the last meeting

several of them accepted their election, and then, suddenly, with no reason given, send in their resignations in a body.

[f] Kenyon Cox, Vice-President, quoted in the *New York Herald*, Jan. 11, 1898, p. 7

I am free to say that I regard the action of the gentlemen who have decided to withdraw as uncalled for. Of course they are at liberty to do as they choose, but this is a time when the society needs encouragement and should not be split into factions. While most of the gentlemen belong to the impressionistic wing of the society they cannot say that they have not been well treated. At least five of them have taken prizes.

[g] Unidentified Society member, quoted in the *Commercial Advertiser*, Jan. 10, 1898, p. 1

The real reason [for leaving] is that these men have nothing more to gain from the Society. The Society helped them when they began, gave them a place to exhibit in, and gave them most of its prizes. Their pictures were always well hung. Now, however, they have made their reputations. They can sell their pictures without the Society's aid, and think it no longer necessary to help the Society. If they were interested in art as they say they are, they would feel more keenly the necessity of the existence of art tradition. Tradition and art are inseparable, and consequently we see in Europe that institutions of art command gratitude, respect and a certain amount of self-sacrifice from their members. But in America there is yet no deep feeling of tradition. These men who are withdrawing are men of talent who are rendered impatient by anything which seems to them in any way to have a bearing otherwise than upon their own immediate development or interests. The venerable and distinguished John La Farge is President of the Society, but to much that makes an environment necessary to the cultivation of art these men seem insensible.

It is particularly unfortunate that these artists should withdraw before the Society is really placed solidly on its feet financially. It is a blow at the cause of art—a blow at once at the Art Students' League, at the Society of American Artists and at the Architectural League, for they were all started as a corporation called the American Fine Arts Society, with a design to erect a building for exhibitions and schoolrooms. It needs fine reckoning to carry the enterprise through. Loyalty would hold it together, and if held together for twenty years it would become the property of the stockholders. If it bursts now, however, only the gift fund will be paid back. If they had any real grievance it would be another matter. It was said that the present threatened withdrawal is similar to the movement against the old Academy, which shaped itself into the present Society, but in reality this thing is very different. Then the trouble was that good pictures were excluded. Now the trouble is that mediocre pictures are not excluded. We are not exclusive enough to suit these men, and yet there are only a little more than a hundred in the Society.

The thing that is really reprehensible in their conduct is the fact that a piece of paper was passed around among them requiring a pledge of resignation. Does not this seem like a deliberate attack on the Society? Why should not each one merely leave it, independently of anyone else, and not aim a blow at the whole thing? There was no pledge when the artists left the old academy. They object to the fact that men who are not prominent painters should take offices, wear badges and do the work, and yet no one of them could be induced to do it himself. They don't even attend regularly, and don't exhibit except when it pays, and yet they complain when they don't have the whole control. It is true that the seceders are among the best artists in the Society, and that it would be a blow to us for them to resign, and I have no doubt that it is the wish of us all that they will remain with the Society. But, like many careless artists, they are for themselves and do not care to foster a general spirit of kindly art.

[h] Unidentified, letter to the editor signed "H.," *Commercial Advertiser*, Jan. 11, 1898, p. 4

... Perhaps it is true, as the secessionists claim, that a number of men in the Society have found their way to membership through favor; certainly a few of the societaires have little right in the organization by reason of high artistic attainments; however, the seceders and their friends, by concerted action, could have kept them out at the time they were voted upon. But the pictures of these men make little showing on the walls at the annual exhibitions, and as it stands today the Society is at least an organized body, recognized by the public, which is a necessary evil People do come to see its exhibitions, and every one of the men who have resigned has been treated with great liberality, indeed, no less than four of them have taken the annual prizes

Inasmuch as two of the retiring members are on the roll of the other and even less catholic body of painters—the National Academy of Design—to be quite consistent, their resignations from that organization should immediately follow, though in the face of what must have been highly disturbing to their aesthetic sensibilities, they have remained in the midst of this not overartistic—judged by their standards—crowd for some years now, with no little complacency. For exhibition purposes, if that were the aim, it would surely have been possible to have organized a little "Group" within and without the Society of American Artists where there could have been displayed any phase of art the men saw fit to exploit.

While a majority of the seceders are men of highly impressionistic tendencies, at least three of them are working in harmony with those who contribute pictures to the annual exhibitions, and even the impressionists in the rebellion have always been taken seriously by the jury ... and their canvases hung in the best places, a concession at times requiring, it must be confessed, great magnanimity. At no times have the conditions prevailed that existed when the split took place at the Academy of Design and the new organization was formed which today is threatened with disruption.

... It will be interesting to watch the outcome of this movement. The awful crime of painting interesting and salable pictures will receive its due punishment, though, to be logical in this matter, several of the seceders will have to be dropped as falling under that dreadful ban, while those curious and unusual impressionistic conceptions of nature, as translated on canvas and hitherto scattered through a large exhibiton, will be concentrated in one harmonious "Group," which will surely point a moral, though its ability to adorn the tale is as yet entirely a matter of speculation.

IV. Childe Hassam on the Founding of the Ten

From Childe Hassam, "Reminiscences of Weir," in *Julian Alden Weir: An Appreciation of His Life and Works*, New York, 1922, pp. 67–68.

"The Ten American Painters" was started during the winter of 1897–98. I proposed the idea to Weir one evening in his house on 12th Street. I remember thinking the whole thing over on my walk down town from 57th Street, where I had my apartment and studio in the old Rembrandt. I remember that I walked down Seventh Avenue and through Longacre (now Times) Square, then down Broadway "The Ten" was my idea entirely. Weir fell for it like—well, like an artist! Twachtman was the first painter to whom we talked. Thayer was asked and the three Boston men, Tarbell, Benson, and De Camp, but Thayer did not come in. Then the other men, Metcalfe [sic], Dewing, Simmons, and Reid, whom we met often at "The Players' Club," made up "The Ten." The plan was to have an exhibition at the Durand-Ruel Galleries, then at 36th Street and Fifth Avenue. It was one of the large, old New York mansions with a gallery that had a top-light—a real picture gallery of moderate size. There were to be no officers, and the meetings to arrange for the Exhibitions were at first held at The Players' Club. Some of the earliest Exhibitions—two or three, if not more—were hung by dividing the wall space into ten centres, one wall cut by a door not being so good. Weir was always enthusiastic about this method of hanging. He was always well represented in every Exhibition which "The Ten" held, and never missed one—which was a much better record than some of us made. In fact, Weir and Twachtman may be said to have contributed most to its artistic success. At least I thought so at the time, and I think so more than ever now.

V. Edward Simmons on the Founding of the Ten

From Edward Simmons, *From Seven to Seventy: Memories of a Painter and a Yankee*, New York and London, 1922, p. 221 ff.

The Ten American Painters was started quite by accident, and when the too-human elements began to enter, it died a natural death. We never called ourselves the "Ten"; in fact, we never called ourselves anything and it was our purpose, at

first, to have twelve. We were just a group who wanted to make a showing and left the Society as a protest against big exhibits. At our first exhibition at the Durand Ruel's Gallery, we merely put out the sign—"Show of Ten American Painters"—and it was the reporters and critics speaking of us who gave us the name. In the original group were Twachtman, Dewing, Metcalf, Reid, Hassam, Weir, Benson, De Camp, Tarbell, and myself. After the death of Twachtman, Chase was voted in to take his place. We had asked both Winslow Homer and Abbot [sic] Thayer to join us. Homer replied that he would have been mighty glad to be a member, but that he never meant to paint again, that he was tired of it all; and as far as I know he never did. Thayer accepted with enthusiasm, but later wrote: "Tell the boys I must decline. The poor society needs me too much."

The first few years we divided the wall into equal spaces and drew lots for them, each man having the right to use it as he saw fit, hanging one picture or a number of pictures. As long as we adhered to that idea all went well. But then objections came in. I, being a mural decorator, had large work, and those members with small canvases naturally did not want them hung next to mine. This of course restricted me in my showing. At last, to save controversy, we left the hanging to the dealer, and he placed those which sold the best in the choice parts of the room and the others elsewhere.

We left the Society as a protest, not believing that an art show should be like a child's bouquet—all higgledy-piggledy with all the flowers that can be picked. We were accused of starting as an advertisement, and, indeed, it proved a big one, but there was no such idea in the mind of any one of us. Many others took it up, and a group followed us, calling themselves "The Eight" in an attempt to boil the egg over again. When the wives of our members "butted in" and made the proposals of sandwiches and tea and finally wanted us to have music at our openings (music with painting is like sugar on oysters), we struck. The "pep" and enthusiasm of youth started the Ten American Painters and age finished it. Peace to its ashes!

Biographies

Frank Weston Benson

Born: Salem, Massachusetts, March 24, 1862
Died: Salem, November 14, 1951

Descended from an old merchant family of comfortable means, Benson remained a lifelong resident of his native Salem, except for several student years spent abroad. He entered the Boston Museum school in 1880, becoming classmates with Tarbell and Reid. While a student he also taught evening drawing classes in Salem and painted outdoors during the summer at Marblehead and Richmond, Massachusetts. In the fall of 1883 Benson went to Paris to study at the Académie Julian, where several of his later associates in the Ten were also studying. He painted in the summer of 1884 at Concarneau, where Metcalf and Simmons were working. His early paintings were conventional peasant and marine subjects, including a large composition, *After the Storm* (private collection), which was exhibited at the Royal Academy, London, in 1885.

On his return to America in 1885, Benson opened a studio in Salem and worked as portraitist and teacher in Portland, Maine. Late in 1888 he established himself in Boston at the Dartmouth Street Studios, where Tarbell worked, as did later Metcalf. In 1888 Benson married Ellen Perry Peirson and, the next year, was appointed to the teaching position resigned by De Camp at the Boston Museum school. From 1891 he became codirector of the school with Tarbell.

Benson attracted considerable attention in New York with his first showing at the Society of American Artists in 1888, where he exhibited the 1887 painting *In Summer* (a fragment of which is preserved in a private collection). Although an outdoor scene, its pale tonality and sharp-edged treatment suggest the *plein air* realism of Jules Bastien-Lepage more than Impressionism. In 1889 Benson won the Hallgarten prize at the National Academy for a nude titled *Orpheus* (lost) and the Clarke prize in 1891 for *Twilight* (private collection), a work typical of his interest during the 1890s in interior scenes illuminated by lamp- or firelight. In 1889 he held his first major exhibition in Boston, together with Tarbell, at the J. Eastman Chase Gallery.

Throughout the later 1880s, and into the mid-1890s, Benson was still searching for a style of his own. Among those who influenced him was Abbott H. Thayer, whom Benson knew during several summers spent in Dublin, New Hampshire, beginning in 1889. Thayer was one of the painters later invited to join the Ten, but who declined. Benson also spent some summers until about 1900 at New Castle, New Hampshire, where Tarbell resided, and where in 1894

they held summer classes together. Benson had begun to use his family as subjects for paintings by the early 1890s, in a fashion that recalled the work of Chase, but in a more conservative vein.

Although vague about the date, and without saying what prompted the experience, Benson in later life described having a revelation sometime in the early 1890s that convinced him that "design" was the key element in painting. Some of Benson's subsequent works of the period, such as *My Little Girl* (1895, private collection), emphasize through sharp silhouettes a stylish curvilinear patterning that reflects his new sense of control and abstract order. In 1896 he executed murals of the "Three Graces" and "Four Seasons" for the Library of Congress, a project

that also inspired several separate decorative compositions of statuesque, allegorical figures. Also in 1896 he won the Shaw prize of the Society of American Artists for his decorative allegory *Summer* (fig. 25), painted in 1890. Though liberated from his earlier representational concerns, it took Benson several more years to move from this type of ornamentalism to involvement with the techniques of Impressionism.

Despite his previous close association with Tarbell, who was involved with Impressionism by the early 1890s, Benson fully embraced the principles of *plein air* painting only after he joined the Ten, taking his first significant step in this direction with *Children in the Woods* of 1898 and giving expression to his fully mature style in *The Sisters* of 1899 (both private collections). The success of the latter painting, which won medals at the Carnegie Institute and at major expositions in Paris in 1900, Buffalo in 1901, and St. Louis in 1904, helped confirm Benson's future direction. Over the next two decades he achieved enormous fame through a series of sparkling outdoor paintings depicting his wife and daughters, executed during long summer residences on the island of North Haven, Maine, which Benson first visited around 1900 and where he eventually acquired the property known as Wooster Farm. Benson continued to live in Salem, commuting daily to his studio and classroom in Boston. Summers were spent painting outdoor scenes at North Haven and, in the winter, he devoted his time to teaching and to studio work, which included commissioned portraits and interior subjects.

After the demise of the Ten, Benson painted a few more figure subjects—including *Reflections*, 1921 (fig. 63), a portrait of his daughter Betty—a still life or two each year, and landscapes. But the bulk of his later activity shifted to wildlife subjects, which had appeared intermittently in earlier periods and which reflected his lifelong avocations as hunter and fisherman. He stopped teaching in 1913 and began to produce etchings, chiefly illustrating wild fowl, which, from their first showing in 1915, proved extremely popular. After 1919 Benson enjoyed what was virtually a second career, achieving great popular and financial success with a prodigious output of watercolors and etchings that, for many years, sold as fast as they could be produced.

He had one-man exhibitions at the St. Botolph Club, Boston, in 1900 and 1909. Major retrospective exhibitions of Benson's work were held at the Guild of Boston Artists in 1917, at the Corcoran Gallery in 1921, at the Carnegie Institute in 1924, and, jointly with Tarbell, at the Boston Museum of Fine Arts in 1938. Benson was one of the most bemedaled painters of his generation, with awards ranging from one

received at the 1893 World's Columbian Exposition in Chicago to various medals won over the years at the Carnegie Institute, the Corcoran Gallery, the Pennsylvania Academy of the Fine Arts, and at the Paris, Buffalo, and St. Louis Expositions.

Literature

Frank W. Benson Family Manuscript Collection, James Duncan Phillips Library, Essex Institute, Salem, Mass.

William H. Downes, "Frank W. Benson and His Work," *Brush and Pencil* 6 (July 1900), pp. 145–57.

Frederick W. Coburn, "Frank W. Benson's Portrait of My Daughters," *New England Magazine* 38 (May 1908), pp. 328–29.

Minna C. Smith, "The Work of Frank W. Benson," *International Studio* 35 (Oct. 1908), pp. xcix–civ.

Charles H. Caffin, "The Art of Frank W. Benson," *Harper's Magazine* 119 (June 1909), pp. 105–14.

William H. Downes, "The Spontaneous Gaiety of Frank W. Benson's Work," *Arts and Decoration* 1 (Mar. 1911), pp. 195–97.

Adam E. M. Paff, *Etchings and Drypoints by Frank W. Benson*, Boston and New York, 1917.

William Howe Downes, "Mr. Benson's Etchings," *American Magazine of Art* 9 (June 1918), pp. 309–13.

Anna Seaton-Schmidt, "Frank W. Benson," *American Magazine of Art* 12 (Nov. 1921), pp. 365–72.

Helen Wright, "Etchings by Frank W. Benson," *Art and Archaeology* 15 (Feb. 1923), pp. 92–95.

Malcolm Charles Salaman, *Frank W. Benson*, London, 1925.

Charles L. Morgan, *Frank W. Benson, N. A.*, American Etchers, vol. 12, New York, 1931.

Claude Reece, "Frank W. Benson," *Prints* 4 (Mar. 1934), pp. 4–8.

Frank W. Benson, Edmund C. Tarbell: Exhibition of Paintings, Drawings and Prints, exhibition catalogue, Museum of Fine Arts, Boston, 1938. With essays by Lucien Price and Frederick Coburn.

Samuel Chamberlain, "Frank W. Benson: The Etcher," *Print Collector's Quarterly* 25 (Apr. 1938), pp. 166–83.

Frank W. Benson, 1862–1951, exhibition catalogue, Essex Institute and Peabody Museum, Salem, Mass., 1956. With an essay by Lucien Price.

Ernest S. Dodge, *Frank W. Benson, 1862–1951*, exhibition catalogue, William A. Farnsworth Library and Art Museum, Rockland, Me., 1973.

Kenneth Haley, "Frank Benson as Colorist," *Apocrypha* 1 (1974), pp. 14–16.

Two American Impressionists: Frank W. Benson and Edmund C. Tarbell, exhibition catalogue, University Art Galleries, University of New Hampshire, Durham, 1979. With an essay by Susan Faxon Olney.

Frank W. Benson: The Impressionist Years, exhibition catalogue, Spanierman Gallery, New York, 1988. With essays by John Wilmerding, Sheila Dugan, and William H. Gerdts.

Bruce Chambers, "Frank Benson: An American Impressionist Painter," *Classic America* 4 (Summer 1989), pp. 8–14.

Frank W. Benson: A Retrospective, exhibition catalogue, Berry-Hill Galleries, New York, 1989. With essays by Faith Andrews Bedford, Susan C. Faxon, and Bruce W. Chambers.

William Merritt Chase

Born: Williamsburg (renamed Nineveh), Indiana, November 1, 1849
Died: New York City, October 25, 1916

Chase grew up in Indianapolis, where he first studied with the local painter Barton S. Hays. He served briefly in the navy in 1867, and went to New York in 1869 to attend classes under Lemuel Wilmarth at the National Academy of Design. During this period he produced conventional flower and fruit still lifes with some commercial success. When his father's shoe business failed in 1871, Chase was forced to leave New York and join his family in St. Louis. The portraits and still lifes Chase painted there persuaded a group of benefactors to sponsor a study trip to Munich, where he enrolled at the Royal Academy in 1872 under the tutelage of Karl von Piloty and Wilhelm von Diez. He was also influenced there by Wilhelm Leibl, whose realistic style derived from an admiration for Gustave Courbet and for earlier Dutch and Spanish masters, particularly Frans Hals and Diego Velázquez. Chase was part of a vigorous company of Americans studying at the time in Munich which included Frank Duveneck, Walter Shirlaw, J. Frank Currier, Toby Rosenthal, and, later, Twachtman and De Camp. Among Chase's most notable works there was a series depicting working-class youths in a vivid, realistic style. A commission from Piloty to paint portraits of the latter's children boosted his reputation both locally and at home.

Chase accompanied Duveneck and Twachtman to Venice in the summer of 1877, staying there nine months before succumbing to a near fatal illness. He reportedly declined the offer of a teaching post at the Munich Academy and returned in September 1878 to America, where his friend Shirlaw arranged for him to obtain a teaching job at the Art Students League. Chase arrived with a reputation already gained through works exhibited in previous years at the National Academy of Design and at the 1876 Philadelphia Centennial Exposition, at which he won a medal for *Keying Up: The Court Jester* (Pennsylvania Academy, Philadelphia). His painting *Ready for the Ride, 1795* (Union League Club, New York) was regarded as one of the highlights of the first Society of American Artists exhibition, held in spring 1878. Some of his old St. Louis admirers, used to the hard *trompe l'oeil* style of his early still lifes, thought that he had been spoiled by Europe. By virtue of his self-assured talent and personal flair, and by using his positions as principal teacher at the Art Students League and as president of the Society of American Artists in 1880 and later, Chase became the most visible and influential spokesman of the new generation of European-trained painters. Upon coming to New York he established a large and spectacular studio in what was once the common picture gallery for the Tenth Street Studio Building, the former stronghold of the Hudson River School painters. Elaborately furnished with a profusion of paintings, tapestries, antique furniture, armor, vases, jewelry, curios, and bric-a-brac of all kinds, it was viewed with awe by visitors unaccustomed to such extravagance. Chase held regular Saturday receptions in the studio, as well as private classes, meetings, dinners, and musical recitals, and many of his best-known paintings of the early and mid-1880s are scenes of quiet life in his studio.

Chase joined the Society of American Artists in 1879, and by that year also had become a member of the Tile club, the famous but short-lived society of bohemian artists and literati formed in 1877, which included Weir, Twachtman, Winslow Homer, Stanford White, Frank D. Millet, Francis Hopkinson Smith, Edwin Austin Abbey, Earl Shinn, and Elihu Vedder.

Chase returned to Europe for the first time in 1881, and paid many visits in the following years, always sailing in time to see the Paris Salon, where he exhibited regularly. Much of Chase's work before 1881 had still tended to be anecdotal, and painted in a bituminous, Old Master technique. It was in Paris, according to Chase's own testimony, that advice offered by the painter Alfred Stevens led him to abandon the dark palette developed in Munich and to concentrate his attention on portraits and scenes of contemporary life. Outdoor work was among his new concerns and, in the early 1880s, he exhibited some landscapes executed in New York and its vicinity. Chase was a restless experimenter and assimilated the lessons of many leading contemporaries. He is once quoted as telling his students, "Be in an absorbent frame of mind. Take the best from everything" (*American Magazine of Art*, 1917), and in his own work he seems to have done just that. While he emulated no single artist, his work at times includes elements reminiscent of such cosmopolitan urban painters as Stevens and Giuseppe De Nittis. Chase's own collection of paintings reflected his tastes as an artist, con-

taining as it did works by Stevens, John Singer Sargent, Mary Cassatt, Antoine Vollon (Chase at one time owned twenty), Giovanni Boldini, De Nittis, Paul-César Helleu, Sir John Lavery, James Tissot, Mariano Fortuny, Carolus Duran, Thomas Eakins, Joaquin Sorolla, Théodule Ribot, and many others. Many of these, including Stevens, Boldini, Sargent, and Eakins, Chase knew personally. An example of his eclectic enthusiasm was recorded in 1903 when, during the course of a single conversation, Chase expressed his admiration for Eakins, Sargent, Twachtman, Boldini, James McNeill Whistler, and the young Rockwell Kent (Bryant Papers, Archives of American Art, Roll # 2542).

In Europe in the early 1880s Chase divided his time between the French capital and excursions to Holland (1882–84), where he painted outdoors with his friend Robert Blum. Together with Blum, Chase turned enthusiastically to working in pastel, a medium which clearly helped to brighten his palette and broaden his color range. In New York Chase became one of the founders of the American Society of Painters in Pastel, and the work he did in that medium in Holland in the summer of 1883 was said to have attracted much attention among the artists in New York (New York Herald, Dec. 31, 1883, p. 8), both before and after the Society's first exhibition was held in 1884. That year Chase also showed with the avant-garde Société des Vingt in Brussels, along with Whistler, Sargent, and members of the French Impressionist group.

After having served as president of the Society of American Artists in 1880, Chase was reelected president in 1885 and held that office for ten consecutive years.

In 1885 he struck up a brief but intense friendship with Whistler in London, where the two painted each other's portraits, and traveled with him to Holland before they quarreled. Chase remained a great admirer of Whistler, stating at one point that his Portrait of the Painter's Mother (Louvre, Paris) was the only modern work that might compare favorably to the work of Chase's foremost idol, Velázquez. It may have been through Whistler's influence that Chase first acquired a taste for Japanese prints, which he collected and studied intently (see plate 32).

In 1886 Chase married Alice Gerson, the daughter of family friends, who often modeled for him both before and after marriage, and who eventually bore him thirteen children, eight of whom survived past infancy. In late 1886 he held his first one-man show in Boston and New York, which included some of the outdoor scenes that he had begun to paint that year in the parks and waterways around New York.

Though supported by a modest number of progressive collectors, Chase was often in financial difficulty, partly as a result of his extravagant spending and collecting habits. The meager proceeds from large auctions of Chase's work held in 1887, 1891, and 1896 were considered evidence of the scandalous neglect suffered by American artists. Chase himself said in 1896 that much of the best work at home went unrewarded and was scarcely acknowledged (Art Amateur, Apr. 1896). Velázquez himself, he declared, would have starved in New York. Unrelenting in the face of criticism, Chase once advised his pupils: "Try to paint the unusual; never mind if it does not meet the approval of the masses. Always remember that it is the man who paints the unusual, who educates the public. I am never so disappointed in a piece of my work as when it meets with the approval of the public" (Art Amateur, Oct. 1894).

In 1891 Chase founded a summer school at Shinnecock, near the fashionable resort of Southampton, Long Island. Surrounded by adoring students, he taught landscape painting there until 1902 and also created some of his own finest outdoor work, depicting his wife and children within the bright, sandy landscape of coastal Long Island. Chase encouraged individuality in his students and it was said of him that no one had done more to spread new ideas of painting.

Chase underwent a major crisis in 1895 and 1896, when he resigned from the presidency of the Society of American Artists and also, under pressure caused by a dispute over teaching methods, gave up his long-held teaching post at the Art Students League. This was accompanied by the dismantling and sale of his famous studio. After these reverses Chase never fully recovered his former vigor and sense of experiment. He began to take on more and more commercial portrait work and to be satisfied even more than previously with teaching and lecturing. In 1896 he founded the Chase School of Art in New York (later the New York School of Art) and, in the same year, began teaching at the Pennsylvania Academy, filling a vacancy left by De Camp. He taught at the New York School of Art until 1907 and at the Pennsylvania Academy until 1909, though he continued to maintain a studio in Philadelphia for portrait work after that date.

Following his years at Shinnecock, Chase took summer classes to Europe nearly every year until 1913. He bought a villa near Florence in 1908, and subsequently did much of his outdoor work in the environs of Florence and in Venice. These Italian views tend to be abstract images of unpeopled landscape, their solitariness suggesting self-absorbed, even private, exercises that lacked the free vigor of his earlier style. In these years he also turned again to painting still lifes in great numbers. These, he said, were done for his own satisfaction, and seemed to embody his life-long dictum that it was not what you painted but how you painted that mattered. Once or twice a year he took great pleasure in giving a bravura performance in painting, finishing a still life or a full-length figure in three hours in the presence of the assembled school.

Chase disparaged the specialist who could practice only one kind of painting, believing that a good professional should be able to perform in a variety of fields. Accordingly, portraits, still lifes, landscapes, nude studies, and scenes of contemporary manners were treated over the course of his career in almost equal measure. His wife and children often served as models for his pictures.

Most critics tended to concede Chase's technical brilliance, but faulted him for superficiality. Kenyon Cox called him "a wonderful human camera—a seeing machine" (Harper's Magazine, 1889), while another writer said earlier that "Mr. Chase is a great painter, but gives no indication of being a man of large or serious motive in painting. He is emphatically of his day and an interpreter of his day in art—a remarkable exponent of artistic surfaces and effects" (Art Interchange, Dec. 4, 1886).

Often overlooked behind Chase's brilliant technical skill was his keen insight into character and his remarkable gift for seizing a fleeting psychological moment, his images often being designed in such a way as to make all their many rich visual elements subordinate to a small, sharply focused pivotal idea or observation.

In 1909 a major exhibition of his works traveled to museums thoughout the country. In January 1910 a still larger retrospective was held at the National Arts Club in New York.

Chase was the recipient of many medals, and a member of numerous art organizations and award juries. He became an Associate of the National Academy in 1888 and an Academician in 1890. He exhibited frequently in Europe, including at the Glaspalast in Munich, where he was a member of the Secession. In 1908 Chase was elected to the American Academy of Arts and Letters, and, in the same year, was made Knight of the Order of St. Michael by the government of Bavaria.

He was the only resident American with a stature to compare at home with that of Whistler or Sargent. In his personal habits, his teaching, his comportment, and in his development as an artist, he was a law unto himself. In later years he grew rather professorial and tended to become obscured by his own legend.

At the time of his death Chase was represented in the permanent collections of many American museums, and had painted his self-portrait for the Uffizi Gallery in Florence. In 1914 he held his last summer class, in Carmel-by-the-Sea, California. In 1915 he was one of the artists chosen to fill a single gallery by himself at the Panama-Pacific Exhibition in San Francisco. In the following year major one-man exhibitions were held in Detroit and Toledo and other midwestern cities. With his health failing, Chase spent the end of summer 1916 in Atlantic City, New Jersey, and returned to New York, where he died a short time afterward. A major retrospective of his paintings was held at the Metropolitan Museum of Art in 1917.

Literature

S. R. Koehler, "Works of the American Etchers," American Art Review 2, no. 1 (1881), p. 143.

Marianna Griswold Van Rensselaer, "William Merritt Chase," American Art Review 2 (Jan. 1881), pp. 91–98; 2 (Feb. 1881), pp. 135–42.

–, "William Merritt Chase," in American Art and American Art Collections, ed. Walter Montgomery, 2 vols., Boston, 1889, pp. 209–30.

Kenyon Cox, "William Merritt Chase, Painter," Harper's Magazine 78 (Mar. 1889), pp. 549–57.

William M. Chase, "Address of Mr. William M. Chase Before the Buffalo Fine Arts Academy, January 28, 1890," Studio 5 (Mar. 1, 1890), pp. 121–27.

Charles De Kay, "Mr. Chase and Central Park," Harper's Weekly 35 (May 2, 1891), pp. 327–28.

William J. Baer, "Reformer and Iconoclast," Quarterly Illustrator 1 (1893), pp. 135–41.

John Gilmer Speed, "An Artist's Summer Vacation," Harper's Magazine 87 (June 1893), pp. 3–14.

Rosina H. Emmet, "The Shinnecock Art School," Art Interchange 31, no. 4 (Oct. 1893), pp. 89–90.

William M. Chase, "From a Talk by William M. Chase with Benjamin Northrup...," Art Amateur 30 (Feb. 1894), p. 77.

William Henry Howe and George Torrey, "William M. Chase," *Art Interchange* 32, no. 4 (Apr. 1894), pp. 102–3.

Lillian Baynes, "Summer School at Shinnecock Hills," *Art Amateur* 31 (Oct. 1894) pp. 91–92.

Jessie B. Jones, "Where the Bay-Berry Grows: Sketches at Mr. Chase's Summer School," *Modern Art* 3 (Autumn 1895) pp. 109–14.

May Clara Sherwood, "Shinnecock Hills School of Art," *Arts* 4 (Dec. 1895), pp. 171–73.

Susan M. Ketcham, in "Echoes," *Modern Art* 4 (Summer 1896), pp. 1–5.

William M. Chase, "Velasquez," *Art Interchange* 37, no. 4 (Oct. 1896), pp. 84–86.

Maibelle Justice, "New York's Newest Art School,"*Demorest's Family Magazine* 33 (Apr. 1897), pp. 305–10.

Spencer H. Coon, "The Work of William M. Chase as Artist and Teacher," *Metropolitan Magazine* 5 (May 1897), pp. 307–13.

William M. Chase, "Out-of-Door Sketching: Talk on Art by William M. Chase," *Art Interchange* 39 (July 1897), pp. 8–9.

–, "Talk on Art by William M. Chase," *Art Interchange* 39, no. 6 (Dec. 1897), p. 126–27.

John Rummell and Emma Modora Berlin, *Aims and Ideals of Representative American Painters*, Buffalo, New York, 1901, pp. 86–94.

Ernest Knaufft, "An American Painter: William M. Chase," *International Studio* 12 (Jan. 1901), pp. 151–58.

William M. Chase, "The Danger of Art Schools," *Metropolitan Magazine* 13 (Feb. 1901), pp. 213–14.

Homer St. Gaudens, "William M. Chase: An Estimate," *Critic* 48 (June 1906), p. 515.

Joseph Walker McSpadden, *Famous Painters of America*, New York, 1907, pp. 327–54. 2nd, enlarged ed., 1916.

E. F. B., "The Art Ideals of Wm. M. Chase," *Evening Post* (New York), Apr. 27, 1907, pp. 1–2.

Ernest Knaufft, "Sargent, Chase, and Other Portrait Painters," *Review of Reviews* 36 (Dec. 1907), pp. 693–94.

William M. Chase, "Artists' Ideals: The Aims of Painters and Actors," *House Beautiful* 23 (Feb. 1908), pp. 11–12.

James William Pattison, "William Merritt Chase, N. A.," *House Beautiful* 25 (Feb. 1909), pp. 50–52, 56.

W. H. Downes, "William Merritt Chase: A Typical American Artist," *International Studio* 39 (Dec. 1909), suppl. pp. 29–36.

"The Chase Exhibition," *Outlook* 94 (Jan. 29, 1910), pp. 229–30.

Katharine Metcalf Roof, "William Merritt Chase: An American Master," *Craftsman* 18 (Apr. 1910), pp. 33–45.

William M. Chase, "The Two Whistlers," *Century* 80 (June 1910), pp. 218–26.

Walter Pach, "The Import of Art (An Interview with William M. Chase)," *Outlook* 95 (June 1910), pp. 441–45.

Arthur Hoeber, "American Artists and Their Art, II: William M. Chase," *Woman's Home Companion* 37 (Sept. 1910), p. 50f.

C. P. Townsley, "William Merritt Chase: A Leading Spirit in American Art," *Arts and Decoration* 2 (June 1912), pp. 285–87, 306.

William H. Fox, "Chase on 'Still Life,'" *Brooklyn Museum Quarterly* 1 (Mar. 1914), pp. 196–200.

"Chase's Americanism," *Literary Digest* 53 (Nov. 11, 1916), pp. 1250–51.

William M. Chase, "Painting," *American Magazine of Art* 8 (Dec. 1916), pp. 50–53.

Duncan Phillips, "William M. Chase," *American Magazine of Art* 8 (Dec. 1916), pp. 45–53.

Gifford Beal, "Chase: The Teacher," *Scribner's Magazine* 61 (Feb. 1917), p. 257.

Howard Russel Butler, "Chase: The Artist," *Scribner's Magazine* 61 (Feb. 1917), pp. 255–57.

Loan Exhibition of Paintings by William M. Chase, exhibition catalogue, Metropolitan Museum of Art, New York, 1917.

Katharine Metcalf Roof, *The Life and Art of William Merritt Chase*, New York, 1917.

–, "William Merritt Chase: His Art and His Influence," *International Studio* 60 (Feb. 1917), pp. 105–10.

–, "William Merritt Chase: The Man and The Artist," *Century Magazine* 93 (Apr. 1917), pp. 833–41.

Leo Stein, "William M. Chase," *New Republic* 10 (Mar. 3, 1917), pp. 133–34.

Frances Lauderbach, "Notes from Talks by William M. Chase: Summer Class, Carmel-By-The-Sea, California—Memoranda from a Student's Note-Book," *American Magazine of Art* 8 (Sept. 1917), pp. 432–38.

"William Merritt Chase: Painter, 1849–1916," *Index of Twentieth Century Artists* 2 (Nov. 1934), pp. 17–27 (reprinted 1970, pp. 270–80, 286, 288)).

Chase Centennial Exhibition, exhibition catalogue, John Herron Art Museum, Indianapolis, Indiana, 1949. Text by Wilbur D. Peat.

James Thomas Flexner, "The Great Chase," *Art News* 48 (Dec. 1949), pp. 32–34, 60.

J. O'Connor, "Tenth Street Studio by Chase," *Carnegie Magazine* 24 (Feb. 1950), pp. 240–41.

William Merritt Chase, 1849–1916: A Retrospective Exhibition, exhibition catalogue, The Parrish Art Museum, Southampton, New York, 1957.

William Merritt Chase (1849–1916), exhibition catalogue, The Art Gallery, University of California, Santa Barbara, 1964–65. With an essay by Ala Story.

Nicolai Cikovsky, Jr., "William Merritt Chase's Tenth Street Studio," *Archives of American Art Journal* 16, no. 2 (1976), pp. 2–14.

The Students of William Merritt Chase, exhibition catalogue, Hekscher Museum, Huntington, New York, 1973. Text by Ronald G. Pisano.

William Merritt Chase (1849–1916), exhibition catalogue, M. Knoedler & Co., New York, 1976. Text by Ronald G. Pisano.

William Merritt Chase in the Company of Friends, exhibition catalogue, The Parrish Art Museum, Southampton, New York, 1979. Text by Ronald G. Pisano.

The Ripening of American Art: Duveneck and Chase, exhibition catalogue, The Fine Arts Museum of the South at Mobile, 1979. Text by Clarence David McCann.

William Merritt Chase: Portraits, exhibition catalogue, Akron Art Museum, Ohio, 1982. With an essay by Carolyn Kinder Carr.

A Leading Spirit in American Art: William Merritt Chase 1849–1916, exhibition catalogue, Henry Art Gallery, University of Washington, Seattle, 1983. Text by Ronald G. Pisano.

William Merritt Chase: Summers at Shinnecock, 1891–1902, exhibition catalogue, National Gallery of Art, Washington, D. C., 1987. With essays by D. Scott Atkinson and Nicolai Cikovsky, Jr.

Nicolai Cikovsky, Jr., "William Merritt Chase at Shinnecock Hills," *Antiques* 132 (Aug. 1987), pp. 290–303.

Joseph Rodefer De Camp

Born: Cincinnati, Ohio, November 5, 1858
Died: Boca Grande, Florida, February 11, 1923

Drawn to art in childhood, De Camp attended night classes at the McMicken Design School (University of Cincinnati) at age fifteen before enrolling there full-time in 1875. He taught briefly at a girls' school in 1876, but left America in 1878 to study at the Royal Academy in Munich. He worked at Polling, near Munich, with Frank Duveneck and others of his circle, including Twachtman and Chase. From 1879 to 1883 he lived in Florence and Venice as one of the famous "Duveneck Boys," with trips to Rome recorded in February 1882 and in 1883. He exhibited one of his Venetian views in the 1882 Paris Salon (*Étude à Venise*, lost), and some twenty of his paintings, mostly views of Venice, were sent home from Italy and sold by his brother Hiram.

After returning to Cincinnati in 1883, De Camp briefly occupied a studio in the same building as Twachtman and Louis Ritter, among other local artists. De Camp moved to Boston in 1884 to teach at Wellesley College and served as instructor of drawing from antique casts at the Boston Museum school from 1885 until spring 1889, when he resigned over a salary dispute.

Although he exhibited a few portraits, landscape painting was De Camp's main interest during his early Boston years and led to his supervising outdoor summer classes that continued at different locations for much of his career. The first of these was held at Oyster Bay, Long Island, but shortly afterward, in 1886, he is documented at Annisquam, near Gloucester, Massachusetts, where, in 1890, he was mentioned teaching summer classes to twenty young Philadelphia women. His *Moorland, Cape Ann* was the first painting exhibited by him at the Society of American Artists in 1888. Other works of this period, also now lost, include the landscapes *Medford Marshes* (1890), *The Mill Pond* (1890), and *Misty Calm* (1891).

In 1891 he married his former student Edith F. Baker, the daughter of the lithographer Joseph E. Baker, who had worked with Winslow Homer in the 1850s. A daughter, Sally, the first of four children, was born the following year and, in 1894, De Camp moved to a nearby farm in West Medford, Massachusetts. Around this time his family began to appear as subjects in his paintings, perhaps also in a number of works now lost, including *The Hammock* (1893), *New England Garden* (1893), *September Afternoon* (1894), *September Morning* (1893), *The Hill Side* (1894), and *Edge of the Orchard* (1895).

Most of De Camp's paintings from the 1880s and 1890s – reportedly several hundred works – were lost in a fire that destroyed his Harcourt Street studio in 1904. The loss is compounded by a scarcity of information from other sources, for, although De Camp was active in Boston art circles, and was famous for his outspoken opinions among friends, he was extremely reticent in public. Little was written about him during his lifetime, and, according to his stepson-biographer Donald Moffat, he "kept no records and never wrote a letter if he could help it." A curt reply to a request from *Century Magazine* for biographical information typified his attitude, its few lines concluding with the comment: "I am a member of no Artistic Society, unless 'The Ten' can be so called. I have had a good many medals, but I don't think they amount to a Tinkers Damn" (Archives of American Art, Roll #N6, frame 1197).

In the early 1890s De Camp was named with Robert Vonnoh as belonging to the most advanced of outdoor painters (*New York Daily Tribune*, Apr. 22, 1893, section III, p. 11) and as a painter "in the Monet advance" (*New York Times*, Apr. 24, 1893, p. 4). Frederick Coburn (1908) recalled his coming to prominence in 1894 with a showing of five works at the St. Botolph Club, which placed him, along with Tarbell, Benson, Theodore Wendel, Lilla Cabot Perry, and a few others, among the dominant group of Boston artists. In the 1890s he experimented with Impressionist techniques in bright, boldly colored compositions, such as *The Hammock* (plate 44) and *The Pear Orchard* (plate 19). Other outdoor compositions are known but remain lost or unstudied. From about 1894 De Camp began also to specialize in painting nudes, reverting in these to a much more subdued palette. They included *Sleep* (1894), *Girl with Globe* (1895), both now lost, and *Magdalene* (1897/98, Cincinnati Art Museum). Another of them, *Woman Drying Her Hair* (Cincinnati Art Museum), won the Pennsylvania Academy Temple gold medal in 1899.

For several years around 1900 De Camp spent summers at Gloucester, Massachusetts, where his wife

Joseph Rodefer De Camp

later remembered receiving visits from Duveneck, Twachtman, Mills, Wendel, and other old Cincinnati friends. Works from this period include *The Landing* (probably the painting now titled *Jetty at Low Tide* of c. 1900 [fig. 45]) and *The Little Hotel* (1903, Pennsylvania Academy). In 1902 he painted at Windsor, Vermont, for part of the summer of 1903 at Cornish, New Hampshire, and in 1905 at Camden, Maine. In 1910 he bought a summer residence on Vinalhaven Island, Maine, not far from that of his friend Benson.

De Camp won silver and gold medals at the 1891 and 1892 Charitable Mechanics Association Exhibitions, and a $3,000 first prize in 1896 for a mural design for Philadelphia's City Hall, a project left uncompleted when the promised funds were withdrawn. He may have reused part of this design for a ceiling he painted in Boston's Hotel Touraine around 1898 (later destroyed). Other major awards included a gold medal at the St. Louis Exposition of 1904 and a silver medal at the Corcoran Annual of 1909.

Like many of his generation, De Camp relied mainly on teaching and portraiture for support. He taught for a time at the Cowles School and, after earlier efforts to hire him apparently failed, he became instructor at the Pennsylvania Academy of the Fine Arts in 1895 as a replacement for Vonnoh. The strain of commuting from Boston, however, caused him to

give up the job after only one year, and his position was subsequently filled by Chase. Episodes of ill health seem to have begun at this date (Morris, 1930), followed in later years by a chronic and progressively painful illness—diagnosed as stomach ulcers—that limited his ability to work after about 1907. At some time around the turn of the century he taught briefly at the Art Students League and, in 1903, he became instructor in portrait painting at the Massachusetts Normal Art School, where he spent the remainder of his career.

Apparently as a result of the loss of his studio, De Camp turned increasingly to portraiture after 1904, eventually gaining many clients from among Boston's prominent business, educational, and social leaders. He was much appreciated as a portraitist not only for his great skills as a draftsman, but also for a willingness to endow his subjects with the time-honored dignity they required. While acknowledged for his uncompromising mastery in this field, there was implicit recognition that he sacrificed some of the openness and experimental freedom that had marked his earlier works. In his 1911 one-man show at the St. Botolph Club ten of the seventeen paintings shown were portraits, and an article at the time quoted him as regretting that portraiture did not allow him more time for landscape work.

Interior figure subjects painted by De Camp in the decades after the studio fire comprise his best-known works and, while not numerous, demonstrate his highly meticulous and craftsmanlike manner. Many of them were preceded by careful preparatory drawings. The most familiar include *The Blue Locket* (c. 1904, private collection), *The Heliotrope Gown* (plate 61), *In the Studio* (1905, private collection), *The Cellist* (1908, Cincinnati Art Museum), *The Pink Feather* (1908, private collection), *The Blue Cup* (fig. 54), *The Fur Jacket* (c. 1910, private collection), *The Window* (fig. 17), *The Silver Waist* (1915, private collection), *The Seamstress* (fig. 55), *The Gray Turban*, *The Blue Bird* (both c. 1918, private collections), and *The Red Kimono* (1918, Cummer Art Gallery, Jacksonville, Florida). His painting *The Guitar Player* (plate 71) was purchased by the Boston Museum of Fine Arts in 1908 along with works by Benson and Metcalf, and that year De Camp was also commissioned to execute a portrait of President Theodore Roosevelt.

In the summer of 1909 he traveled in North Africa, Spain, and England. He held another one-man show of portraits at the Guild of Boston Artists in 1915, but failing health reduced his output in later years. In 1919 he was commissioned to portray the delegates to the Paris Peace Conference and, though he traveled to Europe to execute a few portraits, was unable to complete the project. He died in Boca Grande, Florida, where he had gone to winter while gravely ill. Memorial exhibitions were held in 1924 at the St. Botolph Club, Boston, and at the Cincinnati Museum.

Literature

Frederick W. Coburn, "Joseph De Camp's 'The Guitar Girl,'" *New England Magazine* 39 (Oct. 1908), pp. 238–39.
Arthur Hoeber, "De Camp: A Master of Technique," *Arts and Decoration* 1 (Apr. 1911), pp. 248–50.
William Howe Downes, "Joseph De Camp and His Work," *Art and Progress* 4 (Apr. 1913), pp. 918–25.
George R. Agassiz, *Joseph De Camp: An Appreciation*, Boston, 1923.
Rose V. S. Berry, "Joseph De Camp: Painter and Man," *American Magazine of Art* 14 (Apr. 1923), pp. 182–89.
Harrison S. Morris, *Confessions in Art*, New York, 1930, pp. 64ff., 170ff.
William Howe Downes, "Joseph Rodefer De Camp," in *Dictionary of American Biography*, vol. VI, New York, 1946, pp. 185–86.
Donald Moffat, "Joseph Rodefer De Camp, 1858–1923," unpublished MS, c. 1957, by a descendant of the artist, deposited at the Frick Art Reference Library, New York.
Obituaries: *American Magazine of Art*, Apr. 1923; *Art News*, Feb. 17, 1923; *Boston Herald* and *Boston Evening Transcript*, Feb. 12, 1923.

Thomas Wilmer Dewing

Born: Newton Lower Falls, Massachusetts, May 4, 1851
Died: New York City, November 5, 1938

Left fatherless as a child, Dewing became a lithographer's apprentice in his early teens and was listed in Boston city directories variously as "taxidermist" and "clerk" before he assumed the occupation of "artist" in 1872. He attended pupil-sponsored life classes at the Boston Art Club and may have studied anatomy under William Rimmer. Part of the year 1875 was spent in Albany, New York, drawing charcoal portraits commercially. He left for Paris in July 1876 to study at the Académie Julian under Gustave Boulanger and Jules-Joseph Lefebvre. Little is known about Dewing's student years abroad. He was back in Boston early in 1878, working as an assistant to Otto Grundmann at the newly formed Boston Museum school. Among the enrolling pupils whom Dewing must have encountered there were Metcalf and Tarbell.

Dewing's skill as a draftsman earned him recognition as a rising newcomer among the European-trained artists. Although his paintings of single figures with classical or Near Eastern themes often recall student academic exercises, his early work also revealed an interest in the French painter Jean-Louis Hamon and a more lasting one in the artists of the English Aesthetic movement. Indeed, when he showed the painting *A Musician* (private collection) in the first Society of American Artists exhibition in 1878, Dewing's offbeat moods and fondness for allegory led critics to equate him with the English Pre-Raphaelites in a generally disapproving way. Dewing moved to New York in 1880 and became a member of the Society of American Artists that year. In 1881 he married Maria Oakey, a portrait and flower painter well connected among the city's progressive artists. The two later collaborated on some paintings, and Dewing's subsequent adoption of elaborate floral backgrounds in a work such as *Prelude* of 1883 was seen as further evidence of a Pre-Raphaelite connection by critics such as Clarence Cook, who denounced the painting for its affectation and subservience to outgrown English "fads" (*Art Amateur* 8, May 1883, p. 125). The same charge might have been directed at his painting *The Garden* (Museum of Fine

Arts, Boston), which represented an especially close adaptation of the style of the Englishman Albert Moore.

Dewing's early stylistic phase culminated in the monumental painting *The Days* of 1887 (Wadsworth Atheneum, Hartford), in which the theme of a poem by Ralph Waldo Emerson was personified in a frieze of austere, statuesque figures in ancient dress. *The Days* was generally well received by critics and won the Clarke prize at the 1887 National Academy exhibition, providing Dewing with his first major public recognition. That year he was elected an Associate of the Academy, becoming a full Academician in the next. Dewing also painted a good number of realistic portraits in the 1880s, often on a small scale. His more generalized and single-figure studies, such as the brilliant *Lady with a Lute* (fig. 24), were especially admired and, in 1888, a related, smaller panel, *A Lady in Yellow* (1888, Isabella Stewart Gardner Museum, Boston), was bought by Mrs. Jack Gardner and earned him a silver medal at the 1889 Exposition Universelle in Paris. Dewing taught in New York at the Art Students League between 1880 and 1889.

From 1885 Dewing spent summers at Cornish, New Hampshire, becoming a leader of the famous artists' colony that grew up there, and, around 1889/90, began to develop a new style of outdoor picture — which he put in the category of "decorations" — in which female figures were posed artfully in landscape settings. In them the precision of his earlier pictures gave way to a looser handling of paint in subdued tonal harmonies. The architect Stanford White, who also frequented Cornish, designed the frames for many of Dewing's paintings and also secured decorative commissions for the artist, such as that for a painted ceiling in the café of the Hotel Imperial, New York, in 1892. Dewing was fascinated by the decorative aspects of painting, producing wall and ceiling paintings for private houses in New York, Baltimore, and Detroit in the early 1890s, as well as a unique series of painted folding screens (see fig. 35) in the mid- to later 1890s for his patron Charles Lang Freer and a few of the latter's friends. Although Dewing received a generally mixed press throughout his career, he was sustained critically and financially by the small band of enthusiasts, led by Freer, that included the influential critic Royal Cortissoz and the collector John Gellatly.

Increasingly dissatisfied with the reception of his paintings at home, Dewing sailed to Europe in the fall of 1894, expecting to be gone two years and hoping to capture success abroad. He first visited London, where he met James McNeill Whistler and worked in his studio—a group of Dewing's London pastels was later shown in Boston—and then went to France, where he painted both in Paris and at Giverny. Dewing had little success with the paintings he had brought to show in London and Paris and, ultimately disillusioned and in need of money, he cut short his trip and returned to America in the summer of 1895. The month he returned Cortissoz wrote an important tribute to the artist in *Harper's Magazine*. Dewing's pleasure at being back seems to have faded after a hoped-for commission to execute murals for the Library of Congress failed to materialize.

Shortly after the turn of the century, and not long after he complained to Freer that his outdoor "decorations" went generally unappreciated, Dewing

Thomas Wilmer Dewing

changed stylistic direction once more. Turning from outdoor subjects, he increasingly chose to paint interior scenes, sometimes with several figures, but more usually consisting of single figure studies of ladies placed in a starkly simple studio setting. This change in subject matter seems to have coincided with his departure from Cornish in 1905 and his purchase of property in Green Hill, New Hampshire.

Dewing had his first one-man show, at the St. Botolph Club, Boston, in 1898. The Montross gallery in New York held a retrospective in 1900, and he exhibited there again in 1906, this time together with the painter Dwight W. Tryon—the first of several such joint exhibitions at Montross over the next few years. Dewing was also active as buying agent for Freer and in the administration of various artistic affairs, as he was in helping to arrange Twachtman's estate sale in 1903.

After receiving an award at the 1889 Paris Exposition, over a decade went by before Dewing won further prizes; this may have been due in part to his perennially limited production and his reluctance to exhibit. However, in 1901 he was awarded a gold medal at the Pan-American Exposition at Buffalo, New York, which was followed by other gold medals at the St. Louis Louisiana Purchase Exposition of 1904, at the Munich Glaspalast in 1905, at the Pennsylvania Academy of the Fine Arts in 1906, and at the Carnegie Institute in 1908.

Dewing became a studio artist *par excellence* and, despite the various changes in direction in his work, retained the habit, learned in his academy days, of working almost exclusively with studio models, props, and costumes. He kept a supply of gowns in his studio, made some to order for compositions, and had others created to his own designs. Though perhaps generally inspired, as his friends liked to say, by the themes of Vermeer, the experimental and unorthodox technique, the subdued color range, and often unsettling psychological atmosphere of his works set them apart as belonging to Dewing's own private domain.

In his later years Dewing painted largely for himself or his patrons. With the opening of the Freer Gallery in Washington, D.C., in 1923 Dewing was in the unique position of seeing a large collection of his works (including twenty-seven oil paintings) enshrined in a major public institution. That year the *New York Tribune* reported that Dewing had been working exclusively in pastel for the past five years, that is, since the last of the regular Ten exhibitions. Whether or not this was literally the case, Dewing's work in oils had become minimal by about 1920. When the New York dealer Robert Macbeth offered him an exhibition in 1922 Dewing replied that he had sold practically the last of the few works he could produce each year and had nothing to exhibit (Archives of American Art, Roll #NMc42, frame 586). An exhibition of Dewing's pastels and silverpoint drawings was held at the Corcoran Gallery in the winter of 1923/24. He was given a major retrospective at the Carnegie Institute, Pittsburgh, in 1924.

Literature

Charles De Kay, "The Ceiling of a Cafe," *Harper's Weekly* 36 (Mar. 12, 1892), pp. 257–58.

Sadakichi Hartmann, "Thomas W. Dewing," *Art Critic* 1 (Jan. 1894), pp. 34–36.

Royal Cortissoz, "Some Imaginative Types in American Art," *Harper's Magazine* 91 (July 1895), pp. 164–79.

Charles H. Caffin, "Exhibition of Works by Thomas W. Dewing," *Artist* 27 (Apr. 1900), pp. xxi–xxiii.

Sadakichi Hartmann, *A History of American Art*, Boston, 1902, pp. 299–308.

Thomas W. Dewing, et al., "John Twachtman: An Estimation," *North American Review* 176 (Apr. 1903), pp. 554–62.

Homer Saint-Gaudens, "Thomas W. Dewing," *Critic* 48 (May 1906), pp. 418–19.

Charles H. Caffin, "The Art of Thomas W. Dewing," *Harper's Magazine* 106 (Apr. 1908), pp. 714–24.

Ezra Tharp, "T. W. Dewing," *Art and Progress* 5 (Mar. 1914), pp. 155–61.

Catherine Beach Ely, "Thomas W. Dewing," *Art in America* 10 (1922), pp. 225–29.

C. B. S. Quinton, "Editorial," *Academy Notes* (Buffalo Fine Arts Academy) 18 (Jan.–June 1923), pp. 26–29.

Royal Cortissoz, "An American Artist Canonized in the Freer Gallery: Thomas W. Dewing," *Scribner's Magazine* 74 (Nov. 1923), pp. 539–46.

Nelson White, "The Art of Thomas W. Dewing," *Art and Archaeology* 27 (June 1929), pp. 253–61.

Thomas W. Dewing: A Loan Exhibition, exhibition catalogue, Durlacher Brothers, New York, 1963. With a foreward by Nelson White.

Judith E. Lyczko, "Thomas Wilmer Dewing's Sources: Women in Interiors," *Arts Magazine* 54 (Nov. 1979), pp. 152–57.

Susan Hobbs, "Thomas Wilmer Dewing: The Early Years. 1851–1885," *American Art Journal* XIII, no. 2 (Spring 1981), pp. 4–35.

Kathleen Pyne, "Classical Figures: A Folding Screen by Thomas Dewing," *Bulletin of the Detroit Institute of Arts* 59 (Spring 1981), pp. 4–15.

Susan Hobbs, "Thomas Dewing in Cornish, 1885–1905," *American Art Journal* XVII, no. 2 (Spring 1985), pp. 3–32.

J. K. Schiller, "Frame Designs by Stanford White," *Detroit Institute of Arts Bulletin* 64, no. 1 (1988), pp. 20–31.

Frederick Childe Hassam

Born: Dorchester (Boston), Massachusetts,
October 17, 1859
Died: East Hampton, New York, August 27, 1935

Hassam came from an old New England family—his
surname was a corruption of Horsham—and his
father was a prosperous merchant who collected an-
tiques. He studied in the Boston public schools and
participated in evening drawing classes at the Lowell
Institute and in life class at the Boston Art Club.
From his third year in High School he worked in a
wood engraver's office producing ornamental
designs, letterheads, and illustrations. Hassam began
his public career in Boston as a watercolorist with a
one-man show at the Williams & Everett gallery in
1882, and exhibited there again in 1884, when he
showed many works from a European trip underta-
ken the previous year. He worked during the 1880s as
an illustrator of children's books and also provided
illustrations for William Dean Howells's *Venetian Life*
(1891) and a book of verse by Celia Thaxter titled *An
Island Garden* (1894).

Earning increasing recognition in Boston, by the
mid-1880s he was also exhibiting in Philadelphia and
New York. In 1886 the *Art Amateur* (Nov. 1886, p. 113)
referred to him as an "audacious and brilliant water-
colorist," while his paintings of rainy Boston street
scenes called forth a mixed reaction.

Hassam had a long career with a remarkably varied
output. He was an extremely prolific artist who, in
the course of his career, produced several thousand
works in oil, watercolor, pastel, and print media, and
who, through constant effort and effective self-pro-
motion, was able to secure a degree of financial sta-
bility that freed him from dependence on teaching.

In 1886 Hassam went to Paris to study at the
Académie Julian, where he remained for three years.
Despite his pursuit of academic training it was during
these years that Hassam first truly embraced the prin-
ciples of Impressionism. While still abroad, he held
several exhibitions in Boston at the Noyes, Cobb &
Co. gallery, the second of which comprised mainly
street scenes and garden views painted in Paris and its
environs. These were noted by many reviewers as
being far more advanced in their bold color and
bright outdoor light than the more romantic Boston
street scenes he had shown previously.

Hassam's Paris experience, and the continuing
attention he paid to the work of French Impressionist
painters, were obviously important to his develop-
ment. Yet, perhaps because he was largely self-
taught, he always retained a measure of defensiveness
on the subject of his training and artistic formation.
He adamantly denied a connection to the French
Impressionists, and preferred instead to trace his artis-
tic lineage to English sources—John Constable,
J. M. W. Turner, and the watercolorist Richard Parkes
Bonington, who themselves had influenced the
French. These men, said Hassam, were the first to
work outdoors with a clear palette, and it was they
who influenced his early work in watercolor: "I made
my sketches from nature in watercolor and I used no
white. It was this method that led me into the paths of
pure color. When I turned to oils, I endeavored to
keep my color in that medium as vibrant as it was in
watercolor" (quoted in *Boston Evening Transcript*,

Aug. 27, 1935). He similarly denied the commonly
held idea that he followed French formulas for paint-
ing in broken colors. In a letter of December 3, 1934
(Archives of American Art, Roll #NAA2), he wrote:
"I have to de-bunk the idea that I use dots of color, so
called, or what is known as impressionism (every-
body who paints and sees is probably an im-
pressionist) but none of those men who are supposed
to have painted with dots and dashes ever really did
do just that. There are only two or three who ever
tried it and they gave it right up. It never amounted to
anything."

Hassam returned to the United States in the fall of
1889 and settled in New York, where he soon became
acquainted with Weir and Twachtman, painting with
them in Connecticut in the 1890s. New York City
provided Hassam with his richest source of motifs.
He always remained fascinated by the dynamic
character of life in New York, whose beauties he
aggressively promoted as against what he always
maintained were the more superficial attractions of
Paris: "The very thing that makes New York irregular
and topsy turvey," he said, "makes it capable of the

most astounding effects. From the tops of enormous
buildings one can get magnificent sweeps along the
rivers and over the tops of buildings. And, then, the
atmosphere! Why, toward the late afternoon the big
masses of buildings in New York come out in that
light with a significance and an effect which makes
the Paris kind of thing quite trivial. Even the elevated
railroad is at some times of day, in some lights,
extremely effective. To see the thing shoot by, send
off great spiral masses against the sky is inspiring in
the extreme. Light! Atmosphere! Why Paris atmo-
sphere is no good in comparison" (*Commercial Adver-
tiser*, Jan. 15, 1898, p. 1).

Although he preferred to live in New York, Has-
sam also retained close ties to Boston, and exhibited
there often in the 1890s at the Watercolor Society and
at local commercial galleries. In addition, he held
one-man shows at the St. Botolph Club in 1896, 1900,
and 1916.

Hassam was a restless, peripatetic traveler who
painted everywhere he went, or rather went
everywhere to paint. Subjects for his paintings were
found throughout Europe, in France, Spain, Italy, the
Netherlands, and so on, while in America his pre-
ferred painting sites were mainly in New England.
Most of the year, except for deep winter, was spent
shuttling between his favorite New England coastal
towns and summer resorts, often visiting several in
one season. In the 1880s he first visited Appledore
Island, Maine, part of the Isles of Shoals, where he
later recalled the stimulating company of artists,
musicians, and literary figures that gathered at the
summer retreat of the poet Celia Thaxter. It was
Thaxter, in fact, who first suggested to the artist that
he drop his Christian name Frederick in favor of his
more picturesque middle name, Childe. The famous
garden at Thaxter's residence inspired Hassam to
develop an original combination of landscape and
floral still life. Thaxter died in 1894, and, for a few
years afterward, Hassam seems to have avoided the
Isles of Shoals, but he was there again in 1898 and,
beginning in 1901, painted there at least part of the
summer for nearly every year through 1916. The sea-
scapes he produced in that period tended to concen-
trate on the juxtaposition of bright masses of rocky
coast, sea, and sky. In the 1890s Hassam also became
a regular visitor to Gloucester, Massachusetts,
where, like Metcalf and Twachtman, he painted
views of the picturesque harbor. He also frequented
Cos Cob, Connecticut, and nearby Old Lyme, where
he painted, some of the time with Metcalf, from 1903
to 1907. He was at Provincetown in 1900, at Newport,
Rhode Island, in 1901, and painted also at least once
on Nantucket Island. From 1917 he went regularly to
East Hampton, Long Island, which he had first vis-
ited many years earlier and where he eventually
bought a house. He was in Havana, Cuba, in 1895,
and painted in Oregon in 1904 and again in 1908,
when he completed some three dozen scenes of the
Harney desert (near Bend, Oregon), which were
shown at the Montross gallery in 1909 and at the Port-
land Art Association. In 1910 he was in Holland and in
London and Paris, which he visited again in 1911.

Hassam was also a regular exhibitor abroad. He
exhibited at the Paris Salons from 1887 to 1890, was
represented at the Internationale Kunstausstellung,
Munich, in 1888, at the Paris Exposition Universelle
of 1889, where he won a bronze medal, and at the

Galerie Georges Petit, Paris, in 1889, and also won a silver medal in Munich in 1892. He held a large auction of his works in New York in February 1896 and, the next year, left for an extended trip to Europe, where he produced numerous views of Brittany (Pont-Aven), Naples, Florence, and Rome. Many of these were included in large showings he had at the new Salon at the Champs des Mars in 1897 and 1898. In September 1901 he was given a one-man show at the Durand-Ruel gallery in Paris.

By the end of the century Hassam was beginning to concentrate more on indoor figural scenes in the winters and to favor the addition of figures, usually nudes, to his summer landscapes. His designs became tighter and more deliberate, while he also placed greater emphasis on the modeling of solid forms through the buildup of thick pigment. From 1905 to 1907, in particular, he produced a number of outdoor nude studies, which showed wooded landscapes, or seascapes with mythological figures—nymphs, "Lorelei," "Leda," "Aphrodite," and so forth—which allowed contemporary critics to point out that he, too, along with others in the Ten, was reverting to conservative values. Classical figures were also often featured in his works executed after about 1920.

Hassam continued to paint cityscapes of New York after the turn of the century, a number of which focus on the engineering and construction projects that were rapidly changing the look and character of the city (*Washington Bridge*, 1902 [lost]; *Brooklyn Bridge* [lost] and *The Hovel & Skyscraper* [private collection], both 1904).

From around 1907, stimulated perhaps by similar work being done by his Boston colleagues, Hassam began a series of interior scenes featuring a single female model posed against the luminous background of a picture window. Throughout the teens he produced at least one major work in this "Window" series each year.

At the end of 1918 he exhibited at the Durand-Ruel gallery another notable series: twenty-four "flag" paintings begun two years earlier in which he recorded the spectacle of New York's Fifth Avenue (temporarily renamed "Avenue of the Allies") draped with patriotic banners during World War I. These were also exhibited at other galleries in New York and Pittsburgh in 1919, and at the Corcoran Gallery of Art in 1922.

In New York Hassam held annual winter exhibitions, often back to back with those of Metcalf, at the Montross gallery from 1905 through 1917. He acquired an enormous number of prize medals over the course of his career and was a member of many artistic organizations beyond the Ten, including the Société National des Beaux-Arts, Paris, the Munich Secession, the American Watercolor Society, The Society of Artists in Pastel, and the New York Watercolor Club, which he helped found in 1889 and served as its first president. After about 1900 American museums vied with each other for the chance to acquire one of his works. He became an Associate of the National Academy of Design in 1902, and a full Academician in 1906.

Hassam took up printmaking around 1914 and had his first exhibition of etchings and drypoints at Keppels gallery in 1915. With characteristic energy he went on to produce nearly four hundred etchings and lithographs over the course of his remaining career.

The Durand-Ruel gallery held a retrospective exhibition in January 1926, while the Buffalo Fine Arts Academy devoted a major retrospective to him in 1929.

Overtaken by illness, Hassam spent much of the last year of his life at his home in East Hampton, Long Island. He had been elected a member of the American Academy of Arts and Letters in 1920, an honor of which he was extremely proud. On his death all the paintings in his estate were bequeathed to this organization for private sale, the proceeds to be used to fund the purchase of works by American and Canadian painters for art museums.

Literature

Frank T. Robinson, *Living New England Artists*, Boston, 1988, pp. 101–6.

A. E. Ives, "Talks with Artists: Mr. Childe Hassam on Painting Street Scenes," *Art Amateur* 27 (Oct. 1892), pp. 116–17.

Mariana G. Van Rensselaer, "Fifth Avenue with Pictures by Childe Hassam," *Century* 47 (Nov. 1893), pp. 5–18.

William Henry Howe and George Torrey, "Childe Hassam," *Art Interchange* 34 (May 1895), p. 133.

"New York Beautiful," *Commercial Advertiser*, Jan. 15, 1898, p. 1.

Childe Hassam, *Three Cities*, New York, 1899.

Frederick W. Morton, "Childe Hassam, Impressionist," *Brush and Pencil* 8 (June 1901), pp. 141–50.

Charles Caffin, *American Masters of Painting*, New York, 1902.

Albert E. Gallatin, "Childe Hassam: A Note," *Collector and Art Critic* 5 (Jan. 1907), pp. 101–4.

James W. Pattison, "The Art of Childe Hassam," *House Beautiful* 23 (Jan. 1908), pp. 19–20.

Israel L. White, "Childe Hassam: A Puritan," *International Studio* 45 (Dec. 1911), pp. xxix–xxxvi.

"Who's Who in American Art," *Arts and Decoration* 5 (Oct. 1915), p. 473.

"The Etchings of Childe Hassam," *Nation* 101 (Dec. 9, 1915), pp. 598–99.

Carl Zigrosser, *Childe Hassam*, New York, 1916.

"An Almost Complete Exhibition of Childe Hassam," *Arts and Decoration* 6 (Jan. 1916), p. 136.

Charles L. Buchanan, "The Ambidextrous Childe Hassam," *International Studio* 67 (Jan. 1916), pp. lxxxiii–lxxxvi.

Frank Weitenkampf, "Childe Hassam and Etching," *American Magazine of Art* 10 (Dec. 1918), pp. 49–51.

"Painting America: Childe Hassam's Way," *Touchstone* 5 (July 1919), pp. 272–80.

Eliot Clark, "Childe Hassam," *Art In America* 8 (June 1920), pp. 172–80.

Nathaniel Pousette-Dart, *Childe Hassam*, intro. Ernest Haskell, New York, 1922.

Frederick Newlin Price, "Childe Hassam: Puritan," *International Studio* 77 (Apr. 1923), pp. 3–7.

Catalogue of the Etchings and Dry-Points of Childe Hassam, N. A., intro. Royal Cortissoz, New York, 1925.

Retrospective Exhibition of Works by Childe Hassam, 1890–1925, exhibition catalogue, Durand-Ruel Gallery, New York, 1926. With an introduction by Frank Jewett Mather.

A Catalogue of an Exhibition of the Works of Childe Hassam, exhibition catalogue, American Academy of Arts and Letters, New York, 1927.

Childe Hassam, "Twenty-Five Years of American Painting," *Art News* 26 (Apr. 14, 1928), pp. 22–28.

Carlo Beuf, "The Etchings of Childe Hassam," *Scribner's Magazine* 84 (Oct. 1928), pp. 415–22.

Exhibition of a Retrospective Group of Paintings Representative of the Life Work of Childe Hassam, N. A., exhibition catalogue, Albright Art Gallery, Buffalo, 1929. With an introduction by Ernest Haskell.

James C. McGuire, *Childe Hassam, N. A.*, American Etchers, vol. 3, New York, 1929.

Paula Eliasoph, *Handbook of the Complete Set of Etchings and Drypoints of Childe Hassam, N. A.*, New York, 1933.

"Childe Hassam and His Prints," *Prints* 6 (Oct. 1935), pp. 2–14, 59.

"Childe Hassam: Painter and Graver, 1859–1935," *Index of Twentieth Century Artists* 3, no. 1 (Oct. 1935), pp. 169–83 (reprinted 1970, pp. 461–75, 477).

Adeline Adams, *Childe Hassam*, New York, 1938.

Royal Cortissoz, "The Life and Art of Childe Hassam," *New York Herald Tribune*, Jan. 1, 1939, section VI, p. 8.

Priscilla C. Colt, "Childe Hassam in Oregon," *Portland Art Museum Bulletin* 14 (Mar. 1953), unpaginated.

Jacob G. Smith, "The Watercolors of Childe Hassam," *American Artist* 19 (Nov. 1955), pp. 50–53, 59–63.

Fuller Griffith, *The Lithographs of Childe Hassam: A Catalogue*, United States National Museum Bulletin, No. 232, Washington, D. C., 1962.

Mahonri Sharp Young, "A Quiet American," *Apollo* 79 (May 1964), pp. 401–2.

Childe Hassam: A Retrospective Exhibition, exhibition catalogue, Corcoran Gallery of Art, Washington, D. C., 1965. Text by Charles E. Buckley et al.

William E. Steadman, *Childe Hassam, 1859–1935*, exhibition catalogue, University of Arizona Museum of Art, Tucson, 1972.

Joseph S. Czestochowski, "Childe Hassam Paintings from 1880 to 1900," *American Art Review* 4 (Jan. 1978), pp. 40–51, 101.

Mahonri Sharp Young, "A Boston Painter," *Apollo* 108 (Nov. 1978), pp. 344–45.

Donelson Hoopes, *Childe Hassam*, New York, 1979.

Joseph S. Czestochowski, *94 Prints by Childe Hassam*, New York, 1980.

Jennifer A. Martin Bienenstock, "Childe Hassam's Early Boston Cityscapes," *Arts Magazine* 55 (Nov. 1980), pp. 168–71.

Childe Hassam, exhibition catalogue, American Academy and Institute of Arts and Letters, New York, 1981.

Stuart Feld, *Childe Hassam 1859–1935*, exhibition catalogue, Guild Hall Museum, East Hampton, N. Y., 1981.

Gail Stavitsky, "Childe Hassam and the Carnegie Institute: A Correspondence," *Archives of American Art Journal* 22, no. 3 (1982), pp. 2–7.

–, "Childe Hassam in the Collection of the Museum of Art," *Carnegie Magazine* 56 (July-Aug. 1982), pp. 27–39.

Childe Hassam in Indiana, exhibition catalogue, Ball State University Art Gallery, Muncie, Indiana, 1985. With essays by Alain G. Joyaux, Brian A. Moore, and Ned H. Griner.

Childe Hassam in Connecticut, exhibition catalogue, Florence Griswold Museum, Old Lyme, Conn., 1987/88. With an essay by Kathleen M. Burnside.

The Flag Paintings of Childe Hassam, exhibition catalogue, Los Angeles County Museum, 1988 (traveled to Washington, D. C., and Fort Worth, Texas). Text by Ilene Susan Fort.

Childe Hassam: An Island Garden Revisited, exhibition catalogue, The Denver Art Museum, 1990 (traveled to New Haven, Connecticut, and Washington, D. C.). Text by David Park Curry.

Willard Leroy Metcalf

Born: Lowell, Massachusetts, July 1, 1858
Died: New York City, March 9, 1925

Metcalf came from a working-class family that moved during his youth between various New England towns. He began painting in 1874, the year he was apprenticed to a wood engraver, and attended night classes at the Massachusetts Normal Art School. In 1875 he began a one-year apprenticeship with the painter George Loring Brown and also studied life drawing at the Lowell Institute. He opened a studio in Boston in the fall of 1876 and received a scholarship at the end of that year to the Boston Museum school, where he studied under Otto Grundmann until 1878. During the summers he

produced paintings for resort patrons in Massachusetts, Maine, and Vermont. In 1881 Metcalf traveled to the American Southwest to illustrate an article on the Zuni Indians for *Harper's Magazine* and produced similar illustrations the next year for *Century Magazine*.

In April 1882 he held an exhibition and auction sale at the J. Eastman Chase Gallery in Boston in order to finance a period of study abroad. Included were studies and finished pictures of New England subjects from Manchester and Longwood, Massachusetts, Plymouth, Vermont, and Vinalhaven, Maine, as well as illustrations from his New Mexico trips. He realized a little over $800 for works that ranged in price from a few dollars for some studies to $102 paid for a painting titled *An Interesting Story* (now lost).

Metcalf left for Paris in September 1883 and enrolled at the Académie Julian to study under Gustave Boulanger and Jules-Joseph Lefebvre. In the spring of 1884 he went to England and, later, to Pont-Aven, Brittany, while Benson was in nearby Concarneau. The following fall Metcalf was at Grèz-sur-Loing. He spent the winter of 1884 in Paris, where he seems to have met Twachtman, and returned to Grèz in February 1885, painting there for several seasons in the company of other Americans, including Emil Carlsen and Theodore Robinson. Metcalf's work at Grèz was given over to landscapes and to Millet-inspired scenes of peasant life that recall the popular style of expatriate American painters Charles Sprague Pearce and Daniel Ridgway Knight. In the spring and fall of 1886 Metcalf was at Giverny—evidently the first American painter to visit it—and, in December of that year, left for a trip of several months to Algeria and Tunisia. In the summers of 1887 and 1888 he was at Giverny once more, this time as part of a larger group of Americans, including Theodore Wendel, Louis Ritter, John Breck, and Robinson. He received Honorable Mention in the Paris Salon of 1888 for his painting *Marché de Kousse-Kousse à Tunis* (now lost), a work he exhibited the next year at the Society of American Artists, of which he had been a member since 1887.

Metcalf returned to America in December 1888 and held a one-man exhibition the following spring at the St. Botolph Club, Boston. In 1889 he went briefly to Philadelphia to work as a portraitist and, the next year, opened a studio in New York. For several years he was mainly occupied as an illustrator and a portraitist. He began teaching at the Cooper Institute in 1891, remaining there for many years, and also taught briefly at the Art Students League. At various times during the 1890s he shared studios and living quarters with Simmons and Reid.

In 1895 Metcalf journeyed to the far West, and that summer painted at Gloucester, Massachusetts. From a group of Metcalf's Gloucester paintings exhibited the following spring at the Society of American Artists, *Gloucester Harbor* (plate 6) was chosen to receive the Webb prize. At about this time he gave up illustration work permanently and, for several years, seems to have produced very little.

In 1899 he painted murals for Appelate Courthouse in Madison Square, New York (*Justice* and *Banishment of Discord*), a project shared with Reid, Simmons, and others. Metcalf's model for these and other paintings was the young divorcee and stage performer Mar-

Willard Leroy Metcalf

guerite Beaufort Hallé, with whom he lived and whom he eventually married. The artist's diaries around the turn of the century document his fitful personal relationships and unproductiveness as he succumbed to a life of theatregoing, lavish spending, and heavy drinking. Twachtman, Reid, Simmons, and, for a time, De Camp, who came to New York to teach at the Art Students League, were his frequent social companions.

A result of his lifestyle was that Metcalf's contributions to the first few Ten exhibitions were fairly negligible, comprising as they did some portraits, an old-fashioned *Death of Orpheus* (now lost), which was universally criticized, a reclining nude called *La Siesta* (also lost) in 1900, and the more important but already familiar works from the mid-1890s done at Gloucester.

Metcalf began to revive artistically in 1902, a year in which he traveled to Havana, Cuba, to prepare studies for a mural commission he had received through Stanford White for the Havana Tobacco Company Store in the St. James Building, New York. That year he also produced a number of notable canvases, including *The Boat Landing* (plate 14) and *Battery Park—Spring* (plate 58). During the spring and summer of 1903 he painted at Old Lyme, Connecticut, with Hassam, and was married that fall. Several months later his deteriorating personal life led Metcalf to leave New York City and to take up residence at his parents' home in rural Clark's Cove, Maine. There he turned to painting with renewed dedication and produced several dozen canvases over the winter and summer months of 1904. That fall he commuted

to a weekly teaching job at the Rhode Island School of Design, returning to New York in November. He spent each summer from 1905 through 1907 painting at Old Lyme with Hassam and, in those years, held a series of successful exhibitions, including several at the Fishel, Adler & Schwartz Gallery, New York, in 1905 and 1906. However, it was his one-man exhibition at Boston's St. Botolph Club in November 1906 that proved a turning point, after which critical acclaim—and sales—began to mount steadily. Audiences responded with sympathy to his broad, gentle views of New England hills that kept to a human scale, discovering in them qualities that were reassuringly familiar and truthful to nature in a way that was considered truly American. His light-filled, delicately colored landscapes were often characterized by critics as a kind of portraiture of places in varying moods. Often deceptively simple in appearance, his compositions embody a combination of spare, understated judgment and an enormous fund of technical skill. In 1907 his *May Night* (fig. 53) won the Corcoran gold medal and his *The Golden Screen* the Temple gold medal at the Pennsylvania Academy of the Fine Arts, where it has remained to this day.

From 1909 to 1920 Metcalf often spent winter months at Cornish, New Hampshire, where he painted some of his most appealing and popular winter landscapes. He held one-man exhibitions at the Montross gallery in New York each January between 1908 and 1911. In the latter year a large one-man exhibition toured the country and he entered into a second marriage, with Henriette Alice McCrea, a union which produced two children and lasted nine years before separation and eventual divorce.

Metcalf held one-man exhibitions in 1912 and 1913 at the Copley Gallery in Boston and in 1913 at Knoedler's in New York. In the spring of that year he began a nine-month tour of Europe, painting in Paris, Norway, England, and Italy. He returned to the United States in February 1914. In 1915 he won a gold medal at the Panama-Pacific Exhibition for *Trembling Leaves* (Pennsylvania Academy).

Metcalf, like Hassam, traveled constantly in search of painting sites. In 1917, for example, he spent the winter months in Cornish and Plainfield, New Hampshire, the summer at Waterford, Connecticut, and was at Deerfield, Massachusetts, in October. In 1919 he spent a good part of the year at Woodbury, Connecticut, and in his later years often painted at Chester, Lower Perkinsville, and Springfield, Vermont. After the demise of the Ten, Metcalf remained active as a painter and continued to sell up to his death, although after 1920, when he separated from his wife, creative periods were interrupted by ill health and renewed drinking problems. His 1920 painting *Benediction* (now lost), a "portrait" in moonlight of the church at Kennebunkport, Maine, was sold three years later for $13,000, a record price for the work of a living American artist.

In January 1925 the Corcoran Gallery held a large exhibition of his work, followed in the spring by a show at the Milch Gallery, New York, during which Metcalf died of a heart attack. In his later years the artist tried to repurchase his early paintings, in which he no longer believed, and instructed his executors to destroy any works in his estate that might diminish his reputation. Accordingly, of the sixty-two works

left in his studio at his death about a dozen of what were called academy studies from 1887/88, as well as some later finished paintings, were destroyed.

Literature

Sylvester Baxter, "Father of the Pueblos," *Harper's Magazine* 24 (June 1882), pp. 72–81 (with ills. by the artist).

–, "An Aborigine Pilgrimage," *Century Magazine* 24 (Aug. 1882), pp. 526–36 (with ills. by the artist).

–, "Along the Rio Grande," *Harper's Magazine* 27 (Apr. 1885), pp. 687–700 (with ills. by the artist).

Philip Gilbert Hamerton, Jr., "Book Illustrators, III: Willard L. Metcalf," *Book Buyer* 2 (Apr. 1894), pp. 120–22.

Arthur Hoeber, "A Summer in Brittany," *Monthly Illustrator* 4 (Apr.-June 1895), pp. 74–80 (with ills. by the artist).

Royal Cortissoz, "Willard L. Metcalf: An American Landscape Painter," *Appleton's Booklovers Magazine* 6 (Oct. 1905), pp. 509–11.

Christian Brinton, "Willard L. Metcalf," *Century Magazine* 77 (Nov. 1908), p. 155.

Catherine Beach Ely, "Willard L. Metcalf," *Art in America* 13 (Oct. 1925), pp. 332–36.

Bernard Teevan, "A Painter's Renaissance," *International Studio* 82 (Oct. 1925), pp. 3–11.

Royal Cortissoz, "Willard Leroy Metcalf," in *Commemorative Tributes to Metcalf*, New York, 1927, pp. 1–8.

William Howe Downes, in *Dictionary of American Biography*, vol. XI, New York, 1946, pp. 582–83.

Willard Leroy Metcalf: A Retrospective, exhibition catalogue, Museum of Fine Arts, Springfield, Mass., 1976. With essays by Francis Murphy and Elizabeth de Veer.

Elizabeth de Veer, "Willard Metcalf in Cornish, New Hampshire," *Antiques* 126 (Nov. 1984), pp. 1208–15.

Elizabeth de Veer and Richard J. Boyle, *Sunlight and Shadow: The Life and Art of Willard L. Metcalf*, New York, 1987.

Robert Lewis Reid

Born: Stockbridge, Massachusetts, July 29, 1862
Died: Clifton Springs, New York, December 2, 1929

Later known principally as a decorative painter and muralist, Reid was educated at Phillips Academy and at a school run by his father in Stockbridge, Massachusetts. The family moved to several other New England towns after the school failed in 1878. Reid enrolled in 1880 at the Boston Museum school where he remained, part of the time as assistant instructor, through 1884. He then went to New York to study at the Art Students League and, in the fall of 1885, left for Paris, where he enrolled at the Académie Julian. During his stay abroad Reid traveled in Italy and spent summers in Etaples, Normandy, where he painted peasant genre scenes. He exhibited paintings at the Paris Salons of 1887 (*Une premiere* [sic] *communicante*), 1888 (*Flight Into Egypt*), and 1889 (*Avant le départ des bateaux*), all of which have been lost. His *Death of the First Born* (Brooklyn Museum, New York), depicting a peasant mother mourning her infant, was exhibited at the Society of American Artists in spring 1889, a few months before he returned to America. He became a member of the Society in 1891.

Reid, like Hassam, settled in New York in 1889, and for several years seems to have been mainly employed as a portraitist. From 1893 to 1896 he taught at the Art Students League and had become an instructor at the Cooper Union by 1893 at the latest. He also taught private summer classes at various times, documented in 1892 at Farmington Valley, Connecticut, and at Cos Cob in 1912, when he offered instruction in outdoor figure and landscape painting.

Reid began his career as a muralist in 1892 with a commission to paint one of the domes in the Liberal Arts Building at the Chicago World's Columbian Exposition (allegories of Ornament, Design, Metal, and Textiles), where he worked alongside Weir and Simmons. In 1894 he executed a monumental altarpiece, *The Martyrdom of St. Paul*, for St. Paul's Roman Catholic Church in New York which, on account of its effects of sunlight and open air, was considered at the time to be the first "impressionistic" painting to adorn an American public building.

Reid also completed murals for hotels in New York—including the Imperial Hotel and the Fifth Avenue Hotel (a colossal ceiling measuring 85 by 21 feet, painted in 1894 in three sections and depicting an allegory titled *The Enthronement of New York*)—for private residences, including those of Mrs. O. H. P. Belmont and G. H. Harkness, and even for an ocean liner. His exhibitions regularly included a sampling of decorative panels. In 1896/97 he painted decorations for the Library of Congress, Washington, D. C. (*Five Senses*, and *Wisdom, Understanding, Knowledge, Philosophy*), and, two years later, for the New York Appellate Courthouse (*Justice, Peace, Prosperity, Liberal Arts*). Other public commissions included murals for the American Pavilion at the 1900 Paris Exposition (*America Revealing Her Natural Strength*), for which he received a gold medal; for the Assembly Hall at Central High School, Springfield, Massachusetts (*The Light of Education*, 1910); and for the Fine Arts Building, Panama-Pacific Exposition, San Francisco, 1915. To accommodate his mural painting he occupied an enormous studio (nicknamed The Golf Links) in the Gibson Glass Co. building on 33rd Street, which he often used for his own exhibitions.

Reid's painting *Reverie* (plate 40) of 1890 shows that he was conversant with the techniques of Impressionism by the time he returned to America. The small scale of the picture, however, may give a somewhat misleading impression of his direction, while his painting *The Red Flower* (private collection) of the same year already shows him committed to a favorite later theme in which a single statuesque figure (here a small child, seen frontally) strikes a deliberate pose within a garden or parklike setting. Reid held his first one-man exhibition in 1896 at the Pratt Institute, New York. There he displayed a typically varied selection of work, ranging from studies for mural projects to landscapes, nudes, and brightly colored outdoor figure studies, of which some—for example, *A Summer Girl* (plate 39) and *Reflections* (private collection)—depicted contemporary models, while others, such as the well-known *Fleur-de-Lis* (Metropolitan Museum of Art, New York), were explicitly ornamental, ideal types seen amidst elaborate floral surrounds. His decorative panel *Moonrise*, the rendering of an idealized nude, won the Clark prize at the National Academy in 1897, and the next year his ceiling panel *Dawn* received the Academy's Hallgarten prize. In 1898 he held a solo exhibition, a brief, one-day showing of thirty-seven canvases at the Durand-Ruel gallery that immediately followed the first exhibition of the Ten. A reviewer for the *New York Daily Tribune* (Apr. 20, 1898, p. 6), probably Royal Cortissoz, said that Reid managed to retain

what was good in the Impressionist movement while steering clear of the bad, and commended his skill in combining good draftsmanship with bold color: "All of Mr. Reid's figures are solid bodies, surrounded by light and air and, as in actual life, the observer realizes the solidity as much by virtue of the play of light and shade as by virtue of the mere density of the figures. This is the true test of the impressionistic idea, to render the last, most subtle and evanescent aspect of a subject, but to take nothing from its reality." The next year Reid held an exhibition in his own studio of old and recent works.

From 1901 to 1905 Reid was mainly occupied with designing some twenty stained-glass windows for the H. H. Rogers Memorial Church at Fairhaven, Massachusetts, and with painting murals for the State House, Boston (*James Otis Arguing Against the Writs of Assistance*, 1901, *Paul Revere's Ride* and *Boston Tea Party*, 1904/5). During these years he is said to have done little or no easel work, but afterward he was reported to be painting outdoors at Medfield, Massachusetts, and at Somers Center, New York. On the occasion of his exhibition at the Montross gallery, New York, in 1911, it was said that his work there had helped impart a new quality of light and air to his compositions (see Brinton, 1911). The critic Sadakichi Hartmann, a personal friend and an admirer of Reid's wholesome, buoyant female types, coined the phrase "decorative Impressionist" in 1910 to capture the somewhat contradictory nature of Reid's work. Among his most notable later works was a series begun about 1910, pictures in which his models were posed against Japanese screens. In 1913 he had further one-man exhibitions at the Montross gallery and at the Fine Arts Academy, Buffalo. One-man exhibitions were held at the St. Botolph Club, Boston, in 1902 and 1912. He was elected Associate of the National Academy of Design in 1902 and Academician in 1906.

A popular social figure, both in and outside the artistic community, Reid was an extremely tall man,

impetuous and flamboyant by nature. He was especially vain about his appearance, and always dressed and groomed himself with exceptional flair. He was extravagant in matters of money as well as of personal style and, though he was said in later years to have earned a good income from portrait painting, his expenses for socializing and gambling always exceeded his earnings. He once told how, within a period of two weeks, he had splurged away a $3,000 painting fee by giving dinner parties at a restaurant.

In 1915 he first exhibited his "portrait impressions," which consisted of rapidly sketched portraits on backgrounds of coarse, unprimed canvas, at the Seligman Gallery, New York. His marriage in 1907 to Elizabeth Reeves, the model for several of his works, ended in divorce in 1916, at which time he moved to Chicago and stayed the better part of a year fulfilling portrait commissions. In 1917 he went to Colorado Springs, where he helped found the Broadmoor Art Academy and worked as a portraitist. In his later years he executed a series of moonlight paintings and a sequence of twelve pictures titled *The Affairs of Anatol* which were among the last things he produced.

About three years before he died Reid suffered a stroke which paralysed his right side. After moving permanently to a sanatorium at Clifton Springs, New York, he taught himself to paint again with his left hand and exhibited occasionally thereafter. He died after a fall near the sanatorium.

Literature

William A. Coffin, "Robert Reid's Decorations in the Congressional Library, Washington, D.C.," *Harper's Weekly* 40 (Oct. 17, 1896), pp. 1028–29.

C. H. Caffin, "Some Recent Work by Robert Reid," *Artist* 23/24 (Apr. 1899), p. lxiv.

Royal Cortissoz, *In Summertime: Paintings by Robert Reid*, New York, 1900.

W. G. Bowdoin, "In Summertime," *Artist* 28 (June 1900), pp. 44–47.

Pauline King, *American Mural Painting*, Boston, 1902, *passim*.

Charles Henry Hart, "Robert Reid's Mural Decoration in the New State House at Boston," *Era*, n.s., 9 (Apr. 1902), pp. 445–47.

Irene Sargent, "The Mural Paintings by Robert Reid in the Massachusetts State House," *Craftsman* 7 (Mar. 1905), pp. 699–712.

Royal Cortissoz, "The Work of Robert Reid," *Appleton's Booklovers Magazine* 6 (Dec. 1905), pp. 738–42.

James William Pattison, "Robert Reid, Painter," *House Beautiful* 20 (July 1906), pp. 18–20.

Henry W. Goodrich, "Robert Reid and His Work," *International Studio* 36 (Feb. 1909), pp. cxiii–cxxii.

Arthur Hoeber, "Robert Reid," *Century* 77 (Mar. 1909), p. 799.

Sadakichi Hartmann, "Robert Reid," *Stylus* 1 (Feb. 1910), pp. 9–18.

Christian Brinton, "Robert Reid: Decorative Impressionist," *Arts and Decoration* 2 (Nov. 1911), pp. 13–15, 34.

Evelyn Marie Stuart, "Finished Impressions of a Portrait Painter," *Fine Arts Journal* 36 (Jan. 1918), pp. 32–40.

Frank Crowninshield, *Exhibition of Paintings by Robert Reid, N.A.*, exhibition catalogue, Grand Central Galleries, New York, 1927.

Stanley Stoner, *Some Recollections of Robert Reid*, Colorado Springs, n.d. [c. 1934].

Dictionary of American Biography, vol. 15, New York, 1935, pp. 479–80.

H. Barbara Weinberg, "Robert Reid: Academic 'Impressionist,'" *Archives of American Art Journal* 15, no. 1 (1975), pp. 2–11.

Mural Sketches and Impressionist Paintings by Robert Reid, exhibition catalogue, Utah Museum of Fine Arts, University of Utah, 1977.

Edward Emerson Simmons

Born: Concord, Massachusetts, October 27, 1852
Died: Baltimore, Maryland, November 17, 1931

Simmons was the son of a Unitarian minister of old New England stock who died when the boy was three years old. A nephew of Ralph Waldo Emerson on his mother's side, Simmons was brought up a sickly child in his grandmother's house, the Old Manse made famous by Nathaniel Hawthorne. Simmons described feeling himself an outcast in the austere intellectual climate of the Concord literati and, after graduating with honors in 1874 from Harvard – where he had helped found the university's daily newspaper, *The Crimson*—he traveled aimlessly for several years, first to Cincinnati, where by chance he met Frank Duveneck, and then to California, where he worked variously as a salesman, teacher, clerk, journalist, and so forth, while also dabbling in painting. In 1877/78 he taught art briefly in Bangor, Maine, and studied at the Boston Museum school and with William Rimmer. In 1879 he went to Paris to study at the Académie Julian under Gustave Boulanger, which for Simmons, unlike most stu-

dents, provided his first serious introduction to the practice of painting. Simmons registered at the Ecole des Beaux-Arts on March 16, 1880, as pupil of Boulanger, but in his autobiography he mentioned only studying at the Académie Julian (see Weinberg, 1981, p. 73).

In 1881 he settled in Concarneau, Brittany, and became one of the leaders of the artists' colony there, which included Alexander Harrison and the French *plein air* realist Jules Bastien-Lepage, both of whom Simmons knew well and learned from. Reputedly, Simmons was the model for the romantic hero in Blanche Willis Howard's novel *Guenn*, which was written in his studio in the summer of 1881. He made his Salon debut in 1881 with a portrait of a gentleman in Scottish Highland costume and received honorable mention the next year with a depiction of a Breton laundry girl, *La Blanchisseuse* (now lost). Over the next decade Simmons continued to paint subjects derived from the humble lives of fishermen and peasants in works that for the most part remain unlocated: *Les Vanneurs*, *Coin du Marché* (both Salon of 1883); *Le Printemps*, 1883 (plate 30); *Le Dout de la Cour* (Salon, 1884): *Awaiting His Return*, 1884 (fig. 23); *Low Tide* (Salon, 1885); *The Critic*; and *Vieillard et Enfant* (Salon, 1887).

While still abroad in 1883, he held an exhibition of his works at the Doll & Richards Gallery, Boston, which was reviewed favorably. He was married that year to Vesta Schallenberger, the author of several fictional works and painter who, after marriage to Simmons, exhibited a number of landscapes and scenes of life in Brittany at the Paris Salons during the later 1880s. Following a brief trip to Spain in 1886, Simmons resettled with his family in the English coastal town of St. Ives, Cornwall, where the Swedish painter Anders Zorn also worked for a time. In 1886 Simmons's painting *Mother and Child* (unlocated), depicting an exhausted peasant woman asleep at her child's bedside, won a $2,000 prize in New York's Second Prize Fund Exhibition. Simmons continued to paint scenes of peasant genre in England, and exhibited sporadically at the Royal Academy in London; he also began to paint seascapes after the manner of his friend Alexander Harrison. His large *Bay of St. Ives at Evening* (fig. 43), shown at the Society exhibition of 1888, won a bronze medal the next year at the Paris Exposition Universelle. Simmons also worked for varying periods in France at Grèz-sur-Loing, Carrière St. Denis, and Barbizon, where he was acquainted with Ruger Donoho, Charles Harold Davis, Theodore Butler, Charles Jacques, and William Babcock, the American disciple of Jean François Millet.

Simmons returned to America in 1891 to design a stained-glass window commissioned by his college graduating class for Harvard's Memorial Hall. The subject of "Aristides and Themistocles meeting before the Battle of Salamis" was meant to symbolize the reconciliation between North and South after the Civil War. This thoroughly scholarly amalgam thus evoked the American war through a scene from Greek history, while taking its design from a Roman relief. Before returning to Europe briefly in June 1892, Simmons was commissioned to execute murals for the Manufactures and Liberal Arts Building at the World's Columbian Exposition in Chicago ("Four Forms of Labor"—*Wood, Iron, Stone, Fiber*). This, by

his own admission, was a turning point in his career that led to his conversion from easel painter to muralist. "Chicago gave me a taste of the joys of decorative painting, and I resolved in my mind the idea of devoting all my energies to it," he later wrote. He established a permanent studio in New York in 1892, where he produced many mural designs for the city and beyond. Those in New York included a ceiling for the Metropolitan Club (c. 1894); murals for the Criminal Court Building (*Justice*; *The Fates*; *Liberty, Equality, and Fraternity*—all 1894/95), the first commission granted by the New York Municipal Art Society; the Astor Gallery in the Waldorf Hotel (a 35 x 100-foot ceiling for the banqueting hall completed in several months and representing the *Four Seasons* and the *Twelve Months*); the Appellate Court (*Justice*, 1899); and various private residences. His work elsewhere included murals for the Library of Congress, Washington, D.C. (*Nine Muses*, 1896); Massachusetts State House, Boston (*The Battle of Concord, Return of the Battle Flags*, 1900–2 [see fig. 47]); Minnesota State Capitol, St. Paul (dome and four pendentives); State Capitol, Pierre, S. Dakota; and Court Houses at Mercer, Pennsylvania, and Des Moines, Iowa. His prizes included a gold medal for decoration at the Pan American Exposition in Buffalo in 1901. He was also active as a portraitist and, briefly, as an illustrator.

Simmons was a striking figure, austere and erect in his bearing. He described himself as looking alternately like Uncle Sam or an Iroquois Indian. A writer for the *Sun* in 1907 (Mar. 22, p. 8) observed that he had "a typical American head, both mystic and shrewd." He became a member of the Society of American Artists in 1888 and, on moving to New York, was quickly drawn into the circle of the Players and other social clubs: he described his life in the 1890s as a frantic program of daytime work and nightly socializing that often left little time for sleep. He became a picturesque fixture in the New York art world, facilitating an active bohemian life by choosing to leave his family abroad. His prolific gift for talk was legendary, and a standing joke among his friends. In 1903, after the death of his first wife, he married Alice R. Morton. Simmons spent the years 1904 to 1906 in Paris, while working on murals for the Capitol Building in St. Paul, Minnesota. Soon after his return in 1906 he stayed for a short time at Old Lyme, Connecticut, where Hassam and Metcalf were painting, although he apparently did little work there himself.

Around 1912, after two decades of mural work in which he took pride in historical accuracy, Simmons gave up painting for a while, having decided that his previous work was "too literal and too full of detail." While painting decorations for the 1915 Panama-Pacific Exposition in San Francisco—where he worked alongside Hassam and Reid—he decided to experiment with Impressionism in his 46-foot-long canvases, using only three brushes and the three primary colors. Before World War I he completed several more residential commissions, including decorations for the John D. Rockefeller estate at Tarrytown and for Frederick Vanderbilt in Hyde Park, both New York.

Although his work might seem to belie it, he was a fierce champion of James McNeill Whistler, and wrote bitterly on what he considered the Americans'

inborn disregard for the visual arts. He lived his last few years with his son in Baltimore, Maryland, where he died. He was remembered almost solely for his mural work.

Literature

William Henry Howe and George Torrey, "Edward E. Simmons," *Art Interchange* 33 (Dec. 1894), p. 121.
Arthur Hoeber, "Edward Emerson Simmons," *Brush and Pencil* 5 (Mar. 1900), pp. 241–49.
Pauline King, *American Mural Painting*, Boston, 1902, *passim*.
Edward Simmons, "The Fine Arts Related to the People," *International Studio* 63 (Nov. 1917), pp. ix–xiii.
–, *From Seven to Seventy: Memories of a Painter and a Yankee*, New York and London, 1922 (reprint, New York, 1976).
F[rederick] W. C[rowninshield], in *Dictionary of American Biography*, vol. XVII, New York, 1946, pp. 168–69.
Americans in Brittany and Normandy: 1860–1910, exhibition catalogue, Phoenix Art Museum, Phoenix, Arizona, 1982. Text by David Sellin.
Obituaries: *Art Digest*, Dec. 1, 1931; *New York Times*, Nov. 18, 1931.

Edmund Charles Tarbell

Born: West Groton, Massachusetts, April 26, 1862
Died: New Castle, New Hampshire, August 1, 1938

Raised by his grandparents in Dorchester, Massachusetts, after his father died, Tarbell claimed that he decided to be an artist when he was about ten years old and set about getting expelled from school when he was fifteen, after which he worked at the Forbes Lithographic Co. for about three years. He entered the Boston Museum school in 1879 and there, according to his friend and fellow painter Philip Hale, he was particularly influenced by his teacher, the Antwerp-trained Otto Grundmann, and is said to have admired the Spanish painter Mariano Fortuny. He became a student-instructor after his first year and was commissioned to make illustrations for the catalogue of the 1883 Foreign Exhibition, which introduced many French Impressionist paintings to the Boston public.

Tarbell's activities in the 1880s are not well known, with the result that existing biographies often contain errors in dating. He certainly spent part of the time in Europe, arriving in Paris in 1884 to study at least one winter at the Académie Julian. By his own account, he also spent a year attending weekly classes there run by the American painter William Dannat, in which Reid, Metcalf, and other Boston friends also took part. Tarbell is said to have traveled in Germany and to have spent a winter in Venice. He exhibited in the Paris Salon of 1886 (*La Lecture*) and returned to America the same year, as is indicated by a letter of December 1894 (Pennsylvania Academy of the Fine Arts archives) in which Tarbell described returning to the United States a year before he joined the Society of American Artists.

The extent to which Tarbell may have been influenced by the Impressionists in Paris is not known, though statements he made at the time of the 1893 Chicago World's Columbian Exposition suggest that during his European years his allegiance remained

with the academic masters. After returning to the United States, Tarbell worked as a portraitist and illustrator, and drew favorable notice with a number of portraits exhibited in Boston and at the Society of American Artists in 1887 and 1888. The critic for the *Nation* (46, Apr. 26, 1888, p. 353) called him "a brilliant performer," while in Boston his portraits were favorably compared to those of the local hero, John Singer Sargent (*Art Amateur* 18, Apr. 1888, p. 110). In 1888 Tarbell married Emeline Souther, who had modeled for one or more of these portraits.

Tarbell became instructor at the Boston Museum school in 1889 along with Benson, and, when the head of the school, Otto Grundmann, died in 1890, the two became codirectors. Together they directed the school for over two decades until December 1912, when they resigned in a dispute over new management policies. In 1891 Tarbell and Benson made their public debut in a joint exhibition at the St. Botolph Club, and were thereafter linked as the two most prominent members of the Boston School of painters.

Like Benson, Tarbell gained his first significant recognition outside of Boston. He won the Clarke prize at the National Academy of Design in 1890 for an interior scene titled *After the Ball* (private collection). That year he also produced *In a Garden* (plate 42), his first great success in *plein air* painting, which was followed in the next few years by series of outdoor paintings—among them, *In the Orchard* (plate 46), *Mother and Child in a Boat* (fig. 8), and *Lady with a Horse*—that brought him to national prominence and marked him as one of the more audacious rising young artistic stars. He continued to paint a variety of interior scenes, winning the Shaw prize of the Society of American Artists in 1893 for *The Bath* (fig. 41) and the National Academy's Hallgarten prize in 1894 for his *Arrangement in Pink and Gray* (private collection). His victory with the latter, comparatively modest composition seems to have been part of a compromise worked out at the Academy between the modern and traditional factions, since that year's prize in the more senior category of figure painting went to an entirely antithetical, comic genre picture by H. W. Watrous called *Bills*, in which a stern father was shown confronting his spendthrift daughters with their fashion bills. Traditionalists, in fact, thought Tarbell typified the modern artist's willingness to glorify, in theme and technique, the ephemeral at the expense of the time-honored values of sentiment and morality. A reviewer for the *New York Times* in 1894 (Apr. 9, p. 2) characterized his work of recent years as consisting of "very coarse, sometimes very repulsive, paintings planned in violent and unnatural colors."

Tarbell held one-man shows in Boston in 1894 at the J. Eastman Chase Gallery and at the St. Botolph Club in 1898 and 1904, the last shown concurrently with the great Whistler Memorial exhibition at Copley Hall. In 1895 he won the Temple gold medal at the Pennsylvania Academy of the Fine Arts and was reported that year to have a summer school near Boston. He seems at least once to have tried mural work, for in 1896 he was noted as having executed "an important decoration" for Tremont Temple in Boston (*Art Interchange*, July 1896).

Tarbell, like Benson, was much absorbed by abstract design problems. Although he continued to paint outdoor scenes—for example, *Schooling the Horses* (plate 17) and *Girl with Sailboat* (plate 73)—his

Edmund Charles Tarbell

work toward the turn of the century is marked by a certain restlessness in which one detects the influence of varying sources—Edouard Manet, Edgar Degas, and even the eighteenth-century English portraitists. In works such as *Interior* (Cincinnati Art Museum) and *Across the Room* (Metropolitan Museum of Art, New York) he experimented with steep perspectives after the fashion of Degas and Japanese prints, which he is known to have studied; he explored problems of interior-exterior light in paintings such as *The Venetian Blind* (Worcester Art Museum) of 1898, where brilliant streams of light are contrasted with otherwise dim interiors.

Out of this searching a new style emerged, which he referred to as his "second manner," softly lit interior scenes inspired by the seventeenth-century Dutch genre painters, in particular Vermeer. Critics were not entirely unjustified in their charge that he focused upon technical problems above all else. Though Tarbell's own views, surprisingly, went unrecorded, Philip Hale enumerated in print on several occasions the problems of modeling and subtle tonal relationships that absorbed himself and others of the Boston School (see *Boston Sunday Herald*, Nov. 11, 1906, p. 1). Tarbell's new mature manner was first introduced to the public in 1905 in the painting *Girl Crocheting* (Canajoharie Library) and continued to dominate his work during the next decade.

Tarbell was an Associate (1904) and an Academician (1906) of the National Academy of Design and a founding member and first president of the Guild of Boston Artists (1914). During the latter half of the Ten's existence Tarbell exhibited often, though with a dwindling number of new inventions. He had one-man exhibitions at the Montross gallery in 1907 and 1912, at the Corcoran Gallery, Washington, D.C., in 1908 and 1916, and a joint show there with Edward Redfield in 1918. At home in Boston he was given a major exhibition at Copley Hall in 1912, an honor hitherto accorded only Sargent and James McNeill Whistler.

Tarbell developed a third career as a figure painter, in connection with which he received many lucrative commissions in his later years for official portraits of business, political, academic, and judicial leaders. Not especially prolific at any period in his life, his portrait work reduced his output of figural work to an even greater degree: only a few new works—among them *Girl Writing* (fig. 65), a typical late interior—were included, for example, in the exhibition of Tarbell's works held at the Knoedler gallery, New York, in 1918 and at the Guild of Boston Artists. Figural works were particularly few and far between after 1918, when he moved to Washington, D. C., to become head of the Corcoran School of Art, initiating a period in which he counted among his sitters Presidents Wilson, Coolidge, and Hoover. While he continued to paint some figured interiors, in a style that grew increasingly hard and mannered, as well as some floral still lifes, he was by then so firmly identified with portrait work that, in the entry written just over thirty years ago in the *Dictionary of American Biography* of 1958, he was described as an artist certain to be best remembered as a portraitist.

Tarbell left Washington in 1926 and retired to his home in New Castle, New Hampshire, but continued to paint and exhibit in Boston to an appreciative audience. His death in 1938 occurred only a few months before the opening of a major retrospective devoted to him and Benson at the Boston Museum of Fine Arts.

Literature

William Henry Howe and George Torrey, "Edmund C. Tarbell, A. N. A.," *Art Interchange* 32 (June 1894), p. 167.
Sadakichi Hartmann, "The Tarbellites," *Art News* 1 (Mar. 1897), pp. 3–4.
"A Note on Tarbell," *Gallery and Studio* 1 (Oct. 1897), p. 5.
Dora M. Morrell, "A Boston Artist and His Work," *Brush and Pencil* 3 (Jan. 1899), pp. 193–201.
Homer Saint-Gaudens, "Edmund C. Tarbell," *Critic* 48, no. 2 (Feb. 1906), pp. 136–37.
W. Stanton Howard, "A Portrait by E. C. Tarbell," *Harper's Magazine* 112 (Apr. 1906), pp. 702–3.
Frederick W. Coburn, "Edmund C. Tarbell," *International Studio* 32 (Sept. 1907), pp. lxxv–lxxxvii.
–, "Mr. Tarbell's 'New England Interior,'" *New England Magazine* 38 (Mar. 1908), pp. 96–97.
Charles H. Caffin, "The Art of Edmund C. Tarbell," *Harper's Magazine* 117 (June 1908), pp. 65–74.
Kenyon Cox, "The Recent Work of Edmund C. Tarbell," *Burlington Magazine* 14 (Jan. 1909), pp. 254–260.
Leila Mechlin, "A Painter of American Interiors," *Art and Progress* 2 (Nov. 1910), pp. 20–21.
Philip L. Hale, "Edmund C. Tarbell: Painter of Pictures," *Arts and Decoration* 2 (Feb. 1912), pp. 129–31, 156–58.
–, "'The Coral Necklace' by Edmund C. Tarbell," *Harper's Magazine* 129 (June 1914), pp. 136–37.
John E. D. Trask, "About Tarbell," *American Magazine of Art* 9 (Apr. 1918), pp. 216–28.
"Edmund C. Tarbell," *Mentor* 8 (Dec. 1920), pp. 26–27.
William M. Warren, "Twenty-four Sittings with Tarbell," *Bostonia* 12 (1939), pp. 9–11.
C. C. Cunningham, "Edmund Charles Tarbell," in *Dictionary of American Biography*, supp. 2, New York, 1958, pp. 649–50.
Two American Impressionists: Frank W. Benson and Edmund C. Tarbell, exhibition catalogue, University Art Galleries, University of New Hampshire, Durham, 1979. With an essay by Susan Faxon Olney.
Patricia Jobe Pierce, *Edmund C. Tarbell and The Boston School of Painting 1889–1980*, Hingham, Mass., 1980.
Hilton Brown, "Looking at Paintings," *American Artist* 46 (July 1982), pp. 40–41, 84–85.

John Henry Twachtman

Born: Cincinnati, Ohio, August 4, 1853
Died: Gloucester, Massachusetts, August 8, 1902

The son of German immigrants, Twachtman worked as a boy decorating window shades before receiving his earliest formal training in Cincinnati at the Ohio Mechanics Institute, at McMicken Design School (University of Cincinnati) from 1871, and in Frank Duveneck's studio from 1874. He went to Munich with Duveneck and, in October 1875, enrolled at the Royal Academy, where he studied under Ludwig von Löfftz. Although in Munich a landscapist rather than a figure painter, Twachtman also incorporated in his work features derived from the reigning master, Wilhelm Leibl, in which the influence of Gustave Courbet's realism and of the seventeenth-century Dutch masters came together in a style that was at once somber and vivid. He left Munich in 1877 to spend about nine months in Venice with Duveneck and Chase, applying the dark Munich palette even to his Venetian views. Twachtman showed two Italian subjects in the first Society of American Artists exhibition, held in 1878, the year he returned to America following the death of his father. Twachtman joined the Society in 1879 and, for several years afterward, wandered restlessly between various New England coastal towns, New York, and his home in Cincinnati, where he taught for a time at the Women's Art Association. During these years he began a lifelong friendship with Weir.

In the fall of 1880 Twachtman went to Italy to teach at Duveneck's school in Florence, and may have had the opportunity to meet James McNeill Whistler during the latter's fourteen-month stay in Venice from September 1879. Though not proven, such a meeting is strongly suggested by the crucial and enduring influence Whistler had on Twachtman's development.

In 1881 Twachtman was back in Cincinnati, where he married Martha Scudder, daughter of a local physician. He returned to Europe on his honeymoon trip, visiting England, Belgium, and Germany, and etched and painted for a time in Holland with Weir. Twachtman's first son, born in 1882, when he was once again in Cincinnati, was given the middle name Alden in honor of Weir. Complaining about the enervating atmosphere in Cincinnati, Twachtman set out for Europe yet again, this time to Paris, where he remained from 1883 to 1885, studying at the Académie Julian under Jules-Joseph Lefebvre and Gustave Boulanger. Summers were spent painting at Honfleur, at Arques-la-Bataille, near Dieppe, and in Holland. Twachtman was determined to develop his drawing skills in France and to cast off the influence of Munich, which he bitterly denounced in a letter to Weir: "I don't know a fellow who came from Munich

that knows how to draw or ever learned anything else in that place" (Boyle, 1897, p. 14). The style he developed in France marked a complete departure from the heavy impasto technique and dark tonality of his Munich pictures. His acquaintance with the *plein air* work of Jules Bastien-Lepage—whom Weir, along with other Americans, especially admired— may have helped Twachtman to lighten his palette, though he specifically disapproved of the literalness and detail in the Frenchman's approach. Whistler's art seems to have been decisive in leading Twachtman towards the strict design discipline which he now emphasized in landscapes composed of broad, flat planes and rendered in thin washes of subtle grays and greens, a style noted for its austerity and deliberateness. Twachtman visited Venice in the winter of 1884, where he met Robert Blum and others of the Duveneck circle, and that year exhibited one of his American snow scenes at the Paris Salon.

Twachtman returned to America in the winter of 1885/86 and, in January 1886, exhibited at the J. Eastman Chase Gallery in Boston—as he had the previous year—a collection of paintings from France and Holland. The years following Twachtman's return to America in early 1886, though poorly understood today, hold special significance, for it was during that time that he again abruptly changed course and turned fully to Impressionism. The possible influence on him of Durand-Ruel's great Impressionist exhibition in the spring of 1886 has yet to be explored. His association in Venice with Blum and, later in New York, with Chase may have stimulated his return to a more painterly style, as it most probably did his involvement with pastel. From 1888 to 1890 he was a major exhibitor with the Society of Painters in Pastel and at the American Water Color Society, both in New York. A reviewer for the *Critic* (15, Mar. 14, 1891, p. 146) said, in fact, that in recent years he had shown little of his work outside of the Pastel Society.

Twachtman's Impressionist phase is associated with his residence at Round Hill, near Greenwich, Connecticut, where he eventually bought a seventeen-acre farm. Undoubtedly drawn to the area by Weir's presence at Branchville, Twachtman seems to have stayed there first as a tenant, possibly as early as 1886, not buying his permanent property until 1890/91. In his largely undated series of mature Impressionist paintings the waterfall, brook, pool, farmhouse, and bridge—still recognizable today—provided virtually all his subject matter. The existing house was enlarged and remodeled with the help of his friend, the architect Stanford White, and Twachtman himself devoted much attention to forming its walks and gardens to complement its natural features. Twachtman received frequent visits in his country home from the other Impressionists, including Weir, Theodore Robinson, Hassam, and Reid.

By the end of the 1880s Twachtman was beginning to experience some modest success. His painting *Windmills* (private collection) won the Webb prize of the Society of American Artists in 1888 and, the next year, he had a successful joint exhibition and sale with Weir at the Fifth Avenue Art Galleries in New York. In 1889 he also became an instructor at the Art Students League, a post which provided him with a steady income until his death. Between 1888 and 1893 he worked intermittently as an illustrator for *Scribner's*

John Henry Twachtman

Magazine and, from 1894, taught at the Cooper Institute. He held summer classes at Newport, Rhode Island, in 1889 and, probably starting the next year, taught summer classes through the 1890s at Cos Cob, Connecticut, at least once in partnership with Weir. Cos Cob in that period proved one of the most popular sites for the Impressionist painters and was visited at various times by Weir, Hassam, Reid, and Robinson.

At the time of his 1889 joint exhibition with Weir, Twachtman was executing delicate pastels in the manner of Whistler, and had begun to concentrate on the snow scenes for which he was later best known. A reviewer for the *New York Times* (Feb. 3, 1889, p. 13) said that the variety of Twachtman's and Weir's handling of paint was a surprise to their friends and praised the former's pictures for having "the bright transparency of watercolors or the clear, vivid dry notes of the chalks.... He paints snow as hardly any other artist one could name—lightly, flakily, with a feeling for its moist, shrouding, enveloping effect."

In 1891 Twachtman had a one-man exhibition at the Wunderlich gallery, New York, in which about thirty pastels and a dozen oil paintings were shown, including the snow scenes *Miossehasseky Falls* and *Snow in Sunlight* (both now lost). Unfortunately, Twachtman's development is particularly difficult to trace in these and following years because he rarely dated his work and cared little about the titles of his paintings, reusing them freely. He once testily informed Harrison Morris, the director of the Pennsylvania Academy annuals, that he did not know the title of a painting he had sent to the exhibition and told him to make one up. Twachtman was truly an unworldly personality, whose chief passions beyond painting were music and poetry. Colleagues and pupils found in him a wonderfully sympathetic

nature that was boyish and even naive. He quipped often, had a wry, sardonic sense of humor, but the toll of the years seems to have cast over him a shadow of melancholy defeat. His underlying frustration may explain why Twachtman the teacher could also be a severe taskmaster, prone to violent tirades and to scathing criticism of his pupils' work. Ironically for an artist devoted to subtlety, from 1889 he was placed in charge of teaching the elementary course to beginners at the Art Students League, where he applied a measure of his own exacting standards. As with others who relied on teaching for support, it was said to have sapped his energies.

In 1893 Twachtman was again joined by Weir in an exhibition at the American Art Galleries which placed their works alongside paintings by Claude Monet and Paul Albert Besnard. In 1894 he won the Temple gold medal and, about the same time, executed a series of paintings of Niagara Falls commissioned by Charles Carey of Buffalo. The following year Twachtman painted a similar series of Yellowstone Park, commissioned by Major W. A. Wadsworth, also of Buffalo.

In the spring of 1895 Twachtman and his family suffered a personal tragedy when his wife and three daughters contracted scarlet fever, which eventually took the life of his nine-year-old daughter. By 1900 Twachtman had separated from his wife and children, and he lived his remaining years apart from them.

Twachtman held summer classes at Gloucester in 1901 and again in 1902, along with De Camp. Many, if not most, of Twachtman's late Gloucester paintings were small, quickly sketched compositions—some on cigar-box panels—which show a renewed emphasis on structure and clarity, and in which he reintroduced black into his palette. In these works he seems to have recovered some of the values of his Munich period, possibly inspired by the presence in Gloucester during these years of De Camp, Theodore Wendel, and Duveneck. He spent the winter of 1901/2 alone at Holley House in Cos Cob while his family was visiting his son John Alden, then studying art in Europe.

In Twachtman's last year there was increasing interest in his work. He exhibited together with his son in 1900 at the St. Botolph Club, Boston. In January 1901 a major exhibition of his work was held at the Art Institute of Chicago and later shown at the Cincinnati Museum. In March 1901 he exhibited at the Durand-Ruel gallery just prior to the Ten exhibition.

After Twachtman's death, his Ten colleagues Dewing, Hassam, Reid, Simmons, and Weir each wrote an appreciation of his work (*North American Review*, 1903). Dewing found the originality and immediacy of his snowy landscapes comparable to a page from Henry David Thoreau. Hassam, interestingly, most admired his design values, as well as his special mixture of strength and qualities that were "delicate, even to the point of evasiveness." All his colleagues emphasized the painful neglect he had suffered throughout his career from both the public and institutions.

A posthumous sale of his paintings, which appears to have been arranged by Dewing, was held in March 1903 at the American Art Galleries, netting about $16,600 for ninety-eight canvases and pastels. Other paintings withheld by the family were gradually sold

in New York over the following years through a Mr. Dunstan. Posthumous exhibitions were held at the Knoedler gallery in 1904, at the New York Lotos Club in 1907, and in 1913 at the New York School of Design for Women and at the Buffalo Fine Arts Academy.

Literature

"Paintings and Pastels by J. H. Twachtman and J. Alden Weir," *Studio* 4, no. 3 (Feb. 1889), pp. 43–44.

"Oil Paintings and Pastels by Mr. Twachtman," *Critic* 15 (Mar. 14, 1891), pp. 146–47.

"An Art School at Cos Cob," *Art Interchange* 43, no. 3 (Sept. 1899), pp. 56–57.

"John H. Twachtman: Death of the Famous Landscape Painter at Gloucester, Mass.," *New York Times*, Aug. 9, 1902, p. 9.

"John H. Twachtman: An Estimation," with essays by T. W. Dewing, Childe Hassam, Robert Reid, Edward Simmons, and J. Alden Weir, in *North American Review* 176 (Apr. 1903), pp. 554–62.

Katherine Metcalf Roof, "The Work of John H. Twachtman," *Brush and Pencil* 12 (July 1903), pp. 243–46.

Alfred H. Goodwin, "An Artist's Unspoiled Country Home," *Country Life in America* 8 (Oct. 1905), pp. 625–30.

Charles C. Curran, "The Art of John H. Twachtman," *Literary Miscellany* 3 (Winter 1910), pp. 72–78.

John Cournos, "John H. Twachtman," *Forum* 52 (Aug. 1914), pp. 245–48.

Charles De Kay, "John H. Twachtman," *Arts and Decoration* 9 (June 1918), pp. 73–76, 112ff.

Duncan Phillips, "Twachtman: An Appreciation," *International Studio* 66 (Feb. 1919), pp. cvi–cvii.

Eliot C. Clark, "John Henry Twachtman," *Art in America* 7 (Apr. 1919), pp. 129–37.

Margery A. Ryerson, "John H. Twachtman's Etchings," *Art in America* 8 (Feb. 1920), pp. 92–96.

Forbes Watson, "John H. Twachtman: A Painter Pure and Simple," *Arts and Decoration* 12 (Apr. 25, 1920), pp. 395, 434.

Marsden Hartley, *Adventure in the Arts*, New York, 1921, pp. 74–79.

Robert J. Wickenden, *The Art and Etchings of John Henry Twachtman*, New York, 1921.

Eliot C. Clark, "The Art of John Twachtman," *International Studio* 72 (Jan. 1921), pp. lxxvii–lxxxvi.

Carolyn C. Mase, "John H. Twachtman," *International Studio* 72 (Jan. 1921), pp. lxxi–lxxv.

Jonathan Thorpe, "John H. Twachtman," *Arts* 2 (Oct. 1921), pp. 9–10.

Eliot C. Clark, *John H. Twachtman*, New York, 1924.

Allen Tucker, *John H. Twachtman*. American Artists Series, New York, 1931.

"John Henry Twachtman, Painter, 1853–1902," *Index of Twentieth Century Artists* 2 (Mar. 1935), pp. 87–91 (reprinted 1970, pp. 353–57, 365, 366).

John O'Connor, Jr., "From Our Permanent Collection: 'River in Winter' by John H. Twachtman (1853–1902)," *Carnegie Magazine* 25 (Apr. 1951), pp. 136–38.

John Douglas Hale, "The Life and Creative Development of John H. Twachtman," 2 vols., unpublished Ph. D. dissertation, Ohio State University, 1957 (University Microfilms).

John Henry Twachtman, 1853–1902, exhibition catalogue, Ira Spanierman, New York, 1966. Text by Richard J. Boyle.

A Retrospective Exhibition: John Henry Twachtman, exhibition catalogue, Cincinnati Art Museum, Cincinnati, 1966. Text by Richard J. Boyle and Mary Welsh Baskett.

James L. Yarnall, "John H. Twachtman's 'Icebound,'" *Bulletin of the Art Institute of Chicago* 71 (Jan.–Feb. 1977), pp. 2–5.

Richard J. Boyle, *John Twachtman*, New York, 1979.

Twachtman in Gloucester: His Last Years, 1900–1902, exhibition catalogue, Spanierman Gallery, New York, 1987. With essays by John Douglas Hale, Richard J. Boyle, and William H. Gerdts.

In the Sunlight: The Floral and Figurative Art of J. H. Twachtman, exhibition catalogue, Spanierman Gallery, New York, 1989. With essays by Lisa N. Peters, William H. Gerdts, John D. Hale, and Richard J. Boyle.

John Twachtman: Connecticut Landscapes, exhibition catalogue, National Gallery of Art, Washington, D. C., 1989. With essays by Deborah Chotner, Lisa N. Peters, and Kathleen A. Pyne.

Julian Alden Weir

Born: West Point, New York, August 30, 1852
Died: New York City, December 8, 1919

Weir was the youngest son in a family of sixteen children headed by Robert W. Weir, an historical painter who served as drawing instructor at the U. S. Military Academy at West Point, New York, for over forty years. Several of his siblings were also painters, the most notable being his brother John Ferguson, who headed the Department of Art at Yale University from 1869 to 1913. Weir first studied with his father, and painted on and off in his brother's New York studio during the late 1860s. From 1870 to 1872 he was a student under Lemuel Wilmarth at the National Academy of Design. In September 1873 he left for Paris to study at the Ecole des Beaux-Arts as a pupil of Jean-Léon Gérôme. In summers he painted in the French countryside, notably at Pont-Aven in Brittany, where he became acquainted with Robert Wylie, and at Cernay-la-Ville southwest of Paris. He also made trips to England and Spain, and to Holland in 1874/75, where he particularly admired the work of Frans Hals. The extensive correspondence Weir maintained with his family while in Europe provides one of the most comprehensive accounts of an American student's experience abroad after the Civil War. Weir's early work consisted mainly of portraits and scenes of peasant life in Brittany. In 1875 he exhibited for the first time at the Paris Salon (*Portrait of Mr. N.*, private collection) and simultaneously at the National Academy of Design, New York (*Interior: House in Brittany*, private collection).

Well known for his good looks and affable personality, Weir seems to have made friends easily, and counted among his acquaintances and friends in Paris John Singer Sargent, J. Carroll Beckwith, and the French painter Jules Bastien-Lepage. Weir also knew Frederick Bridgman there and, in the summer of 1877, he recorded meeting a "Mr. Dewings," which may have been his first contact with his future colleague in the Ten (Archives of American Art, Roll #71).

Weir returned to New York in October 1877 and joined the Society of American Artists that year, probably with the help of his friend, the painter Wyatt Eaton. He contributed seven paintings to the first Society exhibition and was active in the organization's administration, being elected vice-president in 1880 and president in 1882. Weir also was a member of the informal artists' group known as the Tile club, where he was in contact with Chase and Twachtman. Weir became an Associate of the National Academy in 1885 and a full Academician the next year.

Weir gave private lessons in painting after his return to America and, from 1878, also taught at the Cooper Institute. From 1885 to 1889 he taught a portrait class at the Art Students League and, between 1897 and 1901, held summer classes at his home in Branchville.

Weir exhibited at the Paris Salons, winning a silver medal in 1882, and returned regularly to Europe during the late 1870s and early 1880s, his trips supported in part by his service as a buying agent for collectors Erwin Davis and Henry Marquand. In 1881 he painted in Holland with his older brother and with Twachtman, and met James McNeill Whistler for a second time in London. In 1882 Weir purchased a farm of several hundred acres in Branchville (now Wilton and Ridgefield), Connecticut, and, through the family of his wife, Anna Dwight Baker, whom he married in 1883, also eventually acquired another large home and property at Windham, Connecticut. From 1886 he also owned a house in New York, and for most of his career divided his time about equally each year between residence in the city and in his homes in Connecticut, where he loved to fish and hunt when not painting.

In the early 1880s Weir specialized mainly in portraits and still lifes, while occasionally painting historical or allegorical subjects. His first child, Caroline, was born in 1884, and after that date he looked increasingly to his family and homelife for subjects for his paintings. The most ambitious of these family genre scenes was the large painting *Idle Hours* (plate 29), which won the Fourth Prize Fund Exhibition of 1888 and was donated to New York's Metropolitan Museum of Art.

Weir had a particularly close relationship, both personally and professionally, with Twachtman, whom he had known since at least 1880. Weir acted as a sort of public protector of Twachtman, while the latter seems to have taken the artistic lead. Following Twachtman's move to Connecticut in 1887, Weir became deeply involved with printmaking and with pastel, and also developed his interest in landscape. In 1889 Weir and Twachtman held a joint exhibition at the Fifth Avenue Galleries, New York. The critic for the *New York Times* (Feb. 3, 1889, p. 13) said their pictures were "a surprise to their friends [in] the solid qualities of painting they exhibit and the variety in ways of handling paint." These were evidently intimations of the dramatic conversion to Impressionism that Weir underwent the next year. The years 1889 and 1890 represented a turning point in Weir's artistic

career. His father died, leaving him bereft of his closest critic, and he visited the Exposition Universelle in Paris. When he returned to New York his outlook was transformed. Landscape gained increasing importance for him, his palette grew considerably lighter, and his drawing looser under Impressionist influence. In January 1891 Weir held his first major one-man show at Blakeslee Galleries, New York, in which he exhibited many landscapes from the previous summer and which firmly identified him as belonging to the Impressionist group. In January 1892, a few weeks after the birth of his third daughter, Cora, his wife died. Weir later married her sister, Ella Baker. In the summer of 1892 Weir went to Chicago to execute murals for the World's Columbian Exposition, where he worked alongside Reid and Simmons. In 1893 he began a series of life-size figures posed out of doors, including *The Hunter* of 1893, *An Autumn Stroll* of 1894 (both now Brigham Young University, Provo, Utah), and *In the Dooryard* (fig. 29). In 1893 he again exhibited with Twachtman at the American Art Association, where their work was juxtaposed to that of the French painters Paul Albert Besnard and Claude Monet. In December of that year Weir and Twachtman exhibited together at the St. Botolph Club, Boston.

From 1894 he shared with Twachtman an enthusiasm for Japanese prints, whose influence may be seen in the broad, flat silhouettes of his figure compositions as well as in the asymmetry and strict, architectonic design of a work such as *The Red Bridge* (plate 51). Like Twachtman, Weir painted a number of snow scenes in the mid-1890s and, in a more original vein, produced a notable series of landscapes centering upon the old industrial buildings of Connecticut, such as *U.S. Thread Company Mills, Willimantic, Connecticut* (plate 48).

In 1895 an exhibition of his drawings and etchings was held at the Wunderlich gallery in New York and, in the spring of 1897, he exhibited paintings at the Boussod Valadon gallery there, which the reviewer for the conservative *Art Interchange* (38, no. 4, Apr. 1897, p. 95) found extremely "eccentric" and denounced as being either the work of a comic or the result of defective vision and training. To him, "Mr. Weir's wriggles of the brush, and his spots of pure, chalky color, and weak drawing, seemed the work of the veriest novice."

By about 1898 Weir's academic background was beginning to reassert itself, as he sought to combine something of his former precision in drawing with the effects of brightly colored broken surfaces. In works such as *The Donkey Ride* (c. 1900, private collection) he favored a very deliberate application of thick paint, often relying almost solely on a palette knife to arrive at a textured, tapestry-like effect. This was in marked contrast to the objective, realistic quality of his earliest work, as well as to his looser and freer paint application of the mid-1890s. Despite his penchant for thick, impasto surfaces, Weir painted with a restraint and delicacy that appeared prim to the next generation, but which was rewarded with a gold medal at the St. Louis Exposition of 1904. From 1905 to 1907 Weir executed a number of nocturnes such as Hassam and Metcalf were also painting; they were exhibited at his one-man show at the Montross gallery in 1907. A major retrospective of Weir's paintings traveled in 1911 and 1912 to Boston, New York,

Pittsburgh, Buffalo, and Cincinnati. From about that time he began to suffer from heart disease, which prompted a recuperative trip to Nassau, Bahamas, in 1912 (see plate 81), and which caused a decline in his output thereafter. In December 1911 Weir was elected President of the Association of American Painters and Sculptors, but resigned the position immediately on learning of the group's radical intentions. He did, however, show a large group of earlier paintings, watercolors, and etchings in the famous Armory show which the Association staged in 1913. The next year he held an exhibition of his recent work at the Montross gallery. Weir served as president of the National Academy of Design between 1915 and 1917, eventually resigning the post because of ill health. In a group of letters written to the Boston dealer Robert Vose he mentioned doing very little work in the years from about 1916 to 1918. In August 1918 he underwent an operation and moved out of his New York apartment, saying, nevertheless, that "I still hope to accomplish some good work." After his death the following year, memorial exhibitions were held at the Vose Gallery, Boston, and at the Century Association, New York, in 1920. A major retrospective was held at the Metropolitan Museum of Art in 1924. Most of Weir's property at Branchville, including his house, barns, studio, and land, is now preserved as an historical site administered by a combination of private and governmental agencies.

Literature

J. Alden Weir, "Jules Bastien-Lepage," *Studio* 13 (Jan. 31, 1885), pp. 145–51.

–, et al., "Open Letters: American Artists on Gerome," *Century Magazine* 37 (Feb. 1889), 634–36.

"Paintings and Pastels by J.H. Twachtman and J. Alden Weir," *Studio* 4, no. 3 (Feb. 1889), pp. 43–45.

"Recent Pictures by J. Alden Weir," *Studio* 6 (Jan. 31, 1891), pp. 81–82.

"Paintings by Mr. J. Alden Weir," *Art Amateur* 24 (Feb. 1891), p. 56.

"Mr. J. Alden Weir's Exhibition," *Art Amateur* 32 (Apr. 1895), pp. 133–34.

Edward King, "Straightforwardness Versus Mysticism (With original illustrations by John [sic] Alden Weir)," *Monthly Illustrator* 15 (July 1895), pp. 29–32.

J. Alden Weir, "Jules Bastien-Lepage," in *Modern French Masters*, ed. John C. Van Dyke, New York, 1896, pp. 227–35.

George Henry Payne, "J. Alden Weir," *Criterion* 18 (July 30, 1898), pp. 20–21.

Kenyon Cox, "The Art of J. Alden Weir," *Burlington Magazine* 15 (May 1909), pp. 131–32.

Walter Pach, "Peintre-Graveurs contemporains: M. J. Alden Weir," *Gazette des Beaux-Arts*, 4th ser., 6 (Sept. 1911), pp. 214–15.

Guy Pène du Bois, "The Idyllic Optimism of J. Alden Weir," *Arts and Decoration* 2 (Dec. 1911), pp. 55–57, 78.

Howard Russell Butler, "J. Alden Weir," *Scribner's Magazine* 59 (Jan. 1916), pp. 129–32.

Duncan Phillips, "J. Alden Weir," *American Magazine of Art* 8 (Apr. 1917), pp. 213–20.

Robert B. Brandegee, "Living Artists No. 1: J. Alden Weir," *Art Review International* 1 (May 1919), pp. 9–10.

Hamilton E. Field, "Julian Alden Weir: An Optimist," *Arts and Decoration* 12 (Jan. 1920), pp. 200–2.

Frank Weitenkampf, "Weir's Excursion into Print-Land," *Arts and Decoration* 12 (Jan. 20, 1920), pp. 208–9.

Duncan Phillips, "J. Alden Weir," *Art Bulletin* 2 (June 1920), pp. 189–212.

Eliot Clark, "J. Alden Weir," *Art in America* 8 (Aug. 1920), pp. 232–42.

Margery Austen Ryerson, "J. Alden Weir's Etchings," *Art in America* 8 (Aug. 1920), pp. 243–48.

Elizabeth Luther Cary, "The Etched Work of J. Alden Weir," *Scribner's Magazine* 68 (Oct. 1920), pp. 507–12.

Edwin H. Blashfield, *A Commemorative Tribute to J. Alden Weir*, New York, 1922.

Duncan Phillips, et al., *Julian Alden Weir: An Appreciation of His Life and Works*, New York, 1922.

Frederick Newlin Price, "Weir: The Great Observer," *International Studio* 75 (Apr. 1922), pp. 127–31.

Agnes Saumarez Zimmerman, "An Essay Toward a Catalogue Raisonné of the Etchings, Drypoints and Lithographs of J. Alden Weir," *Metropolitan Museum of Art Papers* 1, no. 2 (1923), pp. 1–50.

–, "Julian Alden Weir: His Etchings," *Print Collector's Quarterly* 10 (Oct. 1923), pp. 288–308.

A Memorial Exhibition of the Works of Julian Alden Weir, exhibition catalogue, Metropolitan Museum of Art, New York, 1924. With an essay by William A. Coffin.

Catherine Beach Ely, "J. Alden Weir," *Art in America* 12 (Apr. 1924), pp. 112–21.

"Two Paintings by J. Alden Weir," *Brooklyn Museum Quarterly* 13 (Oct. 1926), pp. 124–25.

John I. H. Baur, "J. Alden Weir's Partition of 'In The Park,'" *Brooklyn Museum Quarterly* 25 (Oct. 1938), pp. 125–29.

J. Alden Weir, 1852–1919: Centennial Exhibition, exhibition catalogue, American Academy of Arts and Letters, New York, 1952. With an essay by Mahonri Sharp Young.

Dorothy Weir Young, *The Life and Letters of J. Alden Weir*, New Haven, Connecticut, 1960.

J. Alden Weir (1852–1919), exhibition catalogue, Larcada Gallery, New York, 1966.

Fearn C. Thurlow, *J. Alden Weir*, exhibition catalogue, Montclair Art Museum, Montclair, N.J., 1972.

J. Alden Weir: American Impressionist 1852–1919, exhibition catalogue, National Collection of Fine Arts, Washington, D.C., 1972. Text by Janet A. Flint.

Paintings by Julian Alden Weir, exhibition catalogue, Phillips Collection, Washington, D.C., 1972. With an essay by Mahonri Sharp Young.

Doreen Bolger Burke, *J. Alden Weir: An American Impressionist*, Newark, 1983.

Chronology

1863
Salon des Refusés, Paris.

1865
End of the American Civil War.

1867
Exposition Universelle, Paris: first U.S. national participation in international exhibition.

1869
Central Pacific and Union Pacific railroads join May 10, forming first U.S. transcontinental railroad.
Mark Twain, *Innocents Abroad.*

1870
Founding of the Metropolitan Museum of Art, New York, and the Boston Museum of Fine Arts.

1872
Robert Wylie the first American to win medal at the Paris Salon, for *A Fortune Teller of Brittany.*

1874
Weir meets John Singer Sargent in Paris and Robert Wylie at Pont-Aven.
First Impressionist exhibition in Paris.
John La Farge's paintings refused at the National Academy of Design.

1875
Art Students League founded and protest exhibition held in New York by young artists opposing the teaching and exhibition policies of the National Academy of Design.
Frank Duveneck exhibits portraits in Boston.

1876
Philadelphia Centennial Exposition celebrating the anniversary of the signing of the Declaration of American Independence, July 4, 1776: Thomas Eakins exhibits *The Gross Clinic*; Chase receives a medal.
Third Impressionist exhibition in Paris.

1877
First important participation of young European-trained Americans at the National Academy of Design exhibition, creating controversy among older Academicians.
American Art Association, soon renamed the Society of American Artists, formed in May; early members include Weir, Chase, Twachtman, and Dewing.
James McNeill Whistler begins his "Nocturne" series, provoking attack by John Ruskin.
Mary Cassatt meets Edgar Degas in Paris and is invited to join the French Impressionist group.
Grosvenor Gallery opens in London with exhibition of works by Edward Burne-Jones, Whistler, and the French Impressionists.

1878
Chase, Twachtman, and Dewing separately return to America after studies in Europe.
First exhibition of the Society of American Artists.
Whistler brings libel suit against Ruskin in London.
Exposition Universelle, Paris.
Théodore Duret, *Les Peintres Impressionistes.*

1879
Thomas A. Edison develops incandescent light bulb.
Whistler begins fourteen-month stay in Venice, associating there with Duveneck and other members of the American Munich school.
Edouard Manet's *The Execution of Maximilian* exhibited in New York and Boston.

1880
Benson, Reid, and Tarbell pursue studies at the Boston Museum school.

1881
Weir meets Manet in Paris and purchases three of his works for collector Erwin Davis.
Henry James, *The Portrait of a Lady.*

1882
Standard Oil Trust organized by John D. Rockefeller, inaugurating the era of (monopolistic) trusts.
Oscar Wilde begins eighteen-month lecture tour of America promoting the English Aesthetic movement and its cause of "art for art's sake."

1883
From 1883 Benson, Twachtman, Metcalf, and Simmons simultaneously in France, to be joined during the following years by Tarbell and Reid.
Foreign Exhibition in Boston shows work of French Impressionists loaned by Paul Durand-Ruel.
Pedestal Fund Exhibition held in New York; Chase and J. Carroll Beckwith in charge of the Painting Collection.
Exhibition of American art at the Munich Glaspalast.
Death of Manet, April 30.
Claude Monet settles at Giverny.

1884
Societé des Vingt (Les XX) founded in Brussels; Chase, Whistler, and Sargent invited to exhibit.
Society of American Artists fails to hold an exhibition.
Sale of Manet's studio.

1885
Chase begins ten-year tenure as president of the Society of American Artists.

1886
Haymarket Labor Riot, Chicago, May 4; American Federation of Labor reorganized.

Twachtman moves to Connecticut after three years in France.
Hassam leaves for three-year stay in Paris.
Metcalf paints at Giverny, possibly with Theodore Robinson and Theodore Wendel, and continues to do so for several years with other American painters.
The Impressionists of Paris exhibition in New York includes nearly three hundred works from the collection of Durand-Ruel.
Eakins dismissed from the Pennsylvania Academy of the Fine Arts school.
Paul Gauguin writes from Pont-Aven of American artists' interest in his Impressionist works.
Eighth and final Impressionist exhibition held in Paris.
Henry James, *The Bostonians*; Emile Zola, *L'Œuvre.*

1887
Durand-Ruel's auction of Impressionist paintings and second exhibition in New York.
Sargent visits America amidst great acclaim; holds first one-man exhibition in Boston the following year.

1888
Metcalf and other American painters return from Giverny to Boston.
First publication in America of Whistler's "Ten O'Clock Lecture," delivered in London in 1885.

1889
Benson and Tarbell join faculty of the Boston Museum school, becoming joint directors the next year.
Hassam moves to New York after three years in Paris.
Manet's *A Boy with a Sword* and *Woman with a Parrot* acquired by the Metropolitan Museum of Art.
Exhibition of Whistler's "Notes," "Harmonies," and "Nocturnes" at Wunderlich & Co., New York.
Exposition Universelle, Paris, celebrates a century of French art, 1789–1889. Gauguin organizes exhibition of the *Groupe impressioniste et synthétiste* on the Exposition grounds at Volpini's Café des Arts.

1890
Société Nationale des Beaux-Arts founded (Salon de Champs de Mars).

1891
Chase opens his famous summer school at Shinnecock, Long Island.
Exhibition of Monet, Camille Pissarro, and Alfred Sisley at J. Eastman Chase gallery, Boston. Monet exhibition at Durand-Ruel gallery, New York.

1892
Weir, Reid, and Simmons begin murals in Chicago for forthcoming World's Columbian Exposition.

Theodore Robinson returns to America after several years at Giverny.

One-man exhibition of Monet at St. Botolph Club, Boston.

Eakins resigns from Society of American Artists, May 7.

Cornerstone laid on 57th Street for future building of The American Fine Arts Society, newly combining the Society of American Artists, the Architectural League, and the Art Students League.

Founding of the Munich Secession.

1893

Financial and industrial depression begins.

Weir and Twachtman exhibit alongside Paul Albert Besnard and Monet at the American Art Association, New York.

World's Columbian Exposition, Chicago: Thomas Hovenden's genre painting *Breaking Home Ties* voted popular favorite.

Puvis de Chavannes commissioned to paint murals for the Boston Public Library; installed 1895/96.

1894

Dewing departs for a year in Europe.

1895

Metcalf and Hassam paint at Gloucester, Massachusetts.

Chase resigns as president of the Society of American Artists and from his teaching post at the Art Students League.

Exhibitions of Cassatt, Theodore Robinson, and Robert Vonnoh at Durand-Ruel gallery, New York.

1896

Chase is forced to liquidate his famous Tenth Street studio and establishes private school.

Death of Theodore Robinson.

Bernard Berenson, *The Florentine Painters of the Renaissance.*

1897

Members of the Ten draw up organizational agreement December 17, pledging their resignations from the Society of American Artists, which they submit several days later.

Hassam paints in Italy and France.

Vienna Secession founded.

1898

Spanish-American War declared. U.S. acquires Guam, Puerto Rico, and the Philippines; separately annexes Hawaii.

Controversy erupts in January over the resignations of the Ten from the Society of American Artists.

First exhibition of the Ten American Painters at the Durand-Ruel gallery, New York.

First exhibition of the Vienna Secession.

1900

Exposition Universelle, Paris.

Theodore Dreiser, *Sister Carrie.*

1901

Pan American Exposition, Buffalo, New York.

1902

Twachtman dies at Gloucester, Massachusetts, August 8.

Flatiron Building, New York.

1903

Orville Wright makes first powered airplane flight.

Hassam and Metcalf first paint at Old Lyme, Connecticut.

Death of Whistler.

1904

First subway in New York opened.

Fire destroys De Camp's studio.

Whistler Memorial Exhibition at Copley Hall, Boston.

Louisiana Purchase Exposition, St. Louis, Missouri.

1905

The Ten relocate their annual exhibition to the Montross gallery, New York, where they remain until 1915.

Chase elected to replace Twachtman in the Ten.

Alfred Stieglitz opens Photo Secession Gallery at 291 Fifth Avenue.

Henri Matisse heads the Fauves at Salon d'Automne, Paris; *Brücke* founded in Dresden.

1906

Merger of Society of American Artists and the National Academy of Design; Hassam, Reid, and Tarbell elected Academicians.

Chase first exhibits with the Ten. Exhibitions of the Ten on extended traveling tours in 1906 and 1907 to Providence, Boston, Detroit, Chicago, Milwaukee, St. Louis, Pittsburgh, and Philadelphia.

1907

Pablo Picasso, *Les Demoiselles d'Avignon.*

1908

Ford Motor Company begins mass production of Model-T automobile.

Major retrospective of the Ten American Painters at the Pennsylvania Academy of the Fine Arts, Philadelphia, April 11–May 3.

Boston Museum of Fine Arts purchases paintings by De Camp, Benson, and Metcalf (and by Tarbell the following year).

First group exhibition of The Eight in New York.

Upton Sinclair, *The Metropolis.*

1909

Filippo T. Marinetti's *Futurist Manifesto* published in Paris.

1910

Exhibition of Independent Artists, New York.

1913

International Exhibition of Modern Art (the Armory show) opens in New York at the 69th Regiment Armory.

1914

World War I begins.

1915

Sinking of the Lusitania.

Ten move their annual exhibition to Knoedler gallery, New York.

Weir elected president of the National Academy of Design; serves until 1917.

Panama-Pacific Exposition, San Francisco, celebrating opening of the Panama Canal: individual exhibitions devoted to Chase, Tarbell, Twachtman, Hassam, Whistler, Sargent, Duveneck, Edward Redfield, and Gari Melchers.

1916

Chase dies, October 25.

1917

America enters World War I.

Last regular exhibition of the Ten American Painters in New York.

1919

Paris Peace Conference following end of World War I the previous year.

Retrospective exhibition of the Ten American Painters at the Corcoran Gallery, Washington, D.C.

Weir dies, December 8.

General Bibliography

For literature on individual members of the Ten, see the artists' biographies.

Contemporary Surveys (to 1919)

Anderson, Margaret Steele. *The Study of Modern Painting*. New York, 1914.

Benjamin, Samuel Greene Wheeler. *Art in America*. New York, 1880.

Brinton, Christian. *Modern Artists*. New York, 1908.

Bryant, Lorinda Munson. *American Pictures and Their Painters*. New York and London, 1917. Further eds., 1920, 1921, 1925, 1926, 1928.

Caffin, Charles H. *The Story of American Painting*. New York, 1907.

–. *American Masters of Painting*. New York, 1913.

Cook, Clarence. *Art and Artists of Our Time*. 3 vols. New York, 1888.

Cortissoz, Royal. *American Artists*. New York, 1923.

Dewhurst, Wynford. *Impressionist Painting: Its Genesis and Development*. London, 1904.

Hartmann, Sadakichi. *A History of American Art*. 2 vols. Boston, 1902.

Isham, Samuel. *The History of American Painting*, New York, 1905. Rev. ed., 1915.

King, Pauline. *American Mural Painting*. Boston, 1902.

Koehler, Sylvester R. *American Art*. New York, 1886.

McSpadden, Joseph Walker. *Famous Painters of America*. New York, 1907. Rev. ed., 1916.

Montgomery, Walter, ed., *American Art and American Art Collections*. 2 vols. Boston, 1889.

Moore, George. *Modern Painting*. London, 1900.

Muther, Richard. *The History of Modern Painting*. 4 vols. London, 1907.

Rummell, John, and Emma Modora Berlin. *Aims and Ideals of Representative American Painters*. Buffalo, New York, 1901.

Sheldon, George W. *American Painters*. Rev. ed. New York, 1881.

–. *Recent Ideals of American Art*. New York, 1890.

Sherman, Frederic Fairchild. *American Painters of Yesterday and Today*. New York, 1919.

–. *Landscape and Figure Painters of America*. New York, 1919.

Van Dyke, John Charles. *Modern French Masters*. New York, 1896.

–. *American Painting and Its Tradition*. New York, 1919.

Van Rensselaer, Marianna Griswold. *Book of American Figure Painters*. Philadelphia, 1886.

Von Mach, Edmund. *The Art of Painting in the Nineteenth Century*. Boston, 1908.

Books, Catalogues, and Articles

Academy: The Academic Tradition in American Art. Exhibition catalogue. National Collection of Fine Arts, Washington, D.C., 1975. With essays by Lois Marie Fink and Joshua C. Taylor.

The Advent of Modernism: Post-Impressionism and North American Art, 1900–1918. Exhibition catalogue. High Museum of Art, Atlanta, Georgia, 1986. With essays by Peter Morrin, Judith Zilczer, and William C. Agee.

Alexander, John W. "Is Our Art Distinctively American?" *Century Magazine* 87 (Apr. 1914), pp. 826–28.

American Impressionism. Exhibition catalogue. Henry Art Gallery, University of Washington, 1980. Text by William H. Gerdts.

American Impressionist and Realist Paintings and Drawings from the Collection of Mr. & Mrs. Raymond J. Horowitz. Exhibition catalogue. Metropolitan Museum of Art, New York, 1973.

American Impressionist Painting. Exhibition catalogue. National Gallery of Art, Washington, D.C., 1973. Text by Moussa M. Domit.

American Paintings by "The Ten." Exhibition catalogue. Montclair Art Museum, Montclair, New Jersey, 1946.

The American Renaissance, 1876–1917. Exhibition catalogue. The Brooklyn Museum, New York, 1979. With essays by Richard Guy Wilson, Diane H. Pilgrim, and Richard R. Murray.

The American Ten. Exhibition catalogue. Newtown Art Gallery, Newtown, Connecticut, 1951. With an introduction by Nelson White.

"Art in Boston: The Wave of Impressionism." *Art Amateur* 24 (May 1891), p. 141.

Bacon, Henry. "Glimpses of Parisian Art." *Scribner's Monthly* 21 (Dec. 1880), pp. 169–81; 21 (Jan. 1881), pp. 423–31; 21 (Mar. 1881), pp. 734–43.

–. *A Parisian Year*. Boston, 1882.

Bartolo, Christine. *The Ten: Works on Paper*. Exhibition catalogue. Sterling and Francine Clark Art Institute, Williamstown, Mass., 1980.

Baur, John I. H. *Leaders of American Impressionism: Mary Cassatt, Childe Hassam, John H. Twachtman, J. Alden Weir*. Exhibition catalogue. The Brooklyn Museum, New York, 1937.

–. "Photographic Studies by an Impressionist." *Gazette des Beaux-Arts*, ser. 6, 30 (Oct.-Nov. 1946), pp. 319–30.

Benjamin, Samuel Greene Wheeler. "Present Tendencies in American Art." *Harper's Magazine* 58 (Mar. 1879), pp. 481–96.

Beta. "The Art Clubs of Boston." *Art Amateur* 11 (Oct. 1884), pp. 100–2.

Bizardel, Yvon. *American Painters in Paris*. New York, 1960.

Boime, Albert. "America's Purchasing Power and the Evolution of European Art in the Late Nineteenth Century." In *Saloni, Gallerie, Musei e loro influenza sullo sviluppo dell'arte dei secoli XIX e XX*, ed. Francis Haskell, pp. 123–39. Bologna, 1979.

Bolger, Doreen. "William Macbeth and George A. Hearn: Collecting American Art, 1905–1910." *Archives of American Art Journal* 15, no. 2 (1975), pp. 9–15.

–, et al. *American Pastels in the Metropolitan Museum of Art*. New York, 1989.

Boyle, Richard J. *American Impressionism*. Boston, 1974.

Brinton, Christian. "The Conquest of Color." *Scribner's Magazine* 62 (Oct. 1919), pp. 513–16.

Brown, Milton W. *American Painting: From the Armory Show to the Depression*. Princeton, 1970.

–. *The Story of the Armory Show*. 2nd ed. New York, 1988.

Brownell, William Crary. "The Younger Painters of America." *Scribner's Magazine* 20 (May 1880), pp. 1–15; 20 (July 1880) pp. 321–35; 22 (July 1881), pp. 321–34.

–. *French Art: Classic and Contemporary Painting and Sculpture*. New York, 1892.

–. "French Art, III: Realistic Painting." *Scribner's Magazine* 12 (Nov. 1892), pp. 604–27.

Caffin, Charles H. "Unphotographic Paint: The Texture of Impressionism." *Camera Work* 28 (Oct. 1909), pp. 20–23.

Child, Theodore. "The King of the Impressionists." *Art Amateur* 14 (Apr. 1886), pp. 101–2.

–. "A Note on Impressionist Painting." *Harper's Magazine* 74 (Jan. 1887), pp. 313–15.

–. *Art and Criticism*. New York, 1892.

Clark, Nichols. "Charles Lang Freer: An American Aesthete in the Gilded Era." *American Art Journal* 11, no. 4 (Oct. 1979), pp. 54–68.

Coburn, Frederick W. "Seeing Nature with Both Eyes." *World Today* 9 (Nov. 1905), pp. 1210–14.

Connecticut and American Impressionism. Exhibition catalogue. William Benton Museum of Art, University of Connecticut, Storrs, 1980. With essays by Harold Spencer, Susan G. Larkin, and Jeffrey W. Anderson.

Cook, Clarence. "The Impressionist Pictures." *Studio* 1 (Apr. 17, 1886), pp. 245–54.

–. "A Representative American Artist." *Monthly Illustrator* 11 (Nov. 1895), pp. 289–92.

–. "Some Present Aspects of Art in America." *Chautauquan* 23 (Aug. 1896), pp. 595–601.

Cortissoz, Royal. "Egotism in Contemporary Art." *Atlantic Monthly* 73 (May 1894), pp. 644–52.

–. "The American School of Painting." *Scribner's Magazine* 50 (Dec. 1911), pp. 765–68.

Daulte, François. "Le marchand des Impressionistes." *L'Oeil*, no. 66 (June 1960), pp. 54–61, 75.

De Kay, Charles [Henry Eckford]. "Whistler, the Head of the Impressionists." *Art Review* 1 (Nov. 1886), pp. 1–3.

–. "A Turning Point in the Arts." *Cosmopolitan Magazine* 15 (1893), pp. 265–79.

Dempsey, Charles W. "Advanced Art." *Magazine of Art* 5 (1882), pp. 358–59.

Downes, William Howe. "Boston Painters and Paintings, VI: Private Collections." *Atlantic Monthly* 62 (Dec. 1888), pp. 777–86.

–. "Impressionism in Painting." *New England Magazine*, n. s., 6 (July 1892), pp. 600–3.

–. "Boston Art and Artists." In F. Hopkinson Smith et al., *Essays on Art and Artists*, pp. 265–80. Chicago, 1896.

du Bois, Guy Pène. "The Boston Group of Painters: An Essay on Nationalism in Art." *Arts and Decoration* 5 (Oct. 1915), pp. 457–60.

Durand-Gréville, M. E. "La Peinture aux Etats-Unis: Les Galeries privées." *Gazette des Beaux-Arts* 2 (1887), pp. 65–75, 250–55.

Eddy, J. Arthur. "Edouard Manet, Painter." *Brush and Pencil* 1 (Feb. 1898), pp. 137–40.

Edgerton, Giles. "Is America Selling Her Birthright in Art for a Mess of Pottage?" *Craftsman* 11 (Mar. 1907), pp. 657–70.

–. "The Younger American Painters: Are They Creating a National Art?" *Craftsman* 13 (Feb. 1908), pp. 512–32.

–. "Pioneers in Modern American Art." *Craftsman* 14 (Sept. 1908), pp. 597–606.

The Edwin C. Shaw Collection of American Impressionist and Tonalist Painting. Akron Art Museum, 1986. With essays by Carolyn Kinder Carr and Margot Jackson; catalogue by William Robinson.

Eldredge, Charles. "American Impressionists: The Spirit of Place." *Art in America* 62 (Sept.-Oct. 1974), pp. 84–90.

Fairbrother, Trevor J. *The Bostonians: Painters of an Elegant Age, 1870–1930.* Exhibition catalogue. Museum of Fine Arts, Boston. With contributions by Theodore E. Stebbins, Jr., William L. Vance, and Erica E. Hirshler.

Fink, Lois Marie. "American Artists in France, 1850–70." *American Art Journal* 5 (Nov. 1973), pp. 32–49.

–. "The Innovation of Tradition in Late Nineteenth-Century American Art." *American Art Journal* 10 (Nov. 1978), pp. 63–71.

–. "American Participation in the Paris Salons, 1870–1900." In *Saloni, Gallerie, Musei e loro influenza sullo sviluppo dell'arte dei secoli XIX e XX*, ed. Francis Haskell, pp. 89–93. Bologna, 1979.

–. *American Art at the Nineteenth-Century Paris Salons.* Washington, D. C., and Cambridge, Mass., 1990.

Fitzgerald, Desmond. "Claude Monet: Master of Impressionism." *Brush and Pencil* 15 (Mar. 1905), pp. 181–95.

–. *Loan Collection of Paintings by Claude Monet and Eleven Sculptures by Auguste Rodin.* Exhibition catalogue. The Copley Society, Boston, Mar. 1905.

–, et al. *Catalogue of Paintings by The Impressionists of Paris: Claude Monet, Camille Pissarro, Alfred Sisley.* Exhibition catalogue. Chase's Gallery, Boston, Mar. 17–28, 1891.

Forgey, Benjamin. "American Impressionism from the Vital to the Academic." *Art News* 72 (Oct. 1973), pp. 24–27.

Fowler, Frank. "The New Heritage of Painting in the Nineteenth Century." *Scribner's Magazine* 30 (Aug. 1901), pp. 253–56.

"French and American Impressionists." *Art Amateur* 29 (June 1893), p. 4.

French Impressionists Influence American Artists. Exhibition catalogue. Lowe Art Museum, University of Miami, 1971. With essays by Richard Boyle et al.

"The French Impressionists." *Critic* 5 (Apr. 17, 1886), pp. 195–96.

W. P. Frith. "Crazes in Art: 'Pre-Raphaelitism' and 'Impressionism.'" *Magazine of Art* 2 (1888), pp. 187–91.

Gammell, R. H. Ives. "A Reintroduction to Boston Painters." *Classical America* 3 (1973), pp. 94–104.

Garczynski, Edward Rudolf. "Jugglery in Art." *Forum* 1 (Aug. 1886), pp. 592–602.

Garland, Hamlin. *Crumbling Idols: Twelve Essays on Art Dealing Chiefly with Literature, Painting and the Drama,* 1894. Reprinted Cambridge, Mass., 1960, ed. Jane Johnson.

Gerdts, William H. *American Impressionism.* New York, 1984.

Glackens, William J. "The American Section: The National Art—An Interview with the Chairman of the Domestic Committee, Wm. J. Glackens." *Arts and Decoration* 3 (Mar. 1913), pp. 159–64.

Hale, Nancy. *The Life in the Studio.* Boston, 1969.

Hale, Philip. *Jan Vermeer of Delft.* Boston, 1913.

Hamilton, Luther. "The Work of the Paris Impressionists in New York." *Cosmopolitan Magazine* 1 (June 1886), pp. 240–42.

–. "The True Impressionism in Art." *Scribner's Magazine* 46 (Oct. 1909), pp. 491–95.

Hartley, Marsden. *Adventure in the Arts.* New York, 1921.

Hartmann, Sadakichi. "The Tarbellites." *Art News* 1 (Mar. 1897), pp. 3–4.

–. "A Plea for the Picturesqueness of New York." *Camera Notes and Proceedings* 4 (Oct. 1900), pp. 91–97.

Hassam, Childe. "Twenty-Five Years of American Painting." *Art News* 26 (Apr. 14, 1928), pp. 22–28.

Heming, Arthur. *Miss Florence and the Artists of Old Lyme.* Essex, Connecticut, 1971.

Herbert, Robert L. *Impressionism: Art, Leisure, and Parisian Society.* New Haven and London, 1988.

Hills, Patricia. *Turn of the Century America: Paintings, Graphics, Photographs, 1890–1910.* Exhibition catalogue. Whitney Museum of American Art, New York, 1977.

Hobbs, Susan. "A Connoisseur's Vision: The American Collection of Charles Lang Freer." *American Art Review* IV, no. 2 (Aug. 1977), pp. 76–101.

Hoeber, Arthur. "Plain Talks on Art: Impressionism." *Art Interchange* 37, no. 1 (July 1896), pp. 5–7.

Homer, William Innes. *Robert Henri and His Circle.* Ithaca, New York, 1969.

Hooper, Lucy. "Art Notes from Paris." *Art Journal* (New York) 6 (1880), pp. 188–90.

Hoopes, Donelson F. *The American Impressionists.* New York, 1972.

Huth, Hans. "Impressionism Comes to America." *Gazette des Beaux-Arts*, ser. 6, 29 (1946), pp. 225–52.

"Impressionism and After." *Scribner's Magazine* 21 (Mar. 1897), pp. 391–92.

Impressionism: The California View. Exhibition catalogue. Oakland Museum, Oakland, California, 1981. With essays by John Caldwell and Terry St. John.

Impressionism and its Influence in American Art. Exhibition catalogue. Santa Barbara Museum of Art, 1954.

Impressionism in America. Exhibition catalogue. University of New Mexico Art Gallery, Albuquerque, 1965. With an introduction by F. Van Deren Coke.

"Impressionism in France." *American Art Review* 1 (1880), pp. 33–35.

Impressionistes Américains. Exhibition catalogue. Smithsonian Institution Travelling Exhibition Service, 1982, Petit Palais, Paris (traveled to Berlin, Vienna, Bucharest, and Sophia). With essays by Harold Spencer, Barbara Novak, et al.

"The Impressionists." *Art Age* 3 (Apr. 1886), pp. 165–66.

"The Impressionists." *Art Amateur* 30 (Mar. 1894), p. 99.

"The Impressionists." *Art Interchange* 29 (July 1892), pp. 1–7.

"The Impressionists." *Gallery and Studio* 1 (Oct. 1897), pp. 6–7.

"Impressionists and Imitators." *Collector* 1 (Nov. 15, 1889), p. 11.

"The Impressionists' Exhibition at the American Art Galleries." *Art Interchange* 16, no. 9 (Apr. 24, 1886), pp. 130–31.

"Mr. Inness on Art Matters." *Art Journal* (New York) 5 (1879), pp. 374–77.

Inness, George. "An Artist on Art." *Harper's Magazine* 56 (1878), pp. 458–61.

Inness, George, Jr. *Life, Art, and Letters of George Inness.* New York, 1917.

International Exhibition for Art and Industry: Catalogue of the Art Department (Illustrated)—Foreign Exhibition. Boston, Mass., 1883.

James, Henry. "The Grosvenor Gallery and the Royal Academy." *Nation* 24 (May 31, 1877), pp. 320–21.

Johnson, Virginia C. "The School of Modern Impressionism." *Art Interchange* 42 (Apr. 1899), p. 88.

Kysela, John D. "Sara Hallowell Brings 'Modern Art' To the Midwest," *Art Quarterly* 27, no. 2 (1964), pp. 150–67.

La Farge, John. *The Higher Life in Art.* New York, 1908.

Lanes, Jerrold. "Boston Painting 1880–1930." *Artforum* 10 (Jan. 1972), pp. 49–51.

Langren, Marchal E. *Years of Art: The Story of the Art Students League of New York.* New York, 1940.

Lasting Impressions: French and American Impressionism from New England Museums. Exhibition catalogue. Museum of Fine Arts, Springfield, Mass., 1988. With essays by Jean C. Harris, Steven Kern, and Bill Stern.

Lathrop, George Parsons. "The Progress of Art in

New York." *Harper's Magazine* 86 (1892–93), pp. 740–52.

Leader, Bernice Kramer. "The Boston School and Vermeer." *Arts Magazine* 55 (Nov. 1980), pp. 172–76.

–. "Anti-Feminism in the Paintings of the Boston School." *Arts Magazine* 56 (Jan. 1982), pp. 112–19.

Lejeune, L. "The Impressionist School of Painting." *Lippincott's Magazine* 24 (Dec. 1879), pp. 720–27.

Lewison, Florence. "Theodore Robinson: America's First Impressionist." *American Artist* 27 (Feb. 1963), pp. 40–45, 72–73.

–. "Theodore Robinson and Claude Monet." *Apollo* 78 (Sept. 1963), pp. 208–11.

"Louise Cox at the Art Students League: A Memoir." *Archives of American Art Journal* 27 (1987), pp. 12–20.

Low, Will Hicok. *A Chronicle of Friendships 1873–1900.* New York, 1908.

–. *A Painter's Progress.* New York, 1910.

Mann, Virginia. "Connecticut and American Impressionism." *Arts Magazine* 55 (Nov. 1980), pp. 166–67.

Mather, Frank Jewett, Jr. *Modern Painting.* New York, 1927.

McLaughlin, George. "Cincinnati Artists of the Munich School." *American Art Review* 2, no. 1 (1881), pp. 1–4, 45–50.

Mechlin, Leila. "The Freer Collection of Art." *Century* 73 (Jan. 1907), pp. 357–70.

–. "Contemporary American Landscape Painting." *International Studio* 39 (Nov. 1909), pp. 3–14.

–. "Some American Figure Painters." *Studio* 39 (1910), pp. 185–94.

Meltzoff, Stanley. "The Rediscovery of Vermeer." *Marsyas* 2 (1942), pp. 145–66.

Meservey, Anne Farmer. "The Role of Art in American Life: Critics' Views on Native Art and Literature, 1830–1865." *American Art Journal* 10 (May 1978), pp. 72–89.

Moore, Charles Herbert. "The Modern Art of Painting in France." *Atlantic Monthly* 68 (Dec. 1891), pp. 805–16.

Moore, George. *Impressions and Opinions.* New York and London, 1891.

Morris, Harrison S. *Confessions in Art,* New York, 1930.

Munich and American Realism in the 19th Century. Exhibition catalogue. E. B. Crocker Art Gallery, Sacramento, California, 1978. Text by Michael Quick and Eberhard Ruhmer.

"The National Note in Our Art: A Distinctive American Quality Dominant at the Pennsylvania Academy." *Craftsman* 9 (Mar. 1906), pp. 753–73.

Neuhaus, Eugene. *The History and Ideals of American Art.* Stanford, California, and London, 1931.

Novak, Barbara. *American Painting of the Nineteenth Century.* New York, 1969.

O'Brien, Maureen C. *In Support of Liberty: European Painting at the 1883 Pedestal Fund Exhibition.* Exhibition catalogue. Parrish Art Museum and National Academy of Design, 1986.

"Painters' Motifs in New York City." *Scribner's Magazine* 20 (July 1896), pp. 127–28.

Paris 1889: American Artists at the Universal Exposition. Exhibition catalogue. Pennsylvania Academy of the Fine Arts, 1989. With essays by Annette Blaugrund, Albert Boime, D. Dodge Thompson, H. Barbara Weinberg, and Richard Guy Wilson.

"The Pedestal Fund Art Loan Exhibition." *Art Amateur* 10 (Jan. 1884), pp. 41–43.

Perlman, Bennard B. *The Immortal Eight: American Painting from Eakins to the Armory Show (1870–1913).* New York, 1962.

Perry, Lilla Cabot. "Reminiscences of Claude Monet from 1889 to 1909." *American Magazine of Art* 18 (Mar. 1927), pp. 119–25.

Phillips, Duncan. "The Impressionistic Point of View." *Art and Progress* 3 (Mar. 1912), pp. 505–11.

–. "What is Impressionism?" *Art and Progress* 3 (Sept. 1912), pp. 702–7.

Pierce, Patricia Jobe. *The Ten.* Concord, New Hampshire, 1976.

Pilgrim, Dianne H. "The National Gallery's Impressionist Show." *American Art Review* 1, no. 2 (Jan.-Feb. 1974), pp. 76–80.

–. "The Revival of Pastels in Nineteenth-Century America: The Society of Painters in Pastel." *American Art Journal* 10 (Nov. 1978), pp. 43–62.

Pisano, Ronald G. *The Art Students League: Selections From the Permanent Collection.* Exhibition catalogue. Hekscher Museum, Huntington, New York, 1987.

"The Point of View." *Scribner's Magazine* 9 (May 1891), pp. 657–58.

The Quest for Unity: American Art Between the World's Fairs 1876–1893. Exhibition catalogue. Detroit Institute of Arts, 1983. With an essay by David C. Huntington.

Rand, Harry. "American Impressionism." *Arts Magazine* 50 (May 1976), p. 13.

Randall, Lillian M. C., ed. *The Diary of Geòrge A. Lucas: An American Art Agent in Paris, 1857–1909.* 2 vols. Princeton, 1979.

Rewald, John. *The History of Impressionism.* 4th rev. ed. New York, 1973.

R. R. [Roger Riordan]. "The Impressionist Exhibition." *Art Amateur* 14 (May 1886), p. 121; 15 (June 1886), p. 4.

–. "What is Impressionism? From Another Point of View." *Art Amateur* 27 (Dec. 1892), p. 5.

Robinson, Frank T. *Living New England Artists.* Boston, 1888.

Robinson, Theodore. "Claude Monet." *Century Magazine* 22 (Sept. 1892), pp. 696–701.

Saint-Gaudens, Homer. *The American Artist and His Times.* New York, 1941.

Seaton-Schmidt, Anna. "An Afternoon with Claude Monet." *Modern Art* 5 (Winter 1897), pp. 32–35.

Sellin, David. *Americans in Brittany and Normandy: 1860–1910.* Exhibition catalogue. Phoenix Art Museum, Phoenix, Arizona, 1982.

Seymour, Ralph, and Arthur Stanley Riggs. "The Gellatly Collection." *Art and Archaeology* 35 (1934), pp. 109–25, 144.

Shinn, Earl. *The Art Treasures of America.* 3 vols. Philadelphia, 1879–81.

–. *Mr. Vanderbilt's House and Collection.* 2 vols. New York, 1884.

Skalet, Linda. "Thomas B. Clarke, American Collector." *Archives of American Art Journal* 15 (1975), pp. 2–7.

Smith, Francis Hopkinson, ed. *Discussions on American Art and Artists.* Boston, 1890.

Soissons, S. C. de. *Boston Artists: A Parisian Critic's Notes.* Boston, 1894.

Special Exhibition: Works in Oil and Pastel of the Impressionists of Paris. Exhibition catalogue. National Academy of Design, New York, 1886.

Stark, Otto. "The Evolution of Impressionism." *Modern Art* 3 (Spring 1895), pp. 53–56.

Steele, Theodore C. "Impressionism." *Modern Art* 1 (Winter 1893), unpaginated.

Stein, Roger B. *John Ruskin and Aesthetic Thought in America, 1840–1900.* Cambridge, Mass., 1967.

Stephens, Henry G. "'Impressionism': The Nineteenth Century's Distinctive Contribution to Art." *Brush and Pencil* 11 (Jan. 1903), pp. 279–97.

Strahan, Edward. "Works of American Artists Abroad." *Art Amateur* 6 (Dec. 1881), pp. 5–6.

Taft, Lorado. *Painting and Sculpture in Our Time: Syllabus of a Course of Six Lecture Studies.* Chicago, 1896.

The Ten. Exhibition catalogue. Art Museum of South Texas, Corpus Christi, Texas, 1977.

"Ten American Painters." *Art Amateur* 38 (May 1898), pp. 133–34.

"Ten American Painters." *Collector* 9 (Apr. 15, 1899), p. 180.

Ten American Painters. Exhibition catalogue. Spanierman Gallery, New York, 1990. With essays by William H. Gerdts et al.

Troyen, Carol. *The Boston Tradition: American Painting from the Museum of Fine Arts, Boston.* Exhibition catalogue. Boston and New York, Museum of Fine Arts and American Federation of Arts, 1980.

Trumble, Alfred. "Impressionism and Impressions." *Collector* 4 (May 15, 1893), pp. 213–14.

–. "A Painter's Progress." *Quarterly Illustrator* 2 (Jan.-Mar. 1894), pp. 48–50.

Van Dyke, John C. "The Bartholdi Loan Collection." *Studio* 2, no. 49 (Dec. 1883), pp. 262–63.

Venturi, Lionello. *Les Archives de l'Impressionisme.* 2 vols. Paris and New York, 1939.

W. H. W. "What is Impressionism?" *Art Amateur* 27 (Nov. 1892), pp. 140–42; 27 (Dec. 1892), p. 5.

Waern, Caecilia. "Some Notes on French Impressionism." *Atlantic Monthly* 69 (Apr. 1892), pp. 535–41.

Weber, Nicholas Fox. "Rediscovered American Impressionists." *American Art Review* 3 (Jan.-Feb. 1976), pp. 100–15.

Wedmore, Frederick. "The Impressionists." *Fortnightly Review* 39 (Jan. 1883), pp. 75–82.

Weinberg, H. Barbara. "American Impressionism in Cosmopolitan Context." *Arts Magazine* 55 (Nov. 1980), pp. 160–65.

–. "Nineteenth Century American Painters at the Ecole des Beaux-Arts." *American Art Journal* 13 (Autumn 1981), pp. 66–84.

–. *The Lure of Paris: Nineteenth Century American Painters and their French Teachers.* New York, 1990.

Weinberg, Louis. "Current Impressionism." *New Republic* 2 (Mar. 6, 1915), pp. 124–25.

Weitzenhoffer, Frances. "First Manet Paintings to Enter an American Museum." *Gazette des Beaux-Arts* 97 (Mar. 1981), pp. 125–29.

–. *The Havemeyers: Impressionism Comes to America.* New York, 1986.

Weller, Allen S. "The Impressionists." *Art In America* 51, no. 3 (June 1963), pp. 86–91.

Young, Mahonri Sharp. *The Eight: The Realist Revolt in American Painting.* New York, 1973.

Zug, George Breed. "The Story of American Painting, IX: Contemporary Landscape Painting." *Chautauquan* 50 (May 1908), pp. 369–402.

Index of Names

Photograph Credits